CONSTELLATION
OF GENIUS

CONSTELLATION OF GENIUS

1922: MODERNISM YEAR ONE

KEVIN JACKSON

FARRAR, STRAUS AND GIROUX

NEW YORK

Farrar, Straus and Giroux
18 West 18th Street, New York 10011

Copyright © 2012 by Kevin Jackson
All rights reserved
Printed in the United States of America
Originally published in 2012 by Hutchinson, Great Britain
Published in the United States by Farrar, Straus and Giroux
First American edition, 2013

Library of Congress Cataloging-in-Publication Data
Jackson, Kevin, 1955–
 Constellation of genius : 1922: modernism year one / Kevin Jackson. — First
American edition.
 pages cm
 Includes bibliographical references and index.
 ISBN 978-0-374-12898-2 (hardcover)
 1. Modernism (Literature) 2. Nineteen twenty-two, A.D. I. Title.

PN56.M54 J32 2013
809'.9112—dc23

 2013015124

Designed by Jonathan D. Lippincott
The display type is set in Metropolis 1920, a typeface created and designed by
Josip Kelava, and is used with his permission.

Farrar, Straus and Giroux books may be purchased for educational, business,
or promotional use. For information on bulk purchases, please contact
the Macmillan Corporate and Premium Sales Department at 1-800-221-7945,
extension 5442, or write to specialmarkets@macmillan.com.

www.fsgbooks.com
www.twitter.com/fsgbooks • www.facebook.com/fsgbooks

1 3 5 7 9 10 8 6 4 2

In memory of

Tom Lubbock

Il miglior fabbro

CONTENTS

ACKNOWLEDGEMENTS

My friends and colleagues Mark Booth, Jocasta Hamilton and Peter Straus all acted well above and beyond the call of duty to help see this book into the world. I am grateful beyond ready expression.

Of all my other friends, Ian Irvine was the most indefatigable supplier of information, rare texts, citations, wisdom and cerebral support during the years spent working on this book.

Gratias ago also to:

The late Gilbert Adair (RIP), Ian Alister, Pamela Allen, Mohit Bakaya, Jo Banham, Alastair Brotchie, Kate Bassett, John & Marie-Do Baxter, Tobias Beer, Anne Billson, Prof Simon Blackburn, Peter Blegvad, Jacqui Brocker, Kate Bolton, Jonathan Burt, Pete Carpenter, the Cuddon family, Richard Cohen, Prof Anne Dunan-Page, Hunt Emerson, Tig Finch, Francis FitzGibbon QC, Sir Christopher Frayling, Philip French, Alexander Fyjis-Walker, Spike Geilinger, Mark Godowski, Colin Grant, Richard Humphreys, Magnus Irvin, Robert Irwin, Dr Mary-Lou Jennings, Dr Glyn Johnson & Dr Evie Johnson, Philip Gwyn Jones, Gary Lachman, Shan Lancaster, Dr Anne Leone, Nick Lezard, Kevin Loader, the late Tom Lubbock (RIP), Kevin Macdonald, Rob Macfarlane, Fiona McLean, Roger Michell, Deborah Mills, Colin Minchin, Alan Moore, Kim Newman, Simon Nicholas, Charlie and Sally Nicholl, Holly O'Neill, Prof Christopher Page, the Parsons family, Tanya Peixoto, David Perry, Mark Pilkington, Marzena Pogorzaly, Toby Poynder, the Preston family, Nick Rankin, Dr David Ricks and Dr Katy Ricks, Dr Stephen Romer, Martin Rowson, the Royal family, Prof Jonathan Sawday, Marcus Sedgwick, the Shepherd-Barron family, Iain Sinclair, Tom Sutcliffe, Dr Peter Swaab & Andrew MacDonald, Dr Bharat Tandon, David Thompson, Prof Martin Wallen, Prof Marina Warner, Lisa Williams, Clive Wilmer, Louise Woods, David & Linda Yates.

Without my wife, Claire: nada.

KJ
8 June 2012

CONSTELLATION OF GENIUS

INTRODUCTION
1922 AND ALL THAT

The American poet Ezra Pound referred to 1922 as Year One of a new era. In his view, the previous epoch – the Christian Era, he called it – had ended on 30 October 1921: the day, that is, when James Joyce wrote the final words of *Ulysses*. Pound suggested that all enlightened people should henceforth adopt his new calendar. For a while, he actually took to dating his letters *p. s. U. – post scriptum Ulixi*. It was a short-lived habit. Later in Anno Domini 1922, Benito Mussolini's fascists took control of Italy. They too initiated a new calendar; and Pound, an increasingly keen admirer of Mussolini, abandoned the Joycean time scheme and adopted the Italian one.

Had he been kidding about the era-slaying nature of *Ulysses*? To some extent, yes. Still young enough in years – he turned 37 in 1922 – and younger in spirit, Pound loved to tease and provoke; better still, to outrage. But his proposal that the world had somehow changed radically at or by the start of 1922 was not altogether a folly – or so it came to seem, anyway, when scholars of later decades began to look back on those heady and unequalled days, and to assess their lasting significance. Long before the end of the twentieth century, it had become almost a commonplace that 1922 unquestionably was the *annus mirabilis* of literary modernism. It was the year that began with the publication of *Ulysses*, and ended with the publication of *The Waste Land*, by T. S. Eliot: the most influential English-language novel of the century, the most influential English-language poem of the century. Despite several revolutions in taste, these two works remain the twin towers at the beginning of modern literature; some would say of modernity itself.

To be sure, not everyone has gone along with the 1922 party line. There have been other candidates for the hypothetical moment of transition from pre-modern to modern – the year 1910, for example, as in Virginia Woolf's well-known declaration (in 'Mr Bennett and Mrs Brown', 1924): 'in or about December 1910, human character changed'. Another modern

novelist, D. H. Lawrence, insisted that 'It was in 1915 that the old world ended.' (He proposed that date in his Australian novel, *Kangaroo*, written in . . . 1922.) The pastime of calling an old world dead and a new one either freshly born or imminent was rather popular in the early decades of the twentieth century. Modern times, it has variously been asserted, began with the first performance of Jarry's *Ubu Roi* in 1896 ('After us, the Savage God,' wrote W. B. Yeats, who had witnessed that rowdy night); with Freud's *Interpretation of Dreams* in 1899; with Einstein's formulation of the Special Theory of Relativity in 1905; with Picasso's *Desmoiselles d'Avignon* in 1907; with Stravinsky's *The Rite of Spring* in 1913; with the outbreak of World War I in 1914 (never such innocence again); or with the October Revolution of 1917.

As this list implies, modern literature was notably lagging behind the other arts in the matter of experimentation. The successful prose writers of the day included the likes of Galsworthy, Bennett, and Kipling: masters of a plain, no-nonsense prose that aspired to the condition of complete self-effacement. Even H. G. Wells, who composed novels of ideas and scientific romance, wrote of strange futures in a good old-fashioned style. With the exception of a few wild souls promoted and recruited by Pound, poets mainly aspired to write in the Georgian manner – short, formal, nostalgic verses steeped in the rural life of England. A. E. Housman was the living god of this tradition. English-language drama had just begun to catch up with Ibsen – an early idol of Joyce – but not yet with Strindberg or Jarry, and Shaw's witty, well-carpentered plays were about the most daring confections that theatrical companies could tolerate.

Let's try to imagine the reactions of an unprepared, average reader of 1922, content with his beer and skittles and his Kipling. Suddenly, enter a skinny, shabby Irishman and a natty, quietly sinister American, between them hell-bent on exploding everything that realistic fiction and Georgian poetry held dear. In Joyce's novel, the old seductions of plot and character come a very poor second to a wild orgy of language. Far from being self-effacing, his prose is offered as a glory in its own right: wildly abstruse philosophical terms rub flanks with words from the pub and the brothel; the pages teem with parodies and pastiches of newspapers and legalese, religious catechisms and scientific reports, nursery rhymes and epic poems, soft porn and hard porn. Language has rebelled against the tyranny of subject matter and character, and become the leading character in its own right. The horror!

Worse still is Joyce's insistence on portraying every aspect of quotidian life in unprecedented detail, including what happens in the lavatory and the marital bed . . . though anyone flicking through its pages in search of spice is soon likely to be discouraged, either by the dauntingly high-flown quality of ruminations in the brain of Stephen Dedalus (a portrait of Joyce as he was in 1904) or by the maddeningly eccentric associative leaps in the brain of Leopold Bloom (the unlikely 'Ulysses' character, a gentle middle-aged cuckold who by the end of the narrative will act the compassionate father to Stephen). Readers impatient to find the dirty words should go straight to the final chapter, a long night-time reverie, almost completely free of punctuation, by Bloom's wife Molly. Plenty of sex there.

As for Eliot's poem: well, it is a good deal less indecent than Joyce when it comes to vocabulary – though it does include a cockney dialogue that is fairly obviously about abortion, and a sordid one-night stand between a spotty youth and a listless secretary. In formal terms, though, it is perhaps even more offensive to the conventional poetry reader, being at first glimpse little more than a series of unnamed voices and barely comprehensible vignettes, bulked out by unashamed plagiarism – dozens and dozens of lines pilfered from earlier poems and other works of literature, in the Lord alone knows how many languages, French and Italian and Provençal and German and – can you credit it? – Sanskrit . . .

So, for ill or for good, English literature at last had its own *Ubu*, its own *Desmoiselles*, its own *Rite of Spring*. Just like Jarry, Eliot and Joyce had produced wilfully offensive, obscene works that revelled in their own (apparent) senselessness. Like Picasso, they had torn apart conventional, 'perspective'-governed rules of representation, dwelt on unmentionable aspects of sexuality, and doted on ugliness and the primitive. Like Stravinsky, they spat on their immediate predecessors and went back centuries or even millennia to the anthropological roots of art and civilisation. (Eliot's endnotes to his poem declared his essential debt to recent anthropologists.) With Eliot and Joyce, English literature finally entered the new century, just 22 years late for the party.

Many fledgling students of modern writing have noticed for themselves this curious fact, that *Ulysses* and *The Waste Land* belong to the same twelvemonth, and wondered a little about what, if anything, this might

mean. (The curiosity first struck me when I was seventeen, drudging at a mindless summer job in a bank in the City of London – just as Eliot, I knew, had been drudging when he composed his poem – and spending my evenings hungrily devouring *Ulysses* by way of escape into a more vivid world.) Is it a mere coincidence of the kind that crops up throughout the history of literature? Or was there some kind of historical inevitability at work here?

Both, of course. If Joyce had not been so driven by a superstitious need to have his great work published on his fortieth birthday – 2 February 1922 – he might easily have given in to his old habits of procrastination, maddeningly frequent revisions and expansions of page proofs, and general laxness, and *Ulysses* would have been delayed and delayed. If Eliot had not persuaded Lady Rothermere to stump up the funds for a literary quarterly, *The Criterion*, in which he could launch his long poem, publication in the United Kingdom might have been similarly delayed. And so on.

This much conceded, there is more to be said. Reference books will usually tell you that both of these books express the general sense of disillusion and crisis that followed the end of the Great War; and that their look of formlessness and anarchy was a symptom of the complete breakdown of old humanist values. They are, thus, books that were bound to appear in 1922 or thereabouts because they were the first major pieces of writing to take the measure of the world after 1918 – allowing that the composition of a major work is likely to take at least a few years.

Though it is sensible never to make light of the effect of the war on anything that has followed, the case for regarding these books as historically inevitable is often overstated. Recall that neither Eliot nor Joyce had first-hand experience of the trenches. Eliot, though his family sense of duty prompted him to try and join the American armed forces once the USA entered the war, was judged unfit for service and remained at his banking job. Joyce, both a pacifist and a man who paid scant attention to what was going on in the bigger world unless it interfered with his writing or his family, ran to neutral Switzerland for the duration, and liked to affect surprise when told that there was war raging in Europe. *Ulysses* and *The Waste Land* both contain substantial tranches of autobiography, and the men who wrote them were non-combatants.

Recall, too, that the first sketches of both works antedate the war, and

though these first drafts were clearly shaped by the larger movements of the culture (no man, to recall one of Eliot's favourite writers, John Donne, is an island), it would take great ingenuity as well as great tact to sort out quite how they expressed the spirit of the age. Both men, for example, grew up at a time and in cultures when it was expected that decent young chaps should profess Christianity, but when more and more clever and independent spirits found it impossible to make that profession.

Both Joyce and Eliot passed from faith to doubt – and both were exceptionally well read in the philosophy and theology of the Middle Ages, revering Dante and studying the Church Fathers – but they managed and expressed the crisis in very different ways. Joyce ostentatiously cast off his Catholicism as a faith (hyper-ingenious Catholic critics have sometimes tried to recapture him), though he retained a lifelong interest in St Thomas Aquinas; Eliot passed through years of anguish, was powerfully drawn by the teachings of Buddhism, and ended up a member of the Anglican communion. *Ulysses* documents a growth away from belief; *The Waste Land* a passionate, tortured craving for redemption.

But had the seeds of Joyce and Eliot fallen on to unfertile land, we may never have heard of them. The world, or a small but significant fraction of it, was now ready to read books like this. Just a few years earlier, Eliot's handful of published poems had been widely regarded as gibberish – the ravings, as Evelyn Waugh's father put it, of a drunken helot. There were plenty of older men of letters around in 1922 to insist that *The Waste Land* was either fraudulent or insane; naturally, their contempt made the poem all the more glamorous to clever young rebels. The English poet Hugh Sykes Davies, a schoolboy in the 1920s, used to recall one master picking up his personal copy of the poem, reading a few lines with mounting horror, and saying, 'My God, Sykes Davies, this is pretty Bolshy stuff.' (A remark that seems all the more obtuse in the light of Eliot's profound Toryism in later years.) The related cult of *Ulysses* in the 1920s also owed much to its reputation as a wildly indecent act of revolt.

The question of why Joyce and Eliot both broke through in 1922 has a more humble solution than the one which explains them as expressions of the zeitgeist. Both authors owed the launch of their careers proper to the generous, indefatigable and brilliantly discerning Ezra Pound, a restlessly innovative young poet who had come to London to be in the capital of literature, and had been amused and exasperated by the stodginess and

timidity he found there. He concluded that what was needed was another Renaissance. Looking around him for signs of new talent in every field of the arts, from sculpture to music, but especially in writing, Pound had been thrilled to discover two young, obscure writers of wide learning and manifest genius. He spotted them both shortly before the war, and went in to bat for them at once. Given the unpromising conditions in which he was working, a period of about seven or eight years between discovery and launch seems about right.

It is to Pound's eternal credit that he immediately recognised their potential – very few others ever had – and selflessly devoted much of his time and effort for the next few years to cultivating and promoting their work. At first, Pound's friendship with Joyce was mainly carried out in letters, and they only began to meet in person after Joyce yielded to Pound's suggestion and moved to Paris – in the 1920s, already firmly established as the undisputed world capital of the arts.

But Eliot, who was still a graduate student at Oxford, where he was working towards a PhD in philosophy, saw a good deal of Pound in London, where the slightly older American poet introduced him to artistic and bohemian circles. Thanks also to Pound, Joyce and Eliot soon came to know quite a bit about each other – Eliot followed the chapters of *Ulysses* as they were published in *The Little Review*, and was deeply impressed – but they did not meet in person until the summer of 1920.

Seven years earlier, Joyce had been poor, often so poor that he and his family had to go without their dinner. He had been drudging as a language teacher, and (all but unpublished save for a small book of poems) was locked in long and fruitless battles with publishers. He could easily have gone on like this for the rest of his life: an impoverished, embittered drunk, all too aware of the vast talent festering inside him.

Pound put all that to rights with remarkable speed. He finally found a publisher for *A Portrait of the Artist as a Young Man* and other writings; he read the earliest drafts of *Ulysses*, raved about them to Joyce, and bullied or seduced editors (notably the editors of *The Little Review*, Margaret Anderson and Jane Heap; they did not need much seducing) into publishing these, too; tracked down assorted patrons for Joyce, above all the wealthy

and idealistic editor Harriet Shaw Weaver, who provided him with a regular income to live beyond (over the years, her gifts added up to about £600,000 in twenty-first-century values), and the rich New York lawyer John Quinn, who paid handsome sums for manuscripts by both Joyce and Eliot.

Pound was an even more important sponsor for Eliot, and not only in material ways. One of Joyce's most valuable assets was an unswerving belief in his own genius and in the correctness of his choices in life, however grim and discouraging the circumstances. Eliot, by complete contrast, was worm-eaten with doubts. He intuited (or perhaps a more apt word might be 'suspected'; the mood of his early poems is dense with insinuated menace) that he had a significant gift for poetry, but was by no means certain that it would prove enduring, or that it would be worth making great sacrifices to develop his gift.

It was Pound, above all, who told him that his early poetry was not merely promising but probably the best work being written by anyone from the rising generation; Pound who gave him the resolve to throw in his academic career and move to London, despite the pain it would give his parents back in America; Pound who wrote a soothing letter to Eliot's alarmed and disapproving parents, praising their son's literary talents, defending his drastic changes of life – including his recent hasty marriage to Vivien Haigh-Wood.[1] Pound also cited his own career as evidence that a brilliant young American man of letters could make a respectable living in London.

Not that Pound was a slouch when it came to improving the material aspects of Eliot's sad life. He made sure that Eliot met influential people as well as amusing ones, and wangled him reviewing jobs. By 1920, Eliot had already become well known in literary circles as one of the most brilliant critics of the day, even though his contributions to *The Times Literary Supplement* were anonymous, like those of other reviewers. When Eliot finally gave up trying to support himself and Vivien by teaching in boys'

1. She was christened Vivienne, but for some reason disliked the spelling; she and her contemporaries all used the Vivien spelling in letters and diaries, and it will be followed throughout this book.

schools, and took up a modestly paid post at Lloyd's Bank in the City of London, it was Pound who helped organise the so-called *Bel Esprit* scheme. The idea was that Eliot's wealthier admirers would agree to provide him with a regular annual income for at least the next few years. The scheme came to nothing. And if Pound had not stepped in?

The game of alternative histories has only limited value, but we can use early life studies to reconstruct the way sympathetic observers of Joyce and Eliot might have foreseen their futures from the pre-war perspective. Had Pound not intervened, it is quite likely that Joyce would have carried on living in the manner to which he had become accustomed: chronically poor, underemployed and unknown. His pride and his sense of wounded merit would almost certainly have guaranteed that he would continue to alienate publishers as he had done for years. His sense of artistic vocation would have kept him writing stories and books that no one wanted to read. His feckless side would have kept him in cafés and restaurants night after night, spending beyond his means and drinking himself towards an early grave.

To be sure, there are some happier possibilities: he might have capitalised on his local success as a promoter of drama in wartime Zurich, and become some kind of theatrical entrepreneur. He might have made another attempt at launching a cinema chain in Ireland, and this time enjoyed the success he had missed; or he might finally have persuaded a university somewhere in the English-speaking world to take him on as a professor of Italian. But a life of obscure, shabby-genteel drudgery is the most likely fate.

Eliot's alternative life, or lives, are easier to sketch; he sometimes brooded on such matters himself. Yielding, as was in his nature, to a sense of duty and family loyalty, he would probably have returned to the United States, completed his dissertation on F. H. Bradley, and become an academic philosopher, either at Harvard or some other distinguished university. His recognised brilliance at the subject might have made him, eventually, the leading American philosopher of the century. His increasing interest in Buddhism and other Eastern traditions might have led him to write major works on non-Western schools of thought. Or perhaps his want of stamina, his fastidiousness and his diffidence might have made him a notorious non-publisher – something still possible in those days before research assessment exercises. On a happier note, he would proba-

bly have married his sometime sweetheart, Emily Hale, and enjoyed while still young the domestic happiness that in reality came to him only with old age and his second marriage. Would he have written poetry? Eliot himself believed that he probably would have been too drained by the demands of philosophy ever to write verse again.

On the other hand, had Eliot decided to remain in England, but abandoned his literary ambitions and settled for a career in banking – for which he had an unexpected flair – his life might have been a kind of Hell, instead of merely a protracted sentence of wretchedness occasionally mitigated by small triumphs as a critic and poet. It would be hard to exaggerate the misery of Eliot's personal life in the years which led up to *The Waste Land*. He suffered in his own right from assorted physical illnesses (headaches, influenza, bronchial difficulties) as well as overwork, melancholy, lack of will and occasional despair. Compared to Vivien, however, Tom was a model of rude health. Though she had initially attracted Eliot by her apparent vivacity and zest for life, in reality she was in poor bodily health and a worse mental condition. There were long periods in which she was bed-ridden and Tom was her round-the-clock nurse. In recent years biographers (including Ray Monk) have established, with a fair degree of certainty, that she was seduced – possibly within days of their marriage – by the philosopher Bertrand Russell. (There are some cryptic lines in the drafts of *The Waste Land* which hint that Eliot was aware that Bertie and Viv had made him a cuckold.) It also seems likely that their marriage was starved of sexual intimacy; Vivien once remarked that she had been expecting to stimulate Tom but had been disappointed.

Small wonder that Eliot eventually suffered a complete nervous breakdown. His employers were kind, and allowed him three months of sick leave, which he spent in the final months of 1921 on the sea coast at Margate and then in a clinic in Lausanne, where the poem was finally completed. *The Waste Land* is about many things – about the strangeness of London during the war, for instance – but one of its main topics is the woe of marriage in general and the Eliot marriage in particular. Eliot once confided in a writer friend that it was his life with Vivien that brought about the state of mind from which *The Waste Land* was produced. At least his anguish bore exceptional fruit. Without the precious

encouragement, counsel and help of Ezra Pound, Eliot might have grown old and desiccated in the service of Lloyd's Bank, keeping his terrible marriage a secret from all but a few.

Fortunately, Pound did intervene; and his protégés Eliot and Joyce gradually, over the decades, became acknowledged as giants.

It may sound cynical to propose that one reason why *Ulysses* and *The Waste Land* have become the twin peaks of modernist literature is that they are ideal fodder for the classroom. After all, both works made their initial impact well outside the academic world, among select coteries of fellow writers and artists, wealthy patrons and up-to-the-minute dilettantes. Both, as noted, were then taken up by small numbers of idealistic young people, usually as expressions of rebellion against the stuffy world of their seniors or – recall the famous scene in *Brideshead Revisited*, in which an Oxford aesthete chants Eliot's poem through a megaphone – the complacent stupidity of their more conforming contemporaries.

Outside such coteries, they were not exactly overnight sensations. For some years, *The Waste Land* was hardly known at all outside Bloomsbury and its colonies in Cambridge, Oxford and elsewhere – or, in America, among readers of the small literary magazines; *Ulysses* was somewhat better known to the broad public mainly because of the court cases for obscenity brought against the editors of *The Little Review*. For the first 11 years of its life, it was a banned book. In the United States it became legal to publish *Ulysses* only after 6 December 1933, when US District Judge John M. Wollsey declared, in the case of *United States vs One Book Called Ulysses*, that the novel was not pornographic, and therefore not obscene. Random House published the first trade edition of *Ulysses* in 1934; the Bodley Head edition, in the United Kingdom, appeared in 1936. So: *Ulysses* was just a 'dirty book', while *The Waste Land* baffled or disgusted those who still lived in the mental world of the Georgians.

And yet it is the familiar story of modern literature – since, say, the trials of Baudelaire for *Les Fleurs du Mal* and Flaubert for *Madame Bovary* – that the banned and scandalous book of one generation becomes the set text of the following generation. (The same principle can be seen at work even more dramatically in the history of modern painting.) *Ulysses*

and *The Waste Land* truly began their rise to the top when they were taken up by the universities. It helped, of course, that they are works of genius.

The qualities that made Joyce and Eliot ripe for such cherry-picking are self-evident. Their masterpieces are complex works, full of extensive and strange learning, and they demand a degree of attention far higher than that which the average browser is generally willing to give. In certain respects, they are comparable to religious texts, like the Talmud, in that they require a 'professional' reader to mediate between their mysteries and the lay audience. So the critic of such works is transformed into a kind of secular rabbi or priest: no longer a humble dry-as-dust, perhaps even mildly pathetic pedant, like some poor schoolmaster from a Dickens novel. In the wake of the modernist revolution, academic literary critics became more and more important. And with the growth of universities in the following decades, countless thousands of students assimilated the view that Joyce and Eliot topped their respective leagues.

It is quite a complex story, but its leading characters are easy enough to name. In the case of *The Waste Land*, the earliest academic champions in Britain were I. A. Richards – one of the founding members of the new Cambridge English Tripos – and two of his junior colleagues, William Empson and F. R. Leavis. Between them, these three critics – often lumped together as a 'Cambridge school', though their differences are as striking as their similarities – changed the way English literature was taught, not merely in the UK but in departments around the world. Richards was the oldest of the group, the first to be overwhelmed by Eliot's brilliance, and the first to make contact with the poet, whom he tried, without success, to lure up to Cambridge as a full-time teacher.

Empson – now regarded by some as far and away the most gifted of that odd trio – was also profoundly influenced by Eliot, and late in life would write a dazzling essay on the *Waste Land* manuscripts (republished in *Using Biography*, which also includes an idiosyncratic piece on *Ulysses*). But the critic who played the largest role in bringing *The Waste Land* to centre stage was Leavis; the key essay came in his book *New Bearings in English Poetry*, published in 1932. Leavis was less impressed by Eliot's later work, but the *New Bearings* essay – still highly readable today, long after Leavis's fall from power – was a major step towards placing Eliot on every university, and later school, syllabus.

In the United States, the story is fairly similar. The gradual triumph of Eliot in the universities there is also the triumph of the so-called New Criticism, which was the dominant force in the teaching of English literature from around the early 1940s until well into the 1970s. Its leading names include John Crowe Ransom – whose 1941 book *The New Criticism* gave the movement its name – and his friends and fellow Southerners Allen Tate and Robert Penn Warren; followed by R. P. Blackmur, Cleanth Brooks (author of *The Well-Wrought Urn*, 1947), and William K. Wimsatt and Monroe Beardsley, co-authors of a widely read essay, 'The Intentional Fallacy'. Richards, Empson and Leavis are sometimes also referred to as New Critics, but this is sloppy.

The two main things that the British critics had in common with their American colleagues is that they too were concerned with the practice of the close reading of literary texts – pretty much the same discipline known in Cambridge, after Richards's book of that name, as 'Practical Criticism' – and that they all admired Eliot. It is sometimes said that Eliot was the man who inspired New Criticism, and there is truth in this, though Eliot's own essays have almost nothing in common with what he disdainfully called the 'lemon-squeezer school of criticism'. Broadly speaking, the New Criticism was formalist – concerned only with what could be said, sometimes ingeniously, about the arrangements of words on the page, and unconcerned with questions of history, authorial intent or ideology. (Since one of the great strengths of Empson's criticism was his acute sense of the pressure and presence of history in texts, it seems almost farcical that he should have ever been seen as a typical New Critic.)

As a general approach to literature, such a method is lamentably impoverished. As a classroom method, especially for teaching those who are not widely read, it has obvious uses, and obvious consequences. Wordsworth once proposed that major poets create the climate in which they are appreciated; this was certainly the case with Eliot, since the New Criticism was very good at showing at least some of the things that were very good about his poetry.

As Eliot's reputation rose, that of his Irish friend followed in its wake. The books that had once been banned or derided were now compulsory elements of the syllabus. But to be part of a canon is to be safe, and comfortable, and probably dull. None of the few people who read them in 1922 felt that they were either.

•

1922 was a year of remarkable firsts, and births, and foundations. An old world was passing. Newspapers told of the final collapse of the Ottoman Empire, the end of British Liberalism with the crushing defeat by the Conservatives at the 1922 general election, the thwarting of Marcus Garvey's dreams for a new Africa. The Washington Naval Conference saw Britain's naval supremacy – which can be dated back to the defeat of the Spanish Armada – officially pass to the United States. In the world of the arts, Dada was put to rest; and Proust died.

New nations were created, and new modes of government. The world's first fascist state was established in Italy. A treaty at the very end of the year marked the official formation of the Union of Soviet Socialist Republics. Egypt gained at least formal independence from Britain; while Britain began its mandate in Palestine. After a brutal civil war, modern Ireland came into being – and W. B. Yeats, a friend of both Eliot and Pound, was made one of its senators.

It was quite definitely the *annus mirabilis* of radio, the first year in which radio ceased to be a local novelty and grew into a worldwide medium for (old word, new sense) broadcasting, with stations opening across the United States virtually by the day, and the beginning of the BBC in the United Kingdom. From now on, almost every house in the world would be filled with disembodied voices; an experience, as Hugh Kenner and others have noted, comparable to reading *The Waste Land*, where unidentified speakers come and go, uttering cryptic phrases in a range of different languages. It was as if Eliot had prophesied the experience which later became commonplace: turning the dial of a wireless to eavesdrop on strange and distant lands.

Cinema was no longer quite the novelty it had been, but its scale and universality had some unprecedented effects. Hollywood, though badly damaged in 1921 and 1922 by a series of scandals, continued to transform the nature of fame. Charlie Chaplin, adored by the masses and intellectuals alike, was the most immediately recognisable man on the planet, though his popularity was keenly challenged by the likes of Mary Pickford, Douglas Fairbanks and Rudolph Valentino. 1922 was the year in which Chaplin decided to graduate from comedy shorts, and to direct his first true feature, *A Woman of Paris*. He was far from alone in his attempt to mount ever more ambitious productions.

Von Stroheim's *Foolish Wives,* at the start of the year, was the most expensive film ever made, but by the end of the year it had been overtaken by the glorious *Robin Hood* – the first film ever to have a Hollywood premiere. In Britain, an obscure, plump young man named Alfred Hitchcock directed his first feature, *Number Thirteen.* Walt Disney founded the Laugh-a-Gram company and produced his earliest animated shorts. In Weimar Germany, Murnau's *Nosferatu* and Fritz Lang's first film about the master criminal Dr Mabuse brought audiences entirely new forms of cinematic terror. The immensely popular *Nanook of the North* was the world's first documentary feature. *The Toll of the Sea*, the first true Technicolor film, was released. And in Russia – still a few years away from its most triumphant flowering – the young Dziga Vertov began making his Kino-Pravda documentaries.

On all sides, and in every field, there was a frenzy of innovation. Modern linguistic philosophy can be dated from the publication of Wittgenstein's *Tractatus Logico-Philosophicus* that year. Modern anthropology began with the triumphant publication of Malinowski's *Argonauts of the Western Pacific.* Kandinsky and Klee joined the Bauhaus, and added their distinctive talents to that Utopian project. Louis Armstrong took the train from New Orleans to Chicago, joined King Oliver's Band and launched himself as the greatest performer in the history of jazz. African-American culture came of age with the first major manifestations of what became known as the Harlem Renaissance . . .

Ulysses and *The Waste Land* are the outstanding literary works of that year, the sun and moon of modernist writing. But they appeared in a sky – to pick up a metaphor used by the famous American critic Harry Levin – that was blazing with a 'constellation of genius' of a kind that had never been known before, and has never since been rivalled. The following pages attempt to identify the most important stars in this constellation, and to show how the master works of Joyce and Eliot fit on the chart.

JANUARY

I JANUARY

LAUSANNE – PARIS

T. S. Eliot was en route from Lausanne to Paris. He arrived on 2 January, rejoining his wife Vivien and remained in the city for two weeks. During the stay, Ezra Pound introduced the Eliots to Horace Liveright, the American publisher, and they had dinner with James Joyce. For about 10 days, Pound and Eliot worked closely together on the manuscript of *The Waste Land*. In mid January, Eliot returned to London – to his flat at 9 Clarence Gate Gardens.

HOLLYWOOD

At the very start of the working day, Douglas Fairbanks gathered all his colleagues together and declared: 'I've just decided that I'm going to make the story of Robin Hood. We'll build the sets right here in Hollywood. I'm going to call it *The Spirit of Chivalry*.' Among those listening to this impassioned speech was the head of the Pickford-Fairbanks foreign department, Robert Florey, who later reported: 'I will never forget the forcefulness with which Douglas made this pronouncement. He pounded his fist on a small table. Nobody said a word.'

Fairbanks went on to explain that he and his wife Mary Pickford were planning to buy a new studio – the old Jesse Hampton Studio on Santa Monica, which was surrounded by huge empty fields where the filmmakers could re-create Nottingham, the castle of Richard the Lionheart, Sherwood Forest, Palestine, the Crusaders' camp in France . . . They would make thousands of costumes, all based on authentic period designs, and shields, and lances, and . . . Finally, Fairbanks's brother John worked up the nerve to ask just how much all this would cost the company (of which he was treasurer).

'That's not the point!' Fairbanks replied. 'These things must be done properly, or not at all!'

By midday, everyone was agreeing with him. *Robin Hood* must be made.

By the time of release (see 18 October), *Robin Hood* had cost $1,400,000. It was by far the most costly film that Hollywood had produced – almost exactly twice the bill for the previous record-breaker, *Intolerance*, which had eaten up $700,000. The Dream Factory was entering a new phase of ambition, accomplishment and hubris.

PARIS

Marcel Proust saw in the New Year by staying up all night at a ball given by his aristocratic friends, Comte Étienne de Beaumont and his wife. Proust was now famous; he was also very ill (indeed, he was dying, and would not see out the year). The latter condition was only too familiar to the novelist, who might fairly have described his life, in Alexander Pope's phrase, as a 'long disease'. But fame was still a novelty.[1]

Proust enjoyed his fame, as much as his health permitted, though he had new sorrows, too. In January 1919 he took a blow from which he never fully recovered: his aunt announced that she had sold the building in which he had his legendary apartment, 102 Boulevard Haussmann, for conversion into a bank. He was forced to move out at the end of May, and spent most of the summer living at 8 bis Rue Laurent-Pichat, before finally settling at 44 Rue Hamelin.[2]

Still, he continued to work doggedly at revising and correcting the texts of his huge novel, though insomnia and fatigue made the work wretched. He asked his publisher, NRF, for help; for some unfathomable reason,

1. It had begun just a couple of years earlier; to be exact, on the afternoon of 10 December 1919, when the committee of the Goncourt Academy, after their traditional lunch, dispatched the grinning Leon Daudet with a letter informing Proust that he had won the 1919 Goncourt Prize for *À l'Ombre des Jeunes Filles en Fleurs*, which had been published in January. Thanks to the press, Proust could enjoy that mixed blessing of modern times, instant fame. In the words of his biographer George Painter, 'The Prize brought the instantaneous explosion into fame towards which Proust had striven for thirty years.' The next day, there were no fewer than 27 major articles in the French papers, such was the public curiosity about who would win the first post-war Goncourt. Within a month, almost a hundred articles had been published, and the name of Marcel Proust was known to literally millions of French newspaper readers. From now until his death, he would be nationally (and, more and more, internationally) famous.

2. This would be his last address. He hated the place, a small apartment on the fifth floor, or, as he put it, 'a vile hovel just large enough for my bedstead'. He hated the noise from the rest of the house and the neighbourhood, too, and as he gradually cast off more of his furniture and other valued possessions, it grew ever more monastic in appearance.

they put the task of correcting proofs in the hands of André Breton. The proto-Surrealist was sublimely lazy at the task, but he adored the rhythms of Proust's sentences and would read them aloud to his acolytes.[3]

If some of Proust's ailments were psychosomatic in origin, all the approval his work received did nothing to ease them. In the autumn of 1921, he suffered a collapse, and began to exhibit signs of uraemia. Early in October, he accidentally poisoned himself with massive overdoses of opium and veronal. But he kept on revising; and when his symptoms permitted, he continued to go out into society. On 15 January 1922, he attended the Ritz ball, where he was treated to a demonstration of the fashionable new dance steps from Mlle d'Hinnisdael. He was impressed: 'Even when indulging in the most 1922 of dances, she still looks like a unicorn on a coat of arms!'

PARIS

The 25-year-old André Breton[4] and his wife Simone, née Kahn, moved into a two-room studio flat on the fourth floor of an unassuming building at 42 Rue Fontaine, in the northern part of the 9th arrondissement.[5] Downstairs was a cabaret called Le Ciel et L'Enfer; hence playful references, ever since, to the Bretons occupying 'the rooms above Heaven and Hell'.[6]

In 1922 Breton had published little, and was still hardly known outside a small coterie. Born in Normandy, he had begun training as a doctor and psychiatrist. During the war, he spent the early part of his military service in a psychiatric hospital in Nantes, where, in February 1916, he met an extraordinary young soldier, Jacques Vaché, whose weird sense of humour and general air of rebellion impressed him profoundly.[7]

3. The next two volumes of Proust's novel were published on 25 October 1920 and 2 May 1921; meanwhile, the French establishment had made their approval of the Goncourt Prize-winner official by awarding him the cross of the Legion of Honour, on 25 September 1920.

4. Breton is remembered by posterity above all as the founder of Surrealism. He was its major theorist and, in later years, its short-tempered and arbitrary tyrant. Now that the dust of feuds and rivalries has settled, he is also regarded as one of France's great poets.

5. They were still virtually newly-weds, having been married on 15 September 1921.

6. For the past seven years, Breton had been living a mainly itinerant life, in either army barracks, hotels or other people's flats. This was the couple's first proper home, and though Breton later moved downstairs to a slightly larger apartment, 42 Rue Fontaine remained his address for the rest of his long life.

7. Vaché died of an overdose – it may have been suicide – in 1919, and Breton mourned the lost friendship deeply.

Both in the company of Vaché and on his own, Breton began to develop an exotic sensibility and an idiosyncratic set of hobby horses. His touchstones from the past included the likes of Rimbaud, Jarry and Lautréamont.[8] But he was also alert to many contemporary influences. One was Dada, the anarchistic anti-art movement, which he first encountered in January 1919, at almost exactly the time of Vaché's death.[9] Another influence was the body of theory being developed by Sigmund Freud.[10]

Breton began to realise that he was creating something he could not as yet adequately define, and for which he had no name.[11] Still, some five years before the official birth of the movement in 1924, he was assembling key members of his team: Soupault, Aragon, Eluard.[12]

For the meantime, though, Breton was content to join forces with Tristan Tzara as he brought Dada to Paris in a series of rowdy provocations. More prosaically, he quit his medical studies and sought work in publishing: Gallimard not only took him on for a while, but paid him extra money to help Proust with the corrections of *The Guermantes Way*, which they had agreed to publish. To the young man's surprise, Proust was wholly affable to Breton, and welcomed him cordially to long editing sessions at 44 Rue Hamelin late at night.

The Gallimard position did not last long, but after a period of scratching around for part-time jobs, Breton struck lucky. He had been introduced to Jacques Doucet, a wealthy 67-year-old haute couturier and self-appointed patron of the arts, who was the most successful dress designer in Paris after Coco Chanel and Paul Poiret. Doucet had a large and rapidly growing collection of modern manuscripts and paintings in his private collection,

8. Breton was largely responsible for the modern cult of Lautréamont's bizarre prose poem *Maldoror*.

9. Tristan Tzara, one of the leading Dadaists, became Vaché's replacement in Breton's life for a short but intense period.

10. Historians of psychoanalysis generally date its origins to the year of Breton's birth, 1896; Freud had published *Studies in Hysteria* the year before that. Breton actually spent part of his honeymoon in making a pilgrimage to Freud's apartment at Berggasse 19, on 10 October 1921, but the meeting was a profound disappointment to him: he found the older man dowdy, philistine and dull.

11. The word 'surrealism' (or, to be pedantic, 'sur-realism', with a hyphen) had been coined as early as 1917 by Guillaume Apollinaire, in a programme note he composed for the ballet *Parade*, a collaboration between Cocteau, Satie, Picasso and Leonide Massine, performed by the Ballets Russes. The name preceded the phenomenon, though Breton would not select the term until 1924.

12. In retrospect, it is generally agreed that the first works produced in the surrealist manner were a collection of poems, *Magnetic Fields*, created by the technique of automatic writing and published in 1919, and a journal, *Littérature*, which was launched at roughly the same date.

based at 2 Rue de Noisiel in the 16th arrondissement. The collection was now of such a size that it required cataloguing; besides, the uneducated Doucet needed the advice of connoisseurs for his future purchases.

Breton, they both agreed, was the ideal man for the job. He took his work seriously, carried it out with intelligence and flair, and used it to help his friends, persuading Doucet that it would be wise to buy first editions and manuscripts from members of his gang. (He was quite right.) When, towards the end of January 1922, Louis Aragon decided to abandon his own medical studies, Breton persuaded Doucet that he would make an ideal co-curator. With a steady income, Breton could now afford a home.

In fact, the apartment at 42 Rue Fontaine was far more than simply a place to sleep in. As Mark Polizzotti puts it, the studio flat

> acquired a permanence that soon garnered the aura of legend . . .
> it became a symbol, as much a part of the history of Surrealism as
> Breton himself. It was 'his crystal, his universe', as his daughter
> later said; the site of many of the group's evening gatherings and
> the showcase for his various collections.

It was the HQ of the Surrealist movement.[13]

As soon as he moved in, Breton began to furnish the studio, mainly with paintings by artists he had 'discovered' or who shared his preoccupations: Giorgio de Chirico's *The Child's Brain* (1914), for example, which he had first glimpsed in a gallery window from a bus; he was so impressed that he jumped off the bus and ran back to see it more closely. There were also works by Max Ernst, Picabia, Man Ray, Derain, Marcel Duchamp, Picasso, Braque, Seurat.

He also festooned the rooms with artworks and objects from Africa and Oceania – masks, dolls, carvings. It made a powerful impression on visitors, one of whom said that 'Every painting, every object sent out an exceptionally powerful emanation, a hallucination, which adhered to it like a shadow wherever it was put.' In short, 42 Rue Fontaine became a

13. One entered the flat through a door painted with the number 1713. This was a small visual joke: in Breton's calligraphy, the '17', with a crossed '7', resembled an 'A' and the '13' a 'B' – his initials. Aragon reported that Breton's friends sometimes called him 'seventeen-thirteen'.

private museum, or, more exactly, a modern-day Cabinet of Curiosities – the richest and strangest of such collections in the history of Surrealism.[14]

Within weeks of moving into the new flat, Breton had established a routine of quite bourgeois regularity. Immediately after work, usually from about 5.30 to 6.30, he would meet with other members of the embryonic movement, and then have dinner at a cheap restaurant. The company would then go back to number 42, where they would play the games and conduct the experiments that were leading them towards their revelation. André and Simone would then retire to bed, while Aragon and others went on a bar crawl through the neighbourhood. This quiet, domestic life became the soil that nurtured the wild and savage growths of Breton's imagination.

And there was a revolution to be managed. On 3 January 1922, Breton published a note in the journal *Comœdia*, announcing an 'International Congress for the Determination and Defence of the Modern Spirit' (see 17 February).

5 JANUARY

SOUTH GEORGIA

The courageous Antarctic explorer Sir Ernest H. Shackleton died of a massive heart attack. He had found it hard to settle back into everyday life after his exploits and ordeals; like Tennyson's Ulysses, he wished for one last great voyage.[15]

9 JANUARY

PITTSBURGH

1922 was the year of radio. Up till now, radio technology had been used almost exclusively for the sending and receiving of one-to-one messages – as we would now call it, 'narrow-casting'. But in the early months of the

14. It was estimated that the collection eventually included more than 5,300 items.

15. Eliot alerted his readers to the fact that Chapter 10 of Shackleton's book *South* (1919) was the source of a passage in *The Waste Land*: Book V, ll.360-5. Shackleton records the experience of his exhausted band of Antarctic explorers, who had developed the frightening conviction that there was one more person with them than could be counted.

year, a period that has been called the 'Broadcasting Room', station after station came on the air, in the USA and around the world.

The first American AM station launched during the boom was KQV-AM in Pittsburgh, which aired on 9 January.[16]

PARIS

The young American journalist Ernest Hemingway (b. 21 July 1899; he was not yet 23) and his new wife Hadley moved into a smallish fourth-floor flat at 74 Rue Cardinal Lemoine, just off the Place Contrescarpe. They had arrived in Paris a couple of weeks earlier, on 22 December 1921, and had been staying at the Hotel Jacob. Paris would be their base for the next two years, though they both travelled a great deal throughout Europe during this period.

In his memoirs, Hemingway tends to exaggerate the degree of their cheerful poverty in Paris. Their flat cost only 250 francs – about $18 at 1922 exchange rates – and their income from Hadley's marriage settlement alone was a guaranteed $3,000 a year. In addition, Hemingway had a salary from his job as foreign correspondent for the *Toronto Daily Star*. Since he estimated that a Canadian or American could live comfortably on $1,000 a year, this was ample.[17]

Thus pampered by the exchange rate, the Hemingways had enough money to employ a maid, who came and cleaned in the mornings and cooked dinner for them on the nights they did not eat at restaurants. Their flat was, though, a little on the cramped side, and Hemingway soon resorted to renting an office on the Rue Mouffetard. Here he kept regular working hours, and so managed to escape the common fate of those who came to Paris to pursue artistic visions and ended up simply drinking and talking about the work they were going to do.

16. Over the next four or five months, it was rapidly joined by many other stations throughout the United States. By the end of the year, there were more than 500 licensed stations in the United States alone, and radio had reached the lives of almost everyone living in the rich nations, as well as some of the poorer.

17. Hemingway enthused at length about the cheapness of the delicious and varied food at his local restaurant, where he and his wife tucked into roast beef, or veal cutlets, or mutton, or thick steaks with potatoes cooked 'as only the French can cook them' – all for about 50 cents a person, with wine for 60 centimes a bottle. A bus anywhere in the city cost the equivalent of four cents; a decent hotel room about 12 francs a day for two people.

10 JANUARY

PARIS

A new nightclub, Le Bœuf sur le Toit, opened in the Rue Boissy d'Anglas. Its proprietor was Louis Moyses, who named it after a recent musical entertainment written by Jean Cocteau in collaboration with Erik Satie and Darius Milhaud. Wildly popular within just a few days of opening, it rapidly established itself as a major Parisian institution, almost immediately taking over from Cocteau's previous hang-out, La Gaya, as the place to see and be seen. In 1922 and the years that followed, Le Bœuf was 'the very cradle of café society', with a reputation to match or exceed that of Maxim's or the Moulin Rouge. For Paris, the 'Roaring Twenties' – *les années folles* – really began on this evening.

If not the greatest genius of his age and his native city, Cocteau was certainly their most representative figure – the man who set the tone of Parisian modernity and embodied its heady, stylish spirit. Elegant, fastidious, witty, eclectic, fanciful, he was a delightful talent in his own right and a sharp-eyed, energetic promoter of talent in others. He had plenty of enemies – Breton despised him, and often did his best to make Cocteau's life miserable – but a regiment of powerful friends, too. His major biographer, Francis Steegmuller, suggests that Cocteau 'invented' the Paris of the 1920s, and though this is an amusing hyperbole, it is not without a hard centre of truth.

It was Cocteau, for instance, who was credited with introducing the Parisian fad for drinking American-style cocktails (people punned on the verbal similarity of Coct-eau and cock-tail); Cocteau who enthused loudly over the 'universal genius' of Charlie Chaplin; Cocteau who gathered together and promoted Les Six: a group of rising young composers – Francis Poulenc, Germaine Tailleferre, Louis Durey, Darius Milhaud, Arthur Honegger and Georges Auric – who, though usually grateful for his skills as a publicist, sometimes declared that, apart from a shared dislike of Debussy and fondness for Satie, they had little in common. And then there was jazz . . . No doubt Paris would have embraced the new American music soon enough, but Cocteau did his very best to promote the budding love affair – writing jazz criticism for *L'Intransigeant*, inviting the Billy Arnold jazz band over from London (the first ensemble ever to play a concert hall in Paris) and even improvising jazz himself at the piano of La Gaya.

In 1922, Jean Cocteau would celebrate his thirty-third birthday. A gay dandy, greatly influenced by Oscar Wilde, he had first come to public attention with a collection of poems published in 1909, when he was barely out of his teens. It was at around this time that he encountered and was enthralled by the Ballets Russes, for whom he became something of a mascot. He was inspired by Diaghilev to turn his hand to drawing and stage design; he was also charmed by the overtly camp artistic milieu of the Ballets, which Stravinsky, a committed lover of women, grumpily referred to as a 'homosexual Swiss Guard'. Diaghilev was a crucial figure in Cocteau's artistic development; his challenge to the young Parisian to achieve something major – 'Astound me!' – is his single most famous utterance.

Cocteau rose to that challenge with *Parade*,[18] a collaboration with Picasso[19] and Erik Satie. Cocteau followed this coup with more poetry, and more entertainments for the stage: the original *Bœuf sur le Toit*, and the tragicomic *Les Mariés de la Tour Eiffel*, which mingled Greek dramatic conventions and contemporary vaudeville. By the start of 1922, he was a full-blown celebrity.

But his private life was not as glittering as his public career. He was in love with a much younger man; indeed, with a boy, since Raymond Radiguet was only 16 when he turned up at Cocteau's apartment at 10 Rue d'Anjou in June 1919.[20] For the next four years, until Radiguet's death from typhoid in 1923, their bond was as intense as it was volatile. Were they ever lovers in the physical sense? Hard to say. Radiguet was a chronic chaser of women, and often rose up in rebellion against Cocteau's maternal cares and ambitions for him; it may be that the couple never had sex.[21]

The opening night of the *Bœuf sur le Toit* was the occasion for one of Radiguet's small rebellions. According to contemporary accounts – one by Jean Hugo, and one by Nina Hamnett – Radiguet pained Cocteau

18. It was staged at the Théâtre du Chatelet on 19 May 1917 – one of the landmark dates of modernism – and, like all decent avant-garde works of the time, sparked angry shouts and boos; though not, alas, a full-blown riot.
19. Whom he met in 1915, while on leave from his ambulance corps duties.
20. Radiguet was trying to publish his first collection of poems; Cocteau, smitten by both the author's writings and his person, recognised him almost at once (and correctly) as an authentic prodigy.
21. Cocteau must take a lot of credit, though, for introducing enough routine and discipline into Radiguet's often chaotic and drink-sodden life to allow the lad to produce two short but enduring works of French literature: *Le Diable au Corps* and *Le Bal du Comte d'Orgel*. For Radiguet, the year 1922 was dominated by completing the first novella and composing most of the second.

dreadfully by choosing this otherwise triumphant night to stage a tempo-
rary defection. When Nina Hamnett arrived at the bar at about 11 p.m.,
she discovered a small group of smartly dressed people gathered around
Cocteau and Moyses: the Picassos, Marie Beerbohm, Marie Laurencin . . .
but no Radiguet. Thirsty for more and stronger booze, and irritated with
Cocteau's behaviour, Radiguet had made his way to the bar to join Con-
stantin Brancusi, the Romanian sculptor. Brancusi was fed up too, so the
two men went off with Hamnett to Montparnasse.

After a bit of wandering, Brancusi proposed that they go to the Gare
de Lyon to have a midnight bouillabaisse. They did so, but the dish was
not to their taste, so the two men decided to go off in search of a better
one – in Marseilles. Ditching Hamnett, they boarded the night train
southwards. Alas, when they arrived in Marseilles, they found that the
local version of the dish was not greatly to their taste either, so after a pro-
tracted bout of heavy drinking they got on a boat to Corsica. For about a
week they stayed in a huge, freezing hotel, keeping themselves warm (or
under the illusion that they were warm) by drinking gallons of Corsican
brandy. They finally made it back to Paris, and the Bœuf, ten days later.
Cocteau was furious; Brancusi never went back to the nightclub.

Despite this personal upset, Cocteau had every reason to be delighted
with the launch of the new night spot.[22] 'Le Bœuf', as it became abbrevi-
ated by the cognoscenti, was soon the compulsory watering-hole for all of
Cocteau's admirers and co-conspirators: Morand and Milhaud, Radiguet,
the Hugos, Pierre Bertins, the Picabias, and the other members of Les Six.
In Cocteau's own account: 'The Bœuf became not a bar at all, but a kind
of club, the meeting place of all the best people in Paris, from all spheres
of life – the prettiest women, poets, musicians, businessmen, publishers –
everyone met everyone at the Bœuf.'[23]

Men were expected to dress in black tie; women wore the most exclu-
sive designer clothes: Chanel, Lanvin, Vionnet. Bohemians and aristocrats,
avant-gardistes and traditionalists mingled freely, and all could dance and

22. He was widely assumed and reported to be its proprietor; this was not so, though he was quite
certainly its leading attraction, and he revelled in all its follies.
23. The walls of the club were lined with pictures by Cocteau and others – even Picasso, though he
did not often visit the place after opening night, lent a few paintings – though the dominant work of
art was Picabia's painting of a gigantic eye, *L'Œil Cacodylate* (1921). Picabia had asked 50 visitors to
his studio to add whatever they liked to the canvas – graffiti, signatures, clippings from newspapers –
and the work was deemed complete when there was no longer any room for additions.

flirt with the gorgeous youngsters who adorned the dance floor. The club inspired at least two books about the period – *Au Temps du Bœuf sur le Toit* by Maurice Sachs, and *Quand le Bœuf Montait sur le Toit* by Jacques Chastenet – and was mentioned in countless others. In addition to the Cocteau clique, those who were drawn there included Man Ray and Marcel Duchamp, the Prince of Wales and Arthur Rubinstein. In later years, its clientele was even more glamorous: Charlie Chaplin, Coco Chanel, Josephine Baker, Ernest Hemingway and the Aga Khan.

Within a year, Le Bœuf was 'the navel of Paris'. Proust, though seriously ill, could not bear to be left out, and demanded that his friend Paul Brach accompany him there for dinner. The night did not go well; a rowdy group of gay men started a drunken argument with Brach, and Proust felt compelled to challenge one of them to a duel. In the event, a grovelling letter of apology the next morning brought an anticlimactic end to the exchange.

11 JANUARY

CANADA
Insulin was first successfully used to treat diabetes.

USA
Erich von Stroheim's film *Foolish Wives*, the first high-profile cinema release of the year, had its premiere. It was the most expensive film Hollywood had produced to date, thanks to von Stroheim's spendthrift ways, which would become notorious throughout the twenties. Initially budgeted at an already hefty $250,000, *Foolish Wives* eventually cost, by the director's own estimate, $750,000. Von Stroheim was never noted for his modesty, but that estimate seems on the cautious side, since his studio, Universal, later claimed that the actual cost was over a million.[24]

It's hardly surprising that expenses should have spiralled out of control, since von Stroheim insisted on creating a vast and lavish replica of Monte Carlo in California, complete with massive casino interiors. In the

24. Universal tried to make a virtue of a disaster by advertising the film as the first to have cost more than a million dollars.

course of production, the young Irving Thalberg – later to be one of the key figures in Hollywood history, and immortalised in F. Scott Fitzgerald's *The Last Tycoon* – was appointed as head of production, and though Carl Laemmle was awarded sole credit as producer of *Foolish Wives*, Thalberg undoubtedly played a major part in disciplining his director's wilder fancies and so bringing the work to screen in playable form.[25]

What is most striking about *Foolish Wives* today is von Stroheim's intense narcissism: he is in just about every major scene, spectacularly natty in his white military tunic and jodhpurs, officer's cap constantly at a jaunty angle, rimless monocle in eye, outsize cigarette in mouth. When first we encounter him, he is consuming a Nietzschean breakfast: a tumbler of bull's blood for an eye-opener, lashings of oozy caviar in place of cornflakes. In terms of style, the film is a mixture of plain, quasi-documentary set-ups (particularly when showing the peasant communities in the countryside around Monte Carlo) and highly inventive, occasionally expressionist shots, such as the scene at the counterfeiter's house which is slashed by alternating bars of black and white – the shadows of a Venetian blind. Perhaps the strangest touch is that the film's victim-heroine is often seen to be reading a novel. Title: *Foolish Wives*. Author: Erich von Stroheim.[26]

12 JANUARY

PARIS

Cocteau – at first still plainly nervous and jittery, thanks to Radiguet's impulsive flight with Brancusi – had lunch with Valentine and Jean Hugo. After lunch, Ezra Pound arrived and, as Jean Hugo recalled,

25. It is said that von Stroheim originally wanted the film to run for something like six to eight hours; the version now available on DVD lasts a much more digestible two hours.

26. Von Stroheim, originally from Austria, had made his way into movies in about 1915, originally as a technical adviser on Germanic culture, then as an actor. Playing wicked Germans in wartime productions, he rapidly established a bankable reputation as 'The Man You Love to Hate'. His directorial debut came in 1919, with *Blind Husbands*. At this stage, few could have predicted the troubled course of his subsequent career – his reputation as a tyrant, a near-insane perfectionist who would crush actors as blithely as he would smash budgets, leaving behind him a string of damaged masterworks. Today, he is mainly remembered by non-specialists for his semi-autobiographical role as Max von Mayerling in *Sunset Boulevard* (see 2 February).

read and sang his opera on François Villon to the three of us . . . He
wanted me to do the decorations. Cocteau giggled all the time, as
anything to do with the Middle Ages and Gregorian music seemed
then quite ridiculous to him. Pound must have noticed he was
being made fun of, and the decor was not mentioned again.

Nor was Radiguet's absence mentioned. When the boy finally returned,
Cocteau forgave him after a brief period of chilliness. Since Brancusi was
not gay, there was no hint that Radiguet and he had been lovers; none the
less, Cocteau never again mentioned Brancusi in any of his writings on
modern art.

OXFORD

Evelyn Waugh 'commenced scholar' at Hertford College, having won the
college's history scholarship – worth £100 per annum, a fair sum – in ex-
aminations late the previous year. Most of his contemporaries had come
up at the usual time, the previous October, and had already formed their
friendships, so that Waugh was forced to seek out new friends elsewhere;
he regarded himself as a lone explorer of this exotic new land. His late ar-
rival also meant that all the good rooms had been taken, and he was estab-
lished in a small, dark set next to the buttery on the ground floor. This was
dangerous because it meant that his room was in use as a handy stop for
drinkers and idlers at all times of the day and night.[27]

Despite this inconvenience, Oxford struck the young Waugh as a
paradise. 'I can say little because I am too happy,' he wrote to a friend.
'Life is good and Oxford is all that one desires.' The place would teach
him many lessons that had nothing to do with history. As part of his rapid
transformation from bookish child to budding aesthete, he learned to ride
a bicycle, to smoke a pipe, and to speak in the required Oxford slang,
which included the habit of adding the diminutive '-er' or '-ers' to words,
so that the Bodleian became 'Bodder'.

Formerly temperate, Waugh also began to drink and to buy fine clothes,
paintings, first editions and other trinkets that were all well beyond his

27. On one occasion, a straggling member of the notorious Bullingdon dining club stuck his head
through Waugh's open window and vomited – an event later adapted for use in his novel *Brideshead
Revisited*, where the vomiting aristocrat is revealed to be Sebastian Flyte and the timid victim
Charles Ryder.

means. After doing the minimal amount of study necessary to maintain his scholarship by scraping through 'History Previous' at the end of his second term, he then resolutely set about doing no work at all until just a few weeks before his finals, in 1924. One root of this dedicated idleness was his hatred for his tutor, C. R. M. F. Cruttwell, Dean of Hertford.[28] The antipathy between Dean and undergraduate was entirely mutual: Cruttwell referred to Waugh as 'a silly little suburban sod with an inferiority complex and no palate'. Waugh recruited his new friends to a long campaign of persecution, which included spreading the rumour that Cruttwell enjoyed sex with dogs. At one point, he bought a stuffed dog from a toyshop and placed it in a position where it could be seen – or ogled – from Cruttwell's rooms.

Oxford was a place of such charms to Waugh that when he was obliged to spend the Easter vacation at home with his father in the suburbs,[29] he complained of being driven to a state of melancholy madness, and counted off the days until the new term like a prisoner awaiting the end of his sentence. But the intoxications, literal and spiritual, of his early months at Oxford were only a pale anticipation of the pleasures to come after the long summer vacation.

15 JANUARY

IRELAND

Declaration of the Irish Free State, under the terms of the 1921 treaty negotiated by Michael Collins and Arthur Griffith with Winston Churchill and others. Collins became chairman of the Irish Provisional Government. The year would see a terrible civil war, the assassination of Collins and, eventually, Irish independence. It was one of the bloodiest in Ireland's history.

28. Waugh despised this stern and difficult man with a passion that lasted long after he graduated: his first five novels all contain an unpleasant figure who is given the name Cruttwell.

29. The postal authorities had recently shifted neighbourhood boundaries, so that the Waugh family home at 145 North End Road, once part of passable Hampstead, was now shamefully relegated to Golders Green.

16 JANUARY

LONDON
The premiere of Ralph Vaughan Williams's Pastoral Symphony.

19 JANUARY

PARIS
Of the three works submitted by Francis Picabia to the Salon des Inde-
pendents, only one – *Tabac-Rat/Dance of Saint-Guy* – was accepted. That
they admitted this piece is rather surprising, since it consisted of little
more than an empty picture frame with string stretched across its surface,
with the title written on small labels fixed to the string. Picabia intended
the work to be shown free-standing, so that spectators could walk behind
it and be seen as the subject of the picture by others; the artist had himself
photographed in just that way. Picabia, using the occasion for publicity,
fired off a series of protests to the newspapers, and hung the two refused
works on the wall of the Bœuf sur le Toit: *Chapeau de Paille*, and *La
Veuve Joyeuse*, to which was attached a photograph by Man Ray of Picabia
behind the wheel of his car.

20 JANUARY

PARIS
The Picassos shared a box with the Hugos and Georges Auric at the first
night of *Skating Rink*, music by Honegger, abstract set by Fernand Léger.
As one of Picasso's biographers observes, 'it was the most original, star-
tling, and modernist decor since *Parade*'. As so often, the traditionalist
section of the audience greeted the piece with jeers and general uproar.
But on the same night, on the far side of the Atlantic, another musical
premiere was meeting with a much warmer reception.

NEW YORK
Krazy Kat: A Jazz Pantomime, by the Chicago-based composer John Alden
Carpenter (1876–1951), premiered at the New York Town Hall. It was the

first time that a concert composer had ever used the word 'jazz' in a title.
The production was eagerly anticipated, if only as a double novelty: a bal-
let suite boasting jazz elements, and inspired by a newspaper comic strip:
George Herriman's beautiful saga of a cat, a mouse, a dog and a brick. It
is possible that some of the inspiration may have come to Carpenter from
an article by Carl Van Vechten on 'The Cat in Music' in *Musical Quar-
terly*.[30] But the direct motivation had been Carpenter's young daughter
Ginny, who adored the comic.

When Carpenter made a trip to Los Angeles in 1917, he arranged
to meet Herriman and brought Ginny, then aged 12, with him. Ginny
dropped Herriman a curtsey, and said, 'I'm very pleased to meet you.' Her-
riman grinned, and replied, 'Miss Carpenter, you're very easily pleased.'
Four years later, Carpenter wrote to Herriman asking him if he would
care to work together on a concert piece. Herriman replied:

> I've never had any idea that these few humble characters of mine
> would ever have been asked to mingle with the more aristocratic
> arts, and I must say it is all very shocking to me. I can't imagine
> K. Kat, I. Mouse, O. Pupp, and J. Stork cavorting and pirouetting
> en ballet to save my life. However, let's hope the audience doesn't
> get their cue from Ignatz [the mouse] and pack a few bricks in
> with them – with evil intent.

Herriman agreed to write the scenario and design the costumes and
scenery. Gilbert Seldes, who later wrote a pioneering article about Herri-
man in his book *The Seven Lively Arts*, developed his interest in popular
culture as a direct result of working as a volunteer publicist for the Car-
penter ballet. The tale was simple: Krazy, waking from a slumber, sees a
poster for a ball, pulls on a ballet skirt and begins to dance. Joe Stork
brings on a mysterious parcel, which Krazy opens, discovering a vanity
case. He/she (Krazy's gender is an enigma) begins to apply make-up. Ig-
natz hovers menacingly, but Officer Pupp chases the wicked rodent away.
Krazy launches into a Spanish dance; Ignatz, disguised as a Mexican catnip
merchant, presents Krazy with a bouquet of the feline drug. Krazy goes

30. Van Vechten had been moved to write the piece by Stravinsky's composition of 1917, *Berceuses
du Chat*.

into a 'Class A fit', which modulates into a Katnip Blues. Ignatz finally hurls his eternal brick and escapes. The stunned Krazy, as in the strip, has a moment of brick-induced ecstatic recognition – Ignatz has proved his love again! – and goes back to sleep. Officer Pupp patrols, and all is right with the world.

Jazz influences aside, Carpenter's work most closely resembled recent compositions by the likes of Prokofiev (who had befriended Carpenter during his long stays in Chicago), Ravel and Les Six, with its witty but none the less poignant melodies. In part, too, it was a kindly parody of the Ballets Russes. The premiere was a great hit with the audience, who 'could not get enough of *Krazy Kat*. They applauded and demanded encores.' The critics were, by and large, lukewarm, the starchier ones saying that Carpenter's music was as bad as jazz itself, the more fashionable saying that it was either not as good as jazz, or simply not good jazz. And even some of those who otherwise enjoyed the work thought it might have been better done, with a different star. Seldes said that he thought only Chaplin could have done justice to the role of Krazy.

LONDON

Shortly after his return to London in the middle of January, Eliot caught influenza and took to his bed, from where he wrote to his old friend Scofield Thayer, the editor of the literary magazine *The Dial*.[31] Sir John Hutchinson had taken over from Eliot as author of the *Dial*'s 'London Letter' for a trial period, but the one column he contributed had been spiked. Eliot agreed to take the post up again, but asked if the format could become one of 'more general rumination on London' rather than reviews of particular books.

He also referred to a 'poem of about 450 lines, in four [*sic*] parts', and

31. In fact, he was one of Eliot's oldest friends, since he had been a fellow student at Milton Academy, then at Harvard, and then again at Oxford: Eliot had met Vivien in Thayer's rooms at Magdalen College. Thayer (1890–1982) was from a rich Massachusetts family, and never had to worry about money or take a real job. He was the editor of the *Dial* from 1919 to 1925, and under his regime it became probably the most influential and innovative magazine in the United States. A meeting with Thayer inspired Lady Rothermere to back *The Criterion*. From 1921 onwards, Thayer lived in Vienna, where he began a psychoanalytic treatment by Freud. This does not seem to have done much good; he suffered a series of severe breakdowns, and in 1930 he was finally certified insane. He spent the next half-century in care. At this time, Thayer was in Vienna, undergoing analysis with Sigmund Freud.

wondered if the *Dial* would be interested in publishing it. Thus began a long and vexed series of negotiations which were only settled by the late autumn of 1922. On 24 January, he wrote a cordial letter to André Gide, and a business note to Richard Cobden-Sanderson, whom Eliot had recently approached about the possibility of being publisher of a magazine to be financed by Lady Rothermere.

IOWA
Christian K. Nelson took out a patent on the Eskimo Pie.

21 JANUARY

PARIS
In the garden of Jacques Villon in Puteaux, Man Ray and Marcel Duchamp displayed fragments of their latest experiment with film, using spirals attached to an upright bicycle wheel. One of those present at the event was Henri-Pierre Roche, who noted that the effect was 'impressive and quite fantastic'.

LONDON
Virginia Woolf wrote to E. M. Forster:

> Every one is reading Proust. I sit silent and hear their reports. It seems to be a tremendous experience, but I'm shivering on the brink, and waiting to be submerged with a horrid sort of notion that I shall go down and down and down and perhaps never come up again.

Like Proust, Virginia Woolf seemed to be dying. Outside a limited circle of friends and admirers, she was still all but unknown. Her two novels to date had sold poorly, and though she had published many reviews and articles, most of these had appeared anonymously, in *The Times Literary Supplement*. Her health was poor, and her husband Leonard was warned by her doctors that she might not have long to live. Her condition in the early months of 1922 certainly gave him good reason to feel alarmed: she was struck down by repeated bouts of severe flu, she frequently ran high temperatures, and she suffered from a heart murmur. She kept to her

bed in Hogarth House for most of the first part of the year, working
only occasionally. When well enough, she helped the émigré writer
S. S. Koteliansky with his translations from Dostoevsky. Meanwhile,
despite repeated arguments between the two men, Leonard continued to
run the Hogarth Press with Ralph Partridge.[32]

22 JANUARY

ROME
Pope Benedict XV died.

24 JANUARY

Ezra Pound sent an important letter to Eliot, datelined '24 Saturnus
An I'.[33] Certain phrases from this letter have long since passed into
literary history:

> The thing now runs from April . . . to shantih without break. That
> is nineteen pages, and let us say the longest poem in the Englisch
> langwidge. Don't try to bust all records by prolonging it to three
> pages further . . .
>
> Complimenti, you bitch. I am wracked by the seven
> jealousies . . .
>
> It is after all a grrrreat littttteray period.

Eliot replied on or about the 26th: 'Complimenti appreciated, as have
been excessively depressed. V. sends you her love and says that if she had
realised how bloody England is she would not have returned.'

Pound's response, circa the 28th, made an unexpected allusion to
Joyce's prudishness. From time to time, Eliot had produced a series of

32. Partridge lived in a ménage with Lytton Strachey and Dora Carrington.
33. See the calendar that Pound wrote for *The Little Review*, Spring 1922 edition. Note that 'Year
One' of the post-Christian era antedates the 'Year One' of the Italian Fascists. It is this passage that
has inspired the term 'Pound Era', later made famous by Hugh Kenner's influential book of that
name; but note, too, that Pound modestly made Joyce's novel the presiding text of the new world
order. (See 22 March.)

obscene verses detailing the wild sexual exploits of a King Bolo. Most of Eliot's close friends seemed to find them funny, but Pound cautioned: 'You can forward the Bolo to Joyce if you think it won't unhinge his somewhat sabbatarian mind. On the hole he might be saved the shock, shaved the sock.'

25 JANUARY

LONDON

Virginia Woolf's fortieth birthday. She had been born just over a week earlier than James Joyce (see 2 February).

26 JANUARY

LONDON

Agatha Christie (1890–1976) published her second novel, *The Secret Adversary*. She had made her debut two years earlier with *The Mysterious Affair at Styles* – the novel which introduced the world to one of her two immortal detectives, Hercules Poirot.

27 JANUARY

CZECHOSLOVAKIA

Franz Kafka's health was also poor. He had lived through what he described as a 'breakdown' – *Zusammenbruch* – as bad as anything he had ever experienced. He suffered from dreadful insomnia, and a sense that his inner clockwork was radically out of time with that of the outer world: 'the inner one runs on at a devilish or demoniac or in any case inhuman pace, the outer one limps along at its usual speed . . .' He later told his closest friend, Max Brod, that he felt he had been on the verge of madness.

Like Eliot, he had been granted a three-month period of sick leave by his employers, the 'Institute' – that is to say, the 'Arbeiter-Unfall-

Versicherungs-Anstalt für das Königreich Böhmen in Prag': an association for providing insurance to working people.[34] On 27 January, he travelled for the final stage of his sick leave to Spindelmühle, a winter resort near the Polish border.[35] He tried to rally his physical and mental strength with tobogganing and mountain walks, and made cautious attempts at learning to ski.

It was here that he began work on his last major novel, *The Castle*.

28 JANUARY

PARIS

After a seven-month stay in the city, Duchamp left for New York. He supported himself for the first few months of his stay there by giving French lessons, and with a friend founded a short-lived company for dyeing fabrics. Meanwhile, he continued to work on the major work of his idiosyncratic career, *The Large Glass*.

PARIS

The writer Henri-Pierre Roche (mainly remembered for his novel *Jules et Jim*) attended a delightful meal hosted by the Romanian sculptor Constantin Brancusi:

> Dinner at Brancusi's, splendid. His famous purée of cold beans with vinegar and garlic. His grilled steak. He's everywhere, cooking, serving, doing everything . . . There are two violins. Brancusi and Satie take turns to play duets and tease each other. Our jaws are aching with laughter. A galop for the larger members. Brancusi's agility. Nice people and great men: he and Satie.

34. The initial period was 22 October 1921 to 4 February 1922, later extended a further three months to 4 May, and then again to 8 June; but his health remained so bad that on June 7, he finally decided to retire.

35. Eerie omen: he found that the hotel, despite having spelled his name correctly in earlier correspondence, had registered him in advance as 'Joseph K'.

29 JANUARY

Thayer wrote from 1 Habsburgergasse 2, Vienna, urging Eliot to hurry with copy for the April issue of *The Dial* and offering flattery: '. . . allow me to state that you are *The Dial*'s favourite foreign correspondent not excepting the indefatigable Ezra. Write about what you damn well please.' He also offered a flat rate of $150 for Eliot's long poem, sight unseen, to be published in the magazine.

31 JANUARY

LONDON

Bertrand Russell wrote to his former lover Ottoline Morrell recording the changes that had taken place in his life since the birth of his first son, John Conrad,[36] on 16 November 1921 – probably, he thought, the happiest day of his life, since he had yearned to be a father for the better part of twenty years. He told her that he was 'amazed to find how much passionate affection one can give to a little creature who as yet is only stimulated to activity by greed and stomach ache'. This unfamiliar sense of happiness proved durable, and John remained the centre of Russell's emotional life for years to come.

Russell, who would turn 50 on 18 May 1922, had spent a good part of the previous year lecturing in philosophy in Peking (Beijing).[37] He had been accompanied on the trip by his lover Dora Black, who was already several months pregnant when they arrived back in England on 26 August 1921. Russell rapidly contrived a divorce from his first wife, Alys, and married Dora on 27 September.

Russell, Dora and John Conrad were now living in a small terraced house in Sydney Street, Chelsea, decorated with the rugs they had brought back from their recent visit to China, and by the wooden furniture that Russell had bought from Ludwig Wittgenstein in 1919. Russell's claim that he hardly did anything save write and dote on his boy must be qualified by

36. The boy's middle name was a tribute to the novelist Joseph Conrad, whom Russell had long admired.

37. It was an experience he had largely enjoyed, though the stay was marred by some serious illnesses, including a bout of pneumonia which almost killed him.

the well-documented fact that he was also enjoying a reasonably full so-
cial life, including frequent dinners – alarming to the unsophisticated
Dora – in Bloomsbury with the Woolfs, John Maynard Keynes and Ot-
toline Morrell. And his genuine delight in being with his son was compro-
mised – even, it might well be said, poisoned – by his new craze for
'scientific' child-rearing: in other words, child-rearing according to the
precepts of behaviourism as espoused by John B. Watson, whose work
Russell had begun to study in 1918.[38]

PARIS

At the Hugos'. Valentine Hugo, née Gross, was a painter, but more cele-
brated as a leading beauty of the day, 'one of the ornaments of le Tout-
Paris', as Steegmuller puts it in his Cocteau biography. Cocteau called her
'his swan'. Her husband, Jean, a descendant of Victor Hugo who she had
married in August 1919, became friendly with Cocteau after his return
from the Front. The couple often hosted evenings for the poet and his
admirers. Cocteau read aloud from the manuscript of *Le Diable au Corps*,
which was nearing completion. Among the listeners were Picasso and Olga;
the Beaumonts; and Radiguet. Madame de Beaumont fell asleep, but the
rest were astonished. Cocteau had been right all along, they agreed: the
novel was a work of genius.

38. Watson's paper of December 1921, in which he describes (with a complacency that now seems
sinister, if not terrifying) how he managed to teach an 11-month-old baby to be frightened of a white
rat, greatly impressed Russell. With Watson in mind, he concluded that the child should at all costs
be made unaware of the importance it had in its parents' minds, and so of the power it might exert
over them. Put simply, he concluded that you should treat children harshly so as to overcome their
taste for tyranny, and thus train them to be better, more selfless adults.
 Many years later, Russell's second child, his daughter Katharine Jane (b. 1923), recalled this
well-meaning policy with some bitterness.

FEBRUARY

1 FEBRUARY

NEW YORK

W. B. Yeats's father, J. B. Yeats, died. His last words, to a Mrs Foster who was keeping him company, were 'Remember you have promised me a sitting in the morning.' A fortnight or so later, Yeats told his friend Olivia Shakespear (the novelist, and mother of Dorothy Shakespear, who had married Ezra Pound in 1914 after a five-year courtship) that he thought it had been a good death.

2 FEBRUARY

LONDON

T. S. Eliot dined with Lady Rothermere at 58 Circus Road, St John's Wood, to discuss their proposed journal – as yet nameless. It would eventually be called *The Criterion*.

PARIS

As well as being James Joyce's fortieth birthday, this was the day on which *Ulysses* was finally published, in an edition of 1,000 copies. It was, as Joyce was well aware, a palindromic day: 2/2/22.

On the previous day, Darantiere, the Dijon-based printer, wrote to Sylvia Beach, assuring her that three copies of the bound book would be sent by post, and would almost certainly arrive in Paris by noon. Joyce, in a state of high nervous anxiety, feared that it was too risky to rely on the post, and he made Sylvia Beach send the printer a telegram, instructing him to hand the three copies to the conductor of the Paris–Dijon Express, due to arrive in the capital at 7 a.m. She duly got up early, met the train and was handed a parcel – which contained only two copies, not three. After dropping off one copy with Joyce, she took the other to display in

Shakespeare and Company[1] from 9 a.m. onwards. Crowds poured into the shop all day to gaze at the long-awaited wonder, and telegrams of congratulation flooded into the Joyces' apartment.

That evening, Joyce, Nora, Giorgio and Lucia celebrated both *Ulysses* and his birthday at Ferrari's, one of his favourite restaurants. The other guests were recent American friends: the painter Myron and Helen Nutting, the book illustrator Richard Wallace and his wife, and Helen Kieffer, the daughter of John Quinn's partner in his legal practice. (It was Mrs Wallace who accidentally provided Joyce with the last words of his novel – he had overheard her in conversation with a young American painter, in which she repeated the word 'yes' again and again in different tones of voice.) Joyce wore a new ring – a treat he had long promised himself for the occasion. But there was no other sign of revelry in his behaviour; it was as if he were suffering from authorial post-natal depression. He looked gloomy, and sighed, and said little; he ordered food but barely touched it; and he kept his copy of *Ulysses* in its wrapping paper until well after dessert, when he yielded to his guests' demands and opened it on the table.

Following his orders, the book had been bound in 'Greek' colours: pure white lettering on a field of blue: white islands rising from a Homeric sea. A toast was proposed, and Joyce, softening a little, appeared deeply moved.[2] The party moved on for drinks at the Café Weber, and Joyce's spirits rose; they stayed on until closing time, and – as so often – he would happily have gone on drinking elsewhere, but Nora steered him firmly towards a cab and homewards. Helen Nutting thanked him for the honour of being present at this momentous evening; he took her hand as if to kiss it, but then dropped it.

MUZOT – SWITZERLAND
The Bohemian-Austrian poet Rainer Maria Rilke (b. 1875) heard a voice, as if from heaven, speaking German words that might be translated as 'O Orpheus sings! O tall tree in the ear!' Supernatural or merely an emanation of his unconscious, these words seemed to open up some door into Rilke's imagination, and after a long fallow period, he began to write verse

1. Which had recently moved to 12 Rue de l'Odéon.
2. Two waiters, attracted by all the congratulations, asked Joyce if he was the author of 'this poem', and borrowed the book for a minute to show off to their boss.

again, and at a rate that astonished him. In the space of three days, from 2 to 5 February, he wrote the entire first half of a sequence of sonnets on the theme of Orpheus.[3]

He put aside the sonnets when he suddenly realised that some new poems – or rather, some long-neglected poems – were also clamouring to be written. On 7 February, he wrote a 'Seventh Elegy' to add to a group on which he had begun working a decade ago, when he was living in the Castle Duino, near Trieste. He followed this Seventh with an Eighth, and then went back to the poem he had abandoned in 1913, the Sixth Elegy. On 11 February, he wrote an exultant letter to his former lover, now loyal friend Lou-Andreas Salome: '. . . at this moment, this, Saturday February 11th at 6 p.m. I put aside my pen, after the last completed elegy, the Tenth'. On the 15th, he went back to work on the sonnets, completing them eight days later.

In just 21 days, Rilke had completed two of the most important, influential and enduring poem sequences of the twentieth century: the *Duino Elegies* and the *Sonnets to Orpheus*.

HOLLYWOOD

At 7.30 in the morning, the body of the prolific film director William Desmond Taylor was found lying in the street outside his bungalow in the affluent Hollywood community of Westlake Park. Crowds soon gathered; one of the onlookers, claiming to be a doctor, made a cursory examination of the body and then ran away, hastily declaring that Taylor had died of natural causes. A proper examination later in the day showed that Taylor had been shot in the back, and had died about 10 or 11 hours before the body was discovered. Police investigations yielded several possible killers – an odd fact, since the victim was generally said to be well liked by almost everyone who worked with him – and it was also made clear to those who could read between the lines of newspaper reports that Taylor had been bisexual.

The case became notorious, inspiring fiction, and one major film.[4]

3. No doubt it helped that he had recently been working on translations of Michelangelo's sonnets, but still . . .

4. Billy Wilder's *Sunset Boulevard* (1950), whose dark heroine is called Norma Desmond, a muffled echo of William Desmond Taylor's middle name, and that of his close friend or mistress, or possibly murderer, Mabel Normand.

Most significantly, it fanned the flames that had already been started by the 'Fatty' Arbuckle scandal, when a young actress, Virgina Rappe, had died from wounds inflicted during a wild party given by Arbuckle on Labor Day weekend, 1921. The Taylor murder launched, on the one hand, a gleeful campaign of muck-raking in the American (and world) press, bent on portraying Hollywood as a Babylon of promiscuity, drug addiction, perversion and subversion; and on the other, a nervous attempt by Hollywood to reassure good citizens that it was an upright, decent and wholesome industry, whose products were entirely fit for family entertainment. Noisy anti-Hollywood campaigns sprang up throughout America, and upright citizens began to boycott the movies, with disastrous effects at the box office.[5]

Leading producers recognised that Hollywood must do more than simply profess its innocence, and that it needed urgently to set its house in order before the government intervened. They banded together to found the Motion Picture Producers and Distributors of America.[6] The man chosen to head the MPPDA could hardly have been more of an establishment figure. Will H. Hays, a lawyer with strong Republican sympathies, had previously been US Postmaster General, and had been the manager of Warren G. Harding's election campaign in 1930.

Hays, a man of exemplary dullness, was paid a huge salary – $150,000 – for a job which consisted largely of travelling the length and breadth of the USA throughout 1922, thundering that government censorship of the movies was downright un-American, and proclaiming no less loudly that the industry must live up to its civic responsibilities. The ploy worked, and the movies were saved, but at a cost. In 1930, the recommendations that Hays had been urging on producers were drawn up as an explicit code, and the Hays Code dominated all Hollywood productions until 1968.[7]

5. By the end of the year, according to the *Daily Mail*, some 65 per cent of American cinemas had been forced to close, and though this may be somewhat exaggerated, there can be no doubt that the movies were in danger of entering an unexpected slump just as other forms of popular entertainment were booming.

6. In 1945, this was changed to the Motion Picture Association of America, and the body retains that name to the present day.

7. Film censorship was also in the air elsewhere in 1922 – in the UK, for example, where the head of the British Board of Film Censors drew up a rating system and a series of guidelines intended to make standards uniform across the country. The biggest film censorship argument of the year was prompted by the movie version of Marie Stopes's work on contraception, *Married Love*; this was finally released as *Married Life*.

3 FEBRUARY

LONDON

P. G. Wodehouse – one of the most popular comic writers of the twentieth century, and still widely considered to be one of the best – published a collection of comic stories about the escapades of golfers: *The Clicking of Cuthbert*. It was the volume which introduced his recurrent character, the 'Oldest Member'.

4 FEBRUARY

SWITZERLAND

Ernest Hemingway reported from Les Avants, Switzerland, on the decline of the Swiss tourist trade, which was largely due to the unfavourable exchange rate, just five francs to the dollar. As a result, Hemingway noted, the resorts which used to be jammed with holiday-makers before the war now resembled the deserted boom towns of Nevada. The country, he concluded, was paying an unforeseen price for its wartime neutrality.

5 FEBRUARY

MINNEAPOLIS

The first edition of *Reader's Digest* magazine, edited by DeWitt and Lila Wallace. The idea of a magazine which would gather together articles from other sources and reprint them in condensed or simplified versions had come to DeWitt Wallace while he was in hospital recovering from shrapnel injuries he had received during his army service in France. He spent some six months working alone in the Minneapolis Public Library, training himself to gut and boil down more elaborate prose into an undemanding, easily readable version. When he showed a mock-up of an issue to Lila, then a friend of a friend, her response was so positive that he proposed marriage to her in the fall of 1921.

The Wallaces put their magazine together in a basement apartment below a speakeasy; they would pay girls from the speakeasy to help them

out.[8] The *Reader's Digest* was successful beyond anyone's expectation, and for many years had the highest circulation of any consumer magazine in the United States.[9] It was also the publication with the largest readership from America's most wealthy citizens. Countless spin-offs included a series of 'condensed books' – simplifications of books that were generally none too complex in the first place. (*Ulysses* never made the list.) The Wallaces were right-wing Republican Protestants, and fiercely anti-communist; in the early years of the magazine, they often published articles that took a dim view of Catholics and Jews, and expressed approval of the rising totalitarian governments in Europe.

6 FEBRUARY

WASHINGTON, DC

The Washington Naval Conference, in progress since 12 November 1921, reached its conclusions. It had been the first international military conference to be held on American soil, and has been regarded as the first modern disarmament conference – a model of successful negotiation in place of conflict. The main intention of the talks, held in the Memorial Continental Hall, had been to limit the extent of Japanese naval power in the Pacific Ocean. But the conference has also been seen as marking the end of an era – that of British naval supremacy around the world. Tacitly, the conference had passed that supremacy into the hands of the United States.

PARIS

The poet, mountaineer, chess fiend, practitioner of 'Magick' and charismatic guru Aleister Crowley – aka the Beast 666 – arrived in town, having travelled from his commune at Cefalù in Sicily, via Naples. On 14 February he went on to Fontainebleau, where he checked in to an inn called Au Cadran Bleu.[10] His plan was to cure himself of his intense heroin addiction

8. Later, the *Digest* moved to Chappaqua, New York.
9. The average present-day circulation is still over seven million copies per issue, and franchised local versions of the magazine thrive in about a hundred nations, including the People's Republic of China.
10. Later in the year, Fontainebleau would become the base for another famous guru of the age, George Gurdjieff.

by a self-imposed regime. Overconfident, as ever, about his mental and physical prowess, he expected to be cured within a week or so, but at the end of a full month he was still treating himself to 'extra' doses of heroin.[11]

It was time to take a grip. At first he did moderately well. The regime was simple: cut down on drinking, take regular walks, eat properly, and divide the day into open (for taking drugs) and closed (for abstaining) seasons. Then reduce the open seasons day by day. For a few days he was fairly strict with himself. Then he began to lapse, knowing all too well that his withdrawal pains could be cured in seconds by a quick hit. He began to see the ghosts of dead friends floating around him . . . and lapsed even further.

He was joined by Leah, his latest mistress, or, as he liked to call her, his Scarlet Woman. Leah was also an addict and in very poor health: she was losing weight, suffered night sweats, and coughed up blood. She was keen to go to Switzerland to seek treatment; Crowley was not so happy with the idea, and after consulting the *I Ching* (Crowley called it the *Yi King*), he decided that London was the place to go. He dressed himself up in full Highland regalia,[12] painted his face and set off for his homeland with Leah. He had just £10 to his name. The trip began in high farcical style: on arrival at Hardelol, near the Boulogne ferry, Crowley was mistakenly identified as a crooked financier, and arrested. He eventually proved that he was Aleister Crowley, distinguished poet and mountaineer, by showing them a book on the Chogo-Ri expedition which included his photograph. He enjoyed this little episode hugely.

ROME

Cardinal Achille Ratti succeeded the late Benedict XV; he became the 259th pope, with the pontifical name Pius XI.

11. For at least two years, Crowley had been taking prodigious quantities of both heroin and cocaine. His daily regime was something like three or four doses in the morning to drag him out of bed, followed by repeated doses practically all day, to the amount of roughly four or five grains. To this daily diet he added two or three cocaine binges every week. Prolonged indulgence on this scale wrecked even Crowley's formidably strong constitution: in his diaries, he complains of vomiting, diarrhoea, insomnia and persistent itching all over his body. Heroin damaged his mind just as badly: he became listless, bored by everything, gave up shaving and washing, and lost his usual fierce pleasure in food and drink.

12. Not only his best, but his only decent outfit; he had recently recovered it from the cleaner's, where it had languished since 1914.

8 FEBRUARY

MOSCOW

Russia's secret police corps, the Cheka, was formally reconstituted as the GPU, a branch of the NKVD – the *Narodnyy Komissariat Vnutrennikh Del*, or People's Commissariat for Internal Affairs. Under Stalin, the NKVD would become notorious as the principal agency for the Soviet Union's persecution of its own citizens.

PARIS

Hemingway and his wife took tea with Gertrude Stein and her companion Alice B. Toklas in their studio at 27 Rue de Fleurus. A few days earlier, Hemingway had sent Stein a letter of introduction from their mutual friend Sherwood Anderson. Stein, who liked Anderson, had responded warmly. Hemingway already knew something of the Stein salon – as did almost everyone who was up to date in their knowledge of American expatriate avant-gardism; she was something of a legend. In addition to her own work as a writer – which Hemingway would soon come to admire passionately, and to boost wherever he could – Stein was a famously generous hostess to visiting writers, composers and artists: William Carlos Williams, Carl Van Vechten, Paul Bowles, Djuna Barnes . . .[13]

Stein was now 48, quite old enough to be Hemingway's mother, and they were an odd couple in other ways too, but they were soon chatting away easily and enthusiastically, each delighted by the other; Hemingway wrote to Anderson a couple of weeks later saying that the two of them were getting along 'just like brothers', while Stein told Anderson that she found the Hemingways 'charming'. Hemingway took to dropping by the studio regularly, or went for long afternoon walks with Stein in the Luxembourg Gardens. She began to instruct him: about writing, about painting, and about what writers could learn from painters. Her own work, she told him, had been profoundly shaped by her study of

13. When Hemingway, decades later, eventually wrote about his times at 27 Rue de Fleurus in *A Moveable Feast*, he had become disillusioned with his some-time tutor, and yet his sense of both physical comfort and intellectual awe survived. He recalled the teas, the delicious snacks, the plum and raspberry liqueurs; the unparalleled collection of modern paintings, beginning with Bonnard, Cézanne and Renoir, and ending with Gris, Matisse and – above all – Picasso. Picasso nudes, Picasso landscapes in the Cubist manner, and Picasso's celebrated portrait of the grand lady herself.

Cézanne, and Hemingway would later claim Cézanne as one of his major influences.

1922 was the year in which Hemingway seriously embarked on his career as a writer; and his two most important mentors in the mystery would be Gertrude Stein and another American-in-Paris he would meet a few weeks later: Ezra Pound.

9 FEBRUARY

ROME

Prime Minister Ivanoe Bonomi, a moderate socialist who had been in power since 1921, retired from office, feeling that the country had become so chaotic as to be in effect ungovernable. His immediate successor, Luigi Facta, only remained in office for a few months, and when Mussolini seized power, Bonomi withdrew from politics for several years. He would become Prime Minister again in 1944 when the Allies took Italy, and oversaw the country's conversion from fascism to democracy.

11 FEBRUARY

'April Showers', sung by Al Jolson, became the best-selling phonograph record in the United States.

SÃO PAULO

From 11 to 18 February, at the Municipal Theatre, one of the most significant cultural events in modern Latin American culture took place: a 'Week of Modern Art', which introduced the achievements of Brazilian *modernismo* to the world. Its main organisers were the painter Emiliano di Cavalcanti and the poet Mário de Andrade – whose major work, *Paulicéia Desvairada (Hallucinated City)*, was read out by the author on the closing night and first published later in the year.

Not all those who attended the events were sympathetic to the modern spirit. There was a good deal of heckling and booing and mockery. One of the participants who went on to enjoy worldwide fame was the composer Heitor Villa-Lobos, who has been described as the single most

important figure in Latin American art music. Villa-Lobos and his musicians played several of his compositions – including his *Quarteto Simbolico*, an evocation of urban life in Brazil – to an often disapproving audience.[14]

But if Villa-Lobos is the best known of these artists outside Brazil, it was the week's co-director, de Andrade (1893–1945), who was the most extraordinary talent. Almost certainly the greatest polymath his country had ever produced, de Andrade was, at various times or simultaneously, a poet, novelist, photographer, journalist and pioneer of ethnomusicology. His 1922 poem-sequence *Paulicéia Desvairada* has been called the *Waste Land* of Latin American literature, and is in some ways formally similar to Eliot's work, being made up largely of powerful and cryptic phrases, in no regular metre or rhyme, that seem to be uttered by the inhabitants of São Paolo, or by the city itself.[15]

GERMANY

The young Bertolt Brecht – still all but unknown, though by the end of the year he would be the most famous playwright of his generation – spent the evening of 11 February reading a collection of letters by Gustave Flaubert, increasingly irate. On the 12th, he wrote in his occasional diary:

> These front-line despatches from a lunatic mammoth are mind-boggling. Who does he think he is? What a sinful, pig-headed, obsessional Gaul! What dedication to a job that must be handled with a light touch! How sure of his material this troglodyte must have been to risk investing so much effort in it! . . .[16]

14. It did not help the composer's dignity that he was suffering from a painful foot infection, and had to appear on stage wearing a single carpet slipper.

15. De Andrade's other major literary work, the novel *Macunaima* (1928), has also been called the *Ulysses* of Latin America, partly for its depiction of modern city life, partly for its intense concern with the mixed linguistic heritage of Brazil, with its various indigenous languages in constant interplay with the Imperial tongue, Portuguese. Some of the novel's complexity may be ascribed to de Andrade's ambiguous social position: though his family were affluent land-owners, he was a mulatto, not a pale descendant of Europe.

His earliest forays in search of indigenous musical forms were carried out with little more than a notebook for help, but later in life, after he became a professor of music and aesthetics at the São Paolo conservatory, he used recording equipment to build up a vast sound library of native Brazilian music – an enterprise comparable to that of Alan Lomax in America. Though de Andrade's reputation fell under a shadow in the last years of his life, he had long since been rehabilitated, and is recognised as one of the great writers of his continent.

16. According to Edmund Wilson's definition of modernist literature in *Axel's Castle* and elsewhere, one property most of the major writers of the movement shared was a debt to Gustave Flaubert.

14 FEBRUARY

HELSINKI

The Finnish Minister of the Interior, Heikki, Ritavuori was shot dead by a lone assassin as he left his house. The killer proved to be a mentally ill young man, the black sheep of a rich family who had become persuaded, after reading articles in the right-wing press, that Ritavuori was a traitor and a menace to the nation. The youth received a lenient prison sentence on the grounds of mental incompetence. Finland, which had almost no history of political murder, was shocked, so much so that the many and substantial accomplishments of Ritavuori's life were overshadowed by the horror at his death.

LONDON

Virginia Woolf, still unwell, noted enviously that 'K. M. [Katherine Mansfield] bursts upon the world in glory next week.' True: *The Garden Party and Other Stories* was about to be published by Constable. This was all the more galling to Woolf since '. . . I have to hold over Jacob's Room [her latest novel] till October; & I somehow fear that by that time it will appear to me sterile acrobatics.'

Her bed was moved into the living room, in front of the fire; she wrote a little, read a lot, and received visitors – including her former lover Clive Bell, with whom she renewed a flirtation.

15 FEBRUARY

PARIS

The *Chicago Tribune*'s European edition published the first major review of *Ulysses*; the reviewer was one George Rehm. '*Ulysses*, long attended upon,' he began, 'waited for these several years with bated breath or hopeful curiosity has at last appeared.'[17]

Bertolt Brecht does not fit easily into the same canon of modernism, so it is only to be expected that his view of the French novelist would be very different.

17. On the evidence of this piece, Rehm was an exceptionally clumsy, pretentious writer, and his prose was cluttered with mixed metaphors: 'Generally, [Joyce] has been condemned . . . by the highly moral, but unperceiving element of Comstockery that reigns with iron hand, turning down an unkempt, sticky thumb on every gladiatorial attempt to break away from the suffocating restrictions laid down by its censorship.' At times, his review came close to being meaningless: 'All known

Though Rehm was broadly sympathetic to Joyce, and managed a few phrases suitable for a blurb – 'passages deep in their understanding, profound in their knowledge, sparkling in their expression' – it is clear by the end that he had no idea what to make of the book. He shirked the reviewer's duty of final verdict, and simply declared that it would take generations to determine whether *Ulysses* was 'masterpiece or rot'.

THE HAGUE
The Permanent Court of International Justice was established.

ENGLAND
The Marconi Company began experimental radio transmissions from Essex.

USA
The First National company released *Cops*, the latest comic two-reeler written and directed by Buster Keaton, who also starred. Keaton released five more two-reelers that year: *My Wife's Relations* (12 June), *The Blacksmith* (21 July), *The Frozen North* (3 August), *Day Dreams* (28 September), *The Electric House* (19 October).

An impressive output, even if judged by quantity alone; and consider too that the first of Keaton's two sons, James, was born in the same year, so he had much to distract him. Yet these six shorts also include some of Keaton's very best work in the form – they shine with a brilliance born, in part, from creative frustration. By now he was chafing against both the financial and artistic limitations of the two-reeler, and was looking towards directing feature films.[18]

Keaton had learned his film craft with quicksilver speed, and stardom came almost as fast. It was not until 1917 that he made his first screen ap-

borders encircling the hemisphere of literature have been traversed with a cynical grin tossed to worldly criticism.'

18. He made only two more shorts – *The Balloonatic* (1923) and *The Love Nest* (also 1923; this is a lost film) – before directing his first full-length film, *The Three Ages*, in 1923.

Then the immortal works come fast and fluent: *Our Hospitality* (1923), *Sherlock Junior* (1924), *The Navigator* (1924) . . . and, in 1926, one of the greatest film comedies, *The General*. By 1929, he had completed a dozen movies, almost all good, some sublime. The fact that they are so wonderfully funny sometimes distracted viewers, even perceptive viewers, from noticing Keaton's astonishing gift for direction. The verdict of posterity has been more astute: a recent poll placed Keaton seventh in the list of Best Directors.

pearance, as a sidekick for Roscoe 'Fatty' Arbuckle in *The Butcher Boy*, produced by Arbuckle's Comique Studios. Barely three years later, he was already writing and directing his own films – an even shorter period than the dates suggest, since Keaton had enlisted in the 40th Infantry and had served his country during the last months of the war and the early months of 1919.

By the end of that year, the producer Joseph Schenck had founded a company devoted entirely to the creation of starring vehicles for Keaton; he bought the former Chaplin studios and reopened them in January 1920 as the Keaton Studio. For the next couple of years, Schenk would register his films under a variety of different company names, until *The Frozen North*, after which they came out under the banner of Buster Keaton Productions Inc. But the most important of Schenck's innovations was to free Keaton of all financial anxieties. As Keaton recalled, his contract 'gave me $1,000 a week, plus 25 per cent of the profits my pictures made'. The money was nice, but better still was the freedom from minor chores. From now on, Keaton could focus on his art.

Joseph Francis 'Buster' Keaton grew up in a show-business family, and escaped formal education entirely. He was born on 4 October 1895, at a time when his parents were still working with travelling medicine shows; Buster was four when they finally made their low-level entry into the world of vaudeville at Hubin's Museum, New York. By this stage, the child Keaton was already a seasoned trouper.[19]

At the age of five he was a skilled and versatile acrobat, and a precociously inventive comic – no wonder many audiences believed he was not a child at all, but an adult midget. Genius needs luck; Keaton's luck was that from the age of three till twenty-one, when the family act finally broke up (the problem was Keaton's father, an alcoholic), the central task of his life was to attempt to make people laugh as they had never laughed before.

Buster was guaranteed box-office, and he was snapped up by the Schubert company for one of their shows at a salary of $250 a week. Thanks to a chance encounter with Arbuckle, though, he opted for the movies, with a much lower starting salary – $40 – but a stake in a future

19. He had been given the name 'Buster' by Harry Houdini, no less, after falling unscathed down a flight of stairs in a theatrical boarding house at the age of six months – or, a more plausible version has it, eighteen months. Houdini saw the tumble and said, 'That was a real buster!' – a 'buster' being the stage term for a particularly spectacular pratfall.

that was as bright as vaudeville's was gloomy. Keaton's agent, he later re-called, encouraged this apparently improvident move: 'Learn everything you can about that business, Buster, the hell with the money. Movies are the coming thing, believe me.' And Buster learned, and learned. He had a good, if limited, teacher in Arbuckle, a man he loved, and continued to admire long after his downfall in the notorious manslaughter case of 1921–2.[20]

Soon the student had outstripped the master, and many critics have suggested that the increasing sophistication of the Arbuckle product after *The Butcher Boy* can mainly be credited to Keaton's presence – constantly refining old jokes or proposing new ones. And when Keaton began to di-rect his own films, in 1920,[21] these productions made Arbuckle's work seem all the more primitive. It was now that Keaton began to develop his main screen persona, his counterpart to Chaplin's tramp: let us call him the Stoic. The Stoic makes his first appearance in *One Week* (1920); this film, about a doomed attempt to build a house from a DIY kit, is often considered Keaton's first masterpiece.[22]

17 FEBRUARY

OXFORD

W. B. Yeats wrote to Olivia Shakespear, partly to tell her that his wife 'George' (formerly Georgie Hyde-Lees) had just gone back to Ireland, and had taken a large and elegant Georgian house for them in Dublin (at 82 Merrion Square) – just within their financial means, especially as George had been able to let the top floor to a pair of lodgers. Yeats was elated:

20. He kept a photograph of Arbuckle on his wall until the end of his life.
21. His debut as a writer and director was *The High Sign*, shot in 1920 though not released until 1921.
22. The golden age of Keaton's art did not outlive the 1920s, though the man lived on until 1966, add-ing dozens of films, radio and television shows, scripts and public appearances to his CV. He lost and made fortunes throughout these decades – his television work made him more money than any of his features – but until the very end of his life, few of his performances have enjoyed much of an afterlife, save perhaps for his cameo in *Sunset Boulevard*. The verdict of his biographer, David Robinson, is harsh but just: 'At thirty-three, Keaton's creative career was virtually at an end.' But he had one last flash of triumph. To his surprise, he was asked to appear in a short, silent, rather terrifying film, called, simply *Film*. This strange work was directed by an inexperienced man of letters, Alan Schneider, and was written by James Joyce's sometime friend and secretary, Samuel Beckett.

I feel very grand especially as I remember a street ballad about the Duke of Wellington:
> In Merrion Square
> This noble hero first drew breath
> Amid a nation's cheers.

Yeats was not, he told her, much disturbed about the state of Ireland, and was fairly sure that it would all 'come right' within a few months.

PARIS

André Breton had proposed a 'Congress of Paris' ('International Congress for the Determination and Defence of the Modern Spirit') for some time in late March, but the process of arranging it had unearthed or initiated so many angry conflicts that he was forced to call for a general emergency meeting at the Closerie des Lilas, a Montparnasse bar and restaurant favoured by several generations of Parisian artists, intellectuals and bohemians; at this period, it was a favourite of Hemingway, Man Ray, Picasso and others. One of Breton's original intentions had been to raise a protest against what he saw as a craven return by many contemporary artists to traditional notions of beauty and craftsmanship, by highlighting all that the various schools of the 'Modern Spirit' held in common, from Impressionism and symbolism via cubism and Futurism to Dada. But one of his other, unstated ambitions was less lofty. Breton was tired of living in Tristan Tzara's shadow; he wanted to be a leader himself. This meant, in the words of his biographer Mark Polizzotti, consigning 'Dada – and Tzara – to the intellectual junkyard once and for all'.

Many of those who signed up for the Congress – an impressive crowd, including artists as disparate as Cocteau and the Italian Futurist F. T. Marinetti, Hans Arp and Brancusi, Man Ray and André Malraux – soon smelled a rat, especially when Breton issued a statement denouncing Tzara as a 'publicity-mongering imposter' from Zurich. This did not play well with the more left-leaning participants, who thought Breton's denunciation sounded xenophobic: Eluard quit, and so did Erik Satie. When, on the evening of the 17th, Breton stood up in front of roughly a hundred intellectuals, passions exploded. Tzara screamed in a high-pitched voice, passionate arguments stopped just short of blows, and the event turned into a kind of kangaroo court, with Breton himself suddenly the prisoner in the dock.

The following day, about half of the attendants strongly disavowed Breton's words and actions; the protesters included old members of Breton's circle: Eluard, Péret. The conference fell apart, though Breton had managed to retain some of his old allies (Aragon, Desnos) and had gained an important new one: Picabia, formerly a close friend of Tzara's. In the space of just two years, Tzara and Breton had gone from close friendship to open hostility. A couple of weeks later, on 2 March, *Comœdia* published Breton's anti-Dada manifesto 'After Dada'. The divorce was official.

LONDON

Eliot wrote to his friend and supporter, Richard Aldington, the poet, novelist, critic and biographer, thanking him for a letter in which Aldington had responded warmly to his first encounter with *The Waste Land*. Aldington had been very helpful to Eliot in recent years, and had introduced him to the editors of various magazines and journals.[23]

The Eliots spent the weekend of the 17th and 18th with the critic and editor John Middleton Murry. On 21 February, Eliot wrote to thank Murry: 'I enjoyed my weekend with you more than I can tell you . . .' but added that Vivien, now 'very ill', had been sent to a nursing home. 'She may not stay very long, but I expect three weeks at least. There was nothing else to be done at the moment. She must be made to sleep.'

19 FEBRUARY

GRANADA

Federico García Lorca, not yet 24 years old, an idling student but already a name to conjure with in Spain's advanced literary circles, delivered his lecture '*Cante Jondo*' ('Deep Song'), on primitive Andalusian song, at the Arts Club. Its arguments were strongly influenced, as Lorca gladly admitted, by the conversations he had been enjoying with Manuel de Falla – by now recognised around the world as Spain's finest living composer – and by the research that de Falla had been pursuing into the history of flamenco music. The aspiring poet and the famous composer had met shortly after

23. In later life, Aldington grew bitterly jealous of Eliot; he wrote biographies of both D. H. Lawrence and T. E. Lawrence, the latter extremely hostile.

de Falla's return to Granada in September 1920. Lorca, who had been wavering between music and poetry as his major art, became a frequent visitor to de Falla's picturesque *carmen*, and de Falla was at once impressed by the young man's many talents and moved by Lorca's obvious admiration for his compositions. Soon they were like father and son, and had dreamed up the idea of a *cante jondo* festival in Granada. Lorca's lecture was part of a long process of whipping up popular interest in the festival.

In the meantime, Lorca had also begun writing poems inspired by *cante jondo.*[24] Excited both by the subject and by the explosion of creativity it had set off in him, he came to believe a number of things about this local form: that it had its roots in poetic and musical forms from the East – Arabic, Persian and Turkish poetry; that it had been shaped by Byzantine liturgical chant; and that it had been brought to perfection by the gypsies of Andalusia. Their music, he felt, was the expression of the depths of the Andalusian soul, which was a thing of melancholy and fatalism, not high spirits and merriment.[25]

21 FEBRUARY

RUSSIA

Vladimir Lenin – now gravely ill, suffering from terrible headaches which drove him almost to hysteria with pain, and utterly despondent at the grim sight of his own machinery of government grinding towards a standstill – wrote a furious, despairing letter to his comrade Alexander Tsyurupa of the SNK – Council for People's Commissars:

24. He hoped to have them published in book form by the time of the festival, Holy Week 1922, but in the event they did not appear until 1931.

25. Perhaps most importantly, Lorca came to believe that the *cantadores* of Andalusia were in effect spirit mediums, through which the people expressed their most profound terrors and desires; and he identified passionately with that function. To put it in anthropological terms, Lorca saw the role of the *cantadores* as shamanistic, and he felt the call of that ancient vocation. And though the lecture does not explictly mention *duende*, it is obvious that he was on the very brink of grasping the full significance of the haunting and elusive term about which he wrote a classic essay in 1933. For Lorca, *duende* (strictly speaking a kind of ghost) was a mysterious communicative power, a kind of Dionysian inspiration, charged with heightened awareness of the tragic dimensions of life. It is the magic which wells up in one who performs before an audience, whether a poet, a dancer, a singer or a musician, and which bonds artist and audience in a mystical union.

Everything among us is drowned in a filthy swamp of bureaucratic 'administrations'. Great authority and strength will be needed to overcome them. Administrative offices – madness! Decrees – lunacy! Search for the right men, ensure that the work is properly carried out – that's all that's necessary!

It was the fateful year for Lenin, and so for the future of the Revolution. It was the year of his illness, his unforeseen political decline and his remarkably rapid loss of power; and as Lenin's fortunes ebbed, so Stalin's waxed. Just a year earlier, Lenin had been the acknowledged master of Russia; the White armies had conceded defeat, and seven years of draining civil war had come to an end. Why was the triumph so short-lived, and so severely compromised?

For one thing, a great many of those who had fought for Red victory felt betrayed by the men who had led them. The economy was in a state of extreme crisis; factories were closed for want of raw materials; peasants were wilfully destroying their grain stores (if they had any) and slaughtering their livestock to prevent the goods from being seized by requisition squads; the Cheka was dealing with discontent by applying the standard Bolshevist panacea: shoot everyone in sight. Matters had come to a tragic head with the savage repression of an abortive rebellion by Red sailors at Kronstadt, the naval base of Petrograd.[26]

Lenin dispatched Trotsky, with full powers to stop the rebellion by any means necessary. Trotsky drew up his armies across the river from the naval base, and waited for eight days – eight days in which the sailors could have secured their position by wiping out shore batteries, or ploughing the river's ice to keep infantry at bay, or even storming Petrograd. Instead, they too waited, following a strict policy of non-aggression.

On the eighth day, Trotsky's army attacked. The sailors fought magnificently, but they were outnumbered and outgunned. Of the 16,000 men involved in the rebellion, barely a hundred escaped over the ice to Finland. The few others who had not died in battle were shot. The civil

26. One of the qualities that makes the Kronstadt rebellion so peculiarly heart-rending is the suicidally noble conduct of the rebel sailors, who – had they behaved like Bolsheviks – could easily have won the military battle before Moscow had the chance to intervene. Their demands were sane and reasonable – they were still socialists, but they wanted a modified form of socialism, free from the atrocities of the Cheka, and less firmly tied to the men of power in Moscow.

war had been full of terrors, but this was the first time that the Revolution had deliberately slaughtered its own so mercilessly; a terrible premonition of the murderous decades ahead under Stalin.

Realising the depth of the crisis, Lenin made a move that would previously have been unthinkable: he introduced the New Economic Policy, or NEP, which – among other measures – took away the state monopoly on trading in grain. Peasants would now be allowed to sell their grain surpluses on the open market. Small industries were put back into private ownership. Selling for profit, previously a major crime, was once again encouraged.[27] But with the loosening of the economy came a tightening of discipline.

The Tenth Party Congress established that absolute obedience to the decisions of the Central Committee was now law. The Cheka was sent out to destroy all last remnants of the Mensheviks, Socialist Revolutionaries and other non-Bolshevist elements. Peasant revolts were put down with massacres. And then there was the famine crisis, a disaster more dreadful than anything that Russia had suffered from war and revolution, and which may ultimately have killed as many as 27 million people. (See 30 July.)

Judging by the coolness of his response to this appalling humanitarian crisis, Lenin was less worried by the millions of deaths than by the astonishingly rapid growth of a bureaucracy for his new nation – a bureaucracy as bad as anything known under the tsars, if not worse: corrupt, sluggish, arrogant, spectacularly inefficient. His disgust at all this, combined with the inevitable fatigue of driving himself at superhuman levels for so many years, had inevitable consequences: he began to suffer from attacks of nausea, fainting fits, insomnia, and, finally, those excruciating headaches. By 7 December 1921, he had been forced to give up his work in Moscow and retreat to his country home in Gorki. It was as though his body were cracking up in sympathy with the disintegration of the nation. Worse would follow.

27. In effect, the NEP was reintroducing a measure of capitalism back into Russia, and the move had a psychological dimension which was as valuable to the economy as any of the practical changes.

22 FEBRUARY

USA

Life magazine ran a cover by the artist F. X. Leyendecker showing a 'flapper' – a fashionable, up-to-the-minute young woman of the 1920s – in the form of a gorgeous giant butterfly. It became, and remains, an elegant defining image of the times. Other illustrators who helped promote and perpetuate the 'flapper' archetype were Russell Patterson, John Held Jr, Ethel Hayes and Faith Burrows.

But it was the cinema that did most to inspire the trend, especially after 1920, and the release in that year of *The Flapper,* starring Olive Thomas, and directed by Alan Crosland. Though it was a harmless comedy, *The Flapper* brought both the name and the look and ethos of this new breed of womanhood to the general American public.[28]

Both in reality and in popular mythology, the flapper was a hedonistic and promiscuous single woman, who would smoke, drink, sniff cocaine and dance to jazz music. Though her face might be heavily made up (and recall that before the First World War, the wearing of all but the most discreet cosmetics was widely held to be the prerogative of actresses, harlots and other ill-bred women), she was slim and boyish to the point of androgyny. She dressed in shocking clothes – unprecedentedly short skirts, no corsets or stays – and kept her hair cut short in the all-but-ubiquitous style of the 'bob'.[29]

The golden age of the flapper was from just after the war until the Wall Street Crash of 1929; and her ideal environments were the speakeasies that blossomed with Prohibition (1920–33) and dance halls. It was an era of dance crazes,[30] most of which emerged from various African-American districts in New Orleans or the West Coast.

28. The screenplay was written by a young woman, Francis Marion (1888–1973), who was, with Anita Loos and June Mathis, one of the three most successful women screenwriters to be employed by Hollywood in the twentieth century.

29. The bob was such a resonant sign of the times that F. Scott Fitzgerald even wrote a short story about women's craze for short hair.

30. The Shimmy: the first 'shimmy' dance music was published in 1917, but it must have been at least a decade or more old by this time. (One suggestion for the origins of its name is that it is a corruption of the French 'chemise' – violently shaken about when the dance is performed.) Mae West was one of several celebrities who claimed to have invented it. The Bunny Hug: a dance for couples, which seems to have stemmed from California, and was originally accompanied by classic ragtime music. The Black Bottom: from New Orleans; the 'Original Black Bottom Stomp' was printed in

In the United Kingdom, the term 'flapper' carried distinct overtones of prostitution, since a 'flap' had meant a whore since the early seventeenth century. By the early 1900s it had come to mean simply a young girl,[31] especially an attractive one: hence, in the 'varsity novel' *Sandford of Merton* (1903) by Desmond Coke, the exclamation 'There's a stunning flapper!' By 1920, the British and Americans both meant roughly the same thing by the term.

Not all designers were in thrall to the fashionable slim, flat-chested look beloved of flappers. At a modest New York dress shop, Enid Frocks, the seamstress Ida Rosenthal – a Russian-Jewish immigrant – and her employer had come to the conclusion that their dresses would look much more elegant if worn by women whose breasts were properly supported by a 'bandeau'-style brassiere, made up of two close-fitting cups joined by a firm vertical cloth band. In 1922, joined by Ida's husband William Rosenthal, they established the Maidenform company; the name declared their war against the 'boy form' of much contemporary fashion. In 1925, William Rosenthal filed a patent for the Maidenform Uplift brassiere, the prototype of countless subsequent designs. Despite the flapper fad, millions of women saw the appeal of Maidenform products, and the firm established a busy factory in New Jersey.

A FLAPPER'S DICTIONARY
AS COMPILED BY MISS ELLA HARTUNG IN 1922

SLANG	MEANING
Dimbox	Taxi cab
Flatwheeler	Young man who takes a young woman to an egg harbor
Egg harbor	Fall dance
Clothesline	One who tells neighbourhood stories
Whiskbroom	Man who cultivates whiskers
Let's blouse	Let's go

1919. The Charleston: most popular after being featured in a stage show in 1923, but, like the other dances, at least a decade or so older.

31. Hence, towards the very end of the flapper era, press references to the UK election of 1929 as the 'flapper election': the first in which British women under 30 could vote, thanks to the Equal Franchise Act of 1928.

Crabhanger	Reformer
Shifter	Grafter
Snugglepup	Young man who frequents petting parties
Petting party	Social event devoted to hugging
Finale hopper	Young man who arrives after the bills are paid; always ready to promise the last wrestle and never there when it comes around; the spendthrift who arrives after the ticket-takers have departed
Hip hound	One who drinks hooch
Sodbuster	Undertaker
Applesauce	Flattery or bunk
Ritz	Stuck up
Alarm clock	A chaperone
Father time	Any man over 30 years
Ear muffs	Radio receivers
Dingledangler	One who persists in telephoning
Cake basket	A limousine
Statts	Conversation that means nothing
Oilcan	An imposter
Fire alarm	A divorced woman
Cuddle-cootie	Young man who takes a girl for a ride on a bus
Forty-niner	Man who is prospecting for a new wife
Tomato	Good-looking girl with no brains
Slat	Young man
Strike breaker	Young woman who goes with her friend's 'steady' when there is a coolness
Dud	A wall flower
Cake-eater (1)	Harmless lounge lizard
Boob-tickler	Girl who has to entertain her father's customers from out of town
Snake-charmer	Female bootlegger
Dive-ducat	Subway ticket
Mad money	Car fare home if she has a fight with her escort
Hikers	Knickerbockers
Whangdoodle	Jazz band
Grubstake	Invitation to dinner
Pillow case	Young man who is full of feathers

Feathers	Small talk
Hush money	Allowance from father
Bean-picker	One who tries to patch up trouble
Corn-shredder	Young man who dances on ladies' feet
Police dog	Young woman's fiancé
Airedale	Homely man
Fig leaf	One-piece bathing suit
John D.	An oily person
Sweetie	Anyone she hates
Sugar	Money
Urban set	A new gown
His blue serge	His girl
Cutting yourself a piece of cake	Making yourself wait patiently
Dog kennels	Pair of shoes
Dogs	Feet
Stilts	Legs
Mouthpiece	Lawyer
Handcuff	Engagement ring
Stutter-tub	Motor boat
An alibi	A box of flowers
Anchor	Bank roll
Monogolist	Young man who hates himself
Dropping the pilot	Getting a divorce
Appleknocker	A hick
Biscuit	A pettable flapper
Dincher	A half-smoked cigarette
Barney-muggin	Love-making
Brush-ape	Anyone from the sticks; a hayshaker
Cake-eater (2)	A wearer of tight clothes, belted coat with spearlike lapels and one button, sausage trousers, greenish pink shirt, and one of those jazzbo ties that give you the giggles
Cat's pajamas	Anything that's good
Dapper	A flapper's father
Darb	Gink with a roll of coin
Frog's eyebrows	Nice, fine

Fluky	Funny, odd, different
Goof	Flapper's sweetheart
Half cut	Happily intoxicated
Kippy	Neat or nice
Sharpshooter	A good dancer (who spends his money freely)
Strangler	What a sharpshooter isn't
Toddler	A finale hopper's faster sister
Sap	A finale hopper
Smoke-eater	A girl cigarette user
Plastered	A synonym for pie-eyed, oiled, intoxicated
They	Refers to objecting parents

WESTMINSTER

In the face of violent nationalist uprisings and riots, Britain proclaimed Egypt – a protectorate since 1914 – a formally independent Kingdom. (It was largely on the advice of T. E. Lawrence's former commanding officer Lord Allenby, now High Commissioner, that the British Government accepted the need to grant the nation independence.) The declaration was ratified on 28 February. The move was, however, to a large extent a diplomatic fiction, since Britain continued to maintain a substantial military presence in the country and to exercise a major influence on its internal affairs.[32]

25 FEBRUARY

PARIS

France's most notorious serial killer, Henri Désiré Landru, was executed by guillotine.[33]

PARIS

From 25 February to 19 March, the Galerie Bernheim-Jeune held a one-man exhibition of work by Henri Matisse, composed of 39 works all

32. On 15 March, Faud I was crowned King of Egypt.
33. His bloody career continued to inspire popular artists for many decades afterwards; most notably Charlie Chaplin's film *Monsieur Verdoux* (1947).

painted in 1921; the catalogue for the show included an essay by Charles Vilrac. Matisse's work would be shown in many mixed exhibitions at the gallery over the next decade.

PARIS

Hemingway told his Canadian readers about the large colony of Russian aristocrats who had fled the Revolution and found their way to Paris. He found them charming but exasperating in their air of childish, vain hopefulness that somehow their plight would be resolved without anyone making a decisive effort. Their finances were a mystery, since few of them seemed to work, and some of them lived quite lavishly; the most obvious source of their income was the sale of jewels and other heirlooms. So many Russian trinkets had been sold lately that the price of pearls had fallen. He feared for their future.

26 FEBRUARY

NAPLES

Just minutes before the gangplank was pulled up, D. H. Lawrence and his wife Frieda (née von Richthofen) boarded the SS *Osterley* at the dock in Naples. Their ultimate goal would be the United States, where they intended to settle permanently, but the first destination on their long journey was to be Ceylon (today, Sri Lanka). This first leg of the voyage, via a stop at Port Said, then through the Suez Canal, past Mount Sinai and across the Arabian Sea, would take them fifteen days. For Lawrence, they were days of unprecedented wonder, and marked a return of his faculty for innocent gazing.

The Lawrences had been living in Italy since November 1919.[34] The war had trapped them in England – an imprisonment made more bearable by his meetings with other writers, artists and thinkers: J. Middleton Murry and Katherine Mansfield; then Eliot, Pound, Russell and others. Their flight from England in 1919 had been the beginning of what Lawrence sometimes called his 'savage pilgrimage', a period of self-imposed

34. They had met in March 1912; Frieda, married with three children, was six years his senior.

exile and wandering which would last for eleven years, until his early death in 1930.[35]

Though he kept himself busy on board ship, Lawrence was not too preoccupied with literary chores to yield, again and again, to astonishment and delight at the sights, sounds and smells they met on the voyage. Dense street crowds and shadowy cafés in Port Said; trains of camels meandering slowly along the Suez Canal shore; flying fish that glittered in the sunlight as they pursued the *Osterley*'s wake. Nor did Lawrence hold himself aloof from the other passengers. He and Frieda soon became friendly with an outgoing Australian fellow passenger, Anna Jenkins, a wealthy widow and Lawrence fan, who invited them to come and stay with her in Perth. They accepted the offer, and suddenly re-planned their journey into a personal version of the Grand Tour that would occupy the entire year: Ceylon, Australia, a Pacific crossing to San Francisco, then overland to Taos, New Mexico.

35. By 3 March 1920, Lawrence had found them a beautiful seventeenth-century stone house, Fontana Vecchia, near Taormina in Sicily. Set on a hillside above the sea, the house had two terraces, a vegetable garden and the *fontana vecchia* itself – an ancient, still-flowing fountain of pure fresh water – and all for just £30 a year. It seemed like a paradise; in later years Frieda would say that 'Living in Sicily after the war years was like coming to life again.'

But the soothing illusion of Sicily as Paradise proved hard to sustain when Italian politics grew more turbulent and violent. On 18 October 1920, Lawrence wrote, quaintly but perceptively, 'I think Italy will inevitably revolute [sic].' None of the Italian leaders – Francesco Nitti, Giovanni Giolotti – had been able to curb a wildly accelerating inflation, and though the rapidly increasing strength of the pound against the lira should have benefited the Lawrences, there was a corresponding shortage of goods for them to buy. It was from this nervous, angry world of impending economic doom that Mussolini's political career was born.

Towards the end of 1921, the Lawrences received a letter from a Mrs Mabel Dodge Sterne, offering them the free use of a furnished adobe house near Taos, New Mexico, and also promising to keep them supplied with all the food, drink and household supplies they would need.

Mabel Dodge Sterne, born in 1897, was a formidable American woman, much given to Good Works and fads. In 1918, she had settled in Taos with her third husband, Maurice Sterne, and had become enchanted by the local culture of the Taos Pueblo – a tribe of about 600 souls. She had taken it into her head that Lawrence was just the writer to come and immortalise the ways of this dwindling people.

The offer was doubly attractive to Lawrence. Their funds were at a low ebb, and the thought of being housed for free was tempting. But he was also drawn by the pure glamour of the project, and told an American friend how much the offer chimed with his long-standing interest in 'The Indian, the Aztec, old Mexico . . .' They decided to accept the offer almost at once; the only problem was arranging transport. Their early attempts to book direct tickets to the United States met with failure, and while he looked into different routes, Lawrence began to feel the attraction of a period of rest before beginning their American life. Partly influenced by his friends the Brewsters, who had embraced Buddhism, he eventually booked two second-class tickets on the SS *Osterley*. Cost: seventy-four pounds a head. A bargain rate for a chance of rebirth.

LONDON

Eliot wrote to Maurice Firuski, proprietor of the Dunster House Press in Cambridge, Massachusetts. He had been told of the press by Conrad Aiken at their lunch on 14 February; Aiken had also shown him one of their recent publications, John Freeman's *The Red Path and, The Wounded Bird* (1921). Eliot had been impressed by the quality of this edition, and was keen on the idea of publishing *The Waste Land* in similarly elegant fashion. 'My poem is of 435 lines,' he explained to Firuski, 'with certain spacings essential to the sense, 475 book lines . . .'

> I have had a good offer for the publication of it in a periodical. But it is, I think, much the best poem I have ever written, and I think it would make a much more distinct impression and attract much more attention if published as a book.

Firuski replied (on 11 March) that he usually paid about $100 for a work of this kind, and told Eliot that if he were sent a copy of the work he would come to a prompt decision.

TRIESTE

Stanislaus Joyce wrote a supposedly congratulatory letter to his brother. He was grudging in his praise of James's book.

27 FEBRUARY

PARIS

Joyce gave a copy of *Ulysses* to Pound. The inscription read:

> *To*
> *Ezra Pound*
> *in token of gratitude*
> *James Joyce*
> *Paris*
> *27 February 1922*

PARIS

Radiguet attended a costume party – the 'Bal des Jeux'. He came dressed up in clay pipes, with a target fixed to his evening dress; the idea was that he had come as a shooting gallery. His friends had dressed in similar spirit: Valentine Hugo as a merry-go-round, Jean Hugo as a billiards table, Jean Godebski as a house of cards. Radiguet used elements of this evening when he came to write *Le Bal du Comte d'Orgel*.

NEW YORK

The first two parts of Shaw's gigantic, and all-but unstageable five-act drama *Back to Methuselah* opened on Broadway. Parts III and IV followed on 6 March; part V on 13 March.

WASHINGTON, DC

A bid to challenge American women's right to vote – established by the recent Nineteenth Amendment to the Constitution of 1920 – was rebuffed by the Supreme Court.[36]

36. Many women in America and Europe had already, in effect, declared their personal emancipation, long before formal political emancipation became a reality. For good or ill, depending on your viewpoint, this was a time when women had far more freedom than had been dreamed of by their mothers and grandmothers. The end of the nineteenth century and the start of the twentieth had seen the emergence of the 'New Woman' – Ibsen's woman, as it were: dissatisfied with the traditional rewards of marriage and children, educated to a higher level than her mother and grandmother, beginning to hammer at the doors of male professions, and often passionately idealistic about social ills. The 'New' New Woman was a feminist of quite a different order.

MARCH

1 MARCH

OXFORD

Yeats wrote to Olivia Shakespear, about Irish affairs:

> We shall have a pleasant energetic life, if the Treaty is accepted at
> the general election, and turmoil if it is rejected. (Lady Gregory is
> anxious. It is the young men, who have not yet fought, who are
> strongest for rejection she says.)
> . . . I have much to fight for – an Irish Academy being founded
> and perhaps a government theatre . . .

LONDON

Eliot wrote a short note to his friend, the artist and writer Wyndham
Lewis: 'am very tired and depressed . . . life has been horrible generally'.[1]

3 MARCH

ITALY

Fascists occupied Fiume and Rijeka.

USA

Publication day for F. Scott Fitzgerald's *The Beautiful and Damned* by
Scribner's. The Fitzgeralds, who were living in St Paul, went back to New
York to celebrate, checking into the Plaza and throwing party after party.
They had good reason for revelry, at least in financial terms: the novel sold
50,000 copies in the first few months, and Fitzgerald sold the film rights to
Warner Brothers for $2,500.[2]

1. The second (and final) issue of Lewis's journal *The Tyro* appeared in March, with the help of a £25
subsidy from his friend Edward Wadsworth.
2. Though when he saw the film later that year, he was appalled: 'it's by far the worst movie

But a surprising number of important reviewers were impatient with the book. It was hardly a secret that *The Beautiful and Damned* was in large measure an autobiographical account of Scott and Zelda's courtship and marriage – the book's cover tipped the wink by showing a smartly dressed young couple who were ringers for the Fitzgeralds – and not everyone was thrilled with hearing about their marital ups and downs. The reviewer for *The Bookman* called it 'blubberingly sentimental'; others said that it was numbingly dull, and even the loyal Edmund Wilson, who had liked the book when it was still in progress, now thought it was undisciplined and disappointing.

The most extraordinary review came from Zelda herself – the *New York Tribune* paid her $15, the first money she had ever earned, for this publicity stunt. She pronounced the book 'absolutely perfect', and gushed that everyone must buy it so that Scott could buy her a platinum ring and the 'cutest' cloth-of-gold dress, a snip at just $300. But she also blew the whistle on one of her husband's more doubtful tactics as a writer of fiction: he had lifted substantial chunks from her diaries and letters and put them, often verbatim, directly into his novel. Since the tone of her piece was so flippant, most people did not think she was in earnest about plagiarism beginning at home; but those who knew the couple realised the truth, and the ominous nature, of her complaints.

By now, Fitzgerald had been working for some months on a satirical play, originally entitled *Gabriel's Trombone*, now renamed *The Vegetable*, and subtitled *or From President to Postman*. The title was inspired by Mencken's essay 'On Being an American', an attack on the national tendency to conform: 'Here is a country in which it is an axiom that a businessman shall be a member of the Chamber of Commerce, an admirer of [the steel tycoon] Charles M. Schwab, a reader of the Saturday Evening Post, a golfer – in brief, a vegetable.'[3]

The Fitzgeralds' New York stay ended in what was in effect a nonstop drunken binge. Scott was usually cheery and agreeable in the early stages of a bout, but could turn nasty as the booze took hold. One early

I've seen in my life – cheap, vulgar, ill-constructed and shoddy. We were utterly ashamed of it.'
3. The play eventually opened on 10 November 1923 in Atlantic City. It was a terrible flop: audiences were so bored that they began talking loudly among themselves, and many simply left. It closed after a week – Fitzgerald's first real taste of failure. It forced him briefly to go on the wagon, and to write for 12 hours a day for week after week to pull the family out of debt.

morning after a night on the town, he went to Edmund 'Bunny' Wilson's apartment, woke him up and invited him for a spin in the park. Wilson refused. He later said that Fitzgerald's drunken face had frightened him; he looked, Wilson said, like John Barrymore playing a deathbed scene.

4 MARCH

BERLIN

The official preview of F. W. Murnau's *Nosferatu* was held in the Marmorsaal of the Berlin Zoological Society. Guests were asked to wear period costumes – to be exact, the formal 'Biedermeier' style that was popular among the wealthier classes in Germany and neighbouring states between about 1815 and 1848.[4] Though its creators were at pains to hush up the fact, *Nosferatu* was a loose and unauthorised retelling of Bram Stoker's *Dracula*, with the main action transferred to Germany and the leading characters given new names: Stoker's Count Dracula becomes the Graf Orlok.[5]

Nosferatu is now regarded as one of the greatest horror films; perhaps the greatest of all. The classic encomium was written by the distinguished German film critic Lotte Eisner, in her magisterial study *The Haunted Screen*. Though she acknowledges the film's powerful evocations of supernatural evil – 'glacial draughts of air from the beyond', as she puts it, borrowing a phrase from another writer – she is most at pains to emphasise the exceptional beauty of Murnau's cinematic style: 'In Friedrich Wilhelm Murnau, the greatest film-maker the Germans have ever known, cinematic composition was never a mere attempt at decorative stylization. He created the most overwhelming and poignant images in the whole German cinema.'[6]

4. The public premiere was held 11 days later, on 15 March, at the Primus-Palast, Berlin.
5. Incidentally, it was *Nosferatu* that established the genre convention that vampires are destroyed by sunlight: Stoker's count could wander around in the daytime quite unscathed.
6. This is well said, though most viewers were and are a great deal more taken by the appearance of the central character, Orlok, portrayed by the astonishing Max Shreck, who – even allowing for the labours of the make-up team – must be the strangest and most hideous leading man in all cinema. Revoltingly thin, bald, hook-nosed, claw-nailed, with rodent-like fangs and mad staring eyes, Shreck/Orlok can still cause shudders by his mere appearance.

Murnau shot most of the film on location – an unusual practice for the German cinema at the time – and used special effects sparingly. Some of the film's pervasively uncanny atmosphere may be due to the influence of its co-producer and production designer Albin Grau, a shadowy figure who was deeply learned in the occult.[7] Grau's fingerprints are all over the production, from the arcane symbols scrawled on the documents that Orlok studies to the name of *Nosferatu*'s production company, Prana Films – *prana* being the Sanskrit word denoting the breath of life. Sad to say, the film itself was short of breath in its opening year: Florence Stoker, Bram's outraged widow, took Prana to court for plagiarism, and the law determined that all prints of the film be destroyed. A few survived, and showed up at the end of the 1920s in New York.

Nosferatu is also, according to votes cast by subscribers to the International Movie Data Base, by far the most popular of all the films made in 1922 among twenty-first-century cinephiles. The list of the top 30 titles from that survey yields some unexpected results:

1. *Nosferatu* (dir: F. W. Murnau)
2. *Haxen* (dir: Benjamin Chistiansen)
3. *Dr Mabuse, der Spieler* (dir: Fritz Lang)
4. *Robin Hood* (dir: Alan Dwan)
5. *Grandma's Boy* (dir: Fred Newmeyer)
6. *Number 13* (dir: Alfred Hitchcock)
7. *Blood and Sand* (dir: Fred Niblo)
8. *Foolish Wives* (dir: Erich von Stroheim)
9. *Phantom* (dir: F. W. Murnau)
10. *Oliver Twist* (dir: Frank Lloyd)
11. *Der brennende Acker* (dir: F. W. Murnau)
12. *Sherlock Holmes* (dir: Albert Parker)
13. *Beyond the Rocks* (dir: Sam Wood)
14. *The Infidel* (dir: James Young)
15. *The Power of Love* (dir: Nat G. Deverich & Harry K. Fairall)
16. *Lure of Gold* (dir: Neal Hart)
17. *The Toll of the Sea* (dir: Chester M. Franklin)
18. *Manslaughter* (dir: Cecil B. DeMille)

7. He claimed to have encountered a real-life vampire incident during his war service.

19. *Othello* (dir: Dmitri Buchovetzki)
20. *Monte Cristo* (dir: Emmet J. Flynn)
21. *Dr Jack* (dir: Fred Newmeyer)
22. *Sodom und Gomorrah* (dir: Mihaly Kertesz)
23. *Der Sinn des Lebens* (dir: Frederick Burau)
24. *Die Gezeichneten* (dir: Carl Theodor Dreyer)
25. *Shadows* (dir: Tom Forman)
26. *West of the Pecos* (dir: Neal Hart)
27. *The Headless Horseman* (dir: Edward D. Venturini)
28. *The Heart of a Texan* (dir: Paul Hurst)
29. *Dusk to Dawn* (dir: King Vidor)
30. *Cranquebille* (dir: Jacques Feyder)

This short list alone is enough to demonstrate that 1922 was a remarkable year for the cinema, both in accomplishment and in promise. Three of the directors on the IMDB list – Murnau, Dreyer and Lang – are now canonical figures of European film. Hitchcock, von Stroheim and Cecil B. DeMille are comparable figures in Hollywood history, while King Vidor and Alan Dwan continue to have cult followings, and Jacques Feyder is still respected, if less often seen.[8]

The IMDB list's concentration on features excludes one of the major amusements of the day: the comedy short, both live and animated. The most popular of these included the shorts, usually two-reelers, by Charlie Chaplin (see 2 April), Buster Keaton and Hal Roach's 'Our Gang'. The other comic giant of the day was Harold Lloyd.[9]

The absence of any Soviet titles from this list may also seem surprising: were the 1920s not the heroic period of Soviet cinema? Indeed they were, but only if one concentrates on the second half of the decade, from – say – the release of Sergei Eisenstein's *Battleship Potemkin* in 1925. Cinema, even of the most modest kind, is a dauntingly expensive medium, and the disastrous state of the Soviet economy in the immediate period after 1917 made the production of films all but impossible. But, thanks

8. Some notable omissions from the IMDB 1922 Top 30 include: *Nanook of the North* by Robert Flaherty, *One Exciting Night* by D. W. Griffith, directed by Louis Delluc, and *When Knighthood Was in Flower*, starring Marion Davies.

9. Although Stan Laurel and Oliver Hardy first appeared together on screen in 1921, in *The Lucky Dog*, they did not become the immortal 'Stan and Ollie' team until 1927.

to reforms brought in by Lenin's New Economic Policy (NEP) of 1921, sections of the economy had begun to pick up by 1922, and the cameras started to turn.[10]

One figure dominates Soviet cinema of the year 1922: Dziga Vertov, with his documentary *History of the Civil War*, and, more importantly, his newsreel series Kino-Pravda, 1–13.[11] Though his name – or pseudonym[12] – is not as well known to the general public as those of Eisenstein, Pudovkin, Kuleshev and company, Vertov's heroic pioneering stature in the world of avant-garde political cinema remains virtually unchallenged – especially since the late 1960s, when he was adopted by the band of ultra-left film-makers (including Jean-Luc Godard) who clubbed together to make anonymous revolutionary film-tracts under the banner of the Dziga Vertov Group.[13]

LONDON

In 1922, a plump young English virgin, Alfred Hitchcock,[14] directed his first film. He had been working as a designer of titles at the Islington studios owned by the American company Famous Players-Lasky – a division of Paramount. Hitchcock's first chance to work with actors came when Seymour Hicks, the star of a new comedy, *Always Tell Your Wife*, had a bitter argument with his director, Hugh Croise, and had the man sacked. Hicks was about to cancel the film altogether when 'a fat youth who was in charge of the property room at the studio volunteered to help me'. He liked the lad, so they carried on as co-directors and completed the film on schedule.

Partly as a result of this small triumph, Hitchcock was assigned by the chief of production to direct a short comedy, to be titled either *Mrs Peabody* or *Number Thirteen*; Ernest Thesiger and Clare Greet were signed up for the lead roles.[15] Hitchcock began to shoot, but found the produc-

10. Notable dramatic productions of the year included: *The Exile* (dir: Vladimir Baroky), *Infinite Sorrow* and *The Miracle Maker* (dir: Aleksandr Panteleyev), *In the Whirlwind of Revolution* (dir: Aleksandr Chargonin) and *The Suram Fortress* (dir: Ivan Perestiani), although only the last of these productions has retained anything of a reputation outside specialist circles.
11. Kino-Pravda translates literally as 'Cinema Truth'.
12. 'Dziga Vertov' was the *nom de guerre* of Denis Abelevich Kaufman (1896–1954), and may be roughly translated as 'spinning top'.
13. Besides the Kino-Pravda series, Vertov's most enduring work is *Man with a Movie Camera*.
14. Born in 1899, he was just a year older than the century.
15. Not much else is known about it, save that it appears to have been set on one of the charitable Peabody Estates which supplied decent housing for the poor in London.

tion more or less being cut away from beneath his feet, as the studio siphoned off its few remaining funds to pay back debts. Although Clare Greet generously funded some further days of shooting from her own savings,[16] *Number Thirteen* was abandoned, and it seems almost certain that the footage was destroyed, apart from a few stills. Hitchcock always said that it was not very interesting anyway.

The whole studio was gradually closing down, and all the leading directors and actors were taking off for Hollywood. Before many weeks had passed, Hitchcock found himself alone with just a few technicians. The Islington studio became a rental outfit, and the remaining staff only worked when some outside company needed to hire their resources. This was soon to change, thanks to Michael Balcon, who could reasonably be described as the saviour of British cinema at this time.

5 MARCH

LONDON

The Observer published the first major review of *Ulysses*, by Sisley Huddleston. 'No book has ever been more eagerly and curiously awaited by the strange little inner circle of book-lovers and litterateurs than James Joyce's Ulysses,' he began; and then, after a certain amount of throat-clearing, came directly to his point: 'Mr James Joyce is a man of genius.' The bulk of his sympathetic article is given over to emphasising to *Observer* readers that Joyce is a writer of high seriousness, and not at all a pornographer – though he adds, 'I cannot, however, believe that sex plays such a preponderant part in life as Mr Joyce represents.' Huddleston also considered that Molly Bloom's soliloquy was 'the vilest, according to ordinary standards, in all literature'. Broadly, though, he judged the book a magnificent achievement:

> There are phrases in which the words are packed tightly, as trim, as taut, as perfect as these things can be. There are fine ellipses in which a great sweep of meaning is concentrated into a single

16. It was a futile gesture, but Hitchcock never forgot her kindness, and repaid her by casting her in several films when he became a successful director.

just-right sentence. There is a spot of colour which sets the page aglow . . .

It was a far warmer and more appreciative response than the Joyce crowd might reasonably have expected, and its publication boosted sales nicely; on one particularly brisk day, Sylvia Beach's shop received 136 orders for Joyce's book.

6 MARCH

NEW YORK
Babe Ruth signed a three-year contract with the New York Yankees for $52,000 a year.

LONDON
The Eliots temporarily moved out of Clarence Gate Gardens and to the flat at 12 Wigmore Street leased by Lucy Thayer, the cousin of Eliot's old Harvard friend Scofield Thayer, who was travelling.[17] (Contemporary gossip had it that Lucy had once made a rather embarrassing pass at Vivien Eliot, falling to her knees and proclaiming her undying love.) Two days later, Eliot turned down Scofield Thayer's offer of $150 to publish *The Waste Land* in *The Dial*.

8 MARCH

LONDON
The Greek-Armenian mystic and guru George Gurdjieff arrived in town. His purposes were strangely similar to those of Eliot at the time; he wanted to see Lady Rothermere, and to seek her patronage for a pet project – in Gurdjieff's case, the foundation of an institute for his teachings in France. Like Eliot, he was a successful suitor; like Eliot, he would launch his new enterprise at the start of October. Gurdjieff and his disciple Ouspensky played a much larger role in literary mod-

17. They stayed here until late June.

ernism than many standard accounts of the period have noted. (See 1 October.)

OXFORD

Yeats wrote to Olivia Shakespear, about *Ulysses*.

> I am reading the new Joyce – I hate it when I dip here and there but when I read it in the right order I am much impressed. However I have but read some thirty pages in that order. It has our Irish cruelty and also our kind of strength and the Martello Tower pages are full of beauty. A cruel playful mind like a great soft tiger cat – I hear, as I read, the report of the rebel sergeant in '98: 'O he was a fine fellow, a fine fellow. It was a pleasure to shoot him.'

9 MARCH

PARIS

Hemingway wrote to his friend Sherwood Anderson in fervent praise of *Ulysses*:

> Joyce has a most goddamn wonderful book. It'll probably reach you in time. Meantime the report is that he and all his family are starving but you can find the whole crew of them every night in Michaud's where Binney and I can only afford to go about once a week.
>
> Gertrude Stein says Joyce reminds her of an old woman out in San Francisco. The woman's son struck it rich in the Klondyke and the old woman went around wringing her hands and saying 'Oh my poor Joey! My poor Joey! He's got so much money!' The damned Irish, they have to moan about something or other, but you never heard of an Irishman starving.

Either a singularly tasteless remark, or a singularly ignorant one: had Hemingway never heard of the Great Hunger?

NEW YORK

Eugene O'Neill's brutal play *The Hairy Ape* opened at the Provincetown Playhouse, NY.[18] There were 127 performances in all, and most of the audiences were enthusiastic. This degree of box office success is surprising, as the play is almost unrelievedly grim – and the reviews were far from encouraging. A modern tragedy, of sorts, it tells of the downfall of the brutal, unreflecting Yank, a stoker on board an ocean liner. Initially proud of his physical strength, Yank starts to doubt himself when a rich young woman, terrified by his appearance, calls him a brute – or a 'hairy ape', as his shipmates report it. Ashore in Manhattan, he has a sequence of grim adventures, including a bout in prison and a failed attempt to find solidarity with the IWW – International Workers of the World. The play ends with Yank trying to find his spiritual kin – a real-life ape in the zoo. He crawls into its cage for an embrace, and ends by being crushed to death.[19]

Just five days earlier, on 4 March, another of O'Neill's plays, *The First Man*, had opened in New York. It should have been a triumphant time for O'Neill, but the reviews for *The First Man* were dreadful, and the play was to close after only 27 performances. Yet this was not the main reason for O'Neill's intense gloom at the time. His mother, Ella, had died in Los Angeles on 28 February; her body, clumsily prepared by the undertakers, was shipped across country and – a coincidence that most playwrights would shun as heavy-handed in its symbolism – arrived at Grand Central on the same night that *The Hairy Ape* opened.[20]

A friend rushed straight from the deafening applause as the curtain fell on *The Hairy Ape*'s premiere, only to find O'Neill so plunged in despair that he had not the slightest interest in this good news. All night the two men walked around Central Park, as O'Neill vented his misery and memories – of his mother's drug addiction, his brother's alcoholism, all the pain and guilt and tyrannies of the O'Neill family history. By dawn he was exhausted, and staggered back to his hotel.

18. It later transferred to the Plymouth Theater.
19. *The Hairy Ape* has been revived many times since, once with Paul Robeson in the lead, and was made into a film.
20. Years later, O'Neill made use of this horrible experience in *A Moon for the Misbegotten*.

9–10 MARCH

PARIS
Pound wrote to Thayer:

> I am afraid Eliot has merely gone to pieces again. Abuleia, simply
> the physical impossibility of correlating his muscles sufficiently to
> write a letter or get up and move across a room . . .[21]
>
> His poem is as good in its way as Ulysses in its way – and
> there is so DAMN little genius, so DAMN little work that one can
> take hold of and say 'this at any rate stands, and makes a definite
> part of literature'.

Pound also tried to recruit Thayer to the cause of rescuing Eliot from his
bank job, and suggested several possibilities, including 'some sort of job
on the Century or Atlantic [that is to say, in an editorial position for a lead-
ing literary journal], or perhaps a professorship somewhere'.[22]

> Three months off and he got that poem done. I think he is [his]
> being in that bank is the greatest waste now going on in letters,
> ANYWHERE. Joyce is provided for, at least he now has a steady
> income only somewhat too small. Wd. be AMPLE if he hadn't
> two offspring, which I can't see that he has any business to have.

10 MARCH

BOMBAY
At 10.30 in the evening, a police car drew up on the road about 80 yards
from Mohandas Gandhi's hut in the Sabarmati Ashram, Bombay, and a
junior officer was dispatched to explain, courteously, that the Indian
leader[23] should consider himself under arrest on charges of sedition, and

21. Eliot found the word 'abuleia', from the Greek for 'non-will', in his readings of theology and
mysticism. With the adapted spelling 'abulia', it is still in use among neurologists.
22. Pound notes with exasperation that 'Some bloody college has given FROST a job with no du-
ties'; the college was the University of Michigan, which employed Robert Frost from 1921–3.
23. Since 1920, he had been first a member, then president of the All-India Home Rule League.

should present himself as soon as he was ready. Gandhi led 10 of his fol-
lowers in a hymn, then walked up the path, climbed into the car and was
driven to Sabarmati prison. At the preliminary hearing the next morning,
he gave his age as 53 and his profession as 'farmer and weaver'. He was
then formally charged with writing three seditious articles for *Young India*
magazine, on 19 September 1921, 15 December 1921 and 23 February 1922.

The trial was held in Government Circuit House at Ahmedabad.
In September 1921 Gandhi had abandoned, for good, his former habitual
outfit of cap, sleeveless jacket or vest, and long-flowing dhoti, and had
taken the loincloth as his sole garment; this was his dress for the trial.
Both sides were eloquent. Far from wishing to protest his innocence, Gan-
dhi said that the charges brought against him were 'entirely fair . . . It is
very true and I have no desire whatsoever to conceal from this court the
fact that to preach disaffection from the existing system of government
has become almost a passion for me.' He therefore invited the judge either
to pass 'the highest penalty that can be inflicted upon me', or to resign.
He went on to outline all his objections to British rule in India. He con-
cluded by asking once again for the severest penalty.

Mr Justice Broomfield, presiding, bowed to the prisoner and passed
sentence. His summary was, in its way, as unconventional as Gandhi's: it
was impossible, he said, 'to ignore the fact that you are in a different cate-
gory from any person I have ever tried or am likely to have to try. It would
be impossible to ignore the fact that, in the eyes of millions of your coun-
trymen, you are a great patriot and a great leader. Even those who differ
from you in politics look upon you as a man of high ideals and of noble
and even saintly life.'[24]

None the less, he said, he was obliged to sentence Gandhi to six years
of imprisonment, adding that if anyone later saw fit to reduce the sen-
tence, 'no one would be better pleased than I'. Gandhi replied that he
considered the sentence mild, and his treatment throughout the proceed-
ings impeccably courteous. Many spectators wept as Gandhi was led away
to jail.[25]

This show of force on the part of the British authorities is an indication

24. Indeed. Gandhi's followers had been calling him by the honorific term 'Mahatma' – 'Great
Soul' – ever since he came from South Africa to India in 1914.
25. In the event, he served only two years of his term.

of the extent to which Parliament was becoming more and more aware of the need to yield to growing demands for Indian self-determination. On 13 March, HRH the Prince of Wales, the future Edward VIII,[26] inaugurated the Prince of Wales Royal Indian Military College in Dehradun: a move towards making the officer cadre of the British Indian Army more racially integrated. It is unlikely that this small gesture did much to postpone the inevitable move towards independence.

12 MARCH

LONDON

Virginia Woolf wrote in her diary:

> I have seen people – & people. Eliot, Clive [Bell], Violet [probably Violet Trefusis, 1894–1972, the lesbian writer who was one of the inspirations for Woolf's novel *Orlando*], – if no one else. Of these Eliot amuses me most – grown supple as an eel; yes, grown positively familiar & jocular & friendly, though retaining I hope some shreds of authority. I mustn't lick all the paint off my Gods. He is starting a magazine; to which 20 people are to contribute; & Leonard & I are among them! So what does it matter if K. M. [Katherine Mansfield] soars in the newspapers, & runs up sales skyhigh?

She adds that Eliot 'has written a poem of 40 pages, which we are to print in the autumn. This is his best work, he says.' In a more gossipy vein, she also notes Clive Bell's insistence that Eliot uses violet face powder to make himself seem more cadaverous.

At the same time, she mused on the sadness of E. M. Forster, whom she had just seen off after a brief visit. He had been back in England for a week, and he struck Woolf as almost paralysed with depression.

> To come back to Weybridge, to come back to an ugly house a mile from the station, an old, fussy, exacting mother, to come

26. Soon to be spotted by D. H. Lawrence in Ceylon (see 13 March).

back having lost your Rajah, without a novel, and with no power to write one – this is dismal, I expect, at the age of 42. The middle age of buggers is not to be contemplated without horror . . .

Over the next few weeks, Forster's depression deepened to the point at which he could hardly bear to see people. He also decided to burn all his 'indecent' short stories.

LONDON
Eliot wrote to Pound, telling him that he had changed the epigraph of his poem from a quotation from Conrad's *Heart of Darkness* to one from Petronius's *Satyricon*. He also went on to discuss his correspondence with Thayer, claiming that he might have been willing to accept the low fee of $150 had Thayer been more courteous in his approach. He also explained that 'I have now settled with Lady Rothermere about the quarterly review . . .', which she had agreed to finance for at least three years. He invited Pound to contribute a regular 'Paris Letter', and any of the Cantos he might care to submit, and to start scouting around for possible contributions from the 'best people'.

On the same day, Eliot wrote to the influential French critic and *homme de lettres* Valéry Larbaud, proposing that his lecture on James Joyce[27] might be published in the first volume of the new quarterly review: 'I am not at present aiming at a very large public, but at the most enlightened part of the British public – there are, I think, at least a thousand people in England who are aware of the low state of literary journalism here.'

13 MARCH

LONDON
Eliot wrote an important letter, in French, to Hermann Hesse (1877–1962). He explained that he had encountered Hesse's *Blick ins Chaos* and wondered whether one or two sections of the book might be translated for publication in his quarterly. 'Je trouve votre Blick ins Chaos d'un sérieux qui n'est pas encore arrivé en Angleterre, et je voudrais en répandre la réputation.'

27. First delivered at the Maison des Amis des Livres in December 1921.

Hesse was a long-term student of Buddhism and other Eastern spiritual traditions; his major publication of 1922, the short novel *Siddhartha*, is a summary of his reflections on Buddhist teaching.[28] Eliot also had a very considerable knowledge of Buddhism, and had been tempted to adopt the religion. There are overt references to Buddhist wisdom in *The Waste Land*, and some critics have read the whole poem as essentially Buddhist.

CEYLON

D. H. Lawrence was also coming into first-hand contact with Buddhism. After disembarking from the SS *Osterley* on 13 March, the Lawrences were met by their American friend Earl Brewster, and the trio went by train to Kandy, in the country's interior.[29] Very soon after their arrival, they attended a major Buddhist festival, the Perehera, which had been mounted in celebration of a state visit from Edward, the Prince of Wales.[30] A dizzying mass spectacle of giant elephants, heavily festooned with decorations, accompanied by the pounding of countless tom-toms and the tantalising smells of ceremonial oils and smokes and blazing coconut torches, the Perehera made a profound, almost overwhelming impression on them. Lawrence wrote about it in a number of letters, and in his poem 'Elephant'.[31]

It did not take long for disenchantment to set in. Lawrence rapidly came to the conclusion that Buddhism was a barren, pernicious faith that denied the existence of the soul. Heedless of the fact that it was the Brewsters' adopted religion, he would be rude and surly both about the Buddha himself – 'Oh, I wish he would stand up!' he shouted after seeing yet another recumbent statue – and about Buddhistic detachment from the world: it 'affects me like a mud pool that has no bottom to it'. When he

28. *Siddhartha* became a major best-seller and a kind of Bible to the hippie movement of the 1960s and 1970s, during which years the English translation sold over a million copies.
29. Leonard Woolf had been a colonial administrator in Kandy in 1907–8; he had found the country 'entrancingly beautiful'.
30. The 28-year-old prince struck them as thin and nervous.
31. Their sense of being stunned and disoriented did not greatly abate even when they moved into the Brewsters' bungalow, overlooking Kandy Lake, for the noise of wildlife – slithering vipers, cawing birds, chattering monkeys – made it seem as if the whole universe were exploding with frenzied life all around them, by day and by hot sleepless night. At midday, particularly, Lawrence reported, the terrible heat was like being in prison, or trapped under a bell jar. And yet they, like Leonard Woolf before them, were also enchanted by the intense beauty of the place, and for a couple of weeks Lawrence did enjoy his long walks with Earl Brewster through the jungle, visiting Buddhist temples and watching elephants haul timber.

reached a temple, he stubbornly refused to follow the etiquette of taking off his hat and shoes, and stood outside, hatted and booted, declaring that he did not belong in such places and never would. Worse, the unrelentingly hot, humid climate of Ceylon eventually sapped his usually powerful will to work, and he gave way to hypochondriac fantasies that the ultraviolet light was rotting his blood, or that he had somehow contracted malaria. But there was nothing hypochondriac about the stomach bug which gave him three weeks of diarrhoea and agony – the worst pain he had ever known. He did not like the local food, not even the delicious fruit, and he lost a dangerous amount of weight.[32]

14 MARCH

BOSTON

After a six-day drinking spree, Harry Crosby finally quit his hated job at the Shawmut National Bank.[33] In the early months of 1922, Crosby was largely unknown outside the upper-crust circles of New England. He had been born into one of the wealthiest families in the United States – his uncle was the financier J. P. Morgan Jr – and he later used his inheritance to fund his many indulgences in ways that horrified his more strait-laced relatives. He was also a conspicuously brave and principled young man, however, and had volunteered to serve as an ambulance driver in France before the United States entered the war, later enlisting in the US Army.[34]

On his return to America, he took an accelerated course for veterans at Harvard, and then went, as his family expected, into banking. He found the job tiresome, and his misery deepened when he fell, suddenly and violently, in love with a married woman six years his senior, Mrs Richard

32. Eventually, by early April, he was so debilitated that he had to take emergency measures. Drawing on a thousand dollars of American royalties, he booked tickets for the SS *Orsova*, due to leave Colombo on 24 April and scheduled to land at Fremantle, Western Australia, on 4 May. The 'savage pilgrimage' was under way again.

33. By the time of his death by suicide in 1929 – an event often taken as a symbol for the end of the Jazz Age – Crosby would be one of the most notorious figures of American expatriate Bohemia: a rich, extravagant, unbridled hedonist, womaniser, connoisseur of opium and other drugs; but also a poet, and, as founder and editor of the Black Sun Press, the publisher in exquisite editions of many of the leading writers of the day – Pound and Joyce, Hemingway, Hart Crane and others.

34. In recognition of his gallantry, the French government awarded him a Croix de Guerre, making him one of the youngest Americans ever to receive the honour.

Peabody – otherwise Mary, otherwise Polly, otherwise (later) Caresse. His family was appalled by their scandalous affair, and tried to force the couple apart. By February 1922, Polly had given in to Harry's pleas and divorced her husband, but she still did not move in with him. Once again, Crosby's family intervened, and J. P. Morgan arranged for him to be given a new job with Morgan, Harjes et Cie in Paris. Crosby set off for Paris in May, still resolved to win Polly if he could. (See 2 September.)

PARIS

Pound wrote a long, angry and occasionally ranting letter to Eliot outlining his general position. He had not the slightest interest in England, nor in any writer active in England save for Eliot himself. He scorned the rates being offered for his contributions as stingy even by the standards of most literary reviews. He categorically refused to have anything to do with any review that did not guarantee Eliot enough money to bail him out from his position at Lloyd's. He damned all Englishmen (and, probably, ladies or Ladies); he had the gravest doubts as to the character of Lady Rothermere (who, he correctly assumed from her name, had married into 'a family which is NOT interested in good literature'). And so on. On the other hand: 'Of course if Lady R. is willing to cooperate with me in a larger scheme which wd. mean getting you out of your bank, and allowing you to give your whole time to writing, I might reconsider these points.'

He ended with a lengthy tirade against England, a lament for all the writers it had destroyed or sent into exile – Landor, Keats, Shelley, Byron, Browning, Beddoes – and an uncompromising statement of the only conditions under which he would consider becoming a contributor. On 18 March, he wrote to the poet and doctor William Carlos Williams: 'Deer Bullll: The point is that Eliot is at the last gasp. Has had one breakdown. We have got to do something at once.'

15 MARCH

PRAGUE

Franz Kafka read the first chapter of *The Castle* to Max Brod. He carried on working at the novel throughout the spring and summer, finally putting it to one side in late August.

17 MARCH

VIENNA

Wilhelm Reich (b. 1897), trainee doctor and psychoanalyst, married Anne Pink, a medical student; the bride was 20, the groom 25. Reich went on to take his MD degree in July, and set up a private psychoanalytic practice, which he ran in conjunction with his advanced studies in medicine. Though Freud – whom Reich had met three years earlier – seems to have approved of Reich warmly, and permitted him to begin treatments at a very early age, Reich would go on to be the strangest and most notorious of all Freudian heretics, first with his attempts to effect a synthesis of Marxist and Freudian teachings, and then – after fleeing Nazi Germany and eventually settling in the USA – with a series of experiments that read like science fiction: machines for 'cloud-busting', and the 'Orgone Accumulator', a box in which believers would sit in the hope of boosting their cosmic energy levels.[35]

LONDON

The *Daily Herald* ran a review of *Ulysses* by George Slocombe. He adopted a jocular tone, with facetious references to the legal actions against *The Little Review* ('. . . a squad of six large Irish policemen sprang up kinema-fashion from their porterhouse-steak breakfasts and sallied forth to suppress . . .') and to Joyce's long labours: 'It took, I understand, nearly six years of Mr Joyce's life to write, and it will take nearly six of ours to read.' Having proved his waggishness, Slocombe then went on to give an admirably concise synopsis of Bloom's day (he did not mention Dedalus – the novel's portrait of the artist as a young idler, who dominates the first section of *Ulysses*), and, after the usual tut-tutting about obscenity, ended on a highly approving note: '. . . the book is a staggering feat which, once attempted and more than half achieved, may never be attempted again – the way of a cosmic atom under heaven during a day and a night'.

35. Derided by orthodox science, and hounded by the FDA and other state institutions with unusual, not to say undue ferocity, Reich died in police custody in 1957, apparently of a heart attack. But he had a kind of posthumous revenge on his persecutors, since his books were widely published and read in the 1960s and 1970s, and he became regarded both by the New Left and by fuzzier counter-cultural types as a visionary, a hero and a martyr. His influence in popular culture has been far more telling than in medicine or science.

20 MARCH

BERLIN

The wealthy diplomat, publisher, man of letters and self-styled 'cosmo-
politan' Count Harry Kessler,[36] wrote in his diary:

> Dined with the Einsteins. A quiet, attractive apartment in Berlin
> West (Haberlandstrasse). Rather too much food in the grand style
> to which this really lovable, almost still childlike couple lent an
> air of gravity. Guests included the immensely rich Koppel, the
> Mendelssohns, Warburg, Bernhard Dernburg (as shabbily dressed
> as ever), and so on. An emanation of goodness and simplicity on
> the part of the host and hostess saved even such a typical Berlin
> dinner-party from being conventional and transfigured it with an
> almost patriarchal and fairy-tale quality.
>
> I had not seen Einstein and his wife since their major excur-
> sion abroad. They admitted quite unaffectedly that their reception
> in the United States and Britain were veritable triumphs. Einstein
> gave a slightly ironical, sceptical twist to their description by claim-
> ing that he cannot make out why people are so interested in his
> theories. His wife told me how he kept on saying to her that he felt
> like a cheat, a confidence trickster who was failing to give them
> whatever they hoped for.

Einstein went on to quiz Kessler carefully about what might be expected
of him during his imminent trip to Paris; he hoped, he said, to be able to
use the visit to bring about improved relations between scholars in France
and Germany.[37] When the other guests had left, Kessler stayed on with
the Einsteins to talk quietly, and admitted that he was someone who
could sense the significance of Einstein's theories rather than fully grasp
them. Einstein kindly gave him a simple way of grasping them, by way of
imagining a glass ball with 'beetles' moving about its surface – a surface
that, though finite, is also limitless . . .

36. Count Harry Kessler (1868–1937) met many leading figures of his times. In 1922 he represented
Germany at the Genoa conference. His Cranach Press, founded in 1913, produced beautiful limited
editions of classic texts. In 1933, when Hitler came to power, he fled Germany and lived as an exile
in Paris until his death.
37. He also revealed that he planned to accept invitations to lecture in China and Japan later in the year.

Just a few days later, the Einsteins set off on their trip to Paris. Einstein had been invited there by the French physicist Paul Langevin, professor at the College de France, to discuss his work with a group of mathematicians, physicists and philosophers. But his fame was now such that, as in the UK and the USA, this modest project soon launched a popular craze. According to the *Berliner Tageblatt* of 12 April:

> All newspapers carried his picture, a whole Einstein literature has grown, science and snobbism honour the modern scientist . . . He has become the great fashion, academics, politicians, artists, policemen, cab drivers and pickpockets know when Einstein lectures. Tout Paris knows everything and tells more than it knows about Einstein.

PARIS

The art critic Marcel Sembat, formerly an ardent champion of Matisse's work, wrote an angry letter to their mutual friend Paul Signac, denouncing the painter's recent development: 'He's given in, he's calmed down, the public is on his side.' The immediate cause of Sembat's disgust was the sale of *Odalisque in Red Culottes* to the French state (to be exact, the Musée du Luxembourg); it was the first time that Matisse had received such official recognition, and in Sembat's view, it sounded the death knell for his career as a serious artist.[38]

As Matisse's biographer Hilary Spurling explains, his reputation split in two at the beginning of the 1920s. The former revolutionary continued to be strong meat for more conservative tastes – so strong that when, in 1921, three of his canvases were exhibited as part of a group show at the Metropolitan Museum in New York, they were derided as 'pathological'; and when the Detroit Museum of Art bought its first Matisse in 1922, the curators had to defend their scandalous purchase by insisting, ludicrously, on the painter's allegedly nice clean house and thoroughly respectable habits.[39]

38. Sembat might well have changed his mind about Matisse's new styles had he seen more of them, but he died of a heart attack in September 1922; his wife shot herself 12 hours later. Their substantial collection of early Matisses went to a museum in Grenoble – at the time, the only major gallery to show any interest.

39. It is true, if utterly irrelevant, that Matisse did work exceptionally long hours and usually lived with marked frugality.

But one man's strong meat may be another man's soft-centred chocolate. In Paris, advanced opinion was now turning swiftly and decisively against Matisse, in large part because his post-war works violated one of the most cherished principles of Bohemia: lots of people found them quite pleasant to look at, and they were beginning to sell in healthy quantities. In Matisse's eyes, the chromatic experiments he had been undertaking since 1919 were as desperately serious as any of his earlier phases had been, but their cheery air of sexiness and their suggestions of delicious harem adventures made them fatally commercial. It is a familiar modern story: the fans turn against their former idol, and accuse him of selling his soul to Mammon. No wonder Matisse often complained of intense loneliness during these early years in Nice.

PARIS

Joyce wrote to his brother that he had been visited by Desmond Fitzgerald, a minister in the new Irish Free State government, and that Fitzgerald intended to propose that Ireland nominate Joyce for the Nobel Prize for Literature. Joyce reflected that such a move would be unlikely to secure him the prize, and would probably have Fitzgerald thrown out of office.

21 MARCH

IRELAND

Yeats sent a despairing postcard to his wife, who had asked him to speak out against violence: 'I could do no good in this whirlpool of hatred . . .'

22 MARCH

PARIS

Pound wrote his celebrated, era-defining letter to H. L. Mencken: 'The Christian Era ended at midnight on Oct. 29–30 of last year. You are now in the year 1 p.s.U. [post scriptum Ulysses], if that is any comfort to you.'

He also noted that 'Shaw writes to me twice a week complaining of the high price of Ulysses.'

NEW YORK

The brilliant and profoundly eccentric Serbian-born physicist Nicola Tesla filed a patent entitled 'Improvements in Methods of and Apparatus for the Production of High Vacua'.[40]

23 MARCH

SPAIN

Rudyard Kipling arrived in Algeciras for the start of an extended holiday in Spain – 'the nearest Oriental land I know', as he fondly called it. He was tired and in poor health.[41] Some of his exhaustion could be blamed on his intense labours for the Imperial War Graves Commission – among other contributions, he had ghosted a major speech for King George V to deliver at cemeteries in France and Belgium during a tour of May 1922; he also wrote a long poem, 'The King's Pilgrimage', about those memorial ceremonies.[42] (See 15 May.)

In Spain, he was joined by the young George Bambridge, who had served with Jack Kipling in the Irish Guards and soon became a surrogate son for the older man.[43] It seems likely that Bambridge organised one of the most unlikely literary encounters of this year of strange meetings, between Kipling and the young poet and playwright Federico García Lorca. At this time, Lorca liked to hang out with a group of aspiring and actual writers who called themselves the Rinconcillo, and who used as their regular meeting place the Café Almeida in Granada's Plaza del Campillo.

40. Despite the modest title, this paper came under close scrutiny years later, during the Cold War, when both the United States and the Soviet Union put their scientists to work on the development of that old standby of science fiction adventures, a 'Death Ray'. In the real world, nothing came of the research; but in the world of popular culture, the myth that Tesla had indeed developed such a deadly ray gun has been recycled dozens, perhaps even hundreds of times.

41. All his teeth had been extracted the previous year, and he was suffering from chronic stomach pains, which by the end of the year would be severe enough to require major surgery.

42. Kipling was worn down by the difficulties he had encountered in completing his two-volume official history of the Irish Guards – the regiment in which his son Jack had served, and died, at the battle of Loos in 1915. After completing several substantial drafts, he thought that he had finally put the manuscript to rest on New Year's Day, 1922, but a need for yet further revisions brought him back to it again and again until 27 July. The history, published in 1923, is still regarded as the finest work of its kind.

43. Two years later, in 1924, George would marry Elsie Kipling and become Rudyard's actual son-in-law.

25 MARCH

LONDON

The *Daily Express*, a mass-circulation conservative newspaper, ran its review of *Ulysses*. The verdict, no surprise, was negative. Under the headline 'An Irish Revel: And Some Flappers', S. P. B. Mais wrote:

> Our first impression is that of sheer disgust, our second of irritability because we never know whether a character is speaking or merely thinking, our third of boredom at the continual harping on obscenities (nothing cloys a reader's appetite so quickly as dirt) . . .
>
> Reading Mr Joyce is like making an excursion into Bolshevist Russia: all standards go by the board . . .

Even the more conservative readers of Joyce in the twenty-first century would tend to agree that the 'Bolshevist' slur says much more about the reviewer than the novel.

PARIS

Hemingway reported on the agitation caused by the award of the Goncourt Academy Prize to *Batouala*, a novel by René Maran: 'a Negro'. Maran had been bitterly attacked for his portrait of French imperialism, and particularly for a preface to the novel which described how peaceful African communities of some 10,000 could have dwindled away to less than a tenth of their original size.[44]

Hemingway was in no doubt as to the literary qualities of Maran's work:

> You smell the smells of the village, you eat its food, you see the white man as the black man sees him, and after you have lived in the village you die there. That is all there is to the story, but when you have read it, you have seen Batouala, and that makes it a great novel.

44. One of the minor oddities of the affair was that Maran himself, on French governmental service in Central Africa, two days' march from Lake Tchad, was still unaware that he had been awarded the Goncourt.

26 MARCH

GERMANY

The Frankfurt Opera staged three one-act musical dramas by the still relatively obscure violinist and composer Paul Hindemith (1895–1963): *Mörder, Hoffnung der Frauen* (written in 1919), a setting of a short play by the painter Oskar Kokoschka; *Das Nusch-Nuschi* (written in 1920), 'a play for Burmese marionettes', by the expressionist writer Franz Blei, about a philandering character who is eventually punished by castration; and *Sancta Susanna* (written in 1921), adapted from a story by August Stramm about a sex-crazed nun who rips the loincloth from the crucified Christ.[45]

The evening was by far the most widely publicised event of Hindemith's career to date, and amounted to a professional breakthrough. The scandal helped make him something of a hero among the young intelligentsia, who applauded him in direct proportion to the hostility of the old guard.[46] 1922 was also a highly productive year, even for the prolific Hindemith, who managed to compose no fewer than 11 full-scale works, including his first ballet, *Der Dämon*, the *Kammermusik No. 1*, which makes use of jazz idioms, the Sonata for Solo Violin, the *Suite 1922* for piano, and the beginning of his major song cycle *Das Marienleben* (completed in 1923), an exploration of his roots in early eighteenth-century polyphony.[47]

45. *Das Nusch-Nuschi* had already created a local scandal the year before, when the audience at the Stuttgart Landestheater had reacted with shock, not so much to the violence of the castration scene as to the horrifying fact that Hindemith had set the scene to a pastiche of Wagner's *Tristan und Isolde*. Sacred music was being profaned! Members of the orchestra did not mind the Wagner-teasing at all; they found it amusing.

The conservative press rose to the occasion just as splendidly after the Frankfurt performance, squealing in outrage. 'A perverse and entirely immoral affair,' thundered the critic for the *Zeitschrift für Musik*, who was outraged both by what he had seen on stage and by the fact that a large section of the audience had obviously enjoyed these obscenities.

46. At a concert soon afterwards in Heidelberg, Hindemith's performance of his new violin sonata was hissed and booed by most of the audience, but the local students cheered him, hoisted him up on to their shoulders and carried him to their favourite watering hole, the Goldener Hecht. There was a battered old piano in one corner, and Hindemith charmed the youngsters with his party trick – playing the piano as if his arms were a seal's flippers, with his hands flat, and improvising wicked parodies of Liszt, Chopin and Wagner, to their delighted laughter.

47. In later years, Hindemith came to take a dim view of the three short operas which had set the whole machinery of fame in motion, and disowned them as no more than apprentice pieces.

27 MARCH

PARIS

This was the centenary of the birth of Henri (aka Henry) Murger, whose highly influential collection of stories *Scènes de la Vie de Bohème* (written 1845–6; collected 1851) had helped make the feckless, rebellious, impoverished, hedonistic ways of his Parisian crowd world-famous – and, to many, deeply attractive.[48] Murger's centenary prompted a wave of speculation and commentary. His admirers held ceremonies at his tomb in the Montmartre cemetery, and before his bust in the Luxembourg Gardens. The Parisian press teemed with articles about Murger and *la vie de Bohème*. The event also inspired a number of books, published over the next year or so, on the heroes of Bohemia: Verlaine, Alfred Jarry and others. The general tone of these publications was nostalgic: the myth of the struggling artist among the thieves and prostitutes had lost its allure; the glory days were past; romantic Bohemia, the country of the young, was dead and gone.

These obituaries could hardly have been more poorly timed. Over the next few years, the massive influx of 'artistic' Americans and other relatively well-off foreigners – drawn to Paris by the favourable exchange rate, by Prohibition and 'Babbitry' – the narrow-minded, money-grubbing, complacent philistinism satirised in Sinclair Lewis's best-selling 1922 novel *Babbit* – and by the potency of Murger's fable – made the city notorious as the home to a spectacular new avatar of the bohemian spirit.

LONDON

Eliot wrote again to Hermann Hesse, thanking him for the manuscript of an essay on 'Recent German Poetry'; translated by F. S. Flint, it would appear in the first issue of Eliot's quarterly, *The Criterion*.

48. His particular gang called themselves the 'Water Drinkers' – a name chosen partly from sarcasm, partly to insist on their genuine poverty.

Murger's book was the source, among other enduring works of art, for Puccini's *La Bohème*; the character of Rodolphe was an approximate self-portrait. 'Bohemia', the country of struggling young artists, rapidly became one of the most potent myths of the nineteenth century.

30 MARCH

LONDON

Pound's essay 'Credit and the Fine Arts . . . a Practical Application' appeared in A. R. Orage's influential avant-garde journal of arts and politics *The New Age*. It was mainly about the 'Bel Esprit' project – Pound's charitable initiative to raise enough money from Eliot's supporters to bail him out from his exhausting job at Lloyd's Bank.

31 MARCH

PARIS

Jean Hugo noted in his diary that he had just been to Fontainebleau, in the company of Georges Auric, to hear Radiguet read out what appeared to be the completed final section of *Le Diable au Corps*. The full story is a little more complex.

What had happened was that Cocteau had shown his protégé's work-in-progress to the publisher Grasset, who was convinced that it would be a best-seller and paid Radiguet handsomely for the rights. The young man immediately bought himself an expensive camel-hair overcoat, an equally expensive pigskin suitcase and other treats, and then went off to Fontainebleau to compose the necessary conclusion. But Cocteau – ill at the time with sciatica – was deeply disappointed by the perfunctory effort that Radiguet handed over to him, and told the lad that it read like a hastily scribbled homework assignment. Radiguet was furious, and threw the pages into an open fire. The next day, however, he repented, and told Cocteau that he had been right. Cocteau then took Radiguet to Chantilly, where – by his account – he literally locked the young man in a hotel room until he had written a satisfactory final section.

PARIS

Einstein gave the first of his four famous lectures at the Collège de France, outlining the basics of his theories of Relativity. He spoke in French, without notes, and carefully avoided making any asides on non-scientific matters, well aware that there was a small but potentially dangerous number of French patriots who were outraged that a *Boche* should be offered such a distinguished platform so soon after the end of the war.

L'Humanité reported that:

Everyone had the impression of being in the presence of a sub-
lime genius. As we saw Einstein's noble face and heard his slow,
soft speech, it seemed as if the purest and most subtle thought was
unfolding before us. A noble shudder shook us and raised us above
the mediocrity and stubbornness of everyday life.

APRIL

1 APRIL

'Aramis', the reviewer for the *Sporting Times* – also known as the *Pink 'Un* – began his review of *Ulysses* in fighting terms:

> After a rather boresome [*sic*] perusal of James Joyce's *Ulysses*, published in Paris for private subscribers at the rate of three guineas in francs, I can realise one reason at least for Puritan America's Society for the Prevention of Vice, and can understand why the Yankee judges fined the publishers of *The Little Review* one hundred dollars for the publication of a very rancid chapter of the Joyce stuff, which appears to have been written by a perverted lunatic who has made a specialty of the literature of the latrine . . .

The reviewer carried on in the same vein: 'The main contents of the book are enough to make a Hottentot sick'; 'glorification of mere filth'; 'supremely nauseous' . . . And yet, Aramis conceded in a tone pitched somewhere between outrage and disbelief, 'there are quite a number of the New York intelligentsia who declare that Joyce has written the best book in the world . . .'

Joyce, meanwhile, had more than just hostile reviews to make him unhappy.

Nora set off with the children for Ireland, via London. Joyce was bitterly opposed to the trip. They arrived in London on the 2nd, and checked into the Bonnington Hotel on Southampton Row.[1] After 10 days in London, they went on to Dublin, where they met Nora's uncle, Michael Healy

1. Nora was in good spirits; she liked London very much, and wondered whether she might be able to persuade Jim to settle here instead of Paris. Simply to hear English spoken all around them was a great relief to her.

(a Galway Port official) and Joyce's father; they then went on to Galway, where Healy put them up in his house on Dominick Street.

Back in Paris, Joyce was fretting: 'And do you think they are safe, really?' he asked his American friend and financial supporter Robert McAlmon. 'You don't know how this is affecting me. I am worried all of the day and it does my eye no good.' To Nora he wrote: 'I am like a man looking into a dark pool', and he begged her to return.

Shortly after Nora arrived in Galway, fighting broke out there between the Free State forces and those of the Irish Republican Army. When combatants decided to use the family bedroom as a firing position, Nora, not unreasonably, panicked. Joyce, more anguished than ever, arranged to have a small plane fly to Galway to pick them up, but Nora was too frightened to wait, and bundled her children on board a train for Dublin. Almost immediately, the train came under fire. Nora and Lucia hugged the floor, but Giorgio stubbornly kept his seat. An elderly fellow passenger, who also remained seated, puffed on his pipe and asked Giorgio, 'Aren't you going to get down?'

'No,' said Giorgio.

'You're right. They never shoot straight. They're probably shooting blanks anyhow.'

Blanks or not, the Joyces arrived safely in Dublin.[2]

GALWAY

By the start of April, Yeats was established at his tower – Thoor Ballylee, as he had renamed the place. 'Thoor is Irish for tower and will keep people from suspecting us of modern gothic and a deer park.'

> All we can see from our windows is beautiful and quiet and has been so; yet two miles off near Coole, the Black and Tans flogged young men and then tied them to their lorries by the heels and dragged them along the road till their bodies were torn in pieces. I wonder will literature be much changed by that most momentous of events, the return of evil . . .

2. Joyce took the shooting incident very seriously, convinced that the attack had really been directed at him. His friends thought this ridiculous, but he would not be talked out of his belief that certain people in Dublin meant him serious harm.

2 APRIL

HOLLYWOOD

First National released *Pay Day*, a 28-minute two-reeler starring, written and directed by Charlie Chaplin. It was the last two-reeler he ever made, and is sometimes said to have been Chaplin's own favourite among his short films.

By the end of 1922, Chaplin (1889–1977) was 33 years old and had made 71 films. He was a millionaire; a co-founder of United Artists; and, since about 1915, probably the most famous man in the world, except in Russia (where, so far, only the privileged intelligentsia – including Eisenstein – knew and raved about him), Colombia, Yugoslavia and Germany.[3] In 1921, needing a break from seven years of intensive work, Chaplin had taken a long holiday, which brought him back to his native Britain, where he was mobbed by adoring crowds and courted by the great and good, and then on to Paris, where he was mobbed by adoring crowds.[4]

The cinema gave the world an entirely new type of waking dream life: imaginary heroes and villains, friends and sweethearts, enemies and terrors, often more intensely experienced than the real things. Chaplin, especially in his guises as 'the Little Man' and 'the Tramp' (a character first seen in the Keystone short *Kid Auto Races in Venice*, released in February 1914), was not merely known by almost everyone; he was loved by almost everyone.[5]

3. The Germans and their allies were only just beginning to catch up with Charlie's clowning, since American imports had been forbidden during the war.

4. Chaplin's life story is as astonishing as it is well known: the working-class child from south London, progeny of an alcoholic (and soon to be absentee) father and a feeble, malnourished mother who suffered increasingly from mental illness; a delicate waif who supported himself from the tenderest of years as a child performer, and then, in early manhood, as a member of a clowning troupe and a bit player in vulgar knockabout comedies in Hollywood. The passage from bit player to major box office attraction took about a year. Over the previous couple of decades, the wildfire expansion of cinema around the world had transformed the nature of renown for ever. True, there were some astonishing success stories in the pre-cinema era – cases of exceptionally gifted men and women from humble origins who had earned fame, riches and power through feats of arms, or political vision, or quirk of fate: no wonder that Chaplin was fascinated by Napoléon, and hankered to play him on screen.

5. Years later, after being branded as a Red in the McCarthy period, he would come to be hated by millions. As early as 1922, he had come to the attention of the authorities thanks to his (not very well-informed) remarks in favour of the Bolsheviks, and his friendships with leading members of the American Left, including Max Eastman, the charismatic editor of *The Masses*.

'Charlot' (as his French fans called him) was as important to the powerful as to the powerless. From about 1916 onwards, it became commonplace for intellectuals to refer to Chaplin as a major artist, a poet, a genius – the only genius to have been produced by the cinema, Shaw declared.[6] For those with eyes to see, Chaplin was established not merely as a versatile comic performer, but as a director possessed of a talent to rival the likes of D. W. Griffith.[7] There are some who still think he is the greatest of all directors.

It is some indication of Chaplin's unique type of celebrity that at some point or other he met, and in several cases became close friends with, many of the leading figures in this book: Einstein and Eisenstein, Stravinsky and Schoenberg, H. G. Wells and John Maynard Keynes (Chaplin fancied himself as a bit of an economist), Gertrude Stein and Winston Churchill, Picasso and Aragon, Claude McKay and Gandhi, Aldous Huxley and Sinclair Lewis, Nijinsky and Diaghilev, Valentino, Bertolt Brecht and Eugene O'Neill (who became his father-in-law).

1922 was to be a turning point in Chaplin's career. He was chafing against the requirements of his contract with First National, and keen to make his first film for United Artists. He also wanted to make his first serious film, and by the end of the year had already begun it: *A Woman of Paris*. So he negotiated with First National, who eventually agreed to let him go once he had delivered the short *Pay Day* and a longer comedy, *The Pilgrim*.[8]

Barely more than a week after the release of *Pay Day*, Chaplin began to shoot his final First National production, *The Pilgrim*. For this swansong, he would be neither Tramp nor Little Man. In the original script, he

6. That reputation was consolidated by the triumph of *The Kid* in 1921 – a box-office smash that also impressed all but the most sceptical viewers with its inventiveness and emotional range.

7. D. W. Griffith (1875–1948) is widely held to be the Father of American cinema; he is often credited with having created all the fundamental elements of cinematic 'grammar' – the medium shot, the close-up, the tracking shot, cross-cutting and so on. Whether or not he deserves such credit is a matter for pedants. The reality is that he was the first Hollywood director to make immensely popular films that broke away from the pseudo-theatrical productions of early cinema, and were instead composed of that mixture of shots and camera movements with which we are still familiar. Griffith's artistic reputation has suffered in recent decades because of the – undeniable and at times alarming – racism shown in some of his films, above all in *Birth of a Nation* (1915). His significance as an innovator, however, has never been seriously challenged.

8. *Pay Day* is standard Little Man fodder. Chaplin plays a downtrodden construction worker trapped between the rock of a terrifying boss (Mack Swain) and the hard place of a still more frightening wife (Phyllis Allen) armed with the traditional weapon of the Battleaxe Missus, a rolling pin.

was an escaped convict who steals clothes from a missionary and is then mistaken for a young preacher who has come to bring righteousness to the sinful frontier town of Heaven's Hinges. Innocent enough; but in the bitterly anti-Hollywood climate of the months following the Arbuckle scandal and the William Desmond Taylor murder (see 2 February), even gentle satire against the clergy was a risky path for film-makers. So Chaplin rewrote it, toning down the satirical elements. It was not enough. When the film was released, in February 1923, it was branded as an 'insult to the gospel' and churches demanded that it be withdrawn from distribution.

This wave of protests was not a disaster for Chaplin, and some of his greatest triumphs – *The Gold Rush, City Lights* – were still ahead of him. It was, though, the first clear sign that the audience which had doted unreservedly on him up to this point might not always be so adoring.

3 APRIL

MOSCOW

The 43-year-old Joseph Stalin was appointed General Secretary of the Communist Party. This was one of the most fateful moments of the Russian Revolution, and indeed of the twentieth century. It opened the path to Stalin's later role as supreme dictator.[9]

9. Officially born on 21 December 1879, but in fact a year earlier, on 6 December 1878, Stalin – originally Joseph Vissarionovich Djugashvili – had grown up in Gori, a small town on the river Kura in a remote district of Georgia. His father was an impoverished and usually drunken cobbler, given to thrashing both his small son – then known as 'Soso' – and his wife. Soso grew into an ugly, surly youth, his face ravaged by scars from an attack of smallpox, but he was obviously intelligent, and his pious mother hoped that he would one day become a priest.

Soso attended the local church school, and then, in 1894, won a scholarship to the seminary in Tiflis, capital city of Georgia. His time at the seminary, from which he was expelled in 1899, was his only stint of formal education. He became an atheist in his first year, studied Marx keenly, and joined the Russian Social Democratic Workers' Party, adopting the new nickname 'Koba', after the hero of a Georgian novel about outlaws of the Caucasus. He also took a post at the Tiflis Meteorological Institute – his only day job before becoming one of the rulers of Russia in 1917.

In 1902, he was arrested and sent into exile in Siberia, the first of seven such exiles. It was here that he encountered, and was enraptured by, the writings of Lenin. In 1905, he returned to Tiflis, and soon afterwards married his first wife, Ekaterina, who bore him a son, Yakov.

When the 1905 Revolution broke out, Koba – or so he claimed – organised a sequence of peasant revolts; when these failed, he turned to a traditionally Caucasian method of fund-raising: bank robberies. His wife died in 1907, leaving him genuinely distraught, though he abandoned his son to be looked after by her family, and soon took up with other women.

In 1912, the 'wonderful Georgian', as Lenin then called him, was re-cruited to the Central Committee of the Communist Party, and after the collapse of the Romanov monarchy in February 1917, he became an es-sential part of Lenin's entourage.[10] But Stalin already had long-term plans. He consolidated his reputation as a mass slaughterer by steaming into the city of Tsaritsyn on the lower Volga aboard an armoured train manned by 400 Red Guards. Anyone so much as suspected of counter-revolutionary sympathies was shot. He also arrested a group of Trotsky's men, put them on a barge on the Volga, and sank the barge. It was at this moment that he formulated one of his key political ideas: 'No man, no problem.' Or: when in doubt, kill.[11]

By 1920, the Revolution was still on the brink of collapse. Both the peasants and the workers resisted Lenin's forces with strikes and uprisings. The new governmental structures that Lenin hastily cobbled together in this period were designed as emergency measures to fend off disaster. He himself ran the country as Premier and Chairman of the Council of People's Commissars, and he orchestrated Stalin's appointment as Gen-eral Secretary, a post that came with extensive powers, including military authority. Lenin would very soon live to regret this move bitterly.

LONDON

Eliot wrote to the poet T. Sturge Moore – a close friend of W. B. Yeats, and brother of the famous philosopher George Moore – inviting him to submit work for the quarterly – 'I should like to start publication in June, but am not certain it will be possible until autumn . . .'

On the same day he wrote to Alfred Knopf, offering him the chance – under the terms of the contract he signed at the time of *Poems* – of publishing *The Waste Land*. Eliot explained that he had already been

10. In the bloody and terrifying months that followed the 1917 Revolution, the Bolsheviks were in a desperate state; Lenin was forced to cede much of the Ukraine and the Baltics to the Kaiser and then, after Germany's surrender, to British, French and Japanese forces. As the empire dwindled, Lenin was wounded in an assassination attempt; during his recovery, he declared Russia a military camp. The main weapon in the Bolshevik arsenal was the ruthless suppression of dissent, and Lenin's two most merciless warlords were Trotsky and Stalin. At this point it was Trotsky who was widely seen as the hero of the Revolution, and as Lenin's number two.

11. This off-handed murder of the men who were supposed to be his comrades was overstepping the mark even by Lenin's standards, so he recalled Stalin, who from this point on loathed Trotsky to the point of madness.

approached by Liveright, who had offered to publish the poem for $150 in the autumn, and that he was anxious to have the work in print as soon as possible. Knopf replied graciously on 1 May, saying that Eliot was free if he wished to proceed with the Liveright offer, and that he looked forward to seeing his next prose book with a view to publication.

5 APRIL

PARIS

Pound wrote to Wyndham Lewis: 'If there aren't 30 or 50 people interested in literature, there is no civilization and we may as well regard our work as a private luxury, having no aims but our own pleasure.'

7 APRIL

PARIS

'Le Corbusier' – a name adopted by the painter, writer and architect Charles-Edouard Jeanneret (1887–1965) in the October 1920 issue of his own magazine, *L'Esprit Nouveau* – wrote a part-boastful, part-thoughtful letter to his friend and ethical mentor William Ritter: 'A new incarnation seems to dawn for Le Corbusier: glowing prospects . . . In architecture, complete success: I am alone in my category . . . Succes d'esteem [*sic*] in the press and elsewhere, in Paris and abroad.'[12]

Succès d'estime perhaps. More concrete signs of success were relatively scanty, as his pensive afterthought tacitly admitted: 'At thirty-five, you are old enough to be given credit, but it is an age when you must produce.'[13]

12. A faint hint of megalomania: he had already taken to referring to himself in the third person.
13. Over the next 40 years, he would produce on a massive scale.

Among the dozens of major buildings and developments he created are the Villa Savoye (1928 – probably one of the three or four best-known houses of the twentieth century), the massive housing project Unite d'Habitation in Marscilles (1947–1952) and many large civic buildings in Chandigarh, India (1952–1959).

8 APRIL

LONDON

The anonymous author of a column, 'Diary of a Man About Town', in the *London Evening News,* noted the arrival in London of a book called *Ulysses*, 'which has nothing at all to do with Homer': 'The book itself in its blue paper cover looks at first glance like nothing so much as a telephone directory.' The tone of the piece was moderately welcoming, though, like other newspaper reviews, it lamented the obscenities: 'It seems a pity that Mr Joyce, who might be a universally admired writer, restricts the appeal of his work by so many Zolaesque expressions, which are, to say the least, disfiguring.'

LONDON

Lydia Lopokova (b. 1 October 1892), until very recent weeks a major star of the Ballets Russes, began a long-term correspondence with her new lover, the economist John Maynard Keynes (b. 5 June 1883), who had just left England to attend the Genoa economic conference as a special correspondent for the *Manchester Guardian*. He was 38; she 29.

The couple had first met in the autumn or winter of 1918, possibly as early as 10 October at the Sitwells' house, but certainly by the end of December, when Lydia wrote Maynard a polite two-line note thanking him for a book. They probably did not meet again until, at the earliest, May 1921.[14] Maynard was not initially struck either by her talent or her charms, and unchivalrously remarked to a friend 'She is a rotten dancer – she has such a stiff bottom.'

In April 1921, Lydia danced for Diaghilev in the *Firebird*, *Petrushka* and *Les Sylphides* in Paris. In May 1921, the company transferred to London, where she took additional roles in *Parade*, *Prince Igor* and *La Boutique Fantastique*. London became crazed for ballet, the shows were a smash hit, and Lydia – 'the popular Lopokova' – was the hottest star in town. Emboldened by this success, Diaghilev decided to mount a lavish

14. Her life in the intervening three years had been turbulent: she left the man she had always believed to be her husband (Randolfo Baraocchi; his marriage to Lydia was illegal because he had not waited for the decree absolute in his divorce from his first wife), quit Diaghilev's company and suffered some kind of mental breakdown. Lydia and Maynard were eventually to marry three years later, on 4 August 1925, as soon as it became legally possible.

production of *The Sleeping Princess*, with Lydia alternating with Nijinska in the role of the Lilac Fairy, and occasionally taking over the primary role of Princess Aurora.

The Sleeping Princess went well at first, but audiences soon began to dwindle. Maynard, by now smitten with his dancer, would show up at the theatre day after day to watch, conspicuously, from the emptying stalls. The production eventually folded on 4 February 1922, sodden with debts; Diaghilev fled in panic to Paris, leaving most of his artists stranded in London. But by this time – probably around the New Year – Lydia and Maynard had become lovers. Their affair thus began just as her career ended; she never again had a major role or long-term contract.

As the editors of their correspondence have noted, the year 1922 was a turning point in the lives of both Lydia and Maynard. Each in their own way, the lovers were searching for security as well as passion. Lydia was no doubt the more wretched of the two – a refugee, a divorcee from an unhappy marriage, and facing possible destitution. Maynard, though already cutting an impressive figure on the world stage, was lonely and discontented. Since the end of his affair with Duncan Grant in 1908, he had indulged in a series of short-lived gay encounters. Most of his Bloomsbury friends strongly disapproved of his romance with Lydia, but he resolutely ignored them.

Even at this early stage of their passionate relationship, Maynard had installed Lydia in rooms at 50 Gordon Square, where Vanessa Bell and others were living; Keynes was living at number 46 when not resident at King's College, Cambridge. Lydia's great days with Diaghilev might have been over, but she was now dancing for Massine in a number of trifling pieces at Covent Garden, of which the most distinguished was Stravinsky's *Ragtime*.

Lydia wrote to Maynard almost every day of the Genoa conference, reporting on the small events of her new London life and reacting to his articles in the *Manchester Guardian*. Her English, though rich in vocabulary, was still rather quaint:

> I lead simple working man's life, and you – do you go in the evenings to dissipated houses?

> Your expressions in the end give me nice tremblings.

Last night I had such a laughter I thought I could not finish from it – Massine while dancing lost halph of his shirt, collar, hat, when I saw that I immediately thought to have a decidedly funny disaster is to lose his trousers.

I place melodious strokes all over you. Maynard, you are very nice.[15]

Convinced that Keynes's genius was more than up to the task of solving the world's ills, she urged him to stay at the conference as long as possible. Keynes was more pessimistic, and, having fulfilled his agreement to cover the proceedings for three weeks, came back to England at the end of the month.

10 APRIL

CHINA

The beginning of hostilities in the Zhili–Fengtian war for control of Peking (Beijing). This was one of many conflicts between rival military factions in the so-called Warlord Era of the early Chinese Republic, which ran from 1916 to 1928. This short war ended on 18 June 1928 with the surrender of the Fengtian army, and the fall of its leader Zhang Zoulin.

ITALY

The key economic event of the year, the Genoa conference, was held in the Grand Hall of the Palazzo San Giorgio; delegates from 34 nations convened to debate and negotiate the terms of the world economy in the wake of the Great War.

Ernest Hemingway was present as a reporter, and filed many articles – some only a paragraph long, others running to a few pages – between 10 April ('Canada's Recognition of Russia') and 13 May ('Lloyd George's Magic'). He began in vivid style: 'Genoa is crowded, a modern Babel with a corps of perspiring interpreters trying to bring the representatives of forty [sic] different countries together. The narrow streets flow with crowds

15. Unable to pronounce the final consonant, she called him Maynar.

kept orderly by thousands of Italian troops . . .' The reason for the troops, he explained in a later story, was fear that the presence of a Soviet delegation would provoke both communist and anti-communist riots.[16]

It was during this conference that Hemingway mastered the art of telegraphese – crushing as much information as possible into the smallest number of words. Lincoln Steffens, a fellow journalist, reported seeing Hemingway gazing at a recent dispatch and marvelling at his own news skill: 'no fat, no adjectives, no adverbs – nothing but blood and bones and muscle. It's great. It's a new language.' After his experience at Genoa, Steffens believed, Hemingway's style was changed for good.

LONDON

By 10 April, Vivien was back in London from one of her frequent rest cures. She was exhausted by the journey, which had been made in crowded trains, and she was running a temperature of 100 degrees.

16 APRIL

ITALY

The world learned that the Weimar Republic officially recognised the new Russian regime in the Treaty of Rapallo.[17] Foreign Minister Walter Rathenau oversaw the proceedings. The effect was dramatic. On the 18th, Hemingway described the alarm and dismay with which the Italians regarded this treaty, signed by both Rathenau and the Soviet envoy Tchitcherin. The French were equally perturbed, and Britain, in the person of Lloyd George, said ominously that it could only be regarded as the first step towards a Soviet–German alliance. The Genoa conference was on the brink of being dissolved, as France threatened immediate withdrawal, demanding that Lloyd George should call upon Russia and Germany to renounce the treaty.

16. It was a well-founded anxiety. For two years now, Italy – particularly Tuscany and the north – had been blighted by clashes, bloody and at times fatal, between communist and fascist militants. The sizeable pro-Red population of Genoa, estimated at about one third of the total, would unquestionably be cheered and excited by the presence of the Soviets; Hemingway sardonically notes how left-wing fervour increases in direct proportion to the quantities of good red Chianti that have been consumed. But he is equally mordant when it comes to describing the mindless, self-righteous belligerence and brutality of the young fascisti in their black fezzes.

17. Ezra Pound would soon be taking up long-term residence in the small town.

The first full day of the conference, Hemingway reported, had been marked by a passionate outburst from the head of the French delegation, M. Barthou, who insisted that France would not so much as begin to discuss the issue of disarmament; Tchitcherin then stood up and insisted that the issue was central to proceedings. The French appeared to be on the point of walking out in protest when Lloyd George managed to soothe wounded pride on both sides. Hemingway concluded his reports for the month with pessimistic assessments of the performances by both the Russians and the Germans.

Overseas, the treaty was greeted with reactions that ranged from misgiving to outright horror. But while some Western nations had doubts about the prospect of a German–Soviet alliance, elements of the German right believed that certain diplomats were secretly planning for Germany to come under Bolshevik rule – a suspicion that would soon prove fatal for Rathenau.

LONDON
Eliot wrote to the scholar and diplomat Sydney Waterlow (1878–1944), who was on the editorial board of *The International Journal of Ethics,* and commissioned Eliot to write occasional reviews: 'It hardly seems to me worthwhile to say anything about *Ulysses* for six months at least – until all the imbeciles who like and dislike it all for insincere reasons have tired themselves.'

Four days later, in a letter to the novelist and patron of the arts and major supporter of Proust Sydney Schiff, (1868–1944; see 2 May) he declared that he was 'about ready to chuck up literature altogether and retire; I don't see why I should go on forever fighting a rearguard action against time, fatigue and illness and complete lack or recognition of these three facts . . .'

KOREA
On the next stage of his Far Eastern trip, the Prince of Wales visited the Japanese paramilitary youth group Seinendan in Japanese-occupied Korea.

PARIS
Man Ray wrote to his friend Ferdinand Howald about his latest experiments in photography:

You may regret to hear it, but I have finally freed myself of the
sticky medium of paint, and am working directly with light itself.
I have found a new way of recording it. The subjects were never
so near to life itself as in my new work.

He was referring to his recent invention, the 'Rayograph', which he had
been developing throughout the winter of 1921–2. Tristan Tzara had been
the first person to whom he had shown these innovative works, and
was thrilled by what he saw. He praised them extravagantly in a number
of prose poems, as, soon, did the proto-surrealist Robert Desnos. (See
28 November.)

20 APRIL

CAMBRIDGE

Still shocked by the violent death of his father[18] Vladimir Nabokov re-
turned to Cambridge for his final term. Ever since the family had been
driven into exile, he had found the coming of spring almost unbearably
poignant, since it was the time of year when he would have set off for the
Nabokov manor and estate at Vyra, near St Petersburg, just as the lilacs
came into bloom. This spring, he was almost insane with sadness, and
sought refuge in working hard for his finals, studying intensely for 15 or
16 hours a day, and allowing himself few diversions.

Even so, the sunny Cambridge spring had its own consolations of
natural beauty, and he would sometimes allow himself the luxury of read-
ing his lecture notes not in his room, but in a punt or boat moored under
the willows on the Cam. And there was a new source of literary pleasure:
one day, his fellow émigré Peter Mrosovsky ran into his room carrying a
copy of *Ulysses*, fresh from Paris. Mrosovsky began to pace up and down,
joyously reading out passages, especially from Molly Bloom's soliloquy.[19]

18. Vladimir Dmitrievich Nabokov (1870–1922) was assassinated on 28 March at a Constitutional
Democratic Party conference in Berlin. He was shot twice whilst wrestling a gunman to the
ground. The initial target of this far-right Russian activist gunman, liberal politician Pavel Mi-
liukov, escaped unscathed.
19. Many years later, lecturing on *Ulysses* to his students at Cornell, Nabokov said of this section:
'The style is a sustained stream of consciousness running through Molly's lurid, vulgar, and hectic
mind, the mind of a rather hysterical woman, with commonplace ideas, more or less morbidly

22 APRIL

LONDON

John Middleton Murry published his review of *Ulysses* in *The Nation and Atheneum*. He began by taking scornful issue with Valéry Larbaud's declaration that 'With this book, Ireland makes a sensational re-entrance into high European literature': 'European! He [Joyce] is the man with the bomb who would blow what remains of Europe into the sky.' In Murry's view, Joyce's position is essentially that of an anarchist, and the main target for his campaign is inhibition:

> *Ulysses* is, fundamentally (though it is much else besides), an immense, a prodigious self-laceration, the tearing-away from himself, by a half-demented man of genius, of inhibitions and limitations which have grown to be flesh of his flesh.

Confessing that after a fortnight of struggling with the text he was still to some degree baffled by it, Murry none the less conceded that the novel was a masterpiece of some kind: 'This transcendental buffoonery, this sudden uprush of the *vis comica* into a world wherein the tragic incompatibility of the practical and the instinctive is embodied, is a very great achievement.'

LONDON

At approximately 2.30 p.m., the aspiring young playwright Martin Bateson – son of the great Cambridge biologist William Bateson[20] – stepped out into the traffic on Piccadilly Circus, just between the statue commonly known as 'Eros' and Regent Street; a taxi swerved to avoid him. With a theatrical flourish, he pulled a white glove from his right hand, reached into his pocket, took out a .25 calibre automatic pistol, put its barrel behind his right ear and pulled the trigger.

He was rushed to Charing Cross Hospital, but died an hour later with-

sensual, with a rich strain of music in her and with the quite abnormal capacity of reviewing her whole life in an uninterrupted inner verbal flow. A person whose thought tumbles on with such impetus and consistency is not a normal person.'

20. Who, among his other accomplishments, coined the word 'genetics' for the field of science in which he was a pioneer.

out regaining consciousness. He had been four months short of his twenty-third birthday. The yellow press was thrilled. The *Weekly Dispatch* said that this was 'probably the most dramatic and deliberate suicide ever witnessed in London'. The *Daily Mirror* used the dead man's portrait as a poster for its next edition.

What was behind this suicide? Private symbolism, for one thing: Martin staged his death on the exact anniversary of his older brother John's birth, 22 April 1898, at 2.30 p.m.; John, who had been awarded the Military Cross for heroism in battle, had been killed by shelling in the last days of the war. As a passionate admirer of William Blake, he would also have been alive to the significance of embracing death before the statue of Eros – not least since the immediate cause of his suicidal misery was rejection by the woman he loved, Grace Wilson, an unsophisticated 19-year-old actress. But there were other forces joining to deepen his despair.

Martin had followed his father into the sciences, and had done well enough, winning first-class honours in the first part of his Tripos at Cambridge. But he yearned to be a playwright, and had left Cambridge early to join the Royal Academy of Dramatic Art, where he had met Grace Wilson. His father disapproved of this for several reasons, though not from any lack of respect for the arts; on the contrary, he thought that literature, art and music were higher callings, open only to those possessed by creative demons, while any averagely intelligent person might be a scientist. Martin should not be so presumptuous, he believed.

But Martin persisted in following his dream, with various dismal consequences. When he showed his – largely autobiographical – second play to his mother and younger brother, they were horrified at the bitterness with which he had portrayed his father. And when he was foolhardy enough to show it to his muse, Grace, she returned it to him angrily, saying that he obviously cared for her only as a source of creative capital.[21]

21. The full consequences of this sad tale are too complex to unravel; but it seems clear that the loss of two older brothers told deeply on Gregory Bateson, who in the autumn of 1922 himself went up to St John's College, Cambridge, to begin a scientific career of almost unequalled variety, encompassing zoology, anthropology, psychology (he was the originator of the so-called 'double-bind' theory of schizophrenia, usually attributed to R. D. Laing) and cybernetics.

23 APRIL

NEW YORK

Ofrandes became the first of Edgard Varèse's compositions to receive its premiere in New York City.[22] The conductor was Carlos Salzedo; Nina Koshetz was the soloist. The performance was received with relative indifference by the press.

AUSTRIA

Wittgenstein sent the Cambridge linguist, philosopher, bookseller, publisher and polymath C. K. Ogden (1899–1957) a detailed list of comments and suggestions on Frank Ramsay's translation of the *Tractatus Logico-Philosophicus*, which Ogden was editing.[23]

PARIS

Pound wrote to Scofield Thayer on 23 April, rehearsing his usual themes about Eliot, who 'is again ill, I hear', and discussing the matter of Eliot's fee for *The Waste Land*.

GORKI, RUSSIA

A German doctor, Dr Burkhardt, operated on Lenin to remove one of the two bullets which had been lodged in his neck ever since an assassination attempt in 1918. At the time, Lenin's doctors had been unwilling to remove the bullet in case this should cause further bleeding and endanger his life.

The Soviet press had made light of this failed assassination, but it had been a serious threat to the leader. Burkhardt's diagnosis was that Lenin's terrible headaches were being caused by lead poisoning from the embedded shells. Lenin's own doctor was sceptical, but in the end agreed to the removal of a single bullet. The operation was performed under a local anaesthetic, and Lenin remained calm and stoical throughout. Afterwards he said that he would have performed the operation differently: 'I

22. Today, Varèse (1883–1965) is regarded as one of the most influential avant-garde composers of the early twentieth century; his admirers and followers include Stockhausen, Bouklez, Messiaen, Penderecki and the rock musician Frank Zappa.

23. Ogden's most famous book, *The Meaning of Meaning*, which he wrote in collaboration with another Cambridge intellectual, I. A. Richards, was published in 1923.

would have pinched the flesh and cut. The bullet would have jumped out. All the rest is merely decoration.' This drew a gallows laugh from the doctors, who understood that Lenin was referring to his own expertise as a 'surgeon' of societies.

The operation was a success, but 1922 continued to be a very bad year for Lenin's health. In May he suffered a major stroke, the first of three before his death (on 21 January 1924), and in December, a second stroke left him partly paralysed on his right side. From this point on he played no further part in practical politics; but he continued to write, or more exactly to dictate, some important documents, above all the famous *Testament*, which he began to compose in December 1922.

25 APRIL

PARIS
George Moore was in conversation with a friend at the Restaurant Voltaire:

> Take this Irishman Joyce, a sort of Zola gone to seed. Someone recently sent me a copy of *Ulysses*. I was told I must read it, but how can one plow through such stuff? I read a little here and there, but, oh my God! How bored I got! Probably Joyce thinks that because he prints all the dirty little words he is a great novelist. You know, of course, he got his ideas from Dujardin? What do you think of *Ulysses*? . . .

Before his friend could reply, Moore steamed ahead:

> Joyce, Joyce, why he's nobody – from the Dublin docks: no family, no breeding. Someone else once sent me his *Portrait of the Artist as a Young Man*, a book entirely without style or distinction; why, I did the same thing, but much better in *The Confessions of a Young Man*. Why attempt the same thing unless you can turn out a better book? . . .
>
> *Ulysses* is hopeless, it is absurd to imagine that any good end can be served by trying to record every single thought and

sensation of any human being. That's not art, that's attempting to copy the London Directory. Do you know Joyce? He lives here in Paris, I understand. How does he manage to make a living? His books don't sell. Maybe he has money? You don't know? I'm curious. Ask someone that question.

26 APRIL

LONDON

Eliot wrote to Ottoline Morrell, telling her that both he and Vivien had been suffering from incessant illness since a week before Easter. They desperately needed some rest, and though Eliot could not take any more leave from the bank for the time being, he was considering the possibility of staying in Brighton, from where he could easily commute into the city by early trains.

27 APRIL

BERLIN

The widely publicised, long-awaited premiere of Fritz Lang's *Dr Mabuse, der Spieler* was held at the Ufa-Palast-am-Zoo. In fact, since the film's running time was some four and a half hours, only part one – *Der grosse Spieler – Ein Bild der Zeit* – was shown to the first-night audience. Part two – *Inferno, ein Spiel von Menschen unserer Zeit* – was held over until the following evening.[24] The audience knew they were in for something special, though; the film had spawned excited rumours about spiralling costs, unprecedentedly thrilling special effects and Lang's almost fanatical perfectionism, which had driven his poor cast and crew to fantasies of murder.[25]

24. With Murnau's *Nosferatu*, and perhaps Weiner's *Caligari*, the two-parter was eventually to become regarded as one of a small number of permanent cinematic masterpieces produced by the German cinema during the Weimar period.

25. Born into a Catholic/Jewish family in Vienna, Lang had entered the film industry shortly after serving in the Austrian army. He started work as a writer, mainly for the Decla company, but was soon snapped up by other companies; his debut as a director was *Halbblut* (*The Half-Breed*), for Decla-Bioskop in 1919. Seven more films for various production companies followed in rapid succession. His commercial breakthrough came with the first movie of a two-parter entitled *Die Spin-*

Dr Mabuse, der Spieler was Lang's largest, most lavish production to date. He began filming it towards the end of 1921 in the Neubabelsberg studio. It was based on a recent novel by Norbert Jacques, a former journalist, and told the lurid tale of a crime lord whose hypnotic powers made him almost demonic. Stalking the upper levels of society like a feral creature, Mabuse seduces the rich into wild betting sprees that leave them hopelessly in debt to him; he steals state secrets, and manipulates the stock market. The only person who seems able to take on this menace is a police inspector, von Wenk, who shares with Mabuse a dangerous weakness: they are both smitten by the beautiful Countess Told. Their battles result in all manner of mayhem: car chases, explosions, machine-gun shoot-outs and ghastly murders. But it is much more than a straightforward gangster film.

Like the novel, Lang's film takes place in a milieu of studied decadence and vague occultism: drug addiction and sex clubs, seances and gambling halls, all against a background of inflation. Thus far, then, an unillusioned 'picture of the times', as the subtitle explained. There were more mystic dimensions, too: Lang, who had been interested in 'mind control' since boyhood, played up all the more uncanny aspects of the Mabuse character, making the villain less an Al Capone than a dark magus.

nen (*The Spiders*): *Der Goldene See* (*The Golden Lake*). This was a fast-moving romp featuring an Indiana Jones–style hero and his sworn enemies, the Spiders, a murky troupe of villains given to leaving tarantulas at the scenes of their murders by way of calling cards.

Der Goldene See proved such a success with audiences that Lang was rushed away from another film he would otherwise have directed: *Das Kabinett des Dr Caligari* (*The Cabinet of Dr Caligari*), no less. Soon he had completed his sequel, *Das Brillantenschiff* (*The Diamond Ship*). It was another hit, and Lang was already being talked about in awed terms as one of Germany's leading directors. He completed his lightning ascent to the top ranks with his most ambitious film to date, 1921's *Der müde Tod* (*Weary Death*, aka *Destiny*) – a sort of cross between a fairy tale and an allegory.

Der müde Tod was co-written by Lang's wife-to-be, the actress Thea von Harbou, whom he had met in 1920 when she was still married to one of Lang's leading actors, Rudolf Klein-Rogge. Soon they became lovers, and Thea co-wrote all his films from 1921 to 1931: these included productions that are now considered among the highest points of Weimar cinema, if not world cinema: *Die Nibelungen* (1924), *Metropolis* (1927), and his haunting portrait of a child-killer stalked by police and underworld alike, *M* (1931).

Their union came at a dreadful price. When Lang's first wife, Lisa, discovered the pair embracing, she went upstairs and shot herself between the breasts with Lang's army pistol. Or did she? For the rest of his life, Lang was dogged by the rumour that he had murdered her, that the studio had arranged a cover-up, and that he had spent a short period in a mental hospital so as to escape prosecution. There was no inquest, and no one has turned up any police records of the incident, but critics have not been slow to note that Lang's subsequent films are crammed with suicides, accidental deaths, and false accusations of murder.

Even so, it may well have been the career of Al Capone that inspired the enormous shoot-out with which the film ends. Von Wenk's armed men lay siege to Mabuse's hideout and a tremendous shooting match follows. Countess Told is rescued, but Mabuse manages to escape through a trapdoor and down into a tunnel of sewage, finally emerging into a room full of old men manufacturing counterfeit banknotes for him. The old men encircle their former slave-master, and close in on him; Mabuse's mind gives way, and he has visions of monsters. By the time the police catch him, he is quite mad; and they lead him off to an asylum.

The first-night audiences were enthralled not only by the film's action scenes and spectacular set pieces, but by its pervasive tone of unease, and its intimations of a society rotten almost beyond redemption. The critics raved, agreeing vigorously that Lang had indeed painted a true picture of the age.[26]

NEW YORK

First publication, by Liveright, of *The Enormous Room* by E. E. Cummings – or, as he would later style himself, e e cummings.[27] F. Scott Fitzgerald said of the book, 'of all the works by young men who have sprung up since 1920, one book survives – *The Enormous Room* by E. E. Cummings . . . Those few who cause books to live have not been able to endure the thought of its mortality.' It was Cummings' first book, though he had already published a number of poems, and like many first books

26. The practice of calling *Mabuse* 'prophetic' began just a couple of months after the film's release, when Walther Rathenau was assassinated (see 24 June) in the street by right-wing thugs – an atrocity that, as people said, might have been lifted directly from its frames. Thanks to the work of film historians of the Weimar period, especially Siegfried Kracauer and Lotte Eisner, it is now commonplace to say that the film as a whole is an augury of the rise of Hitler.

Another aspect of the film that also grows more obvious with the years is Lang's close identification with his master villain. Though Lang would describe the character of Mabuse in many ways, many of his lines are almost embarrassingly close to Lang's personal philosophy: 'Nothing is interesting in the long run – except one thing. Playing with human beings and human fates.' Indeed.

Lang's own eventual fate was to flee the Nazis and build a new career in Hollywood. His wife was much more keen on Hitler, and joined the Party. (See 26 August.)

27. Like many young writers of his generation – he was born in 1894 – Edward Estlin Cummings had enjoyed a tranquil childhood and adolescence until the coming of war. His father taught sociology and political science at Harvard, and later became a Unitarian minister; Edward followed him to Harvard, taking his BA in 1915 and his MA in 1916. His friends there included John Dos Passos and Scofield Thayer – the poet and, later, editor of *The Dial*. In 1917, Cummings and Dos Passos decided to enter the European war as ambulance drivers, and they both enlisted in the Norton-Harjes Ambulance Corps. Thanks to bureaucratic incompetence, Cummings found himself at a loose end in Paris for several weeks; he explored the city and became fascinated by it.

it was largely autobiographical – based on three and a half months of imprisonment in the Dépôt de Triage at La Ferté-Macé, in Normandy.[28]

After his imprisonment, Cummings returned to the United States on New Year's Day 1918. Gaunt and grimly silent much of the time, he found the atmosphere suffocating, but realised that he needed food and rest. His father suggested that he should write up his notes on his French experiences – the germ of *The Enormous Room* – and promised a $1,000 Liberty Bond by way of payment. By late February, Edward had escaped to New York, where he launched himself enthusiastically into regulation bohemian life, painting and exhibiting, writing poems, drinking . . . and falling in love. The woman in question was Elaine Orr.[29]

Cummings's bohemian idyll lasted only until the summer of 1918, when he was drafted into the army – the 12th Division. He hated the experience of service life, the idiocies of his fellow soldiers, the institutionalised sadism and racism, but it could have been a lot worse: he was never sent on active service, and spent most of 1918 at Camp Devens, Massachusetts.[30]

Freed from military service on 17 January 1919, he went back to New York and picked up his life of delicious freedom. His new paintings were well received, and he sold quite a few – reliable customers included his father and Thayer. Inspired by Elaine, he composed a large quantity of erotic verse; less happily, he wrote a rather half-baked essay on Eliot, in which his admiration for Eliot's work was so infelicitously expressed that it came out sounding like condemnation. He never again reviewed a book.

28. Cummings's letters home had been intercepted by the French military and been found insufficiently pro-war, so he and a friend were imprisoned on charges of espionage on 21 September 1917. After a number of futile pleas for his son's freedom, Cummings's father finally made a direct approach to President Wilson. He was released on 19 December 1917.

29. Unfortunately, she was the wife of his friend – and, increasingly, patron – Scofield Thayer. It was a curious affair, and though Cummings does not cut a very impressive figure in this strange liaison, it was Elaine who initiated matters. She and Thayer kept separate apartments; she was lonely, and Thayer had lost all interest in sex with her. He seems to have begun indulging a penchant for adolescent boys. Far from trying to prevent the affair, he thanked Cummings for spending so much time with his lonely spouse, and gave him odd sums of money for their dates. She eventually bore Cummings his only child, Nancy, on 20 December 1919; and after divorcing Thayer, married him in 1924. (It would be short-lived. She soon ran away with a rich Irishman.)

30. Military life gave him an unexpected amount of reading time: he devoured Eliot's poems and both *Portrait of the Artist* and *Dubliners* while at Camp Devens, and he also discovered the extracts from *Ulysses* that had been appearing in *The Little Review*. It seems that he wrote an essay on Joyce for *The Dial*, but it was turned down and has never been discovered. What has been found is a fragment listing his heroes of the new age: these included Pound, Brancusi, Eliot, Matisse, Schoenberg, the Ballets Russes . . . 'To this list of genuine phenomena the months have latterly added James Joyce (*Ulysses*).'

Finally determining to knuckle down to the 'French Notes', he went with his parents to Silver Lake, New Hampshire, in July 1920. Here he adopted a spartan regime – he lived in a tent, reached by canoe – and kept steady working hours. By mid-September, he was able to present his father with four completed chapters (his father thought them the work of a 'great writer'), and by 18 October 1920, the whole book was done bar revisions. It was sent out to publishers in January 1921. The first responses, however, were all negative.

Back in New York, Cummings picked up his old friendship with John Dos Passos, and on 15 March 1921, the two writers left New York for Portugal on board the *Mormugao*. Unimpressed by Portugal, they quickly went on to Spain, and then, on 10 May, crossed over into France. From Saint-Jean-de-Luz they went straight to Paris, where, within hours of arrival, Cummings heard that an American publisher – Liveright – had finally expressed an interest in publishing his book.[31]

On 26 August 1921, Liveright wrote to Cummings's mother to confirm the agreement; the book, however, still lacked a title. Cummings dithered and dithered: among the titles he toyed with were *Hospitality, Lost and Found, Held on Suspicion, Unwilling Guest* and *Caught in the French Net*. It was not until 25 November 1921 that he cabled his father: 'Title of Book: *The Enormous Room*'.[32]

The initial reviews in the mainstream press were all either dismissive or hostile, concentrating almost entirely on what they understood to be the anarchist or Bolshevik politics of the work, at a time when there was a major 'Red Scare' in progress. It was not until the summer, when various literary magazines had their say, that the book's formal qualities were duly identified and praised by the likes of Gilbert Seldes, John Peale Bishop and Cummings's loyal pal Dos Passos. The most pleasing response, if also the most terse, came from Ernest Hemingway: 'It is one of the great books.'

31. After a few pleasant weeks of re-exploring Paris, the friends separated for a while, and Dos Passos set off for the Middle East. In mid June 1921, Elaine arrived to join Cummings; and a month or so later, on 28 July 1921, a French court declared her marriage to Thayer void. Thayer did not contest the divorce, and gave Elaine a generous settlement; he would continue to give Cummings money from time to time, especially for baby Nancy's medical bills.

32. The exuberance of first-time authorship went sour when Cummings finally received his author's copies of the book in early May, and saw that it was littered with misprints, that key passages had been silently cut, and that only one of the drawings he had supplied had been used. On 13 May 1922, he wrote a letter to his parents ranting about all of these insults and silent acts of censorship, and demanding that they be made good in a new edition at once. Since he had declined to return to the USA to oversee the proofs himself, this was both a well-founded and an unfair complaint.

29 APRIL

LONDON

The magazine *Outlook* published a long review, 'James Joyce's *Ulysses*', by Arnold Bennett. Though Bennett had some words of high praise for both author and novel – he singled out the 'Nighttown' episode ('the richest stuff, handled with a virtuosity to match the quality of the material'), and Molly Bloom's soliloquy ('I have never read anything to surpass it, and I doubt if I have ever read anything to equal it') – the bulk of the review was hostile, accusing Joyce of dullness, misanthropy, poor artistry and, of course, obscenity.

> He apparently thinks that there is something truly artistic and high minded in playing the lout to the innocent and defenceless reader.

> . . . he has made novel reading into a fair imitation of penal servitude.

> Many persons could not continue reading *Ulysses*; they would be obliged, by mere shock, to drop it.

And so on. Bennett was an influential reviewer, and this notice must have damned the book for many of his readers.

30 APRIL

NEW YORK

Inspired by the recent success of a visiting revue, *Chauve-Souris* (*The Bat*), the wits of the Algonquin Round Table decided to stage their own effort, for one night only. They rented the 49th Street Theater on a Sunday night, and, drawing on their various talents, put on an impromptu musical: *No Sirree!* Dorothy Parker wrote the lyrics for a song, 'The Everlastin' Ingenue Blues', sung by Robert Sherwood,[33] who was backed by a chorus line of actresses both famous and obscure, including Tallulah Bankhead, Helen

33. Robert Emmet Sherwood (1896–1955): American playwright, editor, screenwriter and early member of the Algonquin Round Table.

Hayes and Mary Brandon, whom Sherwood married later that year. Other illustrious names, all friends of the Algonquin set, lent their support: Irving Berlin conducted the orchestra, Jascha Heifetz played violin accompaniments from offstage and Deems Taylor – the composer and journalist, often known as 'the dean of American music' – wrote the tunes. Afterwards, the whole gang went back to the apartment of their friends Herbert and Maggie Swopes for a wild party that lasted until four in the morning.

Though the reviewer for *The New York Times* dismissed the show as 'amateurish' and silly, the audience seemed to enjoy most of it. *No Sirree!* included a wicked parody of Eugene O'Neill's *The Hairy Ape*, and a skit by Robert Benchley – probably best remembered in the twenty-first century for his comic 'instructional' films – that changed the course of his career. Too busy to write his contribution in advance, Benchley devised a sketch in the taxi to the performance. He was to play an undistinguished treasurer suddenly called on to deliver the company's annual report when the usual man falls ill. Almost inarticulate to start with, the man grows increasingly eloquent as the sheer poetry of his subject dawns on him.

Irving Berlin thought 'The Treasurer's Report' hilarious, and, with his business partner Sam Harris, proposed to Benchley that he perform it again, regularly, in their upcoming show *The Music Box Revue*. Benchley was disconcerted: he hadn't so much as written the piece down yet, and he had never appeared in public before. He was also worried that appearing in a show might seriously compromise his integrity as a drama critic. Hoping to put them off, he named what he considered a ludicrously high fee: $500 a week. Harris pondered. 'Well,' he said, 'for five hundred dollars you'd better be awfully good.' This was the beginning of Benchley's wholly unforeseen career as a hugely popular comic performer on stage and screen.

MAY

2 MAY

PARIS

Proust's *Sodome et Gomorrhe II* went on sale in French bookshops. It was a vast and immediate success, and cemented Proust's fame. From now until his death towards the end of the year – and for years after – he became the number one topic of fashionable conversation in Paris. Newspapers hinted excitedly at an imminent Nobel Prize.[1] The pleasure of being confirmed in fame was sweetened by the arrival in Paris, just a few days earlier, of his wealthy English friends Violet and Sydney Schiff. Unfortunately, the accident-prone novelist managed to sabotage the happy reunion.

Proust had recently adopted the practice of taking doses of adrenalin in place of his usual caffeine, to wake himself up from the drowsy states brought on by another of his pet drugs, veronal. To prepare himself for the arrival of his friends, he recklessly took an undiluted dose. The fluid tore into his throat and stomach like acid; he screamed with pain for three hours, and for several weeks after could hardly bear to consume anything but chilled beer and ice cream, brought to him from the Ritz every morning and evening. Some nights after their arrival, he invited the Schiffs to meet his sister-in-law Marthe and his 18-year-old niece Suzy at 44 Rue Hamelin. Proust doted on Suzy, and she adored him. He admitted to the Schiffs that he was terribly anxious about the possibility that Suzy might be tempted to read *Sodome et Gomorrhe*, adding, 'and my next book will be even more terrible for an innocent young girl!'

MOSCOW

Sergei Aleksandrovich Esenin (b. 1895), a well-regarded young Soviet poet from a peasant background, married the dancer Isadora Duncan. He had

1. In fact, the Nobel laureate for literature that year was the Spanish dramatist Jacinto Benavente y Martínez.

met her in November 1921 at the Moscow studio of a mutual friend; though she was 18 years his senior, he seems to have been immediately smitten. On 10 May they set off for a combined honeymoon and dance tour; torn away from his familiar activities, and already drinking heavily, Esenin suffered a nervous breakdown. By the time they reached New York on 1 October, he was a drunken wreck; the marriage was obviously doomed, and he returned to Moscow on his own in 1923.[2] Increasingly unstable, he eventually hanged himself in 1925.

May 1922 was also the month in which an even more prominent Soviet poet, Vladimir Mayakovsky, was allowed out of Russia for the first time, and paid a visit to the Latvian capital, Riga. Mayakovsky, too, eventually took his own life.

CANADA

The *Toronto Daily Star* carried an article by Ernest Hemingway with the headline: 'A Hot Bath an Adventure in Genoa':

> Lloyd George says that conferences are cheaper and better than war, but, as far as I know, Lloyd George has never been blown up by an exploding Italian bathroom. I just have been. That is one of the numerous differences between us . . .

Hemingway's comic article on the experience made great play of the ludicrous discussion he had with the hotel manager shortly after the big bang – Hemingway himself still so winded from the explosion that he could hardly whisper, the manager full of suave if illogical assurances that his guest was in fact a lucky man, a very lucky man, for, after all, was he not still alive?[3]

One eyewitness, probably exaggerating, said that the explosion was so powerful that it blew Hemingway all the way down the hall. Hemingway said only that he was blown against a heavy wooden door; he was painfully but not seriously injured. Despite the fresh wounds, he went on reporting

2. Esenin, clearly an optimist when it came to weddings, had been married twice before he met Isadora, and would go on to marry twice more; his fifth and final wife was Sofia Tolstoya, the granddaughter of Count Leo.

3. It was later explained that a janitor had forgotten to take a cork out of the *siccura*, the safety valve on the water heater in the bathroom.

industriously, writing at length of the intense concentration of the Russians, who would huddle together over documents and figures until four in the morning while all other delegates to the conference were long since in bed.

With a combination of initiative and virile charm, Hemingway had somehow managed to wangle a press pass to the Russian delegation in the Hotel Santa Margherita – one of only 11 such passes issued to the 700 press men. No wonder he considered it one of his most prized trophies. He had already concluded that while he hated the things the Russians did and represented, he was forced into grudging admiration for these men – most of whom had been obscure exiles or prisoners just four years earlier; an admiration that deepened the more he saw just how tirelessly they worked.

His final dispatch from the conference, published on 13 May, was an admiring portrait of Britain's man in Genoa, titled 'Lloyd George's Magic'. He begins with scathing assessments of the appearance of the other national representatives. But when he comes to Lloyd George, Hemingway all but gushes about his charm, his kind and twinkling eyes, his boyish complexion and flowing hair. He signs off the flattering profile with a small emblem: a sketch of Lloyd George by a young Italian boy, which the statesman had indulgently signed for the child.

> I looked at the sketch. It wasn't bad. But it wasn't Lloyd George. The only thing that was alive in it was the sprawled-out signature, gallant, healthy, swashbuckling, careless and masterful, done in a moment and done for all time, it stood out among the dead lines of the sketch – it was Lloyd George.

4 MAY

AUSTRALIA

The *Orsova* arrived in Fremantle. Lawrence's initial plan was to travel to Perth to stay with their ship-board friend Anna Jenkins (see 26 February) for a while, before heading on to Sydney and, if Sydney did not meet their needs, further still until he found somewhere that suited him (and, presumably, Frieda). Their first stop was at a guest house some 16 miles east

of Perth, in Darlington, run by a former nurse and would-be novelist, Mollie Skinner.[4]

Anna Jenkins, who had arranged this accommodation for them, would show up in her car and drive them out into the wilderness for picnics – Lawrence's first glimpse of the outback. He felt spiritually refreshed by the sense – or fantasy – that no human had ever made the smallest mark on this virgin soil, or so much as drawn a breath here. Frieda was less charmed. Where Lawrence suffered from chronic wanderlust, she was more of a nester, and now ached for some semblance of stability and domestic order. At her insistence, they left Darlington in search of a house to rent, somewhere close to Sydney. Between 18 and 27 May, they travelled roughly 2,500 miles around the coast of Australia on the *Malwa*.

It did not take long for them to discover that Sydney was shockingly expensive – far beyond their modest means, since they were now down to their last $50. They made a simple plan: they jumped on the first available train out of Sydney and resolved to travel until they found somewhere that looked both cheap and agreeable. This proved to be Thirroul, at that time a small, run-down town about 40 miles south of the city. Two hours after climbing off the train, they had found a furnished house built on a low cliff overlooking the ocean. It was called Wyewurk – 'Why Work?' – and the rent was a very modest seven dollars a week. One reason for the cheapness soon became all too apparent. Besides being filthy, the place was overrun with rats.

Lawrence and Frieda scrubbed and polished and killed furiously for a couple of days, until the place was decent enough. Then they settled back into the kind of domestic routine they had known in Sicily. The local produce was good, plentiful and extremely cheap; the climate, even in this southern winter, was pleasantly cool at night and warm by day; they could sunbathe in privacy, beach-comb, dress up their house prettily with shells and jetsam. Once again they could reasonably feel that they had found an earthly paradise.

4. Lawrence helped her to rewrite her debut fiction, *The Boy in the Bush*, and later arranged for it to be published in both the UK and the USA. This was his first contribution to the literature of Australia.

ITALY

Pound visited Venice in the early part of the month; he was there by 4 May. His most important publications of the month both appeared in *The Dial*. One was his 'Paris Letter', a triumphant salute to *Ulysses*: 'All men should "Unite to give praise to Ulysses"; those who will not, may content themselves with a place in the lower intellectual orders . . .' The other was his 'Eighth Canto'.[5] Pound's contributions were in illustrious company: other contributors to this issue of *The Dial* included Picasso, Yeats and D. H. Lawrence.

5 MAY

NEW YORK

Construction began on Yankee Stadium, in the Bronx.

LONDON

Aleister Crowley and Leah arrived in London in the first week of May, and found rooms at 31 Wellington Square. Urgently in need of money, Crowley hawked around several articles, with quick success: *The English Review* took five, publishing them under several pseudonyms: 'Percy Bysshe Shelley' by 'Prometheus'; 'The Jewish Problem Re-Stated' by 'a Gentile'; 'The Drug Panic' by 'a London Physician'.[6] He tried to sell his autobiography to the publisher Grant Richards, who turned it down; he also declined Crowley's proposal for a novel about the drug trade. Crowley took the proposal on to a better-known publisher, Collins, who bought *The Diary of a Drug Fiend* for an advance of £60. Thus far, Crowley had self-published all his many writings; now he could take pride in being a professional author.

He began dictating the novel to Leah on 4 June. Little more than three weeks later, it was complete.

5. This was later revised and reprinted with revisions as Canto II in *A Draft of XVI Cantos* (1925, Paris: Three Mountains Press).
6. Crowley irritated the journal's editor by constant wrangling about fees, so this connection was short-lived.

7 MAY

LONDON

E. M. Forster wrote in his diary that he was plodding ahead with his Indian novel (*A Passage to India*), adapting it in the light of his new-found passion for Proust. He had bought a copy of *Du Côté de Chez Swann* in Marseilles during the last stage of his journey back to England, and had been so excited by it that he felt obliged to modify his approach to writing fiction – though he suspected that the changes he was making suffered from excessive cautiousness, and lacked the inspiration that Proust brought to his great work.

8 MAY

PETROGRAD

Anna Akhmatova (1889–1966) wrote her bitter poem 'Prophecy', a coded tribute to her husband Gumilyov, who had been executed by the Cheka on 25 August the previous year, on trumped-up charges of being involved in a pro-monarchist attempt at a coup. 'Prophecy' was included in her major collection, *Anno Domini MCMXXI*, published later in the year.[7] In 1922, Akhmatova was perhaps the most popular contemporary poet in Russia, her sales rivalled only by those of Alexander Blok, who had also died, bitterly disillusioned by what had become of the Revolution, the previous year.[8]

7. She and her fellow citizens of Petrograd had endured dreadful privations in the years since 1917 – famine, brutal winters, police brutality and killings; it was not possible for her to address those agonies directly, so she resorted to *'tanopis'* – 'secret language' – a kind of indirect, cryptic style that had been known in Russian literature since Pushkin, and was now helping a new generation of writers to express themselves without immediate danger of imprisonment or death.

8. Akhmatova is now regarded as one of the greatest Russian poets of her generation, and indeed of all Russian literature. Thanks to her courageous refusal to do the easy thing and escape to the West, as some of her colleagues chose to do, she has also been revered as one of those who helped keep humane Russian values alive under Stalin's terror. She enjoyed early fame and popularity, but from 1925 onwards was the victim of an unofficial ban on publishing her verses; this brought about the period she called the 'Vegetarian Years', when she lived on a near-starvation diet and survived mainly on the fees from translations of foreign classics. Her work was derided by Stalinist critics, and her son Lev was imprisoned, largely on the grounds of being the son of a hysterical, bourgeois poetess and a suspected monarchist sympathiser. She had several affairs, and a list of her alleged or known poet lovers is quite impressive: Osip Mandelstam (whose wife forgave her), Boris Pasternak,

9 MAY

OXFORD

T. E. Lawrence finished writing the third and final draft of *Seven Pillars of Wisdom*.[9] The following day, 10 May, he burned the manuscript of the rejected second version. He donated the text of the third draft to the Bodleian Library.

10 MAY

LONDON

Dr Ivy Williams became the first British woman to be called to the Bar.

11 MAY

LONDON

The Marconi Company began broadcasting from station 2LO – a name soon to become famous[10] – based in Marconi House, on the Strand. Listening to its transmissions must have been a frustrating experience, since early broadcasting regulations demanded that it had to close down for three minutes after every ten minutes of broadcasting, so that its engineers could listen to their own wavelength and find out whether there were any protests about their signal blocking or interfering with other signals. Things went smoothly enough for the station to be granted a licence to play music.

CORNWALL

Bertrand Russell wrote to Ottoline Morrell telling her of the holiday delights he and his family were enjoying. He had recently bought an ugly

Alexander Blok, Boris Anrep . . . While visiting Paris, she also had an affair with the painter Modigliani, and sat for some 20 portraits by him. The most famous portrait of Anna as a young artist is by Kuzma Petrov-Vodkin, and also dates from 1922.

9. It was this draft that he had printed up by the *Oxford Times* in the limited run of eight copies which is now known (and has recently itself been published) as the 'Oxford' Edition of the book.

10. When the British Broadcasting Company was formed in November 1922, it was this studio and its equipment that was used for the first BBC programmes.

but well-sited former boarding house in Porthcurno, near Penzance.[11] Yielding to an untypical sense of delight in the natural world about him, Russell also relaxed the strict behaviourist-inspired regime he had imposed for John Conrad, and learned simply to play with his son in the fields and by the sea. Not surprisingly, John's early sickliness vanished almost at once, and he became a robust and healthy infant. The summer proved warm and idyllic – years later, Russell said that in his memory ('which, of course, is fallacious'), it was always sunny that year. The family feasted on local cream, sunbathed, swam and hiked, and before long looked a picture of fitness and contentment.

13 MAY

CALIFORNIA

Rudolf Valentino,[12] one of the most famous actors in the world, and the undisputed 'Great Lover' of the screen, married the actress Natascha Rambova, the stepdaughter of a cosmetics tycoon. The nuptials sparked a predictable frenzy among his besotted fans; a frenzy that waxed all the more intense when, eight days later, Valentino was arrested in Los Angeles on a charge of bigamy and thrown into prison.

Valentino's alleged bigamy was in fact something of a legal technicality. He had been granted a divorce from his first wife, Jean Acker, four months earlier, in January 1922. Under the terms of the settlement, he was bound to pay her $12,000 – not an insignificant sum, since, despite his

11. Originally called Sunny Bank, it had been renamed Carn Voel by its fastidious new owners.
12. Valentino was born to a middle-class family in Castellaneta, near the 'heel' of southern Italy, on 6 May 1895. His full baptismal name is almost comically unwieldy: Rudolfo Alfonzo Raffaello Piero Filiberto (or: Pierre Filibert) Guglielmi di Valentina d'Antonguolla. His father, Giovanni Guglielmi, was an ex-cavalry officer turned vet; his mother the daughter of a French surgeon. Signor Guglielmi died when Rudolf was still a boy, and his widowed mother doted on him. Undisciplined and spoiled, he did poorly at school, except in dancing and gymnastics, and in foreign languages: his colleagues often commented on the speed and facility with which he could master new languages and accents.

After some aimless years, the young man followed the example of many ambitious Italians, and went to seek his fortune in the United States. He crossed the Atlantic on the SS *Cleveland* in December 1913, and spent the next couple of years in menial jobs. He became mixed up in a messy divorce suit, and served a few days in prison on some kind of vice charge, almost certainly trumped up. Realising that New York was a risky place to stay, he made his way, via a touring operetta company, to California. He played many bit parts before his big break.

triumphs at the box office, and a weekly salary that had recently rocketed to some $1,250, he was heavily in debt to lawyers and other creditors. He had also failed to note that under Californian law, it was a crime to remarry less than one full year after being divorced.

Jail was a terrible experience for Valentino. He was rapidly bailed out by his friends – but not, he was quick and angry to note, by his employer and artistic patron, the producer Jesse Lasky. The bigamy charge was thrown out by the court in early June, on the grounds that there was no evidence of cohabitation with Miss Rambova.[13] It was an ambiguous victory for Valentino, however, since it added fuel to the rumours that the great ladies' man of the moving pictures might not, in real life, be all that interested in the fairer sex – gossip that would follow him to his early grave and beyond.

Male antipathy to Valentino's persona was every bit as powerful as female adulation, and was one reason for his sudden rise to notoriety. Before his appearance in Rex Ingrams's *The Four Horsemen of the Apocalypse*[14] just the previous year (it premiered on 6 March 1921), he was all but unknown, little more than an extra; the film that made him into a legend, George Melford's *The Sheik*,[15] had premiered on 30 October 1921.

13. The couple set up separate homes for the next few months, and then remarried, this time legally, on 14 March 1923.

14. Critics have agreed that Valentino's entrance in *Four Horsemen* is one of the most dramatic in cinema history. One moment, an empty screen; the next, a big close-up on Julio/Valentino's face, a cigarillo in his mouth, smoke hissing from his nostrils. Julio is a gaucho; he cuts in on a dancing couple, strikes the man to the ground with his stock whip, grabs the girl and leads her into an intoxicating tango. At the end, he presses his lips down on hers mercilessly . . . Audiences went nuts. There was no question in the industry that Valentino had scored a hit, but would he prove to be a one-hit wonder? His next three films – *Uncharted Seas*, *Camille* and *The Conquering Power* (all 1921) – suggested that he might not have much staying power. It was around this time that the great French director Abel Gance visited Hollywood, and reported finding Valentino despondent, and begging to be taken back to work in the European cinema.

15. Adapted from a bodice-ripping novel by Ethel M. Hull, this was the daft but titillating story of an aristocratic woman, Lady Diana Mayo, abducted by a 'barbarian', Sheik Ahmed Ben Hassan.

'Why have you brought me here?' she demands.

'Are you not woman enough to know?' he replies.

Soft porn, in short; but salvaged for respectability at the eleventh hour by the revelation that Ahmed Ben Hassan is actually just a sun-tanned Scotsman, the Earl of Glencarryl, who had been abandoned in the desert as a baby. Not merely a white man, then, but an aristocrat to boot. The ladies swooned.

Boosted by a lively publicity campaign – 'Shriek – For The Sheik Will Seek You Too!' ran the slogan, deftly combining an erotic come-on with a pronunciation tip – and by Valentino's off-screen scandals, *The Sheik* was more than just a box-office hit. It launched a craze. Newspapers were now

15 MAY

LONDON
The Times published Kipling's major poem 'The King's Pilgrimage'.

> *Our King went forth on pilgrimage*
> *His prayers and vows to pay*
> *To them that saved our heritage*
> *And cast their own away . . .*

Kipling, who had lost his only son in the war, was a member of the Imperial War Graves Commission, and its main literary adviser; he composed many of the inscriptions on the monuments put up in France and Belgium after 1918. As his poem states, George V went on an extended tour of these memorials in May 1922, both as a public act of mourning and in the hope of encouraging others to make such journeys of remembrance.[16]

17 MAY

NEW YORK
Marcel Duchamp wrote to Alfred Stieglitz:

> Dear Stieglitz.
> Even a few words I don't feel like writing.
> You know exactly what I think of photography.
> I would like to see it make people despise painting until something else will make photography unbearable –
> There we are.
>
> > Affectionately
> > Marcel Duchamp

crammed with orientalist kitsch, Tin Pan Alley produced a popular silly song called 'The Sheik of Araby' and Hollywood scrambled to cash in with copycat productions: *Arabian Love, Arab, Song of Love* . . . Valentino was now, and for ever, the unrivalled Great Lover.

16. Most readers found the poem very moving, and when it was republished later in the year as part of a book of the same name, including photographs and a prose text by the Australian writer Frank Fox, it became a best-seller.

This short declaration was in response to a questionnaire entitled 'Can a photograph have the significance of art?', which was circulated by Stieglitz; the replies were published in the December 1922 issue of the journal *MSS*.

MADRID

A young French visiting student at the School of Advanced Spanish Studies (later the Casa Velásquez) attended his first bullfight. His name was Georges Bataille, and he had recently graduated from the École des Chartes in Paris as a palaeographic archivist; his mission in Spain for the year 1922 was to examine a number of medieval French manuscripts held in Madrid, Seville, Toledo and elsewhere. He had arrived in Madrid some time in February.[17]

What he witnessed in the ring that afternoon changed his life. The matador, Manolo Granero – he was barely 20 years old – was fatally wounded, in a spectacular manner. 'Granero was thrown back by the bull and wedged against the balustrade; the horns struck the balustrade three times at full speed; at the third blow, one horn plunged into the right eye and through the head': thus Bataille's account in *Story of the Eye*, in the chapter entitled 'Granero's Eye'. In Bataille's novel, the matador's gouged eye is associated with Bataille's childhood terror at the sight of his blind father, whose eyes were blank; and also with eggs, with bulls' testicles, with urination . . .

On this occasion, though, rather than being frightened or disgusted, Bataille found himself gripped by a profoundly exciting combination of horror and pleasure:

> From that day on I never went to a bullfight without a sense of anguish straining my nerves intensely. This anguish did not in the least diminish my desire to go to the bullring. On the contrary, it exacerbated it, taking shape with a feverish impatience. I then began to understand that unease is often the secret of the greatest pleasures.

17. In later years Bataille would become one of the major presences in Continental thought: a philosopher of an all but unclassifiable kind; a novelist, creator of, among other works, the notorious *Story of the Eye* and *The Blue of Noon*; founder of the influential review *Critique* – which introduced the early writings of Barthes, Blanchot, Derrida and Foucault to a non-specialist audience – and hero of the counter-culture. But in 1922 he was still a pious Catholic, and unknown.

Bataille's letters from Madrid also touch on a number of inspirations and affinities. To one correspondent he confided: 'Curiously enough, I have started to write a novel, more or less in the style of Marcel Proust.'[18]

KENT
Eliot wrote to Ottoline Morrell from the Castle Hotel, Tunbridge Wells, where he and Vivien were staying in the hope of improving her health slightly. He told her that his father-in-law had invited him for a two-week holiday in Italy: 'I think this visit to Italy will just save me from another breakdown, which I felt was impending.' In the event, he travelled not to Italy, but to Lugano, in Switzerland.

IRELAND
Yeats, still at Thoor Ballylee, wrote to a friend:

> The whole situation in Ireland interests me. We have here popular leaders representing a minority but a considerable one, who mock at an appeal to the vote and may for a time be able to prevent it. One saw the same thing in Russia when the communists dissolved the constituent assembly.
> . . . I read *Ulysses* and Trollope's Barchester novels alternately.

18 MAY

PARIS
The public premiere of Igor Stravinsky's short burlesque ballet *Le Renard* at the Paris Opera, performed by Diaghilev's company, choreographed by Bronislava Nijinska and directed by Ernest Ansermet.[19] Stravinsky had

18. As his biographer Michel Surya points out, this means that Proust must have been the first 'modern' author Bataille had read – that is, before Dostoevsky, Nietzsche, Gide or the Surrealists . . . though, quite unknown to him, the techniques for altering his consciousness that he was trying to develop were remarkably similar to those which René Crevel and other proto-surrealists were also playing with in 1922. (See 13 and 14 June.)
19. It had originally been commissioned by Princesse Edmond de Polignac in 1916, for performance in her salon; Stravinsky had completed the commission in time, but it proved impractical to stage in such a small area.

settled in Paris in 1920,[20] and the city had been host to all his major ballets to date: it was here that *Le Sacre du Printemps* had its literally riotous premiere in 1913.

In May 1922, Stravinsky was almost 40 – thus just a few months younger than Joyce – and, though derided by a few dissenters, had already been acknowledged by many critics as the greatest living composer.[21]

With *Le Renard*, performed as part of a multiple bill including works by Schumann and Tchaikovsky, Stravinsky managed once again to disconcert Parisian audiences, who thought they had the measure of his new style with *Pulcinella* and *Le Chant du Rossignol*. They had never heard anything like this raucous, almost wild music, which took the form of a band of medieval Russian strolling players staging a folk tale. The animal costumes were by the painter Michel Laryonov; there was a 15-piece band, four male singers and four mimes; Nijinsky's sister Bronislava ('Bronya') played the fox in an exaggerated, clown-like style and the whole thing was a mad frolic. Brilliant, yes, undoubtedly brilliant; but baffling, too. Some parts of the audience applauded bravely; others were quiet.

20. Shortly after his arrival in Paris, he began a passionate relationship with 'Coco' Chanel – the details remain hazy, but it seems to have begun some time around the rehearsals for *Pulcinella*, and to have been over by about May 1921. The likelihood is that he kept the affair a secret from his family by mainly seeing Coco at her apartment in the Ritz.

Chanel appears to have heard Stravinsky working on the score for a revised production of the *Sacre*, to be re-choreographed by Massine, since she turned up at Diaghilev's hotel one day and, without explanation, handed him a cheque for an extremely handsome sum that bailed him out of his latest financial crisis. The restaging was a triumph; 'all Paris' loved it. Meanwhile, Coco had moved on to another lover – one of the men who had killed Rasputin.

21. Born in Oranienbaum in 1882, and raised in St Petersburg, he had been directed by his family towards a career in law. After the death of his father in 1902, he drifted more and more towards music, and took occasional private tuition from Rimsky-Korsakov until 1908. He married his first wife Katerina on 23 January 1906, and they remained married until her death in 1939, despite his long-term affair with Vera de Bosset, who was to be his second wife.

In 1909, his first substantial composition, *Feux d'Artifice*, had its premiere in St Petersburg. Diaghilev was present, and was sufficiently impressed to commission Stravinsky to provide some orchestrations for the Ballets Russes, and then his breakthrough work *L'Oiseau de Feu/The Firebird*, which was staged in Paris in 1910. Stravinsky left Russia the same year, and, apart from a brief research trip for *Les Noces* in July 1914, he did not return there for half a century. He moved to Switzerland – first to Lausanne, where he composed *Petrushka*, and then Clarens, where he wrote *Le Sacre du Printemps/The Rite of Spring*.

In Paris, he formed a business relationship with the pianola manufacturer Pleyel, who provided him with a study in the upper floor of his factory, where he seemed to be able to compose quite fluently in spite of the racket coming from below.

After the performance of *Le Renard*, there was a celebratory feast in Stravinsky's honour.

PARIS

This was the night of the legendary modernist supper party at the Majestic.[22] Diaghilev acted as master of ceremonies, but the hosts were Proust's friends Violet and Sydney Schiff; about 40 guests were invited, including – as Virginia Woolf's brother-in-law, the art critic Clive Bell, reported – 'the four living men he [Sydney Schiff] most admired: Picasso, Stravinsky, Joyce and Proust'. Most were formally dressed, though Picasso wore a Catalan *faixa* wound around his head. The company finally sat down to supper after midnight.

Joyce blundered into the gathering at around the time coffee was being served. He was shabbily dressed, and seemed bewildered and – it was widely and correctly assumed – more than a little the worse for drink. According to Bell: 'He seemed far from well . . . Certainly he was in no mood for supper. But a chair was set for him on our host's right, and there he remained speechless with his head in his hands and a glass of champagne in front of him.' Joyce seldom needed an excuse to punish the white wine, but on this occasion it seems that he had been embarrassed by not owning proper evening dress, and had been in serious need of some Dutch courage.

The next latecomer was a very different character. 'At half-past two in the morning up popped Proust, white gloves and all, for all the world as if he had seen a light in a friend's window and had just come up on the chance of finding him awake. Physically he did not please me, being altogether too sleek and dank and plastered; his eyes were glorious however.' Joyce recalled that Proust entered still wearing his fur coat and looking 'like the hero of *The Sorrows of Satan*'.

Proust was given a place between Mr Schiff and Stravinsky. The conversation did not go well. In the course of trying to pay the composer an elaborate compliment, Proust made the mistake of enthusing about Beethoven. His enthusiasm was sincere, and founded in a genuine knowledge of Beethoven, especially the later works. But Stravinsky, well aware

22. A fine hotel on the Avenue Kleber which in 1919 had been home to the British delegation at the Versailles Conference.

that Beethoven was very much the name to drop in fashionable Paris, was annoyed, and replied grumpily.

Proust: 'Doubtless you admire Beethoven?'
Stravinsky: 'I detest Beethoven' [Not true.]
Proust: 'But, *cher maître*, surely those late sonatas and quartets . . . ?'
Stravinsky: 'Worse than all the others!'

Ansermet had to interrupt this awkward exchange, to prevent it from escalating into a full-blown row.[23]

At about this point, Joyce began to snore, and so helped Bell to leave a sticky situation. The lady seated next to him hinted that she would like to be escorted home, and Bell was happy to oblige. Once he had left, however, Joyce ceased to snore, and began talking to Proust. What exactly passed between them is uncertain, as different witnesses give different accounts. Most of them seem to agree, however, that this meeting between the two greatest novelists of the century was almost hilariously dull and pointless. In one version:

Proust: 'Do you like truffles?'
Joyce: 'Yes, I do.'

In another:

Proust: 'I have never read your works, Mr Joyce.'
Joyce: 'I have never read your works, Mr Proust.'

In another – Joyce's own, according to Frank Budgen:

Proust: 'Ah, Monsieur Joyce, you know the Princess . . .'
Joyce: 'No, Monsieur.'
Proust: 'Ah. You know the Countess . . .'
Joyce: 'No, Monsieur.'

23. It was a regrettable misunderstanding in several ways. Proust had been a loyal fan of both the Ballets Russes and Stravinsky; in his new novel, *Sodom et Gomorrhe*, he had written of Stravinsky's genius. And it was at the musical evenings of the Princesse Edmond de Polignac, Stravinsky's patron, that he had made the acquaintance of Beethoven's late sonatas and quartets.

Proust: 'Then you know Madame . . .'
Joyce: 'No, Monsieur.'

And so the versions multiply. According to one heard by William Carlos Williams, the two great men finally managed to hit it off rather well by talking about one thing they certainly had in common: their poor health. Joyce griped about his eyes and his headaches; Proust about his dreadful stomach aches. They parted on cordial terms.[24]

LONDON

Aldous Huxley – later identified by Cyril Connolly as one of the defining talents of the *annus mirabilis* – published *Mortal Coils*, a selection of short stories, including his most famous exercise in the genre, 'The Giaconda Smile'. Only six months had passed since the publication of his debut novel *Crome Yellow*.[25]

24. In yet another version of the tale, Schiff told one of his friends that when the dinner finally wound down, Proust invited the Schiffs back to his apartment on the Rue Hamelin. Odilon Albaret, husband of Céleste, was waiting outside ready to drive them home in a small car. Joyce invited himself along for the ride, and as soon as he had squeezed into the cramped interior, lit up a ciga-rette – unaware, no doubt, that the severely asthmatic Proust could bear neither smoke nor the fresh air from an open car window. When, after a very short journey – Proust's apartment was only about a minute away – they reached 44 Rue Hamelin, Joyce gave every sign of wanting to be invited up, but Proust insisted that the taxi carry on and take him home. He himself rushed inside, leaving Schiff to complete the argument. But he was in high spirits when Schiff rejoined him, and the three sat up past dawn, chatting and drinking champagne.

And Joyce? It seems that after Proust's death, Joyce would mourn their failure to manage a proper meeting. 'If only we'd been allowed to meet and have a talk somewhere . . .'
25. The novel's initial sales had been decent rather than spectacular – 2,500 copies in its first year, plummeting to a pitiful 86 the year after that. (Recall that Fitzgerald's debut novel, *This Side of Paradise*, had sold 45,000.) No matter: it had added substance to the rumour that Huxley was very much a coming man. Sales of a couple of thousand copies can be significant, if the right people are buying. And the reviewers thought it was dazzling.

Max Beerbohm, who sent the young author a charming letter of congratulations, was among those who recognised his exceptional promise. And it is a sign of Proust's remarkable awareness of reputations across the Channel that he could write, in *Sodome et Gomorrhe*, of a soirée at the Prin-cesse de Guermantes', where the narrator sees an illustrious English physician named Huxley: '*ce-lui dont le neveu occupe actuellement une place prépondérante dans le monde de la littérature anglaise . . .*' '*Actuellement*': this was very up-to-date gossip.

On the debit side, *Crome Yellow* had angered and wounded Lady Ottoline Morrell deeply – much to Aldous's genuine bewilderment. In his view, the novel – which depicts a summer house party that insiders could recognise immediately as a heightened version of Garsington and its habi-tuées – was a light-hearted frolic, a pastiche, an affectionate jape; more compliment than satire. The Garsington set had been quick to spot correspondences between the characters of *Crome Yellow* and their inspirations.

Huxley and his wife Maria were now living in a large two-storey flat near Paddington: 155 Westbourne Terrace – rather a gloomy place to start with, though they soon cheered it up with some lemon paint. Aldous was 28. The couple shared its echoing spaces with their small and often sickly son Matthew (b. 19 April 1920), countless black beetles and a mangy cat who feasted on them.

Their life was more comfortable here than in their previous lodgings, and though they were far from wealthy, they lived well – Aldous breakfasted every morning on porridge with fresh cream, and bacon and eggs – and they enjoyed entertaining. Their regular guests included all three Sitwells – Edith, Osbert and Sacheverell; Eliot's good friend Mary Hutchinson and her husband Jack; Mark Gertler, and others. Dinner would often be followed by trips to the cinema. On evenings when they were on their own, Aldous and Maria enjoyed dancing to records on the gramophone, especially foxtrots and tangos.

Huxley had recently accepted a pleasant day job, at a salary of £750 a year, with Condé Nast, which kept him busy enough composing articles, commissioning new writers – Norman Douglas, Lytton Strachey – and sometimes even drawing covers. For a little extra income, he would also review concerts for the *Westminster Gazette*. But he was allowed to keep fairly free office hours, and there was some spare time for his own work. Some, but not enough.

In the months that followed, he negotiated the terms of a contract with Chatto and Windus which would change his life. In return for writing two new works of fiction a year for the following four years, the publisher agreed to pay him a regular quarterly advance amounting to £500 per annum, thus setting him free from most of his journalistic chores.

Huxley tried to soothe the Morrells in a series of letters, but the grudge endured for years to come. Still, the more general effect of the book was to secure him the fame that he had mysteriously managed to enjoy long before he had done anything to earn it. Younger readers were thrilled by *Crome Yellow*, or deliciously shocked; older people played their conventional part by disapproving. Both sets of readers agreed, for good or ill, that Huxley's ruling quality was 'cynicism'. It peeved him so much that he took a smack at the word in 'The Giaconda Smile':

'Oh, you're cynical.'
 Mr Hutton always had a desire to say 'Bow-wow-wow' whenever that last word was spoken. It irritated him more than any other word in the language.

'Bow-wow-wow'? Because *cynic* is derived from the Greek word for 'dog'.

The contract came into effect on 8 January 1923. Huxley knew he could be productive – *Crome Yellow* had taken him about two months – so he felt sanguine about keeping his side of the contract.

Unfortunately, fate had other plans. He fell desperately in love with Nancy Cunard.[26]

20 MAY

NEW YORK

Carl Van Vechten wrote (from his apartment at 151 East 19th Street) to the English novelist Ronald Firbank:

> Dear gay genius,
> . . . To say that you are a sensation in New York is to speak modestly. All the world is reading you, quoting you, *buying you*, admiring you. You are almost a 'best seller'. One shop cannot keep you in stock at all. They are sold as fast as they come in. I think you are at least as famous in New York as Anatole France. Certainly more than [Max] Beerbohm. Mais, pour quoi pas? . . .

The Firbank minor sensation of 1922 was almost wholly due to Van Vechten's own efforts. He had published an article on Firbank in the *Double Dealer* (April 1922), and banged the drum for Firbank's novels among all his influential friends.[27]

26. An heiress to the Cunard shipping fortune, Nancy Cunard (1896–1965) is one of the most colourful and ubiquitous characters of the age. Though she published a number of her own books, mainly of poetry, she is usually remembered as a benefactor and muse of modernists. She was on good terms with Joyce, Hemingway, Brancusi, Man Ray and William Carlos Williams; she had affairs with not only Huxley but also Wyndham Lewis, Tristan Tzara, Ezra Pound and Louis Aragon. Stylish in an eccentric way, she was a great admirer of the music, art and writings of Africans and African-Americans, and was one of those who helped make *negritude* highly fashionable in 1920s Paris. In later years she became an indefatigable agitator against the rise of fascism.

27. One gratifying result of all these efforts was that by the autumn of 1923, the publisher Brentano's had signed up the American rights to Firbank's novels, beginning with his latest, *Sorrow in Sunlight*; Van Vechten suggested that *Prancing Nigger* would be a better title, and Firbank went along with this. (Van Vechten himself later wrote a novel with the title *Nigger Heaven*.) Grating as this may sound today, Van Vechten was anything but a racist: he was one of the most ardent and efficient white promoters of the Harlem Renaissance, and formed close friendships with many of its leading figures.

LONDON

Eliot wrote to his old friend Gilbert Seldes[28] at the *Dial* to confirm that he had received his review copy of *Ulysses* and, despite his chronic fatigue, hoped to be able to deliver his piece in a month or so. 'It is a big job,' he complained (or explained). He then set off for a fortnight's holiday in Lugano. On the 24th, he wrote again to Hermann Hesse – this time in German – inviting him to tea. 'It would be a great honour and pleasure if I could visit you and speak with the author of *Blick ins Chaos . . .*' Hesse obviously accepted the invitation, as Eliot sent him a warm postcard on the last day of the month, saying that their meeting had left him with agreeable memories.

At some point during his stay in Lugano, he crossed the Italian border to visit Pound, who was staying in Verona.

USA

The cover of the *Saturday Evening Post* was Norman Rockwell's painting *Old Couple Listening to Radio*. Later to be one of Rockwell's most famous images of small-town American life, the painting is some indication of how rapidly the radio had become an essential part of the daily routine of millions.

21 MAY

MOSCOW

The release of the first of Dziga Vertov's Kino-Pravda films; there would be 23 of them in all. (See 4 March.)

ILLINOIS

Bix Beiderbecke, just a couple of months past his nineteenth birthday, was expelled from his boarding school, Lake Forest Academy. Apart from a poor academic record, his main crime had been the habit of sneaking out from the school grounds at night and heading into Chicago, where he loved to watch 'hot' jazz being performed in the clubs and speakeasies. One of his favourite haunts was the Friar's Inn, where he not only enjoyed

28. Seldes later wrote an influential essay on Eliot in *The Nation* (see 6 December).

the sounds of the New Orleans Rhythm Kings but was sometimes allowed to sit in with them, playing the cornet in his idiosyncratic style.[29]

This disgrace was a terrible blow to his respectable, middle-class parents, who had hoped that the boarding school might straighten him out, but it was of the greatest importance to the history of jazz. As a dropout from conventional ways, Beiderbecke now threw himself wholeheartedly into jazz, and by the end of 1923 was playing professionally with the Wolverine Orchestra.[30]

NEW YORK

Eugene O'Neill won the Pulitzer Prize for *Anna Christie*, which had first been produced on 2 November 1921.[31] It was his second Pulitzer, and further confirmation of his astonishing rise from almost complete obscurity to the top rank of American playwrights – a status acknowledged both at home and overseas, where producers were eager to stage anything his agent would let them have.

In October 1922, the distinguished English man of the theatre William Archer wrote to an American relative that *Anna Christie* and *The First Man* were 'the best plays yet written in America', and that 'I am inclined to . . . call O'Neill the greatest dramatist now writing in the English language.'[32]

The Pulitzer was all the more welcome to O'Neill, as the spring of 1922 had been terrible for him: he had been devastated by his mother's

29. He had learned to play by copying records, so did not use the orthodox fingerings, and never would.

30. Jazz historians now consider Beiderbecke and his good friend Louis Armstrong (see 8 August) to be the two most influential soloists in the early years of the music – a claim in no way diminished by the fact that before 1924 or thereabouts there were not all that many soloists to be heard, for both Armstrong and Beiderbecke inspired generation after generation of players and composers. Beiderbecke went on to play with the 'King of Jazz', Paul Whiteman, but his alcoholism caused a number of physical and mental breakdowns. He died in 1931, aged just 28; as in the cases of Chatterton, Keats and James Dean, his early death became an essential part of his myth.

31. This year's Pulitzers also included the first award to a cartoonist: Rollin Kirby of the *New York World*, for his cartoon 'On the Road to Moscow'.

32. It had been a swift journey. His first full-length play, *Beyond the Horizon*, had been staged in 1918, and won O'Neill his first Pulitzer. Then came *The Straw* (written in 1919), *Gold* (1920), *Anna Christie* – a rewritten version of *Chris Christofferson* (1919, 1920), *The Emperor Jones* (1920), *Diff'rent* (1921), *The First Man* (1922) . . . and *The Hairy Ape*. Eight major plays in a little over three years. By the early months of 1923, productions of O'Neill's plays were either running or planned for London, Paris, Berlin, Stockholm, Moscow and Dublin; his name was already being ranked with those of Ibsen, Chekhov and Shaw.

death, and though audiences seemed to like *The Hairy Ape*, most of the critics had greeted it with tepid, uncomprehending reviews. Then, on 19 May, it had been made the subject of a claim by the New York Police Department that it was 'obscene, indecent and impure'. Hence O'Neill's jocular letter to a friend on 25 May:

> Yes, I seem to be becoming the Prize Pup of Playwriting – the Hot Dog of the Drama. When the Police Dept. isn't pinning the Obscenity Medal on my Hairy Ape chest, why, then it's Columbia adorning the brazen bosom of Anna with the Cross of Purity. I begin to feel that there is either something all wrong with me or something all right . . . 'It's a mad world, my masters!' . . .

O'Neill was starting to earn about $850 a week, and began to live up to this income: as well as his first dinner jackets, he also bought a large house in Connecticut – Brook Farm, on 31 acres of land, including woods, pastures and lawns. The house was traditional New England Colonial, with a library, a sun room, a 30-foot living room, four master bedrooms and servants' quarters. He paid $40,000 – a high price for the time, and one that guaranteed to keep him in financial difficulties for a long time to come, despite his considerable new income. To complete his image of himself as a country squire, he also bought an Irish wolfhound, which he called Finn.

SWITZERLAND

Rilke's patron Werner Reinhart bought and restored the Château de Muzot so that the poet could carry on living there rent-free.

PARIS

French prime minister Raymond Poincaré came across a magazine article denouncing the widespread use of English words by French sports journalists: or 'Franglais'. Deeply impressed by this attack on enemies of pure French, Poincaré banned the use of all recent English import-words in official documents.

Oddly, the author of the article was not of French birth, but a recent immigrant from South East Asia. At the time he was mainly known by his pen name, Nguyen Ai Quoc – 'Nguyen the Patriot'. He later became much better known as Ho Chi Minh.

23 MAY

HOLLYWOOD
Walt Disney incorporated his first production company, registering it as Laugh-O-Gram Films.

PARIS
Joyce consulted an eminent French ophthalmologist, Dr Victor Morax, about his increasingly painful iritis. According to Morax's notes, Joyce blamed his condition on an exceptionally riotous night at Pirano some time in 1910, when he had passed out on the ground and remained unconscious throughout the small hours.

Under Morax's treatment, Joyce's vision improved a little, but there was still blood in his eye and a threat of glaucoma. By the end of the month, the pain came back as agonisingly as ever, but Morax was too busy to attend his patient and sent a student, Dr Pierre Merigot de Treigny, in his place. When the young doctor entered the apartment at 9 Rue de l'Université, he was taken aback by its squalor.

'A strange fellow,' Morax remarked to his student. 'But' – using a quaint Americanism – 'a *big boss* just the same.'

26 MAY

LONDON
Wyndham Lewis had now finished reading *Ulysses* and was decidedly underwhelmed. He wrote to Schiff: 'After reading a definitely romantic book like *Ulysses*, you want to get out of this masturbatory, historico-political Irish fairy land as soon as possible . . .'

MOSCOW
Lenin suffered his first stroke.

LONDON
Winston Churchill spent three hours alone with President of the Irish Dáil Arthur Griffith, discussing the agreement between Michael Collins, Chairman of the Irish Provisional Government, and Eamon de Valera, signed just a few days earlier on 20 May, in which it had been determined

that de Valera's Republicans (who wished to destroy the Anglo-Irish Treaty of 6 December 1921 and renounce the Crown) would take 57 seats in an Irish parliament, while the pro-Treaty side, led by Griffith and Collins, would hold 64 seats. Churchill, alarmed by the possible implications of this, had immediately invited the Free State leaders to London for talks; when Collins hesitated, Churchill wrote to him directly: 'I feel it my duty most earnestly to urge you not to allow anything to stand in the way of what may easily be a meeting of far-reaching importance.'

Then came a terrible piece of bad timing. Sir James Craig appealed to London for troops to guard the Ulster border and to bring an end to the increasingly bloody terror campaign in Belfast, where murders were now happening at the rate of about seven or eight a day. The Cabinet agreed to grant Craig's request on the 23rd, and Churchill telegraphed the news before it was made public. In his elation, Craig made the ill-advised proclamation that Britain would henceforth support Ulster in all she did, and that the border would never be redrawn, no matter what the Boundaries Commission said. Churchill was furious, and told Craig so; hardly anything could have been more damaging to the prospects for negotiation with the Free State than Craig's announcement, which, said Churchill, 'seems to show you just as willing as Collins or de Valera to defy the Imperial Government if they take a course you do not like . . .'

In the event, Collins proved a good deal more conciliatory than Churchill and Lloyd George had feared. He arrived in London on the 27th, and joined in negotiations for three days. Churchill summed up the discussions for the benefit of Parliament on the 30th and 31st. In essence, he reported, Collins had agreed (a) to stand by the terms of the Treaty, and thus the British connection, and (b) to hold elections in June. Churchill and company were impressed by him, and agreed to support these elections as Collins had asked. In his speeches on the 31st, Churchill defended the Collins–de Valera compact as the most promising, or anyway the least disastrous way forward. If all went well, the Treaty would hold, Ireland would be formally linked to the Empire and the Crown, and the bloodshed would finally end. On the other hand, MPs were not to underestimate the dreadful gravity of Irish affairs. In southern Ireland:

> Banking and business are curtailed; industry and agriculture are languishing; revenue is only coming in with increasingly laggard steps; credit is drying up; railways are slowing down; stagnation

and impoverishment are overtaking the productive life of Ireland; the inexorable shadow of famine is already cast on some of its poorer districts.

Will the lesson be learned in time, and will the remedies be applied before it is too late? Or will Ireland, amid the stony indifference of the world – for that is what it would be – have to wander down those chasms which have already engulfed the great Russian people? This is the question which the next few months will answer.[33]

28 MAY

FRANCE

Raymond Radiguet wrote a polite letter to Cocteau's mother, saying that he would have written sooner but had been too preoccupied with his new novel *Le Bal du Comte d'Orgel*. He and Cocteau were now staying in the South of France, in Le Lavandre and the nearby village of Pramousquier. The summer and early autumn were times of intense productivity: Radiguet wrote almost all of his novel, while Cocteau composed a collection of poems, *Plain-Chant*, his adaptation of Sophocles's *Antigone* (which would be staged at the end of the year), and two short novels: *Le Grand Ecart* and *Thomas l'Imposteur*. This flowering of talent has been justly described as 'phenomenal'.

LONDON

Eliot, obviously much improved by his rest, wrote to Ottoline Morrell: 'I shd [*sic*] like six months of Italy and heat and sunshine, and have never felt quite so lazy and languid.'

NEW YORK

Joseph Collins reviewed *Ulysses* at length for *The New York Times* under the headline 'James Joyce's Amazing Chronicle'. Though he hedged his main

33. The Speaker of the House, John Henry Whitley, told a friend that it was the best speech he had ever heard. Austen Chamberlain agreed, and on 1 June he wrote to the King: 'It was a masterly performance – not merely a great personal and oratorical triumph, though it was both of these, but a great act of statesmanship.'

verdict around with all sorts of limiting judgements ('disgusting') and words
of caution, often archly phrased, his basic admiration was unambiguous:

> *Ulysses* is the most important contribution that has been made to
> fictional literature in the twentieth century. It will immortalize its
> author with the same certainty that Gargantua and Pantagruel
> immortalized Rabelais, and *The Brothers Karamazof* [sic] Dos-
> toyevsky. It is likely that no one writing English today could paral-
> lel Mr. Joyce's feat . . .

Collins was one of the first reviewers to dwell at some length on what he
saw as the affinities between Joyce and Freud.

- 'His literary output would seem to substantiate some of Freud's
 contentions . . .'
- 'He holds with Freud that the unconscious mind represents the
 real man . . .'
- 'I have learned more psychology and psychiatry from it than
 I did in ten years at the Neurological Institute. There are other
 angles at which *Ulysses* can be viewed profitably, but they are
 not many . . .'

In the same spirit, Collins was savage on the character of Leopold Bloom,
whom most modern readers tend to find likeable, characterising him as 'a
moral monster, a pervert and an invert, an apostate to his race and his re-
ligion, the simulacrum of a man who has neither cultural background nor
personal self-respect . . .' His review ends with a prophecy that *Ulysses* will
be written about in laudatory terms a hundred years in the future; but also
that not ten men or women out of a hundred will be able to read it all the
way through.

29 MAY

DÜSSELDORF

The opening of the Congress of International Progressive Artists, designed
to bring together a wide range of Communist, Socialist and generally

left-leaning creative souls. Conservatives were amused, and cynics unsurprised to note that bitter quarrels broke out almost immediately, and the whole event ended in chaos and farce.

30 MAY

WASHINGTON, DC
Dedication of the Lincoln Memorial.

JUNE

I JUNE

Pound's polemical article 'James Joyce et Pécuchet' appeared in the *Mercure de France*. One of his arguments, as the title suggests, is that Joyce's *Ulysses* should be seen as taking some of its cues from Flaubert's strange final novel *Bouvard et Pécuchet*, about a pair of retired clerks who set out to investigate the whole scope of human knowledge and accomplishment.[1] But his major proposition is that *Ulysses* represents the greatest technical advance in writing since the French author's death. He begins (note the passing reference to a 'new era', his 'Year One' of modernism): 'The Flaubert centenary year, first of a new era, also sees the publication of a new book by Joyce, *Ulysses*, which from certain points of view can be considered as the first work that, descending from Flaubert, continues the development of the Flaubertian art form from where he left it off in his last, unfinished work . . .'[2]

Flaubert was one of his regular touchstones of true literary seriousness. Though Pound could, and increasingly did, become an unconvincing advocate of his most passionately held views, this article is bracing and enlightening – and the first to make public at some length the deeper Homeric structure of the novel:

> What is James Joyce's *Ulysses*? This novel belongs to that large class of novels in sonata form, that is to say, in the form: theme, counter-theme, recapitulation, development, finale. And in the

1. He also notes that the book's brothel sequence may be understood as a reworking of Flaubert's *Tentation de Saint Antoine*, and finds some echoes of passages in *Madame Bovary*.
2. Pound was being a trifle slack about dates here: Flaubert was born on 12 December 1821. And a cynic might suspect that he was also playing to the French gallery by making this comparison. Not so: the terms of his argument are consistent with most of the things he had been saying about Joyce, and about modern writing in general, for some years.

sub-division: father and son novel. It follows in the great line of the *Odyssey*, and offers many points of more or less exact corre-spondence with the incidents of Homer's poem. We find there Telemachus, his father, the sirens, the Cyclops, under unexpected disguises, bizarre, argotic, veracious and gigantesque.

Novelists like to spend only three months, six months on a novel. Joyce spent fifteen years [*sic*] on his. And *Ulysses* is more condensed (732 pages) than any work whatsoever by Flaubert; more architecture is discovered.

Among the conclusions Pound reached was that '*Ulysses* is not a book ev-erybody is going to admire, any more than everybody admires *Bouvard et Pécuchet*, but it is a book that every serious writer needs to read, and that he, in our writer's profession, will be constrained to read in order to have a clear idea of the point of development of our art.'

Two other significant notices of *Ulysses* appeared in the course of this month: one a full-length review by Holbrook Jackson in *To-Day* maga-zine, the other an aside in John Eglington's 'Dublin Letter' for the June edition of *The Dial*. Though it took issue with Joyce for the 'chaos' of his novel, Jackson's piece was largely sympathetic and admiring, and opened with a robust denial of the book's alleged obscenity: 'It is not indecent. There is not a salacious line in it. It is simply naked: naked and uncon-scious of shame . . .' Jackson joined the ranks of those who linked Joyce and Freud: 'every action and reaction of [Bloom's] psychology is laid bare with Freudian nastiness . . .'; he was also among those who found Bloom repugnant: 'Is *Ulysses* a stone flung at humanity – is Bloom the Twentieth Century Yahoo?' After taking Joyce to task at some length for his failure to make himself intelligible at many points, Jackson finally returns on himself: '. . . if it will not amuse the idle novel reader, or even attract the lewd by its unsavoury franknesses, it must claim the attention of those who look upon fiction as something more than confectionery. With all its faults, it is the biggest event in the history of the English novel since *Jude*.

Eglington was far less sympathetic; in fact, mock-modest and con-descending: 'I am by no means sure, however, that I have understood Mr Joyce's method, which is sufficiently puzzling even where he related incidents in which I have myself taken a humble part.' He also affected compassion for Joyce's agonies of composition:

There is an effort and a strain in the composition of this book which makes one feel at times a concern for the author. But why should we half-kill ourselves to write masterpieces? There is a growing divergence between the literary ideals of our artists and the books which human beings want to read . . .

BOLOGNA

At the orders of Benito Mussolini, 15,000 young Fascisti – their average age was estimated at no more than about 19 or 20 – stormed through the streets of 'Red' Bologna, burning the telegraph and post offices, and beating up everyone who stood in their way. Having made this violent show of force, they then withdrew, saying that the next time they mounted such a demonstration they would be 50,000 strong, and they would kill their enemies instead of beating them.

BELFAST

The official formation of the Royal Ulster Constabulary,[3] out of the former Royal Irish Constabulary. It was set up in response to the horrific state of violence in the city, which by the summer of 1921 had become in effect a war zone of beatings, shootings, bombings and arson, usually begun by the IRA, but met with comparably intense violence by Loyalists in reprisals. The RUC's role was unique in British policing, in that it had the dual task of maintaining normal law and order while also clamping down on the activities of proscribed political groups. Its numbers were limited by statute to 3,000 men, and in principle 1,000 of these were to be recruited from the Catholic community, which amounted to roughly one third of the Northern Irish population. However, Catholics were slow to volunteer for what was already suspected of being a tacitly, if not openly, pro-Loyalist force.[4]

3. Over its eight decades of existence – it was formally merged into other bodies in 2001 – the RUC was both accused of brutal and partisan policing methods and praised for its professionalism. What is not disputed is that, from about 1925 until the late 1960s and the start of the Troubles, the region enjoyed not only peace but some of the lowest crime rates in the UK.
4. Catholic representation in the RUC never exceeded 20 per cent, and was more often significantly less.

2 JUNE

PARIS

Gertrude Stein wrote, from 27 Rue de Fleurus, to Carl Van Vechten in New York: 'I am awfully pleased with your book. You are indeed the most modern the least sentimental and the most gently persistent of romantics.' 'Your book' was *Peter Whiffle: His Life and Works*, an experimental novel by Van Vechten in which the author appears as a major character. It is almost certainly the earliest work of fiction to make a direct allusion to *Ulysses*.

3 JUNE

PARIS

Stravinsky's one-act opera *Mavra*[5] had its premiere at the Paris Opera House, conducted by Grzegorz Fitelberg. It was his major work of 1922, and he was very proud of it, once going so far as to say that it was the best thing he had ever done. As the audience drifted out, Francis Poulenc overheard a couple saying, 'Splendid! At last a work of Stravinsky's fit for our daughter's ears!' Other reactions ranged from disappointment to vehement dislike. Diaghilev[6] had wanted to impress the producer Otto Kahn,

5. Not surprisingly, *Mavra*'s reputation languished for many years after the premiere, though it has long since been revalued as one of Stravinsky's major works. An *opera buffa* of about 25 minutes' duration, with a Russian libretto by Boris Kochno closely based on Pushkin's verse yarn *The Little House in Kolomna*, it takes place in a small Russian town in the era of Charles X, and is the slight tale of a hussar who disguises himself as a woman to make his way into the house of his young lover. It opens with the young girl, Parasha, working at her embroidery; her neighbour, the handsome hussar Basil, appears at her window and they sing an amorous duet. Then Parasha's mother enters, and laments the recent death of her faithful cook Thekla. Parasha goes off in search of a replacement for the cook, and comes back with 'Mavra' – in fact, Basil in disguise. Another love duet. Left alone, Basil decides he had better shave; a bad decision, as Parasha and her mother return and catch him in the giveaway act. The mother faints, the hussar takes to his heels, and Parasha cries 'Basil! Basil!' as the curtain falls.

6. In fact, Stravinsky had been inspired to compose the work the previous year while staying with Diaghilev at the Savoy in London. Diaghilev was interested in producing Tchaikovsky's ballet *The Sleeping Beauty*, which had never been seen in the West, so he asked Stravinsky to orchestrate two of the numbers which were missing from his copy of the full score, and were only available in piano transcriptions. Stravinsky's work on these numbers proved to be highly enjoyable, and he became a sudden and vocal enthusiast for Tchaikovsky's genius. He decided that his next major work would attempt to follow in the Pushkin–Glinka–Tchaikovsky tradition. He had completed the opera itself

who attended the premiere in Diaghilev's own box; everyone hoped that Kahn would take the company to America. Alas, Kahn's only comment was 'I like it all, then − "poop" − it ends too quickly . . .' At the interval, members of the audience were heard to pass on a slightly lame witticism: '*Ce* Mavra, *c'est vraiment mavrant*' − 'This *Mavra* is really tiresome'. And the critic Émile Vuillermoz wrote such a vicious review of the work that Stravinsky ruefully, or defiantly, cut it out and pasted it into the manuscript score.[7]

AUSTRALIA

Finding himself with abundant free time in his new Antipodean home, Lawrence set about writing a novel. He planned to have it completed by early August: roughly the date he had set for himself to leave Australia and travel on to the United States.[8] In fact, with almost no distractions, and a great deal of nervous energy, he rattled away at it so swiftly − often managing some 3,000 words per day − that the whole first draft was completed by 15 July.[9]

Lawrence called his new novel *Kangaroo* − no great feat of imagination, this, since the book was all about Australia, particularly Australian politics, and was indebted to Lawrence's careful readings of the *Sydney Bulletin*, which ran both sombre articles about national affairs and a more whimsical column entitled 'Aboriginalities', crammed with amusing and

by March 1922, and added the overture a few weeks later while travelling to Monte Carlo and Marseilles.

Incidentally, among the many musical influences to be found in this rich work were ragtime and, in Stravinsky's own words 'a certain jazz element', requiring 'a "band" sound rather than an "orchestral" sound . . .'

7. Stravinsky was hurt by the poor initial reception of his new work, and often returned to the subject in his critical, autobiographical and polemical writings (including *Poetics of Music* and *Chronicles*), trying to explain and justify his intentions. Briefly, he wanted to distance himself from the conventionally nationalist strain of Russian music (exemplified by Mussorgsky, Borodin, Rimsky-Korsakov *et al.*) and to align himself instead with the European-facing strain in Russian culture (which, as he put it, 'united the most characteristically Russian elements with the spiritual riches of the West'), of which the leading spirits were Pushkin, Glinka and Tchaikovsky − the trio to whom *Mavra* is dedicated.

8. Their money was almost all spent; Lawrence wrote to his American agent, Robert Mountsier, asking for another $700 from his royalties.

9. Some of this nervous energy was the result of irritability: though Lawrence claimed to relish the exceptional isolation of their Australian life, the reality was that he and Frieda could often annoy each other intensely when there was no one else around to offer welcome distraction. For all the superficial pleasantness of their quiet life, they often quarrelled loudly or retreated into icy sulks.

strange tales (including tall tales) of the beasts and monsters to be met in the outback. *Kangaroo* begins in almost directly autobiographical fashion, with an account of the daily lives of a slight, bearded writer, Richard Lovat Somers, and his upper-class European wife Harriet. The couple, who are planning to leave for America in a couple of months, are hungry with the desire to understand Australia, to uncover its 'secret being'.

So far, so transparent. But the later chapters of *Kangaroo* move away from the domestic sphere and into political theory and speculation. Somers is tempted by two paths into politics, represented by two strong men: Jack Callcott, one of nature's followers; and the leader of the clandestine – roughly speaking, fascist – group to which Jack belongs, Ben Cooley, aka 'Kangaroo', a charismatic Jewish lawyer and aspirant Whitmanesque messiah. The novel's various emotional complications end with Somers confronting his memories of war, and finally achieving a catharsis – in effect, a rebirth. Somers is now ready to leave Australia; as was his creator.

4 JUNE

CAMBRIDGE

The 'great and good' Dr W. H. R. Rivers[10] – healer, neurologist, psychologist, anthropologist, Western guru and, since his appointment to the post

10. Thanks to the success of Pat Barker's trilogy of novels, the *Regeneration* series – in which he is a leading character – Rivers is perhaps even better known in the twenty-first century than he was towards the end of his own lifetime, where he had come to be admired and often loved by many of his peers and students in at least four disciplines; by his grateful wartime patients (including Siegfried Sassoon, who wrote a long account of his treatment for 'Shell Shock' by Rivers at Craiglockhart hospital), and, it would seem, by virtually everyone who ever met him. Hundreds of people came from all over Britain to attend his funeral (as an anthropologist, he had long been interested in funeral rites). Sassoon was so distressed that he broke down.

That the world had lost a wise and good man was obvious. But the nature of what Rivers might have gone on to accomplish is uncertain. It is possible that he had already made all the contributions he would ever make to the sciences, and that his subsequent career might have been in quite other fields. Since the war, the previously rather conservative Rivers had been increasingly attracted to socialism. Kingsley Martin, then a socialist undergraduate at Cambridge, reported having seen him at a conference in February 1922 with the likes of Sidney and Beatrice Webb, the Russells, Harold Laski, Hugh Dalton and other prominent intellectuals of the Labour movement. He had already – in April 1922 – been selected as Labour candidate for the University of London constituency at the next general election. Might he have become a major politician?

It is hard to guess. Russell said of Rivers that he had never met a political candidate less motivated by the lure of power and personal aggrandisement, or more purely motivated by idealism

in 1919, Praelector of Natural Sciences at St John's College, Cambridge[11] –
died at the Evelyn Nursing Home, after an emergency operation for a
strangulated hernia. He was only 58, and though his health was far from
robust, this was an unforeseen disaster. Whitsuntide weekend had been
very fine, and everyone who was free to enjoy the weather was out in the
sun. Not wanting to dampen matters, Rivers had kindly told his college
servant to take the Saturday off; he would prepare his own breakfast. That
same night, his bowel twisted, causing him excruciating pain, and he was
trapped in bed, suffering alone for hour after hour. By the time help
came, it was too late for an operation to cure him.[12]

One of Rivers's major recent preoccupations had been the area at
which psychology and psychiatry overlap with sociology and ethnology.
He was working towards a more general view of instinct, of dreams, of
myth, of symbolism in the public and the private spheres, and of the
neuroses – all, for him, different aspects of a larger tendency of the human
mind. Perhaps some grand synthesis might have emerged?

alone. Rivers himself was often nervously jocular about his decision to stand for Parliament, quip-
ping that his main ambition was to psychoanalyse Lloyd George, or that the House of Commons
was in sore need of a resident psychiatrist. But he was earnest when it came to his convictions. In a
speech on 'Socialism and Human Nature' given at University College, London on 25 May 1922, he
said: 'When I speak of socialism I mean a form of society the individual members of which are
ready to work for the common good without the incentive that they as individuals are going to reap
an immediate advantage from their labour.' On accepting the candidacy, he had acknowledged that
the state of the world was perilously unstable: 'Entering practical politics can be no light matter.
But the times are so ominous, the outlook, both for our country and the world, so black, that if
others think that I can be in service in political life, I cannot refuse.'
11. Three years earlier, Rivers had also been made the first president of the medical section of the
newly formed British Psychoanalytic Society – a post he was happy to accept despite the fact that he
had some radical disagreements with classical Freudian theory, notably the idea of 'censorship' and
on the inevitably sexual content of dream symbolism. Such was the respect in which Rivers was
held that – many historians agree – he did more than any single man to make psychoanalysis and
psychotherapy seem respectable in Britain, and not just some nasty Continental crankery or perver-
sion. He might easily have become the British figurehead for talking cures.
12. Many years later, in 1968, one of Rivers's friends and colleagues at St John's, the psychologist
Frederick Bartlett, wrote a moving account of a dream he had about two weeks after Rivers's death:

> I met him again, for the last time. I was in the Combination Room [of St John's Col-
> lege] . . . There was one vacant chair. Then he came in, alert and quick as usual. He went
> to the empty chair and sat down. He had no face. Nobody else knew him, but I knew
> him. I tried to say, 'Rivers! It's Dr Rivers!' . . . Then I woke up. I was in bed, at home. It
> was pitch dark. For what seemed like several minutes I was absolutely sure that he was
> there, in the deep darkness, close to me. It was a dream. We had talked many times
> about death. He had said that if he should die before me, as seemed likely . . . he would
> try to get through to me.

Not least among his post-war interests was a growing interest in the arts and literature – pleasures he had somewhat neglected in his youth.[13] He had founded a discussion group called the Socratics, to which he invited people from far outside his own usual sphere, including writers: Sassoon, of course, but also H. G. Wells and Arnold Bennett (who wrote sympathetic memoirs of their meetings). He saw a good deal of the poet Robert Graves, who later wrote, in *Poetic Unreason*: 'It was personal friendship for Dr Rivers, admiration for his book, *Instinct and the Unconscious*, and the encouragement he gave me in my writing of *On English Poetry* [1922] that has made this book take the shape and title it has taken.'

Graves's *On English Poetry* bears the fascinating dedication: 'To T. E. Lawrence of Arabia and All Souls College, Oxford, and to W. H. R. Rivers of the Solomon Islands and St John's College, Cambridge, my gratitude for valuable critical help . . .'[14] His admiration for Rivers was easy to understand; less obvious, and far more thought-provoking was the intense admiration in which Eliot held him. (See 19 December.)

5 JUNE

DUBLIN

Yeats wrote to John Quinn, explaining that he had just finished writing his book of memoirs, *The Trembling of the Veil* – dedicated to Quinn – and sent it off to the publisher.

PROVIDENCE, RHODE ISLAND

H. P. Lovecraft – probably the twentieth century's single most influential writer of horrific fantasies – completed, in a single day, his short story 'What the Moon Brings'; it was published the following year.[15]

13. Like so many others in this book, he had attended the Ballets Russes, in London.

14. As late as 1948, in his strange and influential book *The White Goddess*, Graves was using a distinction between 'reason' and 'the unwitting' (Rivers's preferred term for what other psychologists usually call the unconscious).

15. 1922 was a productive year for Lovecraft: in the same month, he finished the manuscript of *Herbert West – Re-Animator*, on which he had been working since the previous October, as well as a fragment entitled 'Azathoth'. Lovecraft's other stories of 1922 were 'Hypnos' (March), 'The Hound' (October) and 'The Lurking Fear' (November).

10 JUNE

LONDON

Eliot wrote to Leonard Woolf, discussing the possibility of publishing S. S. Koteliansky's translation of a Dostoevsky text in the forthcoming *Criterion*. A few days earlier, Eliot had paid a visit to Hogarth House, where he read his new work: *The Waste Land*. Virginia Woolf wrote that:

> He sang it and chanted it and rhythmed [*sic*] it. It has great beauty and force of phrase; symmetry; and tensity. What connects it to-gether, I'm not so sure. But he read till he had to rush – letters to write about the London Magazine – and discussion thus was cur-tailed. One was left, however, with some strong emotion. The Waste Land, it is called; and Mary Hutch[inson], who has heard it more quietly, interprets it to be Tom's autobiography – a melan-choly one.

11 JUNE

NEW YORK

Robert J. Flaherty's film *Nanook of the North* opened at the Capitol cinema, New York. Though the picture-going public was now familiar enough with newsreels and other types of non-fiction shorts, *Nanook* was some-thing new: the first commercially successful documentary feature in cin-ema history. To make this unprecedented film, Flaherty had travelled to a sub-Arctic community on the north-east coast of Hudson Bay, and stayed there for 16 months.[16] For his main character – 'Nanook', though that was not the man's actual name – he chose a hunter of the Itivimuit tribe.

 Nanook performed so well at the box office that Flaherty was launched on a directorial career that lasted until his death in 1951.[17] 'Write your

16. The shoot was as hard as it was protracted; sometimes the film stock was so brittle with cold that it shattered; blizzards trapped the crew as they tried and failed to film a bear hunt, and they almost died of starvation and cold. Every day taxed the strength, ingenuity and resourcefulness of both locals and film-makers.

17. The high points of his career include *Tabu* (1931) – which he co-directed with the creator of *Nosferatu*, F. W. Murnau – and *Man of Aran* (1934).

own ticket,' Jesse Lasky of Paramount told him when he signed him up in 1923.

Flaherty had not set out to be a film-maker of any kind; he had planned to follow his father's adventurous career, working as a mining engineer. The young Robert learned advanced survival skills in boyhood, venturing out with his father on long trips into the Canadian wilderness by canoe or snowshoe, meeting the local peoples, enduring the local dangers. When he began his own career, it was as a fearless prospector and explorer, employed by the railway plutocrat Sir William Mackenzie. By the time of his third expedition, in 1913, Mackenzie suggested to him that he might take a camera along to record his adventures.

Flaherty liked the idea, and bought a Bell and Howell and some lighting equipment; his only cinematic training was a three-week crash course in Rochester, NY. During his expeditions of 1914 and 1915, cinematography became his obsession: he shot so much material that film-making almost overtook his hunt for minerals. He began to mount small-scale public screenings of his films, and the response was usually one of wild enthusiasm. Clearly, there was an audience for a film about Eskimo life. Then catastrophe struck. In 1916, while he was preparing to ship all his footage to New York, his cigarette set fire to the stock; within seconds all 30,000 feet was ablaze, and Flaherty only just escaped with his life. Forced into a period of inaction, he began to rethink the project. What he had done so far was too episodic, and lacking in narrative. He needed to concentrate the film: to focus on the life of one Eskimo man and his family. He began to look for someone to back his project, and eventually, in 1920, the French fur trading company Revillon Frères agreed to fund his work.[18]

Even after Flaherty returned to America and completed his film, there was not much reason for optimism. Five major distribution companies had a look at his work; all five turned it down. No one, they explained, wanted to watch Eskimos. But finally the Pathé company picked it up, and the critics were immediately ecstatic: *The New York Times* said that 'Beside this film, the usual photoplay, the so-called "dramatic" work of the screen, becomes as thin and blank as the celluloid on which it is printed.' The

18. The total budget would eventually reach $53,000 – far more than they had originally agreed, though they soon made a handsome profit.

film made a fortune at the box office, and launched a craze for all things Eskimo: a Broadway hit song, 'Nanook'; in Berlin, an ice-cream sandwich called a 'Nanuk'. Some film historians still consider it the greatest of documentary features, not merely the earliest.[19]

13–14 JUNE

GRANADA – SPAIN

After weeks of mounting public excitement, vicious arguments and bitter disappointments, the Lorca/de Falla festival of Cante Jondo – 'Deep Song' – finally began. The town council, who might have been expected to welcome the event as a huge boost to tourism, had proved miserly in the extreme, claiming that it would empty the town's coffers; they would not even sponsor visits by Ravel and Stravinsky, both of whom had announced their interest in attending.[20]

Despite this, the festival, held in the Alhambra's Plaza de los Aljibes, was a huge success, and crammed with spectators. A British reporter, and friend of de Falla, John B. Trend, wrote that 'Wherever one looked there

19. The novelty of Flaherty's work may be judged by the fact that the noun 'documentary' did not exist at the time; it seems to have been introduced to the English language four years later by John Grierson, in a review of another such feature, *Moana*, made by . . . Robert J. Flaherty.

However, if *Nanook* initiated the genre of documentary feature, it also opened a debate which has continued, sometimes angrily, to the present day: to what extent is it permissible for a documentary director to stage fictional sequences, include untrue or misleading details, and generally pass off as unmediated truth events that have been contrived for the camera? Early audiences were enthralled by what appeared to them the sheer authenticity of *Nanook*, but word soon leaked out that much of it was, to use a harsh word, fake. Some of the fakery was harmless enough, simple technical licence – Flaherty had built an open-sided igloo, for example, so as to be able to film Nanook and his family 'indoors'. Some, though, was intentionally misleading: most Eskimos now used modern rifles to hunt, but Flaherty insisted that they revive the traditional spears of their fathers and grandfathers. In this way, he not only falsified the lives of his subjects; he endangered them.

Flaherty was more aware of these contradictions than his critics might care to admit. He defended his own work, and others have taken up the defence on his behalf, saying that he was in the business not of charting the inevitable encroachments of the global economy and its values on Nanook and his people, but of cherishing the last unpolluted moments of their ancient culture in the brief time left before it disappeared. He was less a reporter than a composer of elegies. Such an argument does not disarm all opposition; but it does help account for the enduring power of the film, which one awestruck French critic of the day compared to a Greek tragedy.

20. To take a break from all the hysteria, de Falla and Lorca went for a brief holiday in Seville, where they bumped into the Cuban writer José María Chacon y Calvo, who some years later declared that to meet Lorca in that time and that place had been 'like meeting the very stuff of poetry'.

were exquisite figures in gay, flowered shawls and high combs, while many had put on the silks and satins of bygone days, and appeared in the fashion of the [eighteen] thirties and forties – the Spain of Prosper Mérimée and Theophile Gautier, of Borrow and of [Richard] Ford.' Competitors were of all ages: Saturday night's winner of 1,000 pesetas was a very old *cantaor* who claimed to have walked 80 miles across country to compete; an 11-year-old boy called Manuel Ortega, nicknamed 'el Caracol', the Snail, won another major prize and went on to be one of the greatest *cantaores* of the twentieth century.

Among the visitors to the festival was an obscure French postgraduate: Georges Bataille.[21] (See 17 May.) He was particularly struck by the singer Bermudez: 'He sang – rather, he threw out his voice in a sort of excessive, rending, prolonged cry which, when you thought it was exhausted, reached, in the prolongation of a death moan, the unimaginable.'[22]

The Cassandra-like mutterings about financial disaster proved wholly wrong – the festival made a handsome profit and so, predictably, generated an entirely new series of arguments about what should be done with the hefty windfall. De Falla was disgusted; from this point on, Andalusian references played a much smaller part in his compositions. But Lorca was fired with the success of the event, and determined to carry on writing poems in the 'Gypsy' strain.

14 JUNE

WASHINGTON, DC

President Harding made his first radio broadcast to the American nation.

21. Another traveller who happened to be in Granada in June 1922 was the young Dutch artist M. C. Escher (1898–1972). Escher was sent into raptures by the Alhambra, which remained a major creative influence for him throughout his career.
22. In 1963, Bataille's colleague Alfred Metraux – probably best known in the twenty-first century for his studies of voodoo – published an article in *Critique*, 'Rencontre avec les ethnologues', in which he recalled the vivid impression the festival had made on Bataille: 'His enthusiasm was so lively, the images he evoked so beautiful, that forty years later I can convince myself that I took part in this festival.'

15 JUNE

LONDON

H. G. Wells presided over a public lecture at University College given by his good friend F. W. Sanderson, the headmaster of Oundle School – a man he described as the greatest he had ever known, which, considering Wells's distinguished sphere of acquaintance, is a tribute to be taken very seriously. To the horror of everyone present, Sanderson dropped dead on the platform.[23]

The public record suggests that Wells was in high form in 1922: he published no fewer than three books that year – *Washington and the Hope of Peace*, based on articles he had written during two months of travel in the USA in 1921; *A Short History of the World*, cut down from his ambitious 1920 book *The Outline of History*; and a novel, *The Secret Places of the Heart*. He was also at work on his next novel, *Men Like Gods* (1923), and later in the year he would stand as a Labour candidate in the general election. (See 15 November.)

But the novels he was writing at the time, and for the next two years – *The Dream, Christina Alberta's Father* – tell a rather different, and at times desperate story. The protagonist of *The Secret Places of the Heart*, Sir Richmond Hardy – a character clearly based on Wells himself – seeks help from a psychiatrist, Dr Martineau, because he feels that his life has become meaningless. Hardy is a deeply unhappy man, and like his creator, he has tried to overcome his despair through love affairs, especially with much younger women. In the course of the novel, he begins an affair with an American girl, feels torn with guilt about his obligations to his mistress, experiences a craving for death and dies soon afterwards.

Some factual details may have been changed; otherwise this was a deadly accurate portrait of Wells's own spiritual condition. There was indeed an existing mistress – the novelist Rebecca West, who had been his lover since 1913. And there was an American rival for his affections – Margaret

23. Wishing to help commemorate his friend's achievements, as well as to outline his own ideas on education, Wells agreed to write a biography of Sanderson. This soon met with resistance and interference from Sanderson's widow, who felt, among other objections, that Wells did not make enough of Sanderson's scholarship. In the end, he produced a much blander piece of work than he had intended, published in 1924 as *The Story of a Great Schoolmaster*.

Sanger, the feminist and propagandist for birth control.[24] When Wells came back from America to join Rebecca West for a Spanish holiday, she found him 'desperately tired and practically off his head; enormously vain, irascible and in a fantasy world . . . His temporary deterioration was appalling.'[25]

Though it did not make his symptoms any easier to bear, Wells understood that what was happening to him had happened three or four times before, always at a moment of crisis. Restlessness mounted to a sense of claustrophobia and then downright panic.[26] Possessed by fears of mortality and insanity, Wells described himself as 'a creature trying to find its way out of the prison into which it has fallen'.

LONDON

Eliot wrote to Ottoline Morrell, discussing his plans for *The Criterion*. He had, he explained, kept Lady Rothermere waiting for a whole year to launch the review, and the reason he had taken the early holiday in Lugano was so as to be healthy enough to concentrate solidly on the project for the next three months. Because of this self-imposed commitment, he was now unable to accept any weekend invitations for the foreseeable future.

He also reported that Vivien had recently seen a new specialist, who had diagnosed her entire trouble as 'glands', combined with poisoning from colitis. The doctor had prescribed, he went on, a 'violent' cure which included two days of starvation every week and 'the glands of animals' – though quite which animals, and which glands, appeared to remain uncertain.

16 JUNE

VIENNA

The writer Arthur Schnitzler visited Sigmund Freud in his famous apartment at Berggasse, and wrote a fond description of the meeting in his diary that night.

24. She married an oil tycoon in November 1922; she and Wells remained good friends for many years.
25. The couple finally broke up, at her initiative, in 1923.
26. The four novels he wrote from 1921 to 1924 analyse this panic state, but they were also written in a futile attempt to cure himself. Three out of the four heroes in these books die; the fourth suffers a symbolic death.

At Prof. Freud. (His congratulations on my birthday, my reply, his invitation.) . . . Only spoke to him briefly a few times till now. – He was very affectionate. Conversation about hospital and military service days, bosses in common, etc. – Then he showed me his library – his own things, translations, writings of his pupils; – all sorts of little antique bronzes, etc. – He is no longer in medical practice, only takes pupils who for this purpose are analyzed by him. Gives me a beautiful new edition of his lectures, – Accompanied me late in the evening from Berggasse to my home. – The talk becomes warmer and more personal; about getting old and dying.

Freud had said – jokingly? – that he had been reluctant to meet Schnitzler because he considered him his 'literary doppelgänger' (and, so the superstition runs, to meet one's doppelgänger is the sign of imminent death).

IRELAND
The first Irish general election held under the terms of the 1921 Treaty. Although almost all of the candidates were standing on the Sinn Fein ticket, in reality there was a vast ideological divide into pro-Treaty and anti-Treaty candidates. Michael Collins led the pro-Treaty movement; Eamon de Valera the anti-Treaty side. The result was a clear majority for the pro-Treaty side: 58 seats to 36 seats – enough for W. T. Cosgrove to establish a legal government. But the anti-Treaty forces were not to be silenced; all of their MPs staged a mass boycott of the Dáil. There was dark talk of civil war.

19 JUNE

LONDON
The Eliots moved out of 12 Wigmore Street and back into 9 Clarence Gate Gardens, NW1.

21 JUNE

BERLIN

Vladimir Nabokov (newly minted BA, Cantab) went back to his family's apartment at 67 Sächsische Strasse; he would remain in this flat until his family left for Prague in December 1923.[27] He tried to find a job working in a bank, as did his brother Sergey. Sergey managed to put up with it for a week; Vladimir walked out after only three hours. The work was unbearable for a would-be writer; it was both easier and much more agreeable to supplement a literary income by tutoring languages, or even tennis and boxing. Besides, he was still in a state of deep depression. When he proposed marriage to a pretty 17-year-old girl, Svetlana Siewert, she accepted because he seemed so unutterably sad. Her parents only approved the engagement on the understanding that Nabokov would find a steady job; the arrangement was short-lived.[28]

Depression did not paralyse his talent, though. Shortly after his arrival in Berlin, the émigré publisher Gamayun commissioned him to translate *Alice in Wonderland* into Russian.[29] Having already translated a very difficult novel (*Colas Breugnon*, a Rabelasian text by Romain Rolland), he had few difficulties, and took pleasure in finding Russian equivalents for Carroll's jokes and phrases: the French mouse that came over with William the Conqueror, for instance, became a mouse left behind in Napoléon's retreat, while Alice herself became 'Anya'.[30]

Terrible as his year so far had been, 1922 would at least end in a flourish, with no fewer than four books about to be published.[31] Nabokov was now going under the pseudonym 'Sirin', which he would continue to do for all his publications until he moved to America. Initially he used it to avoid any confusion between his own writing and his father's, but he

27. Nabokov himself remained in Berlin for 14½ years.

28. On 9 January 1923, he listened in tears as her parents broke off the engagement, and announced that they were taking her away. That night he wrote an agonised poem: 'Finis'.

29. Gamayun handed him an American five-dollar bill as an advance; having no other money, Nabokov tried to use it for his tram fare, amazing the conductor so much that he stopped the vehicle to work out the change.

30. The resulting book, *Anya v Strane Chudes*, was published in March 1923. Those competent to judge have sometimes said that it is the best translation of the novel into any language.

31. November 1922 saw the publication of his translation of *Colas Breugnon* as *Nikola Persik*; December 1922 a collection of verses written in 1921–2, *Grozd'* ('The Cluster'); January 1923 another collection, *Gorniy put'* ('The Empyrean Path'); and in March, *Anya*.

maintained it long after his father's murder. In Russian folklore, a *sirin* is a legendary bird of paradise; a firebird.

LONDON

Eliot cabled John Quinn to express his dissatisfaction with the Liveright contract for *The Waste Land,* and asked for Quinn's help.

22 JUNE

BELGRAVIA – LONDON

Agents of the IRA – Reginald Dunne and Joseph O'Sullivan – murdered Field Marshal Henry Hughes Wilson. The killers were soon caught, and sentenced to death on 18 July. Churchill assumed that the pair were working on behalf of anti-Treaty forces; in fact the order to kill had secretly been authorised by Michael Collins.

LONDON

Aaron's Rod, a novel by D. H. Lawrence, was published.

23 JUNE

LONDON

Eliot wrote a bread-and-butter note to Mary Hutchinson, thanking her for an evening with Massine; he said that he liked Massine very much indeed.

He also reported having sat for a portrait for Wyndham Lewis.

24 JUNE

MILAN

Hemingway again travelled to Italy – a country now torn by civil war – to revisit the places he had known in the war: Schio, Lake Garda, Mestre and Fossalta.

During this trip, he also travelled to Milan to conduct the first of two interviews with Benito Mussolini, the editor of the journal *Popolo d'Italia.*

Since he tended to admire anyone who had been under fire – and since at this time he took Mussolini's accounts of wartime bravery very much at face value – Hemingway was inclined to be sympathetic to his interviewee.[32] In his article for the *Toronto Daily Star*, he reported:

> Benito Mussolini, head of the Fascisti movement, sits at his desk at the fuse of the great powder magazine that he has laid through all Northern and Central Italy and occasionally fondles the ears of a wolfhound pup, looking like a short-eared jackrabbit, that plays with the papers on the floor beside the big desk. Mussolini is a big, brown-faced man with a high forehead, a slow-smiling mouth, and large, expressive hands . . .
>
> Mussolini was a great surprise. He is not the monster he has been pictured. His face is intellectual, it is the typical 'Bersagliere' face, with its large, brown, oval shape, dark eyes and big, slow-speaking mouth . . .

The rest of the article was mainly given over to a rapid sketch of Mussolini's rise from humble beginnings.[33]

A parallel article, published the same day in the *Toronto Star Weekly*, dropped all pretence at neutrality. While conceding that bourgeois resentment against the insulting and threatening behaviour of working-class militants immediately after the war was largely justified, Hemingway saw that the Blackshirt movement had taken on a life of its own: 'They had a taste for killing under police protection and they liked it.' Meanwhile, the

32. His account of a subsequent meeting with Mussolini, at Lausanne, was not published until 27 January the following year, but it is worth noting how radically his opinion of the leader had changed for the worse: 'Mussolini is the biggest bluff in Europe . . . Get hold of a good photograph of Signor Mussolini sometime and study it. You will see the weakness in his mouth which forces him to scowl the famous Mussolini scowl that is imitated by every 19-year-old Fascisto in Italy . . . And then look at his black shirt and his white spats. There is something wrong, even histrionically, with a man who wears white spats with a black shirt.'

33. Born 37 years earlier in an area known as a hotbed of anarchist and socialist revolution, the young Benito had been first a schoolteacher, then a journalist, and by 1914 had become editor of Milan's socialist daily paper *Avanti*, from which he was sacked for urging that Italy enter the war on the side of the Allies as soon as possible. He was severely wounded during his wartime service, and decorated several times. In 1919, dismayed by what he saw as a wave of communism in northern Italy, he founded the Fascisti as anti-communist shock troops. By now, Hemingway concluded, Mussolini was at the head of a thriving 500,000-strong movement, both political and military, from Rome to the Alps. So what was he planning to do with his half a million supporters?

communists had taken full measure of the forces ranked against them, and had organised groups of 'Arditi del Popolo' – Redshirts to fight the Blackshirts; while the bourgeoisie, keenly aware that the instability produced by these conflicts was keeping the lira painfully low, had been reduced to bribing their former strong-arm men to do nothing.

Hemingway's conclusion was trenchant: 'The whole business has the quiet and peaceful look of a three-year-old child playing with a live Mills bomb.'

BERLIN

Young right-wing thugs in Berlin, outraged by his part in the Treaty of Rapallo, assassinated Walter Rathenau on his way to work.[34] The murder came as a terrible shock to thoughtful Germans, not only because Rathenau was a highly civilised and gifted man, well liked by many, but because they saw it – correctly – as a portent of far worse violence to come.

Einstein, one of those many friends of Rathenau, wrote a moving obituary:

> My feelings for Rathenau were and are joyous admiration and gratitude for the hope and consolation he gave me in Europe's current dark days . . .
>
> It is no art to be an idealist when one lives in cloud-cuckoo land; he, however, was an idealist even though he lived on earth and knew its smells as few others . . . I had not anticipated that hate, delusions and ingratitude could go that far.

Einstein learned that he too was in danger; he was informed that his name was on some of the same lists of potential assassination targets that had included Rathenau. He decided that it would be prudent to leave the country for a while.

34. One of the witnesses to the killing was a young Dietrich Bonhoeffer, who in later life became one of the most influential theologians of the twentieth century, and one of the noblest Christian martyrs under the Nazi regime.

25 JUNE

LONDON

Eliot wrote to John Quinn, thanking him for his help over the Liveright dispute.[35] Eliot also wrote to Richard Cobden-Sanderson, proposing that – in view of the fact that there were now widespread rumours that the project had been abandoned – it would be 'highly desirable' to issue an announcement of the first issue of their quarterly as soon as possible, ideally by the middle of July. He also explained that he and Lady Rothermere had finally agreed on a title for the publication. Instead of *The London Review*, which they considered a weak name, they had decided upon *The Criterion* – 'a title suggested by my wife'.

27 JUNE

USA

The first Newbury Medal for Children's Literature – created by the American Association for Library Service for Children – was awarded to Hendrick van Loon for *The Story of Mankind*.[36] 1922 was a highly significant year for children's books in other ways, too. In England, Richmal Crompton[37] published *Just William*, the first of her popular books about the adventures of William Brown – an adventurous, dictatorial, highly imaginative anarchist of 11 years. In other words, a naughty but fundamentally good-natured boy.

Enid Blyton also published the first of her many children's books in

35. Two days later, Vivien Eliot wrote to Pound about 'glands'. The letter includes a list of her various ailments, including migraines, insomnia (she said that she had suffered from this for eight years) and mental distress: 'I have a horror of using my mind and spend most of my time in trying to avoid contact with people or anything that will force me to use my mind' . . .

36. The following year's winner was Hugh Lofting, for *Dr Doolittle*.

37. Crompton (1890–1969) – many assumed that she was a man, because of her gender-ambiguous Christian name – was rather a serious-minded young woman: a former classics student and suffragette, who regarded herself as primarily a writer for adults. But her readers' insatiable appetite for the keen humour and eye for social detail in the *Just William* books provided her with such a healthy income that, like Conan Doyle with his great detective, she was obliged to keep returning to William, his gang the Outlaws, and his lisping female nemesis Violet Elizabeth Bott. In all, she wrote 38 William books, which sold 12 million copies in the UK alone. One of the most ardent admirers of the series was a young Liverpudlian, John Lennon, who tried to model himself on William Brown.

1922: *Child Whispers*, a collection of poems.[38] In America, the year's greatest classic for children was *The Velveteen Rabbit* (subtitle: *Or How Toys Become Real*), written by the English-born, American-resident Margery Williams, and finely illustrated by William Nicholson. Williams was 41, and the book brought her almost immediate fame.

28 JUNE

IRELAND

Though he did not know the conflict was about to explode, Yeats wrote to Olivia Shakespear: 'All is I think going well and the principal result of all this turmoil will be love of order in the people and a stability in the government not otherwise obtainable . . .' Famous last words.[39]

The flashpoint for the war was the occupation of the Four Courts in Dublin by some 200 anti-Treaty men. They had occupied the buildings, on the banks of the Liffey, on 14 April, and clearly would not leave peacefully. Their intention was to reunite the two main wings of the nationalist movement and return to war with Britain. Collins and Griffith both realised that the only alternative to allowing the breakaway forces to reignite a war between the two nations was for them to put down the occupation themselves, and in the most ruthless way. Griffith was for immediate action; Collins, dreading the outbreak of civil war (looking more likely day by day), delayed. Meanwhile, Churchill started to pressure Collins, telling him to retake the Four Courts or suffer the consequences.[40]

Finally, on the evening of the 27th, the stand-off broke. Anti-Treaty forces kidnapped J. J. 'Ginger' O'Connell, a general in the newly constituted National Army. Collins, now commander-in-chief of the National

38. Judged purely in statistical terms, Blyton (1897–1968) trumps every other writer in this book: she is the fifth most translated writer of all time, just behind Shakespeare and just ahead of Vladimir Lenin. She wrote some 800 books, and something in the region of 600 million copies have been sold worldwide. At the height of her career, she was capable of producing 10,000 words a day, a rate which has aroused suspicions that she must have employed teams of ghost writers. To date, none has been discovered.

39. The Irish Civil War officially began on 28 June (though there had been many skirmishes in the preceding weeks). It was marked by some of the most appalling violence the country had seen, and left bitter divisions in the nation that shaped its history for decades.

40. He did not mention that the British army was already preparing for its own intervention if Collins hesitated – a move called off at the very last minute.

Army, borrowed artillery from one of the remaining British garrisons and launched a ferocious attack on the Four Courts. It lasted for two days, at which point the anti-Treaty men surrendered.[41]

The end of the siege was the beginning of the war. The streets of Dublin became a battlefield until 5 July, when the National Army established control of the capital. The conflict spread to the rest of the country, and would last until 24 May 1923.

RUSSIA

Weakened by malnutrition, and suffering from both typhus and malaria, the Russian poet Velimir Khlebnikov (b. 1885) died in a friend's house in Kresttsy, Novgorod province, between Moscow and Petrograd/St Petersburg.[42]

30 JUNE

PRAGUE

The Institute informed Kafka that he would be granted retirement, with effect from the following day. His pension would be 1,000 crowns a month. He resolved to go at once to stay for the summer, with his sister Ottla, in the idyllic village of Plana, some 60 miles to the south of Prague. Over the next months, he wrote the final nine chapters of *The Castle*. For the first time in his life he was no longer a civil servant, but a full-time *Schriftsteller*: a writer.

Apart from a couple of brief trips back to Prague, he stayed at Plana until 18 September. At some point during that month, he gave the manuscript of *The Castle* to his translator, Milena Jesenská.[43]

41. In the last hours of the bombardment there was a vast explosion which destroyed the Irish Public Records Office – home to countless documents of Irish history. To this day, it is disputed whether this was an instance of collateral damage, or if the anti-Treaty men had set a bomb.

42. In his earlier days, Khlebnikov had been, with Mayakovsky, one of the blazing stars of the Futurist movement, composing exultant essays about the technological wonders ahead for mankind. In more recent years, though, he had turned more and more towards mysticism and the occult. He studied Slavic mythology, grew obsessed with Pythagorean numerology, and wrote cryptic poems which amounted to a kind of verbal sorcery. Though his reputation has been eclipsed by that of his contemporaries, he retains loyal cult audiences in both Russian and English.

43. Though they only met on a couple of occasions, Franz and Milena conducted a passionate correspondence that amounted to a love affair of the mind. The book arising from this exchange after

LONDON

Eliot wrote to Richard Aldington, in part to discuss the present state of the 'Bel Esprit' scheme to rescue him from Lloyd's, and to express his misgivings about it: '. . . the method proposed by Ezra is rather bordering on the precarious and undignified charity'.

LONDON

Over an eight-day period at the end of June and the beginning of July, young Eric Arthur Blair – later to transform himself into 'George Orwell' – went to the grand headquarters of the India Office, near the Royal Academy in Piccadilly, to sit the examinations which might qualify him for service in the Far East. He was planning to join the Imperial Indian police, in Burma. Blair[44] had spent the last six months living with his parents, who had recently settled in Southwold, on the Suffolk coast, and had been preparing for these tests at the local crammer. He was, it is a fair guess, gloomy.

According to the few people who knew this solitary adolescent at all well, Blair seems to have dreamed of following the path of most of his Etonian contemporaries – especially the high-flying, hard-studying Collegers – and going on to Cambridge or (more likely) Oxford. But his father, now retired and living on a modest pension, was reluctant to support him any longer, and Blair had done so poorly at Eton[45] that an Oxford scholarship was out of the question.

It is harder to judge his motives in opting for the Colonies. Was he deliberately choosing a career of intense loneliness and physical hardship from a sense of masochistic self-sacrifice? Was he following passively in his father's chosen path?[46] Did he feel the lure of the East as a place of romance and adventure? With no war to enlist for – and Blair/Orwell often wrote in later years about the sense of shame and guilt felt by boys of his immediate generation when they met those just five years or so

Franz's death, *Letters to Milena*, has received almost as much attention as his fiction. Though Milena was not Jewish, she stood bravely by her Jewish friends, and was murdered by the Nazis in their concentration camp at Ravensbrück.

44. Born 25 June 1903; he had just turned 19.

45. He had followed a self-imposed regime of slacking at games and Corps, and privately gorging on seditious authors like Wells and Shaw.

46. Blair senior had been in the Opium Department of the Government of India, and Eric had been born in Motihari, Bengal.

older, who had medals, and spoke always of the trenches – did he wish to prove himself as a man? Burma at the time was notorious for having the highest crime rate in the Empire, with a murder rate in some regions six times that of Chicago in Al Capone's glory days. There is evidence for all these feelings in his published writings, but if he kept a teenage diary, it has not survived to enlighten us.

The India Office exams were considered highly competitive, though their intellectual standard was hardly stratospheric.[47] Blair took the compulsory papers in English, history, geography, mathematics and French, and three optional papers in drawing, Latin and Greek.[48] Twenty-six candidates were deemed to have passed the exams, and Blair was placed a respectable seventh. However, he still had to pass a medical, on 1 September, and then take a riding test; not much of a rider, he performed so poorly that he was pushed back to twenty-first of a surviving twenty-three. No matter: Burma, his first choice of posting, was considered something of an Imperial backwater. Blair would do. He was booked for a passage to Rangoon at the end of October.

47. Candidates were asked, among other things, to draw a chair at an angle, or a hut, or a bucket; to name and describe three members of the current Cabinet; to write a character sketch of an old gamekeeper or retired colonel; or to nominate the greatest prime minister since Pitt.
48. Not much challenge in these last two for an Old Etonian. His highest marks were for Latin.

JULY

1 JULY

WEIMAR

The Bauhaus[1] announced that its latest faculty appointment was the Russian painter Wassily Kandinsky (1866–1944), a co-founder of the Blaue Reiter (Blue Rider) school. The right-wing press, already convinced that the Bauhaus was a hotbed of leftists and subversives, exploded in outrage at the appointment of this 'Bolshevik':

> One asks oneself in vain what Kandinsky, whose orgiastic colour mysticism might be at home in the Russian cultural chaos, is do-ing in an academic appointment in [Weimar], a place ennobled through Germany's classical art . . . Kandinsky is a Bolshevist, meaning an anarchist in both politics and art . . .

Judging purely by the public record, the charges were not wholly without foundation, though that of mysticism had more force than the Bolshevist

1. The Bauhaus – in full, Staatliches Bauhaus – had been founded in 1919 by the architect Walter Gropius (1883–1969), though it did not offer courses in architecture until 1927. It was a unique body, whose nearest precedent may have been medieval crafts guilds: part place of learning and teaching, part secular monastery, part Utopian community and experiment in new forms of living. The school went through three phases in its relatively short history: the first in Weimar (1919–25), the next in Dessau (1925–32), and lastly a year in Berlin (1932–3), when it was closed down by the Nazis, and many faculty members fled. Its influence in almost every aspect of the visual arts, from photog-raphy and graphic design to architecture, has been immeasurably pervasive. It gathered together 30 or more of the most gifted, innovative and celebrated artists of the day and changed the look of the world from Chicago to Tel Aviv.

At the very start, there were just four faculty members: Gropius, the German-American painter Lyonel Feininger, the German sculptor Gerhard Marcks, and the strange Swiss painter Johannes Itten – a disciple of Kokoschka, a devotee of the esoteric Persian 'Mazdaznan' faith, and now one of the less well-known Bauhaus names, though a very powerful figure in shaping the school's early aesthetics. In 1920, the core faculty was joined by, among others, Oskar Schlemmer and Paul Klee (1879–1940). Other major names associated with the school at one time or another include: Ludwig Mies van der Rohe (1886–1969), Piet Mondrian (1872–1944), Theo van Doesburg (1883–1931) and László Moholy-Nagy (1895–1946), who replaced Itten after his resignation at the end of 1922.

slur. It is true that Kandinsky had voluntarily returned to pre-Soviet Russia in 1914, after two decades in Germany, but he had initially been declared an enemy alien and life was not easy for him. He had managed to find employment in the new regime's art institutions, and was even asked to establish a new institute for 'the Science of Art'.

It would be wrong to assume that his heart was in the Revolution, however. Soon, his more orthodox colleagues had begun to complain about his 'individualism'.

He had been sent to Germany in 1921 on state orders, with the mission of finding out about the state of cultural activities in the Weimar Republic, and remained on the Russian payroll for at least three months. But the fact that he had gone out of his way to publicise how much he would like to join the Bauhaus suggests that he was at best a lukewarm Leninist, however much the reactionary press might scream otherwise. The reality was that Kandinsky's view of art had always been spiritual, rather than Marxist.

1922 was a turbulent year for the Bauhaus. Economically, the prospects looked good: the local elections of September 1921 in Thuringia had resulted in a leftist coalition – the most radical in Germany – that gave unprecedented support and approval to the school. Encouraged by this, Gropius came up with some far-reaching initiatives that aggravated divisions within the Bauhaus and enraged some factions outside. Hoping to unite himself with the local government's plans for a complete overhaul of the educational system, and also planning to propose the Bauhaus as a prototype for all art education in the region, on 3 February he announced a thorough re-examination of the school's activities.

From this point on, and for the rest of the year, the Bauhaus was split between two factions. On the one side, Gropius, who had become persuaded that the route out of the school's chronic financial problems was to embrace commercialism, both by seeking a major architectural commission which might finally show the public what the Bauhaus could do, and by producing objects which could be sold at a reasonable profit.[2] On the other, Itten, who, despite his strange religious beliefs,

2. In one notorious case of Bauhaus perfectionism, a student had been permitted to spend an entire year making a single metal teapot.

was in some ways more realistic: his main proposal was that the Bauhaus should now concentrate on making models for industrial production.[3]

Conditions deteriorated towards the end of the year. Gropius sacked a recently appointed business manager, who responded by bringing charges that Gropius's direction of the school was shamefully incompetent. Disgruntled Bauhaus members also began to complain that Gropius had been using state funds to pay the salaries of employees in his private practice, and – still more damaging – that he had been seducing female students. By the end of the year, the Bauhaus looked doomed: internally divided, almost bankrupt, subject to a humiliating external investigation, and without even an agreed set of statutes. It was hard to believe that the Bauhaus could survive for more than a few weeks.

TOKYO

The official opening of Frank Lloyd Wright's Imperial Hotel, opposite the grounds of the Japanese Imperial Palace. In fact, work on the hotel was still not altogether complete – by now, the project had run more than three years past its target date, and had cost something in the region of $4.5 million dollars. Only the intervention of the Japanese royal family had made the additional financing possible. Lloyd Wright (1867–1959) was no longer in charge of his own creation; fairly or not, he had been held responsible for a fire on 16 April, and the project was handed over to his senior assistant, Irato Endo.

The Imperial Hotel was Wright's first major commission after the tragic events of 1914 at his self-built house Taliesin, in Spring Green, Wisconsin.[4] Driven almost to despair, Wright managed to pull himself through after having a vision of Taliesin rising, like a phoenix, from the ashes. The commission was all the more welcome to him as he was

3. The deeper conflict here, as Itten explained, was between the school's expressionist heritage and its craft aspect. Was its main function to foster individual creativity, or to perfect a tradition of craftsmanship? The crafts people had angrily decided that they already knew the answer to that one: whenever he visited the workshop apprentices, Itten treated them like lesser beings. These were genuine ideological differences, but Gropius saw that Itten was not a pure idealist; he had his eye on Gropius's job.

4. A recently hired servant had gone on a killing spree, and had murdered seven people with an axe before setting fire to the house and swallowing a large draught of acid. He died in prison hospital seven days later.

passionately fond of many aspects of Japan, especially its classical arts. He had first visited the country in 1905, and became both a collector of and later a dealer in antique prints.[5] He spent the better part of six years working on the Imperial Hotel, and rented a modest but elegant apartment within walking distance, flying back to America from time to time when smaller projects cropped up.

For all its vexed history, the hotel was undeniably impressive, designed by Wright in what was called a 'Mayan Revival' style, incorporating a pyramid structure and an ingenious cantilever system designed to safeguard the building against earthquakes.[6] From July onwards, it became a centre for Tokyo's elite social life.[7] Its high-domed dining room could seat 700 guests at each meal, and there were 285 bedrooms. About four million purpose-made tiles went into its construction. Wright left Japan in the autumn, and never returned.

1922 was also the year in which Wright finally managed to persuade his estranged wife, Kitty, to agree to a divorce.[8]

PARIS

Wyndham Lewis visited Pound's studio and found 'a splendidly built young man, stripped to the waist, and with a torso of dazzling white, standing not far from me. He was tall, handsome, and serene, and was repelling with his boxing gloves – I thought without undue exertion – a hectic assault of Ezra's. After a final swing at the dazzling solar plexus (parried effortlessly by the trousered statue) Pound fell back upon his settee.' The young man was Ernest Hemingway.[9]

5. Though this aspect of his career is not often discussed, his trade in Japanese antiquities – not always entirely scrupulous – was profitable, and often allowed him to support his architectural practice through lean times.

6. Indeed, the Imperial remained unscathed during the major Tokyo earthquake of 1923, which destroyed many buildings in the neighbourhood.

7. Later in the year, Einstein performed on the violin here.

8. This left him free to marry his lover, Maude Noel, in 1923, though this second marriage lasted only a year or so, thanks to Wright's distress at her various addictions. In 1924 he met the woman who would be his third and last wife, Olga Lazovich Hinzenberg, a dancer with the Petrograd Ballet and some-time disciple of Gurdjieff at Fontainebleau. (See 1 October.)

9. Hemingway also recorded a version of this meeting in *A Moveable Feast*, which is very hostile to Lewis: 'He had a face that reminded me of a frog, not a bullfrog but just any frog . . . Lewis did not show evil; he just looked nasty.' Hemingway added that Lewis had the eyes 'of an unsuccessful rapist'.

LONDON

Winston Churchill finally agreed to allow T. E. Lawrence to quit the Colonial Office. Three days later, Lawrence wrote his official letter of resignation. He had now left behind all involvement with the politics of the Middle East, though not his memories of the war, and his attempt to make a great book of them.

UK

Cora Millay, the mother of the American poet Edna St Vincent Millay,[10] wrote from the village of Shillingstone in the county of Dorset to explain to the family why she and Edna had suddenly fled from Paris to rural England. Edna, she explained, was in great need of a rest after her *Vanity Fair* articles, and Paris was too noisy and stimulating; French food disagreed with her; and she was having a bad time with her bowels.

All lies. Edna was pregnant, after a brief and largely sordid affair with a foppish Frenchman[11] who had disappeared just days after learning of the growing foetus. Cora had worked for 15 years as a nurse, and knew some tricks. First she took Vincent (as Edna liked her friends to call her) on brisk 12-mile hikes, trying to induce a miscarriage. When this failed, she deployed her remarkable knowledge of folk remedies, collecting clover, milk thistle, nettles, pigweed, henbane, gentian and borage. The potion she made from these sounds like something from *Macbeth*, but it worked, and her daughter duly aborted.

It was a low point in Vincent's life, and though she was no longer pregnant, she continued to suffer from severe abdominal pains and bloating; later, still ill, she flushed and grew withered. And she could not write; not even a short verse.[12]

10. Thomas Hardy once said that the United States had two great attractions: skyscrapers, and Edna St Vincent Millay.

11. Years later, she could not even remember his name, though it might have been something like 'Daubigny'.

12. She finally returned to New York in January 1923, broke, demoralised and still very ill. Edmund Wilson was one of many friends shocked at her appearance. (It is likely that she was suffering from acute inflammation of the large or small intestine.) But life was soon to be happier. She met, fell in love with, and married a rich and generous man, Eugene 'Gene' Boissevain, who paid for the medical treatment she so urgently needed. And she won the 1923 Pulitzer Prize for poetry – one thousand very useful dollars. She was the first woman to win the prize, and the judges had bent the rules a little to allow it, since her only publication of 1922 was a revised reissue of *A Few Figs from*

3 JULY

WEIMAR

From his new home at the Bauhaus, Wassily Kandinsky wrote to his old friend, the composer Arnold Schoenberg. It was their first contact since the summer of 1914, after which they had been parted both by the war and by Kandinsky's return to Russia.

> My dear Schoenberg
> I was very disappointed when I arrived in Berlin and heard that you were no longer there . . . Everything has really changed since our time together in Bavaria. Much that was a daring dream at that time has now become the past. We have experienced centuries. At times I am amazed that anything from the 'old' world is still to be seen. Here in Germany I have been overwhelmed by new impressions. You know of course that we lived in Russia for four years – seven in all – completely cut off from the whole world and had no idea of what was taking place here in the West. I came with mouth wide open and gulped and gulped – until I felt completely different. I have not worked at all myself, and now lie buried under a mountain of different tasks which I must quickly finish. There is so much to do that I do not know where to begin. But it is a lovely feeling to have so much of one's *own* work before one. In Russia I did a great deal of work, but for 'the public Good' – my [own] work was always left behind; I stole the time for it from the public Good. And I arrived so drained and worn out that I was ill a whole month – could only lie down and read stupid books . . .

By 'public Good', Kandinsky was referring to his immediate post-Revolutionary work as a museum founder, teacher, organiser and theorist of art.

Thistles, originally published in 1920. On their marriage, Gene bought her a valuable emerald ring, much-needed dental surgery, and a house of her own in Greenwich Village.

4 JULY

LONDON

Eliot wrote to Sydney Schiff about Proust. He wanted a piece by Proust to appear in *The Criterion*, and had written to the novelist saying that he did not know of anyone better qualified than Schiff to translate his prose into English.

Also, a tantalising detail: 'I will send the books to Einstein as you request.' Had Einstein expressed an interest in Eliot's work?

PARIS

The third sale from the Kahnweiler sequestrations, at the Hotel Drouot. Daniel-Henry Kahnweiler (1884–1979), the German-born art critic, collector and gallery director, had been the single most generous and vocal champion of the Cubists and other innovative Parisian artists in the years before the First World War; Picasso once wondered out loud what on earth he and his friends would have come to had it not been for Kahnweiler's passionate support. Art historians have referred to Kahnweiler's small Parisian gallery as the 'cradle of Cubism'. But the French government was not impressed by his contributions to French culture, and when war broke out in 1914, Kahnweiler was classified as any enemy alien, and had his entire collection of paintings confiscated. The July 1922 sale was poorly timed – the art market was at its lowest in years, and many of those who might have bought pictures had already left Paris for the summer. The sale included 10 Picassos, 15 Braques, 12 Derains and 30 Vlamincks.

André Breton bought three Braques and a Léger for his employer Jacques Doucet.[13] He was also badgering Picasso to sell Doucet *Les Demoiselles d'Avignon* – Breton was one of the very small group of people who had recognised it as the masterpiece it is now generally acknowledged to be.[14] The fourth and final Kahnweiler sale was held the following year: 7 and 8 May 1923. It included 50 Picassos, six Braques, 36 Derains, 26 Grises and 92 Vlamincks.

13. Doucet deserves mention as a patron. He was willing to listen to Breton's puffings of the young, more or less unknown, and definitely impoverished surrealist poets, and generous in buying their manuscripts. Ultimately, he left his huge collection of manuscripts to the Sorbonne.
14. That sale did eventually go through, but not for another two years.

5 JULY

NEW YORK

Edmund Wilson published a highly perceptive review of *Ulysses* in the *New Republic*; it was, according to Mary Colum (in her 1947 memoir *Life and the Dream*) one of the three reviews that pleased Joyce the most, the others being by Gilbert Seldes (see 30 August) and herself (see 19 July). Wilson was already one of the most influential young critics in America, and his piece did much to establish Joyce's reputation in the United States.

Like Pound, Wilson compared Joyce to Flaubert; unlike Pound, he did not see *Ulysses* as an encyclopaedic farce in the manner of *Bouvard et Pécuchet*: rather, he insisted, it was a book of 730 pages 'which are probably the most completely "written" pages to be seen in any novel since Flaubert'. He praised the Flaubertian precision of Joyce's use of dialects – 'used to record all the eddies and stagnancies of thought'; he disagreed firmly with Arnold Bennett's view that the novel was a misanthropic satire. Joyce's bourgeois figures, he said, 'command our sympathy and respect'.

Wilson conceded some points to the book's enemies; above all, that parts of it are indeed dull. He also questioned the value of the Homeric substructure, and felt that Joyce's yearning for symbolism 'sometimes overruns the bounds of art into an arid ingenuity which would make a mystic correspondence do duty for an artistic reason'; he believed that the author's facility for parody led him astray, and that the passages which grafted burlesque upon realism became simply unreadable.

And yet, he finally asserted, *Ulysses* was a work of 'high genius', which set the standard for prose fiction as high as that for poetry or drama. '*Ulysses* has the effect at once of making everything else look brassy. Since I have read it, the texture of other novelists seems intolerably loose and careless; when I come suddenly unawares upon a page I have written myself I quake like a guilty thing surprised.'

Wilson ended by passing on a rumour he had heard that Joyce was to give up writing. This may be true, he mused, since there were weaknesses of a Flaubertian kind that might point to a want of vitality. But:

> . . . if he repeats Flaubert's vices – as not a few have done – he also repeats his triumphs – which almost nobody has done. Who else has had the supreme devotion and accomplished the definitive

beauty? If he has really laid down his pen never to take it up again
he must know that the hand which laid it down upon the great
affirmative of Mrs Bloom, though it never write another word, is
already the hand of a master.

7 JULY

Count Harry Kessler wrote in his diary:

> Spent the afternoon with the painter and draughtsman George
> Grosz. The devotion of his art exclusively to the depiction of the
> repulsiveness of bourgeois philistinism is, so to speak, merely the
> counterpart to some sort of secret idea of beauty that he conceals
> as though it were a badge of shame. In his drawings he harasses
> with fanatical hatred the antithesis to this ideal, which he protects
> from public gaze like something sacred. His whole art is a cam-
> paign of extermination against what is irreconcilable with his se-
> cret 'lady love'. Instead of singing her praises like a troubadour, he
> does battle against her opponents with unsparing fury like a dedi-
> cated knight. His is an excessively sensitive nature which turns
> outrageously brutal by reason of its sensibility, and he has the
> talent for delineating this brutality creatively.

An admirably perceptive account. The cartoons of George Grosz (1893–
1959) are not only defining documents of the Weimar Republic, but
among the most angry, demonic caricatures in the history of art. His
primary targets were the ruling class and their parasites: bloated, de-
formed, hideous figures whose outward ugliness bore witness to their in-
ner squalor. His cartoons are disgust-driven visions of brutal militarists,
smug businessmen – all the human vermin who had brought about the
horrors of the last war and profited by it, and were hungrily preparing for
the next – and of their lickspittles and hangers-on.[15] His influence on

15. Though obviously very much a man of the left, Grosz tended to fight shy of party dogmas. He
had joined the German communist party (KPD) in 1919, but left it in 1922 after spending several
months in Russia, where he met Lenin and Trotsky and became disillusioned with developments in
the new socialist state. A former member of the Berlin Dada movement, and soon to be a leading

subsequent generations of political (and non-political) cartoonists has been immeasurably far-reaching, and continues in the twenty-first century.

9 JULY

LONDON

Eliot wrote a detailed letter to Pound, mainly about *The Criterion*.[16] Pound had just come back to Paris from his Italian journey. He immediately began to arrange an exhibition, to be held in his own flat, of paintings by his Japanese friend Tami Koume. On the same day, Eliot wrote to the polymath literary scholar E. R. Curtius, in German, requesting a contribution for *The Criterion* – perhaps a reprint of his article on Proust? 'I would . . . very much like to make your work known in England.'

Much of his correspondence from this point on was devoted to recruiting talent for *The Criterion*. Much, but not all. On 13 July he wrote to Richard Aldington: 'You know that I have no persecution mania, but that I am quite aware how obnoxious I am to perhaps the larger part of the literary world of London and that there will be a great many jackals swarming about waiting for my bones.' A couple of days later, Aldington received an angry letter from Vivien: 'He does stand or fall by this review. Can't you understand it? Each person who gives him a push now gives him a push out of England. And that will be damned England's loss.'

11 JULY

CALIFORNIA
The Hollywood Bowl opened.

figure of the so-called New Objectivity, Grosz was most notorious at this time as the author of a bitingly satirical collection of lithographs entitled *Gott mit uns* (God With Us – the traditional motto of the German army), published in 1920. Charged with insulting the army, he was fined 300 marks and the edition was destroyed. He eventually fled the country in 1933 and sought exile in the United States.

16. He also made reference to Dr Lewis Berman, an endocrinologist from New York, and the author of *The Glands Regulating Personality* (1921); Pound had written about him in an article, 'The New Therapy', published in the *New Age* in March.

12 JULY

PARIS

The art dealer René Gimpel met Picasso for the first time, and wrote a memorable, perceptive sketch in his diary:

> We met at Paul Rosenberg's. He speaks good French but has re-
> tained a strong Spanish accent. The head of the cubist school is a
> blood pudding, a bleached blood pudding. He's not yet forty, has
> brown eyes like very worn counters in a child's game. The face
> of this pudding is cut by six perpendicular lines – as though the
> strings of its muslin bag had been untied – falling from the eyes,
> the nostrils, and the corner of the lips.

13 JULY

LONDON

The Polish-born, British-based anthropologist Bronislaw Malinowski pub-
lished *Argonauts of the Western Pacific*, which was almost immediately
acknowledged as one of the greatest of all ethnological tracts. It may even
be said to have revolutionised the discipline of anthropology, certainly in
Britain – where it is widely held to have launched modern anthropology –
but also in other countries.[17]

15 JULY

PARIS

One of Proust's last memorable nights on the town, which turned very
ugly.

His friend Edmond Jaloux had persuaded Proust to join him and Paul
Brach on a trip to the hottest spot in Paris, Cocteau's favourite watering

17. See, for example, Adam Kuper's history *Anthropologists and Anthropology: The British School
1922–1972* (1973).

hole, the Bœuf sur le Toit.[18] When they arrived at the club, Proust began to speak about the future development of characters in his novel. Saint-Loup, he revealed, would become a homosexual like Charlus, and for the same reasons.

Proust thought the food here – a roast chicken – very good, but the service was sloppy and even hostile compared to the high standards he was used to at the Ritz. None the less, he tipped all the waiters more than handsomely, even one who had not served his table, explaining to his friends that he could not bear the man's sorrowful expression. Jaloux left after dinner for another appointment, leaving Proust and Brach alone to cope with a bunch of rowdy drunks who joined them and began to heckle a crowd of pimps and criminal types at the other end of the bar. Before long, one young drunk – apparently annoyed by Proust's foppish fur coat and bowler, and possibly having overheard the talk about homosexuality – lurched over and began to pick a fight. Far from being intimidated, Proust was fired up by this reminiscence of his duelling youth, and he challenged the young man to formal combat at dawn. The more sensible bystanders tried to calm things down, and Proust was led away; though not without having determined that his adversary was one Jacques Delgado, of the Rue Greuze. When he reached home, Proust wrote out a formal challenge, and had his chauffeur Odilon (husband of his faithful housekeeper Céleste) deliver it to Delgado's home.

By now, Delgado was not only sober but full of remorse. He wrote Proust an apology so eloquent that Proust was moved to reply: 'You owed me no excuses, and it is only the more delicate and elegant on your part to offer them . . . The elevated sentiments of your letter give me precisely the pleasure I should have had after a duel. I mean, sir, that of shaking you very cordially by the hand.'

BRITTANY

The Picassos arrived in the fashionable coastal resort of Dinard, and checked into the Hotel des Terrasses. On the 22nd, they moved into their rented summer home, the Villa Beauregard, a sizeable Second Empire

18. Jaloux called for him just as Céleste was knotting his tie and giving him his habitual *tisane*. Proust began to complain that it was not nearly hot enough, but, seeing her wounded look, changed tack and declared that a lukewarm drink was just the thing for his state of health.

house on the Grand Rue.[19] This choice of holiday location was a rare break in Picasso's routine, since he usually preferred to summer in the Midi; it was largely to please Olga that he chose to put up with the overcast skies of Brittany rather than exult in the blazing sun of the south. It rained a good deal that summer, and most of the holidaymakers were driven to seek their amusements in the two casinos and several grand hotels, with their palm courts and dance bands.

Picasso was mainly here to work, though, and did so despite all the distractions of Paolo's screams and tantrums – he was teething – Olga's full social calendar and a number of friends and acquaintances also staying in town.[20] When the weather was good, he would go outside to paint, and executed at least one view of Dinard and a couple of others of Saint-Malo, just the other side of the bay; he also painted pregnant women, and children. It has been said that the works of this summer radiate happiness; but the happiness was short-lived, since Olga fell suddenly ill.

19 JULY

PARIS

Cocteau wrote a letter to his mother, commenting on the novel that he was in the middle of writing, *Le Grand Écart*.[21] The book draws heavily on Cocteau's experiences as a young student, and, he said, on the pains of being 'madly in love' with a woman called Madeleine Carlier. When published, it sold well; there were plenty of sexy scenes, depicting students living a life of light-hearted promiscuity. Gide thought the novel was dishonest about Cocteau's true sexuality, and saw the character of Madeleine as a man in novelistic travesty. Cocteau protested that Madeleine was a real woman, and had indeed been his mistress. To his mother he wrote

19. Today the Avenue Georges V.

20. Most of his work from this summer period was in the vein of cubist still lifes, about 30 in all, some of them in what is known as the 'zebra' style, in which stripes cross over planes of colour. Subjects: the usual cubist repertoire of bottles, glasses, cigarette packets, tobacco. Colours: muted almost to the point of monochromaticism in some, vividly brilliant to the point of garishness in others.

21. The title is hard to translate. In dance terms, it means the move known as 'the splits'. But '*écart*' also means 'separation', 'the distance between' and so on; Cocteau explained that he was alluding to the distance that separates an experienced older woman from an unworldly young man.

that the hero 'is not me, but resembles me in certain respects'. He was try-
ing, he told her, to make the novel both funny and sad; and he concluded
that:

> Now I must 'retouch' every page, go over it until it is a 'likeness',
> as I do with my portraits or caricatures. I, who swore never to
> write again! It is as though a runner swore never to sweat again.
> A mind runs and sweats – that's what a book is.

IRELAND

'The Confessions of James Joyce', Mary Colum's review of *Ulysses*, was
published in the *Freeman*.

As the title suggests, Mary Colum understood *Ulysses* as belonging 'to
that class of literature which has always aroused more interest than any
other': the confession. She proposed that the book could not be properly
understood by anyone unfamiliar with the history of Irish nationalism, or
that of the Roman Catholic Church, or of Dublin and its more prominent
and notorious citizens. 'The author himself takes no pains at all to make it
easy of comprehension.' She noted, too, the encyclopaedic nature of the
knowledge embraced by the novel.

Her review then turned, with admiration, to the character of Stephen
Dedalus, and she asked, rhetorically, what book had ever so adequately
expressed the sense of spiritual humiliation felt by sensitive young Irish-
men under English rule, or the fascination exerted by the Church even
upon those rebel souls, like Dedalus, who were in flight from it. After
further praise for the way in which Joyce represented the inner workings
of Dedalus's mind, and then Bloom's, she declared that the second half
of the book was of no great literary interest, being given too much over
(Edmund Wilson's complaint) to parody. She concluded her piece by ob-
serving that with *Ulysses*, a new literary form had appeared – one that be-
longed as much to science (meaning, presumably, the science of
psychology) as to art. But the grand rhetorical flourish of her piece – and
presumably the part that pleased Joyce most – had come a few paragraphs
earlier.

> What actually has James Joyce achieved in this monumental
> work? He has achieved what comes pretty near to being a satire

on all literature. He has written down a page of his country's history. He has given the minds of a couple of men with a kind of actuality not hitherto found in literature. He has given us an impression of his own life and mind such as no other writer has given us before; not even Rousseau, whom he resembles . . .

LONDON

E. M. Forster wrote to his mother, describing his recent visit to Mr and Mrs Thomas Hardy at Max Gate. He had been introduced to the Hardys by Siegfried Sassoon, and they seemed to get along well, though Forster often asked himself why he pursued the friendship quite so keenly, since the sad reality was that he found Hardy's conversation very dull, especially when the old writer talked about books. This time, Forster tried to steer conversation away from the topic, and for a while he succeeded, until Hardy sensed what was going on, grew angry and insisted on 'revealing the secrets of his art'.[22]

After tea, Hardy took Forster round the graveyard devoted to his generations of cats, each of which had its own headstone. All of them, Forster noted, seemed to have met with violent deaths: Snowball run over by a train; Kitkin cut in two; Pella another train victim . . . and of course, Hardy added, they had only buried those cats whose remains had been discovered. Many more had simply vanished. Forster told his mother that the scene struck him as so Hardyesque that he could remain solemn only with great effort.

20 JULY

AUSTRIA

Arnold Schoenberg (aged 47) replied to a note from his old friend Kandinsky (see 3 July) with a moving letter, from Traunkirchen, about his artistic and spiritual struggles:

22. Next to talking about books, Hardy most liked to talk about his pets; when a reporter called as they were having tea that day, his dog Wessie gave a bark; the doting author took this as a sign of great perspicacity, as though Wessie had intuited that reporters were important people who must be paid attention.

My Dear Kandinsky

I'm very glad to have heard from you at long last. How often I've thought of you with anxiety during these eight years! And how many people I have asked about you, without ever getting any definite and reliable information. You must have been through a great deal!

I expect you know we've had our trials here too: famine! It really was pretty awful! But perhaps – for we Viennese seem to be a patient lot – perhaps the worst was after all the overturning of everything one has believed in. That was probably the most grievous thing of all.

When one's been used, where one's work was concerned, to clearing away all the obstacles often by means of one immense intellectual effort, and in those 8 years found oneself constantly faced with new obstacles against which all thinking, all power of invention, all energy, all ideas, proved helpless, for a man for whom ideas have been everything it means nothing less than the total collapse of things, unless he has come to find support, in ever increasing measure, in something higher, beyond. You would, I think, see what I mean best from my libretto 'Jacob's Ladder'[23] (an oratorio): what I mean is – even without any organisational fetters – religion. This was my one and only support during those years – here let this be said for the first time.

21 JULY

NEW YORK

Publication day for Edith Wharton's keenly awaited novel *The Glimpses of the Moon*. It was an instant hit: 60,000 copies had been sold within three weeks of publication, and in late August Paramount bought the film rights for the very respectable sum of $15,000; noting this fad for Wharton's re-

23. Schoenberg had been working on *Jacob's Ladder* (*Die Jakobslieter*) since 1915, when he was doing his compulsory military service; he abandoned it, unfinished, later in 1922, but it was eventually completed some 10 years after his death (13 July 1951) by one of his pupils, and had its world premiere in 1961. In later life he re-embraced his Jewish faith, probably sometime in 1933, when he was forced into permanent exile by the Nazis. Both Kandinsky and Schoenberg had the honour of being pronounced 'degenerate' by Hitler's aestheticians.

cent fiction, Warner Brothers bought the rights to her previous novel, *The Age of Innocence*, which had won the Pulitzer Prize.

Wharton – who was 60 in 1922 – had been a full-time resident of France for many years, after making frequent visits to the country from her various homes in America.[24] She began *The Glimpses of the Moon* as early as 1919, and had planned a narrative in the vein of her earlier novel, *The House of Mirth*. She put it aside for a couple of years to tend to other projects, and then returned to it in the spring and summer of 1921, completing it in mid-September, a full nine months before the contracted deadline.

She went on to write a novella, *New Year's Day*, which she finished in mid February 1922. Her editor at Appleton, the resourceful and energetic Rutger Bleecker Jewett,[25] sold it to *Red Book* magazine for $6,000 – a sum which, she admitted, amazed her, especially since the exchange rate of dollars to francs was increasingly favourable to those who held American currency.[26] Emboldened by the *Red Book* coup, she asked Jewett for a

24. Her first base had been in Paris, at 53 Rue de Varenne; she had moved in on 3 January 1910 and kept it as her main address until 1919. Among her Parisian adventures of the pre-war period had been attendance at one of the four opening performances of *Le Sacre du Printemps* at the newly opened Théâtre des Champs-Elysées; she thought it 'extraordinary (in the good sense)', though by and large she had little taste for artistic modernism. She also became good friends with the 'adorable' Cocteau.

But the cold of Paris all too often made her ill in wintertime, and by 1922 she had established a habit of migrating between her two new French houses in the countryside. From June to November she would usually stay in Saint-Brice-sous-Forêt, an ancient village at the edge of the Montmorency forest, in the Pavillon Colombe – originally a *folie* built for the actress Marie-Thérèse Colombe towards the end of the seventeenth century, and extensively (and expensively) remodelled and rebuilt by Wharton when she bought the property soon after seeing it in 1918. Because houses near the war zone were now cheap, she was able to buy it for about $10,000 (90,000 francs). By the time of her death in 1937, it was valued at a million francs.

Though she does not seem to have paid much attention to them, she had some remarkable neighbours in Saint-Brice-sous-Forêt: Paul Eluard and his wife Gala (later to be married to Salvador Dalí) lived nearby at 3 Rue Chausse, and they would often be visited by Aragon, Breton, Crevel, Desnos, Ernst, Soupault and other members of the budding pre-surrealist group, who would write, paint, argue and go into trance states.

From December to May, Wharton would travel to the South of France and stay at her other great renovation, Sainte-Claire du Château, in Hyères, which she had built up from 1920 onwards on the ruins of a fourteenth-century castle and its outbuildings. She once said that the things she liked best about *The Age of Innocence* was that the royalties and the $1,000 prize money allowed her to build walls and plant orange orchards there.

25. Jewett had been her editor since the summer of 1919, and would remain so until shortly before her death; he was good for her fortunes, and they became friends as well as colleagues.

26. During the war, the franc had hovered around six or seven to the dollar, but by 1922 it was at 15 to the dollar and weakening all the time; by 1925 it was at 26 to the dollar.

larger advance for *Glimpses* than she had previously agreed to – $15,000 – since she wanted to profit by the exchange rate. 'I know,' she said ominously, 'that I can get practically any advance I like from other publishers.' She was right.

Jewett agreed to the new deal readily, since his team were already reporting brisk advance sales for *Glimpses*. He warned her, though, that the increasingly frank treatment of sexual matters in her work (mild, to be sure, by comparison with *Ulysses*) would prevent her from being published by most of the leading magazines.[27] Perhaps it was difficult, he suggested, for someone who had grown used to France to appreciate quite how touchy the American public could be when it came to such matters as adultery. Adultery was essential to the plot of *Glimpses of the Moon*, which was, as Wharton explained to her friend Bernard Berenson, a complex love story about 'a young couple who believe themselves to be completely *affranchis* [free-thinking, liberated] and up-to-date, but are continually tripped up by obsolete sensibilities and discarded ideals'. What this brief description fails to point out is one of the most unusual and gripping aspects of the tale: its clear-eyed treatment of the power of money over love.[28]

A few of the novel's reviews brimmed with admiration; most were cool or downright hostile. Rebecca West called it a 'dead thing'; Gilbert Seldes in *The Dial* wrote dismissively of the 'watered wine of the plot', and declared that Wharton 'has left her work empty'. The reviewer for *Bookman* dismissed it as 'a puppet show', 'a gaudy thing with no sincerity whatever'; and *The Times Literary Supplement* found it 'slight', with characters

27. As he explained it to her, magazine editors were now 'victims of the bromidic taste and the moral tremors of our dear reading public', and would be on the receiving end of angry letters if they printed anything too racy.

28. Both of the young lovers are, in effect, agreeable parasites – all but penniless, but able to live the highest of high life in London, Paris, Venice, the Greek islands and even India by acting as delightful human pets to the very rich. Both are well aware that ruin faces them the second their charm wears thin. Nick Lansing is, at least to start with, the more idealistic of the two: he has literary ambitions, and probably literary talent, combined with enough realism to see that his poetry and highbrow fiction is of a kind that could never make money; Susy Branch, a professional companion to rich ladies, is at least a shade more materialistic. They fall genuinely in love, and, recognising the potential economic disaster that may come of this, agree to divorce the moment a more lucrative potential spouse should appear. Showered with handsome cheques from all their wealthy friends, they begin their marriage in a waking dream of beauty, calm and luxury; but a fatal crack appears when Nick discovers that the secret price of their stay in a Venetian *palazzo* has been Susy's conspiratorial aid to their hostess's latest extramarital fling.

who were no more than 'algebraical symbols'. Jewett wrote ruefully to Wharton that 'the Young intellectuals . . . like young terriers worrying a muff, have lashed themselves into a rage over your novel'.

The reading public ignored these terrier-critics, and dollars poured into Mrs Wharton's French bank account. In its first month of publication, *Glimpses of the Moon* outsold *The Age of Innocence* by three to one. By mid September, Jewett was able to report to her a rumour that Somerset Maugham might be writing a stage version.[29]

By the end of 1922, receipts from *Glimpses* – sales, serial rights, film rights – amounted to $60,000. In addition to this windfall, Wharton also earned some $10,000 from short stories and the clever satirical novella *False Dawn*, about Ruskin and the art world. Her standing as a best-selling author was unassailable, and however much the snootier critics had sniped at *Glimpses*, her critical reputation was also assured.

OXFORD

T. E. Lawrence received the proofs of the final section of *Seven Pillars of Wisdom*, from the printers of the *Oxford Times*. He corrected them, and eight copies of the book were duly printed and bound. One copy went to Edward Garnett at Jonathan Cape; and the next month Lawrence sent another to George Bernard Shaw. (See 17 August.)

July 1922 was also the month in which Lawrence's close friend Robert Graves published his first critical work, *On English Poetry*, a brief work subtitled 'an Irregular Approach to the Psychology of this Art, from Evidence Mostly Subjective'.[30] This was an unusual work, not much read at the time, though it later came to have a considerable if seldom openly admitted influence on other critics. It was full of references to the early-twentieth-century mythological and anthropological writings of Frazer, Taylor, Marett and others.

Graves freely admitted that he owed most of his knowledge of these thinkers to W. H. R. Rivers – and his fascination with Rivers's theories grew

29. This never happened, but the film version opened in April 1923 – a seven-reel feature, now lost, with Bebe Daniels as Susy and David Powell as Nick. The dialogue – for which he was paid $500 – was by F. Scott Fitzgerald.

30. His latest collection of poems, published in the same year, bore the strange title *Whipperginny*: the word can mean, variously, Purgatory, or an old card game, or a vile woman.

more intense over the following years.[31] Among other matters, *On English Poetry* proposed that the poet might be seen as the modern world's equivalent of a tribal shaman, or, as Graves put it, 'witch doctor': 'When conflicting issues disturb [the poet's] mind, which in its conscious state is unable to reconcile them logically, the poet acquires the habit of self-hypnotism, as practised by the witch doctors, his ancestors in poetry.' In other words, he was proposing that poetry was generally born of trance states, conditions of consciousness in which words can unleash their full – Graves would sincerely have said magical – power.[32]

At the time, Graves and his wife Nancy were living with their young children in a cottage called World's End, in the village of Islip, about eight miles north of Oxford. He was in poor health, suffering from very severe bronchitis that often confined him to bed; so poor, in fact, that he had been unable to sit his Oxford BA finals. Despite this, he had, in 1921, published a collection of poetry, *The Pier-Glass*, a volume which came to be seen as the beginning of his distinctive, mature style as a poet. Some readers may have been surprised to note that the volume was dedicated to T. E. Lawrence: Lawrence of Arabia. It was more than a gesture of admiration: Graves had consulted Lawrence for help with every poem in the book.[33]

31. Rivers was of more than purely intellectual interest to Graves: the poet recognised that the war had left him in a very bad way emotionally and mentally, and he sought to heal himself in accordance with Rivers's principles: 'I decided to see as few people as possible, stop all outside work, and cure myself. I had already learned the rudiments of morbid psychology from talks with Rivers, and from his colleague, Dr Henry Head, the neurologist.' It is pleasing to note that Graves's mental condition did improve greatly over the next couple of years, though whether this can be seen as a vindication of Rivers or simply a case of the healing effects of a quiet, withdrawn life is a matter for debate.

32. What sets this belief apart from other contemporary theories about inspiration and creativity – say, those of the proto-surrealists and their 'sleeping fits'– is that Graves placed great stress on the craft of revision, which would bring these trance findings to the light of common day. He was one of the most tireless revisers among twentieth-century poets.

33. Graves had met Lawrence in March 1920, at a guest night at All Souls, where Lawrence was now a research fellow. Their mutual liking was immediate – the word 'liking' is perhaps too mild, since Graves soon came to hero-worship Lawrence – and the friendship was strengthened by the fact that Lawrence had read some of Graves's poetry as early as 1917, in Egypt, and had liked what he read. Many years later, Graves recalled that on that first encounter Lawrence had 'asked me if I was Robert Graves the poet – which embarrassed me, but it turned out that my brother Philip and my Uncle Robert had been directing activities from Egypt when he first appeared in Arabia . . . He became my best friend . . .'

Lawrence seems to have shared this feeling, and he confided as much in Graves as his fiercely self-protective nature allowed him to confide in any man. It says much for their friendship that

The 'Uncrowned King of Arabia' had always nursed very lofty literary ambitions, all the more ardent now that he was at work on his personal epic, *Seven Pillars of Wisdom*, and he began to bombard Graves with questions about modern poetry.[34] Graves, immensely flattered by these attentions from an international hero, reciprocated by asking Lawrence for advice on his own poetry. It is doubtful that he drew much artistic benefit from these remarks, though Lawrence was a generous and welcome help in financial matters – in the summer of 1921, he gave Graves some fragments from the latest draft of *Seven Pillars of Wisdom* to sell for serial publication in America, and so enabled the impoverished poet to pay off a worryingly large debt.

It was in Lawrence's rooms that Graves met Ezra Pound: 'You will dislike each other,' Lawrence rightly predicted as he introduced them. Graves found many reasons to dislike Pound, from what he took to be a rather limp handshake, to his knockabout slang and his ambition to bring 'continental' forms and tones into English verse. Nor, incidentally, did Graves much care for *The Waste Land*, though he conceded a morbid power to Eliot's earlier verses, and found Eliot interesting as a person.

22 JULY

CANADA

The *Toronto Daily Star* published Hemingway's story 'A Veteran Visits the Old Front'.

It was a rueful, reflective, melancholic piece about how bad an idea it had been for him to go back, in the company of his wife, to the places in

Graves was one of the very few to whom Lawrence confessed his terrible need to be punished. Both in person and in letters, the two men discussed their sexual natures, and the torments of sexual desire, with an openness they showed nowhere else in their lives at the time.

34. One famous fruit of these exchanges is the dedicatory poem of *Seven Pillars*, which Graves helped Lawrence improve from its clumsy original during the first few months of 1922: Graves bluntly told him that this draft was 'neither prose nor verse, but poetic quartz in which the veins of metre run . . . you tempt and disappoint with blank-verse promises . . .' He also correctly identified the original of 'S.A.', the poem's dedicatee, with Selim Ahmed (Dahoum), but Lawrence threw him off the track by telling him that 'You have taken me too literally. S.A. still exists, but out of my reach, because I have changed.'

Italy where he had been under fire during wartime; about the impossibility of finding well-loved places from the past, since peacetime made them something quite different, and strange – not because of their dereliction, but because of their shoddy newness, their lack of emotional associations either for locals or for returning outsiders. 'I had tried to recreate something for my wife and had failed utterly. The past was as dead as a busted Victrola record. Chasing yesterday is a bum show – and if you have to prove it, go back to your old front.'

23 JULY

LONDON

Leonard Woolf read the first draft of *Jacob's Room*, on which Virginia had been working hard most of the year. He pronounced it her best work: 'Amazingly well written.' Despite her excitement at this warm response, she grew anxious at how the book would be received by critics and the general public. Partly to stop her mind from fretting, she kept up a regime of steady labour, writing both essays and the story that would eventually develop into *Mrs Dalloway*.

PARIS

Pound had arranged for Joyce to have a consultation with Dr Louis Berman, an eminent endocrinologist from New York. Dr Berman prescribed endocrine treatment for Joyce's arthritic back, and after just a quick glance at the state of his teeth, recommended that they should be X-rayed at once. When the prints came back, the teeth were revealed to be so rotten that Berman recommended complete extraction.[35] Joyce hesitated at this drastic move, but agreed to the endocrine cure. He also consulted another leading ophthalmologist, Dr Louis Borsch.

35. This operation was eventually performed in April 1923. Joyce said to Giorgio that the loss did not greatly bother him: 'They were no good anyway.'

27 JULY

USA

The young poet Hart Crane wrote to an unknown correspondent, raving about his discovery of *Ulysses*, which a friend had left with him:

> I feel like shouting EUREKA! . . .
>
> You will pardon my strength of opinion on the thing, but it appears to me easily the epic of the age. It is as great a thing as Goethe's *Faust* to which it has a distinct resemblance in many ways. The sharp beauty and sensitivity of the thing! The matchless details! . . .
>
> It is my opinion that some fanatic will kill Joyce sometime soon for the wonderful things said in *Ulysses* . . .

29 JULY

HOLLYWOOD

Walt Disney released his first animated film, *Little Red Riding Hood*. It lasted just six minutes, and was in black and white, and silent. This debut was followed by:

> *The Four Musicians of Bremen* (August 1922)
> *Jack and the Beanstalk* (September 1922)
> *Goldie Locks and the Three Bears* (October 1922)
> *Puss in Boots* (November 1922)
> *Tommy Tucker's Teeth* (November 1922)
> *Cinderella* (December 1922)

An empire was being born.

30 JULY

BUCKINGHAMSHIRE

After many months and years of soul-searching, and instruction from Father John O'Connor, G. K. Chesterton was finally received into the

Roman Catholic Church. The setting for this conversion was incongruously ugly – a makeshift chapel (in effect, little more than a wooden shed with a tin roof), annexed to the Railway Hotel in Beaconsfield. The clergymen attending the ceremony were Father O'Connor and Father Ignatius Rice. Chesterton made his confession to Father O'Connor at 3 p.m.; Father Rice comforted Chesterton's wife Frances, who sobbed uncontrollably throughout. She and her husband were henceforth to be divided by faith.

News of Chesterton's conversion spread rapidly; a convert of his fame and popularity was seen as a very considerable asset to the Catholic cause.

ITALY
A nationwide general strike began, as a mass protest against fascist violence. The fascists reacted by stepping up their violent attacks.

BERLIN
Count Harry Kessler wrote in his diary: 'At noon a "Never Again War" demonstration in the Lustgarten. About a hundred thousand people, with red and red-black-gold flags, Many youth movement adherents. I spoke from the Palace staircase near the bridge.'

MOSCOW
Maxim Gorky wrote to Herbert Hoover:

> In all the history of human suffering I know of nothing more trying to the souls of men than the events through which the Russian people are passing, and in the history of practical humanitarianism I know of no accomplishment which in terms of magnitude and generosity can be compared to the relief that you have actually accomplished. Your help will enter history as a unique, gigantic achievement, worthy of the greatest glory, which will long remain in the memories of millions of Russians whom you have saved from death. The generosity of the American people resuscitates the dream of fraternity among people at a time when humanity greatly needs charity and compassion.

The context of this letter was Hoover's decision to send the American Relief Administration (ARA) to Russia in response to Gorky's appeal 'To All

Honest People', which had appeared in the Western press the previous July. The horrifying fact – hushed up by the Bolshevist press – was that Russia was in the middle of an appalling famine: a combination of natural disaster and political folly now known to historians as the Famine Crisis of 1921–2.[36]

For most of this time, the government refused to admit that there was any crisis; refused even to allow the press to use the word 'famine'. Gorky's intervention was the first glimmer of hope. Despite Lenin's rage at this impudent show of individual humanitarianism, he allowed Gorky to set up the POMGOL, or All-Russian Public Committee to Aid the Hungry – the first, and also the last, independent public body to be founded under communist rule. Hoover, who had established his ARA to help the stricken areas of post-war Western Europe, agreed to come and supply aid to Russia, provided that his people were allowed to operate independently, and that all US prisoners now in Soviet prisons were released.[37]

The ARA worked wonders. By the summer of 1922 they were feeding some 10 million people a day, and pouring supplies into the stricken areas, including the all-important seeds that would enable the two bumper harvests of 1922 and 1923. It cost more than $60 million, but far from expressing gratitude, the Bolsheviks constantly harassed the Americans – stopping convoys, arresting aid workers.[38]

Welcome as Hoover's charitable work was, conditions throughout Russia continued to be, at best, brutal. By 1922, an estimated seven million

36. The crisis had begun when an almost total failure of the Volga region's crops for the harvest of 1920 reduced the local peasantry to rely mainly on the stored grains they had, in line with tradition, stashed away in communal barns for use in just such emergencies. A failed crop was nothing new to them. But this time they were about to be wounded by man as well as God. The economic chaos of the civil war, and forced requisitions by the Bolshevists, had already reduced them to mere subsistence farming, with no stores left to shield them against disaster. So when the crop failed for a second time, in 1921, mass starvation was inevitable. Thousands, and eventually millions (something like five million in all), died in agonies of hunger. Emaciated peasants tried to fill their bellies with tree bark, acorns, clay, sawdust and animal manure. All their animals, from cows to dogs to mice and insects, were slaughtered, and many turned cannibal, especially from November 1921 onwards, when mothers openly made soup from the bodies of their dead. Packs of children hunted and killed adults for their meat; armed guards had to be posted on cemeteries . . .

37. This drove Lenin into still further fits of rage; and though he was more or less forced to allow the ARA into Russia, he took out his anger by closing down POMGOL and having all but two of its members arrested for counter-revolutionary activities, then sent into exile.

38. Their conduct appeared even more immoral when it emerged that the regime had been secretly selling millions of tons of cereal in exports, to raise money for other aspects of the economy. When this double-dealing was exposed, early in 1923, it became impossible for the ARA to continue its Russian relief work, and the operation was closed down in June 1923.

abandoned children – the orphans of the Revolution – were living rough in the ruins, or on rubbish heaps and in drains and sewers. When not employed in paedophile brothels, they tended to run in packs, begging or prostituting themselves,[39] stealing or murdering. Gorky, who had known these conditions at first hand, wrote Lenin a grim letter, saying that he had met a number of 12-year-olds who already had three murders under their belts. For children, the new nation was hell.

39. A survey suggested that about 90 per cent of children aged seven and younger, boys and girls alike, had sold their bodies at some time.

AUGUST

1 AUGUST

PARIS

Adrienne Monnier published an article, 'Lectures chez Sylvia', in the *Nouvelle Revue Française*, in which she recalled a letter that the right-wing French poet and diplomat Paul Claudel had sent to her and Sylvia Beach, protesting about their decision to publish Joyce's novel. Claudel had fulminated that '*Ulysses* like the *Portrait* is full of the most foul blasphemy where all the hatred of a renegade is felt – affected besides with an absence of truly diabolic talent . . .'

PARIS

Linking two of the most fashionable names in upmarket Parisian culture gossip, Camille Vettard published his article 'Proust et Einstein' in the same issue of the *Nouvelle Revue Française*. Proust was delighted. 'Your magnificent article is the greatest honour I could possibly receive,' he wrote to the critic.

2 AUGUST

CHINA

A typhoon, brewing in the South China Sea since 27 July, hit the coastal town of Swatow (today Shantou), with devastating effect. More than 50,000 of the city's 65,000 residents were killed; an equal number of people in the surrounding districts also died before the typhoon dispersed during the daylight hours of the 3rd. This likely death toll of 100,000 or more qualifies the Swatow typhoon as one of the five most deadly on record.

BERLIN

Count Harry Kessler (see 20 March) wrote in his diary:

> First night of the Moscow Experimental Theatre at the Apollo-
> theater. Went with Max Goertz and Guseck. Dramatised Dick-
> ens. Marvellously spirited and realistic acting, for all that it is
> strictly stylized. They are entirely free of that artificiality which is
> so distracting about our Expressionists. The impression is one
> of pure naturalism. The masks are an astonishing achievement,
> their faces real works of art where the painting and the modelling
> is concerned, yet without interfering with the play of the features.
> The actor Chechov is unforgettable . . .

PARIS

At the beginning of the month, an American publisher, William Bird,
asked Pound to supervise a series of prose booklets for the Three Moun-
tains Press.[1] Pound agreed, and told his correspondents that he hoped to
include work by William Carlos Williams, Eliot, Ford and Hemingway.
His own volume was to be a reprint of articles originally published in the
New Age in 1920: 'Indiscretions; or, Une revue des deux mondes'.

4 AUGUST

TURKESTAN

Enver Pasha, the leading Ottoman military commander (and a leader of
the Young Turk revolution) was killed in action against the Bolshevik Red
Army, near Baldzhuan. He was 41.

LONDON

Eliot wrote a brief note to Ezra's wife, Dorothy Pound, who was staying on
Dartmoor, thanking her for a gift of lavender. He wrote again on 9 Au-
gust, saying that he had heard that A. R. Orage had given up writing and
'is taken up with the Gotscheff system'. Eliot's spelling of 'Gurdjieff' is
inaccurate, but his information was not – Orage had indeed become a fol-

1. So called because Paris was built on three mountains.

lower of the Armenian guru this summer.[2] By this time, as can be judged from a letter to Antonio Marichalar, Eliot was already quite far advanced in planning the first two issues of *The Criterion*. The first edition, he said, would include contributions by Larbaud, George Saintsbury, Sturge Moore, Hermann Hesse, Gomez de la Serna and himself, as well as a previously unpublished piece by Dostoevsky; the second would contain essays by the polymath German scholar E. R. Curtius and either Proust or France's most eminent living poet, Paul Valéry.

AUSTRIA

Wittgenstein wrote an irritable letter to his editor Ogden. He had just finished correcting the proofs of the *Tractatus*, and had discovered that the British publisher wanted the book to contain a biographical note, and an explanation of the strange circumstances under which much of the text had been written, in the prison camp at Monte Cassino. Wittgenstein could simply not see the point:

> Why should the general reviewer know my age? Is it as much as to say: You can't expect more of a young chap especially when he writes a book in such a noise as must have been on the Austrian front? If I knew that the general reviewer believed in astrology I would suggest to print the date and hour of my birth in front of the book that he might set *the horoscope* for me.

LONDON

Cecil Maitland's article 'Mr Joyce and the Catholic Tradition' was published in the journal *New Witness*. Thoughtful and sympathetic, the article allowed *Ulysses* great merit, not least the virtue – often unmentioned by the earliest reviewers, though obvious to later generations of readers – of being very funny in parts: '. . . there is in this book enough fun to make the reputation of a dozen humorous writers'. But Maitland thought that the work as a whole was a failure. He found Joyce almost inexplicably obsessed with a 'vision of human beings as walking drain-pipes'; *almost* inexplicably, since Maitland was convinced that this horrified, disgusted view,

2. A. R. Orage (1873–1934) is chiefly remembered for his editorship of the journal *The New Age* from 1907 to 1922. Though this periodical was launched as a forum for left-wing thought, it changed both political and aesthetic complexions a number of times, embracing feminism, mysticism and the maverick economic theory of Social Credit, to which Ezra Pound later became a convert.

which has 'out-done the psycho-analysts' in its bleakness, was Joyce's inheritance from his religious training: 'He sees the world as theologians showed it to him. His humour is the cloacal humour of the refectory; his contempt the priest's denigration of the body, and his view of sex has the obscenity of a confessor's manual, reinforced by the profound conception and consequent disgust of a great imaginative writer . . .'

5 AUGUST

USA

The release of *Blood and Sand*, starring Rudolf Valentino, and directed for Famous Players-Lasky by Fred Niblo. After the relative failure of his last two films, *Moran of the Lady Letty*[3] and *Beyond the Rocks*,[4] Valentino was in urgent need of a new hit, and one which would reinforce the seductive and dangerous image he had established the previous year with *The Sheik*. This new film was just the thing. Based on a popular novel by Vincente Blasco Ibanez,[5] it was the melodramatic story of a brave young peasant lad, Juan Gallardo who gains glory in the bull ring, only to be seduced and betrayed by a vampish woman, and ultimately killed by his last bull.

Blood and Sand replayed, and exaggerated, the tricks that had proved so potent in Valentino's earlier hits. As in *Four Horsemen of the Apocalypse*, he struts and prances his way through a major dance routine, clicking his heels, hands on hips.[6] Throughout, the camera luxuriates in his face and body. In a kind of reverse striptease, he prepares for the *corrida* by dressing in his traditional matador costume, the 'suit of lights' – but behind a screen, so that all that can be seen are tantalising glimpses. Then he emerges, to be wrapped in a cummerbund.[7]

3. In which he played an initially rather foppish socialite who is soon transformed into a virile hero after being abducted and forced into hard labour on a ship, where he also falls in love with the skipper's daughter. The film did poorly on its release (12 February 1922), confirming Valentino's hunch that his true appeal was in costume parts.

4. Which premiered on 7 May 1922.

5. Published in 1908, and adapted by Valentino's close friend June Mathis.

6. His partner tilts her head up expectantly, craving a kiss . . . but he sneers and flings her away. 'I hate all women!' says the inter-title.

7. From this point until his early death, Valentino's films would often include a scene which showed off his assets in this way.

Despite its success, Valentino was unhappy with the film. He had wanted to shoot it on location in Spain; but Lasky, with a keen eye on the budget, insisted that it be filmed on set – though he compromised to the extent of importing a large number of props and costumes from Spain. Audiences did not seem to mind the lack of authenticity: the film was another huge hit.[8]

SPAIN

From his holiday lodgings in Asquerosa, Lorca wrote an excited letter to Manuel de Falla, telling him that he had finally completed the first draft of his puppet play, *The Tragicomedy of Don Cristóbal and Señorita Rosita*, on which he had been working intermittently for over a year. De Falla had agreed to write a musical score for the play, and both men were keen on the idea of founding a new form of puppet theatre in the tradition of the once-popular, now almost extinct Andalusian *guignol*.[9] Lorca also nursed the fantasy that the play might be taken up by Diaghilev, but nothing came of this. For his part, de Falla was convinced that their puppet theatre could be a great success if taken on tour throughout Europe and South America.

But their immediate plans to take the *Tragicomedy* to the Alpujarras region for a try-out production had to be postponed because of an unexpected upturn in Lorca's academic career. Heavily coached by his more scholarly brother Francisco, Federico had somehow managed to pass all but two of his law papers; if he gave it just one last push, he thought, he might be able to finish his degree early in the new year, thus pleasing his anxious father and earning his permission to travel to other countries – starting with Italy.[10]

8. It was the third highest grosser of 1922 at the American box office after *Robin Hood* and *Oliver Twist*.

9. Lorca had been quizzing old people of the region about their faint memories of the shows they had seen in their childhood days, and was tickled to hear how smutty and hilarious these entertainments had been.

10. By way of a creative compromise, the poet and the composer resolved to stage a puppet show in the Lorca family flat; this eventually took place on 6 January 1923, and was recalled by all who attended as a rare and magical occasion.

7 AUGUST

PARIS

Cocteau wrote a letter to Edmund Wilson, commenting on Ezra Pound's article 'On the Swings and Roundabouts: The Intellectual Somersaults of the Parisian vs. the Londoner's Effort to Keep His Stuffed Figures Standing', which had just appeared in the August issue of *Vanity Fair*. Pound's article had been accompanied by one of Cocteau's drawings, a portrait of the composer Auric, and the caption had explained that Cocteau 'in his spare moments operates a cabaret'. Cocteau said that he had found the magazine as a whole amusing, but asked Wilson to tell the editor not to print Pound's 'dangerous jokes': 'I have never managed the slightest bar. I went there the way Verlaine or Moreas went to their cafés – nothing more. If I sometimes played jazz there, it was for fun . . .'

8 AUGUST

ITALY

Confronted by ever-increasing levels of violent intimidation by the fascists, the Italian general strike was broken.

CANADA

Alexander Graham Bell, inventor of the telephone, died in Nova Scotia.

CHICAGO

8 August 1922 was possibly the single most important day in the history of jazz: Louis Armstrong,[11] a cornet player who had just turned

11. Louis Armstrong – commonly known in 1922 as 'Dippermouth' ('Satchmo' was from a later time, the 1930s; by which time his real friends usually called him 'Pops') – came from the kind of background which haunts the dreams of social workers. His grandparents had been slaves; his father, William Armstrong, was a handsome but feckless man, a womaniser who sometimes worked as a charcoal burner, and seldom played a part in raising his son. His mother, Mary 'Mayann' Albert – just 15 when he was born – was almost certainly a prostitute. William, himself not yet 20, ran off with another woman shortly after Louis's birth, leaving Mayann an outcast.

 Until the age of five, Louis was cared for by his maternal grandmother, Josephine. There is no doubting the harshness of his early environment, and yet the adult Armstrong looked back on his childhood with a surprising degree of nostalgia. In fact, he often said that it gave him his main inspiration: every solo was an attempt to recapture times past. 'Every time I close my eyes blowing

21,[12] took the train north from New Orleans to Chicago – the city that, thanks to an enormous influx of Southern African-Americans hoping to find a better life in the North, was now at the centre of the jazz universe. Barely hours earlier, Armstrong had been summoned by telegram to join King Oliver and his Creole Jazz Band, at the handsome sum of $52 a week. Up to this point, he had been strictly a jobbing musician – at best, a well-liked minor celebrity to audiences in New Orleans and on the Mississippi riverboats. In Chicago, he would come to enjoy a measure of real stardom for the first time, cutting his first records and starting to earn serious money.

Armstrong already knew that Chicago would offer a major step up the ladder for him, but to start with, he was as anxious as he was excited: 'I arrived in Chicago about eleven o'clock the night of August 8, 1922 (I'll

that trumpet of mine – I look right into the heart of good old New Orleans. It has given me something to live for.'

This was not wholly a matter of selective memory and unfounded sentimentality. There had been genuinely good things in that lost world of turn-of-the-century Louisiana. If he was materially deprived by the standards of most Americans, his grandmother clothed him, fed him, and most importantly lavished him with affection. Louis knew he was well loved. At the Fisk School, he received a decent if basic education, and learned how to read and write. He learned, too, that even in a society as racially stratified as New Orleans, not all white people were to be feared and hated – he had been treated with great kindness by a Lithuanian-Jewish family, the Karnofskys, rag-and-bone merchants who paid him small sums, more or less adopted him as a son, and bought him his first cornet. For the rest of his life, he wore a Star of David amulet in recollection of the Karnofskys, and always spoke of the Jewish faith with the highest respect.

And then there was music. Though he knew marching bands from his earliest days, he first encountered the full richness of the New Orleans musical heritage in its real home – the brothels to which, for a few cents, he would haul coal, hanging round after the chores were done to look admiringly at the ladies and listen to the bands. By about the age of 11, round about the time he left school, he had learned to play his cornet quite well. A slightly farcical run-in with the law landed him a short term in the New Orleans Home for Colored Waifs – a blessing in disguise, as he was fed properly and put in the marching band. By the time he was 13, he was good enough at his instrument to be a featured player.

He began to worship one of the stars of the New Orleans scene, Joe 'King' Oliver, who noted the boy's growing talent, and became something of a mentor. Louis's mid-to-late teenage years were harsh and uncertain, but at the end of them he had a major stroke of luck. When King Oliver went north to try his luck, Louis took his place in what was, he believed, the best band in town. Not long after the end of the war, he began playing on board the pleasure boats that plied the Mississippi, and he learned so much from his fellow players – including musical notation – that he sometimes called the riverboat period his 'university'. At 20, he entered into a short-lived marriage with the violent and temperamental Daisy Parker, and they adopted a mentally disabled child of three. The marriage was over by the time Armstrong moved to Chicago, but he took responsibility for the child for many years.

12. Though throughout his life he always thought he had been born on 4 July 1900, and thus was 22 that day.

never forget it) at the Illinois Central Station at Twelfth and Michigan avenues . . . I was all eyes looking out the window when the train pulled into the station. Anyone watching me closely could have easily seen that I was a country boy.'

The train had been delayed, and King Oliver, who had planned to meet him, needed to play a gig, but he gave a porter money to steer the new arrival into a cab and send him over to the Lincoln Gardens Café. When he arrived, and heard from outside just how good Oliver's outfit was, Armstrong was overcome with self-doubt and stood dumb, frightened to show himself. Someone must have tipped Oliver off, and he came out bellowing, 'Come on IN HEAH you little dumb sumbitch. We've been waiting for your black ass all night.' A wave of happiness swept through Armstrong. This was his new home.[13]

When it came time for Armstrong to debut, he did so diffidently, well aware that he was being paid as the second cornet, not the star. This was Oliver's band, and though Oliver was a good-natured man, he could rule it like a tyrant.[14] But he was also willing to promote talent when he saw it. The turning point came when an arrogant musical rival, Johnny Dunn, swaggered in to one of the band's shows and started boasting about his prowess on the trumpet. Oliver was enraged; he told Armstrong, 'Go get him!' Finally given space to expand, Armstrong blew a ferocious solo that stunned everyone. By the end of it, Dunn had shuffled away. From that night on, Oliver let Armstrong take big solos every night.[15]

Word got out, and the crowds came to the Lincoln Gardens to see this New Orleans wunderkind.[16] Even though news of the Johnny Dunn inci-

13. Oliver introduced him to the other band members: 'Baby' Dodds, Johnny Dodds, Honoré Dutrey, Bill Johnson: the kernel of the first important small band in jazz. Later he took Armstrong back to his apartment, where Oliver's wife fed him a delicious New Orleans meal of red beans and rice, washed down with iced lemonade. Then, to end this day of wonders, Oliver took his recruit to a boarding house at 3412 South Wabash, where he had reserved a room with a private bathroom. Armstrong was astonished; back home, no one even had a bathtub of their own, let alone a bathroom. The next day, he showed up for some intense rehearsals. Oliver, he noticed, was a prodigious inventor of phrasing, endings, flourishes; he later said that he learned enough ideas from Oliver's playing to last a career.

14. At one point, he broke up an entirely harmless bit of horseplay among the band by threatening to shoot them, and showed them the gun in his cornet case to prove he was in earnest.

15. Historians of jazz often say that he was the first true soloist of the form.

16. Armstrong knew himself how rapidly he was developing, and he added a new talent to his armoury by buying a typewriter and compulsively pounding out letters, diary entries, reminiscences and whatever else crossed his mind. Other musicians noticed that he would even start pounding

dent had spread quickly, other musicians would also show up now and again, confident that they could make minccmeat of this rube. Armstrong always blew them away. When they were insolent towards him – as the highly rated Freddie Keppard was when he showed up for a musical joust – it made Armstrong angry. And when he was angry, he was better than ever. Keppard's career declined from this point, as if Armstrong had broken his nerve.

Egged on by both fans and competitors, Armstrong contrived more and more feats and wonders.[17] Within a matter of weeks, he was making all other jazz musicians sound a little old-fashioned, a little staid. By the end of September, he was the star of Chicago. They came not just to enjoy, but to learn (or plagiarise).[18] Still only 21, 'Dippermouth' was already changing the nature of his art. As one of his biographers puts it: 'Within a few years, a generation of jazz musicians, black and white, would build whole careers on the new style of jazz that Louis began to forge in Chicago in the latter part of 1922.'

On 5 and 6 April 1923, Armstrong made his first recordings. The rest was inevitable. Duke Ellington said, 'Nobody had ever heard anything like it, and his impact cannot be put into words.'

9 AUGUST

IRELAND

Yeats wrote to the poet Herbert Edward Palmer: 'I would ask you to call and see me but I live in a mediaeval Tower in the West of Ireland, beside a bridge that may be blown up any night, and it may be a long time before I am in London.'

the keys between sets, and said that he spent as much time on the typewriter as he did on his instrument. Writing like this became a lifelong obsession.

17. It was said, no doubt truly, that he was able to hit as many as 200 high Cs in a row, but mere statistics cannot convey the sheer thrill that people talked about incredulously after they had seen him in full flight. It was powerful, but it was also delicious, intoxicating, ravishing . . .

18. Some of the musicians, both black and white, became good friends: Hoagy Carmichael, for one, who was introduced to Armstrong by their mutual friend Bix Beiderbecke.

11 AUGUST

AUSTRALIA

Frieda Lawrence's forty-third birthday. Just three months after their arrival in Australia, and with the manuscript of *Kangaroo* now more or less complete and posted off to Robert Mountsier, Lawrence and Frieda boarded the RMS *Tahiti* at Sydney. Ahead of them was a 25-day voyage to San Francisco, sailing by way of New Zealand, the Cook Islands and Tahiti.[19]

Lawrence had hankered to see the Pacific Islands ever since reading Melville's *Typee*,[20] and he also wanted to see the Earthly Paradise that had been sought by one of his literary heroes, Robert Louis Stevenson. But though he found Raratonga 'almost as lovely' as he expected a South Sea island to be, he was unimpressed by Papeete, the capital of Tahiti: 'poor, dull, modernish'. He grew grumpy about the whole idea of tropical paradises, and found more stimulation in observing a crowd of film-makers who joined them in Tahiti: their lack of inhibition both impressed and exasperated him, and though his letters referred to them in bilious terms, Frieda reported that he could hardly keep himself from observing them.

When they arrived in San Francisco on 3 September, with their finances at a low ebb, Lawrence wired Mountsier asking for another advance.[21] Happily, Mabel Dodge Sterne had been thoughtful enough to guess their poverty, and had mailed them train tickets. They left San Francisco on 8 September, and two days later arrived at a small town called Lamy, about 15 miles south of Santa Fe. Dressed in a turquoise robe and silver jewellery, and accompanied by her taciturn, handsome Native American lover Tony Luhan, Mabel was there to meet them at the station. She made a good first impression; Frieda thought that she had the eyes of a woman who could be trusted.

19. There were only 60 passengers on board, so it was hard to avoid making acquaintances. Frieda loved it, and wrote cheerily to her mother about the joys of flirting with a French gentleman admirer. Lawrence was less charmed.
20. Which he would discuss in *Studies in Classic American Literature*.
21. He seems still to have been under the spell of the film crowd, and spent some of his time in the city going to the cinema. It revolted him.

12 AUGUST

WASHINGTON, DC

A key moment in African-American cultural and social history: Frederick Douglass's former house was declared a national shrine. Douglass (1818–1895), one of the most remarkable figures in the abolitionist movement, had himself once been a slave; his polemical and autobiographical writings played a major role in the liberation of African-Americans, and he was judged one of the most eloquent orators of his day.

PARIS

Hemingway filed a light-hearted article about 'The Great Aperitif Scandal' in Paris. In fact, his article concerned two so-called 'scandals' about these beverages, which, as he explained to those unfamiliar with Parisian tippling fashions, 'are all patented mixtures, contain a high percentage of alcohol and bitters, [and] have a basic taste like a brass doorknob'.

The first scandal concerned a pale yellow aperitif marketed under the name of Anis Delloso. Despite its colour, so disappointingly drab in contrast to the 'Green Fairy' of Decadent legend, this drink was in fact good old-fashioned absinthe – a potation banned by the French government six years earlier. When word got out, sales of Anis Delloso rocketed, and for a few heady weeks was the most popular aperitif in the city. The authorities stepped in. One could still buy a brew of that name, but it was absinthe no more.

The second scandal was rather more political in tone. This year, massively subsidised by the government, the traditional Bastille Day celebrations had lasted pretty much non-stop, depending on the stamina of the revellers, from noon on Wednesday the 13th until noon the next Monday – five full nights of drinking, dancing in the streets and all manner of wild behaviour.[22] Marvellous; but in the days of hangover that followed, people began to ask questions about the posters advertising various brands of aperitif that had been festooned around the city in the company of the Tricolor. Had the government been duped into giving millions of francs' worth of advertising to the manufacturers?

22. Including the failed shooting of a prefect of police by a young communist who had mistaken the official for Poincaré.

IRELAND

President Arthur Griffith died; of 'heart failure', preceded by a series of other illnesses. He was only 50; it may be that his constitution had been seriously weakened by overwork.

13 AUGUST

ITALY

The poet, novelist, aviator and right-wing adventurer Gabriele d'Annunzio (1863–1938) was seriously injured in a fall from a high window. The exact circumstances of this incident remain a mystery, and it has frequently been assumed that d'Annunzio was the victim of a failed murder attempt. Accident or attack, the event rendered him more or less an invalid for the next few years, which meant that he played little part in Mussolini's seizure of power and construction of a fascist state in Italy. But there is little doubt that d'Annunzio – who had already briefly ruled over a small section of Italy with the title 'Duce' – was a major influence on Mussolini's beliefs and actions. He has sometimes been called the John the Baptist of Italian fascism.

14 AUGUST

LONDON

Eliot wrote for the first time to Edmund Wilson, who had asked him for an article for *Vanity Fair*; Wilson was managing editor of the magazine from July 1922 to May 1923. Eliot's contribution – a translation of an article he first published in French (*Nouvelle Revue Française*, 1 December 1922) – did not appear until the following summer.

15 AUGUST

PARIS

Ford Madox Ford wrote to the English author Edgar Jepson (1863–1938): '*Ulysses* we shall no doubt differ about till the end of the chapter;

personally I'm quite content to leave to Joyce the leading novelist-ship of the century, think he deserves the position, and hope it will profit him . . .'

MUNICH

The poet, war hero and (later) leading conscientious objector Siegfried Sassoon wrote in his diary:

> *Love* is the test, I suppose. One strives to keep it romantic, to make it a series of dramatic episodes. The truth of life will not remain in a marionette-show passion. In love we find salvation or shameful retreat. But O, it is difficult!

Sassoon's love life had been complicated over the past few years. After long periods of sexual frustration, he had finally managed to overcome his earlier inhibitions and seek male lovers.[23] At the time of writing his pained

23. His first great flame was a 21-year-old army officer, William Atkin, known as 'Gabriel'. Sassoon had first met him only a couple of weeks after the end of the war, on 20 November 1918. Though Gabriel was promiscuous where Sassoon had been rigorously chaste, and much given to drink where Sassoon was a light to moderate toper, they fell deeply in love almost at once and wasted no time in consummating their passion.

The earliest weeks of their affair were idyllic, and thrilling for both, but discontent began to seep in as early as January 1919. Sassoon grew increasingly alarmed that Gabriel's dangerous liking for intoxication extended beyond alcohol to 'dope'. (He later drifted into Cocteau's opium-taking set in Paris.) And now that Sassoon had made his homosexuality known, albeit discreetly and to a privileged group of friends, there were fresh temptations on all sides. It seems likely that in March 1919 he enjoyed a fling with Beverley Nichols, at the time an undergraduate at Balliol. He grew more and more discontented with Gabriel during that year, feeling that his love life was once again becoming as dissatisfying as his public life – he had briefly taken on the job of literary editor for the left-wing *Daily Herald*. His health was also poor, and he suffered terribly from sciatica.

Meanwhile, he had encouraged Gabriel to study art at the Slade. Gabriel had distinct talent, and his early drawings at the school were admirable, but he found it hard to stay committed to any one task. By July 1919, Sassoon was utterly exasperated with him, and they parted for a while, never really managing a stable relationship again. It came as something of a relief when Sassoon was invited on a lucrative lecture tour in the United States, starting in January 1920. But the trip, though full of pleasures, also exposed him to new erotic torments. He fell badly for a rising young actor, Glenn Hunter, who was starring with Alfred Lunt and other leading players of the day in a New York hit show, *Clarence*. The affair was as painful and humiliating as it was short-lived.

Back in England, richer and healthier but still discontented, Sassoon developed a dangerously heavy crush on Walter de la Mare's 15-year-old son, Colin, though he did not act on his impulses. He also tried, unsuccessfully, to woo the 20-year-old Lord David Cecil, incorrectly assuming that a precocious youth who had close homosexual friends must himself be homosexual.

reflection on love in August 1922, the main object of his desire was a lead-ing German aristocrat, Prince Philipp of Hesse – great-grandson of Queen Victoria, nephew of the disgraced Kaiser Wilhelm, and also nephew of the King of Greece.[24] Sassoon first met his prince by way of Lord Berners, the rich eccentric novelist and composer, who had befriended Sassoon during his trip to Rome.

Though Sassoon was a self-declared socialist by this time, following his experiences of social injustice during the war and the benign influ-ence of his father figure W. H. R. Rivers (see 4 June), he remained alive to the glamour of titles and land. This was just as well for their affair, since he did not find the prince particularly handsome: he was already balding, and was heavier and generally much less pretty than Gabriel.

Sassoon had gone to Munich to meet Philipp, travelling by train and leaving Victoria station on 20 July. He arrived in Munich on 1 August, having written a poem – 'Fantasia on a Wittelsbach Atmosphere' – in the course of the journey. The couple stayed together until October, but though they enjoyed an active sex life, Sassoon began to see more and more limitations in his nobleman. Philipp, he came to think, lacked imag-ination and was fundamentally conventional in his views on art and life. He was also a little too sophisticated for Sassoon in his off-handed frank-ness about his dalliances with other male lovers, and with an American woman known simply as 'Babe'.[25]

The affair was obviously doomed. By the time they moved on from Germany to Italy, Sassoon was privately referring to Philipp as 'stupid' and a 'clodpole'. He could all too easily imagine the prince becoming fatter, more complacent and more dull, and it came as something of a relief to him when they finally parted, in Naples.[26]

24. Philipp would later, in 1925, marry the daughter of the King of Italy.
25. He once went so far as to answer a phone call from Babe while he and Sassoon were making love.
26. Over the next three years, Philipp made a few attempts to contact Sassoon again, but Sassoon had already launched himself into a series of new affairs. Besides, he was disillusioned by Philipp's growing enthusiasm for the Nazis – an enthusiasm which would culminate in collaboration with Hitler, and the death of his wife in a concentration camp.

16 AUGUST

MUNICH

Hitler – as spokesman for one of the several nationalist organisations that had come together for a giant protest rally – addressed a large crowd, drawn by the slogan 'For Germany – Against Berlin'. The rally was directed at 'the approaching Jewish Bolshevism under the protection of the Republic'.

This was the first time that the SA – the *Sturmabteilung* ('Storm Detachment', or more familiarly, 'Storm Troopers'; also known as the 'Brownshirts'; founded in 1920) appeared in public as a paramilitary organisation, under its own banners.

LONDON

Virginia Woolf expressed her distaste for *Ulysses*. She seems to have bought her copy at the end of July, and was soon lamenting the expense. In her diary for 3 August, she wrote, 'I am horribly in debt for Joyce & Proust at the moment, & must sell books directly I get back to London.'[27] By 16 August, she was already in difficulties with Joyce's prose, and her first major complaint about the work was a small masterpiece of snobbish disdain:

> I should be reading Ulysses, & fabricating my case for & against. I have read 200 pages so far – not a third; & have been amused, stimulated, charmed interested by the first 2 or 3 chapters – to the end of the Cemetery scene; & then puzzled, bored, irritated, & disillusioned as by a queasy undergraduate scratching his pimples. And Tom [Eliot], great Tom, thinks this on a par with War & Peace! An illiterate, underbred book it seems to me: the book of a self taught working man, & we all know how distressing they are, how egotistic, insistent, raw, striking & ultimately nauseating. When one can have the cooked flesh, why have the raw? But I think if you are anaemic, as Tom is, there is a glory in blood. Being fairly normal myself I am soon ready for the classics again.

27. In the same entry, she notes a meeting with Eliot, who 'was sardonic, guarded, precise & slightly malevolent, as usual'.

I may revise this later. I do not compromise my critical sagacity.

I plant a stick in the ground to mark page 200.

LONDON

Joyce was actually in London at the time Woolf was writing these harsh words. He and Nora travelled there early in August 1922, staying at the Euston Hotel. During this trip, he met his indispensable patron Harriet Shaw Weaver for the first time.[28] When she asked him what he would write next, he said, 'I think I will write a history of the world' – which is, indeed, one way of describing *Finnegans Wake*.

During their stay in London, the Joyces also had a mainly agreeable meeting with his relative Kathleen Murray, who was working at a London hospital. The only tricky moment in an otherwise convivial evening came when Joyce asked Kathleen what her mother, Josephine Murray, thought of *Ulysses*.

'Well, Jim, Mother said it was not fit to read.'

'If *Ulysses* isn't fit to read, life isn't fit to live.'

Far from being soothed by the vacation, Joyce's eyes grew worse. He consulted two ophthalmologists, Dr Henry and Dr James, who both warned him that the fluid in his left eye had begun to 'organise' and become immovable. They recommended an immediate operation. Perhaps hoping for a less threatening second opinion, Joyce fled back to Paris.

17 AUGUST

WESTMINSTER – LONDON

Contrary to popular belief, Lawrence of Arabia did not know Shaw very well at this time; they had met only once, in March 1922, after a lunch at which Sydney Cockerell, curator of the Fitzwilliam Museum, Cambridge, had discussed with Lawrence the ways in which they might help Charles

28. She was now able to witness the alarming sight of Joyce being free-handed with the money she had given him. He would always take taxis rather than buses, and would tip the driver handsomely. Generosity, or profligacy, of this kind meant that he tore through some £200 in the course of his stay.

Doughty, the author of *Arabia Deserta*, who had fallen on hard times. After the lunch, Cockerell suggested that they should drop by the Shaw residence in Adelphi Terrace, where he was due to pick up a portrait of Shaw for the museum. Lawrence was reluctant, and only agreed to accompany Cockerell when told that it was very unlikely that Shaw would be there. This was not so, but the two men hit it off unexpectedly well in a meeting of twenty minutes or so.

It was on the strength of this one meeting that Lawrence wrote to Shaw on 17 August, asking the playwright if he would agree to have a look at *Seven Pillars*. This long letter was almost masochistic in its degree of self-deprecation:

> In my case I have, I believe, taken refuge in second-hand words. I mean, I think I've borrowed expressions and adjectives and ideas from everybody I have ever read, and cut them down to my own size, and stitched them together again. My tastes are daily mailish, so there's enough piffle and romance and wooliness to make a realist sick. There's a lot of half-baked thinking, some cheap disgust and complaint (the fighting fronts were mainly hysterical, you know, where they weren't professional, and I'm not the least a proper soldier): in fact all the sham stuff you have spent your life trying to prick. If you read my thing, it will show you that your prefaces have been written in vain, if I'm a fair sample of my generation. This might make you laugh, if the thing was amusingly written; but it's long-winded, and pretentious, and dull to the point where I can no longer bear to look at it myself. I chose that moment to have it printed!

18 AUGUST

LUGANO

The opening of a conference held by the International Women's League for Freedom and Peace. One of the invited speakers was Hermann Hesse, who, instead of delivering a paper on one of the conference's themes, read out the final part of his new novel *Siddhartha*. On 29 August he wrote to his friend Helene Welti, who had just finished reading the book herself: 'It's a

good thing you have read *Siddhartha*. While it doesn't amount to much as literature, it represents the sum of my life and the ideas that I have absorbed over the course of twenty years from Indian and Chinese traditions. The end of *Siddhartha* is almost closer to taoism than to Indian thought.'

Despite this Taoist flavour, Hesse claimed, a Hindu scholar who had been present at the reading in Lugano had rushed up to the author, proclaiming his astonishment that any Westerner could have grasped so profoundly the essential truths of Eastern spirituality. Whether or not this is the case, the influence of *Siddhartha* as an apparently definitive primer on the essence of Buddhism and related mystical teachings was eventually to become incalculably strong.[29]

Though his fans would violently dispute his verdict, Hesse was perfectly right to say that his novel did not amount to much as literature. Its style, at any rate in English translation, is pompous and mock-archaic, with characters talking like this:

> You have come to the right place, O Samanas from the forest. The Illustrious One sojourns in Jetevana, in the garden of Anathapindika. You may spend the night there, pilgrims, for there is enough room for the numerous people who flock there to hear the teachings from his lips.[30]

There is not much plot: the title character is a Brahmin's son who, like the Buddha himself, grows dissatisfied with his life of privilege and goes off on a lifelong spiritual quest, exploring the paths of renunciation and fasting, then sensuality and worldly indulgence. Few readers will be surprised by the fact that, once introduced to sex, Siddhartha becomes a red-hot lover. 'You are the best lover that I have had . . . stronger than others, more supple, more willing . . .' Then he renounces the material world again, goes to live with a ferryman, grows old, attains enlightenment. As doctrine it may be impeccable; as fiction it is at best tiresome.

29. The book was not translated into English until the early 1950s, and at first it sold slowly, until the counter-culture of the 1960s took it up as one of a handful of essential books of wisdom. In the United States particularly, Hesse became a best-seller on a scale that would have seemed simply impossible from the perspective of 1922.

30. A cynic might wonder from what other part of the Illustrious One's body a pilgrim should expect to hear teachings.

LONDON

The writer and naturalist W. H. Hudson (b. 1841), greatly admired by Virginia Woolf, died. A prolific author, at his most brilliant when writing about wildlife, he is now best remembered for his novel *Green Mansions* (1904) and his autobiography *Far Away and Long Ago* (1918).

LONDON

Virginia Woolf wrote: 'I am now reading Joyce, and my impression, after 200 out of 700 pages, is that the poor young man has only got the dregs of a mind compared even with George Meredith. I mean if you could weigh the meaning on Joyce's page it would be about 10 times as light as on Henry James'.'

On 24 August, in a letter to Lytton Strachey, she managed an untypically vulgar, indeed scatalogical moment of her own. Strachey had offered to donate £100 to the Eliot fund:

> One hundred pounds did you say? You shall have a receipt. Cheque payable to Richard Aldington or O. Morrell as you prefer. My own contribution, five and sixpence, is given on condition he puts publicly to their proper use the first 200 pages of Ulysses. Never did I read such tosh. As for the first 2 chapters we will let them pass, but the 3rd 4th 5th 6th – merely the scratching of pimples on the body of the bootboy at Claridges. Of course genius may blaze out on page 652 but I have my doubts. And this is what Eliot worships, and there's Lytton Strachey paying £100 p.a. to Eliot's upkeep.

Doth the lady protest too much? What is it that excites her fantasy about a carbuncular young man?

22 AUGUST

NEW YORK

Dorothy Parker's twenty-ninth birthday. It was a grim time for her: youth was almost over, and, since she took no pride in her literary accomplishments to date, she felt that all she had to show for her time on earth was a

failed marriage. She and Eddie had been unhappy together for years now, and it had been obvious since the spring of 1922 that he wanted a separation or divorce.[31] The tension between them had come to a head over the Fourth of July holiday season, when they had barely been on speaking terms. A couple of weeks later, she came home and found him shoving clothes into a suitcase, preparing for a move to Hartford.

Her friends at the Round Table, most of whom regarded Eddie as a dull, suburban soul at best, naturally assumed that it was she who had left him. She went out of her way to pretend that the split was good-natured, and that she was as contented with the break as she had assumed she would be. To her surprise, Eddie's defection hurt her deeply, and for a while she became obsessed with him again, and took to drinking Scotch in larger quantities than usual.[32] She also tried her hand, for the first time, at describing her experiences in fiction, though her pain was still too raw to address directly. Instead, she wrote a story about a henpecked husband, obviously inspired by the unhappy marriage of her closest friend, Robert Benchley: 'Such a Pretty Little Picture'. She sold it to Mencken's magazine, *The Smart Set*; in later years, she spoke of it as the best thing she ever wrote.[33]

IRELAND
Michael Collins was killed in an ambush by irregular forces. As the historian Roy Foster remarks: in the space of just 10 days, the Irish Free State had lost its major voice for moderation (Griffith) and now its only broadly popular leader.

23 AUGUST

NORTH AFRICA
Morocco rebelled against its Spanish rulers.

31. She used these unhappy months as the raw material for one of her best-known stories, 'Big Blonde'.
32. Despite her posthumous reputation as a boozer among boozers, until a year or so previously she had been quite a modest drinker.
33. 'Such a Pretty Little Picture' marked the beginning of her career as a mature writer, but at the time it gave her little satisfaction. She was desperately lonely, and in need of a new lover. He arrived promptly. Charles Gordon MacArthur was a charming 27-year-old newspaperman from Chicago, where his best friend was Ben Hecht. She fell for him almost immediately, and hard. (See 25 December.)

24 AUGUST

LONDON

Virginia Woolf wrote: 'I open the paper and find Michael Collins dead in a ditch.'

Two days later, she confided to her diary: 'I dislike Ulysses more & more – that is I think it more & more unimportant: & don't even trouble conscientiously to make out its meanings. Thank God, I need not write about it.'

26 AUGUST

BERLIN

At 8.30 a.m., Fritz Lang married Thea von Harbou, in Berlin-Schmargendorf.[34] The German press adored the new golden couple, and when the Langs set up home together in a large and lavishly decorated apartment at Hohenzollerndamm 52,[35] glossy magazines ran endless fawning articles about their wonderful union. The couple were more than happy to play along; in fact, they often orchestrated their own publicity campaign, being careful always to appear at the right parties and opening nights, charity balls and exclusive restaurants.

Their wealth was real, but the rest was a sham. Lang's passion for Thea faded not long after the wedding, and she learned to be tolerant of his many affairs and flings, and even his penchant for expensive prostitutes. While he went out on the erotic prowl at night, she would usually stay home and go to bed early: she also continued to work hard on the screenplays he would film with such conspicuous success.[36] They remained on surprisingly cordial terms for the remainder of their marriage, which lasted until 1933. 'We were married eleven years,' Mrs Lang later said, 'because for ten years we didn't have the time to get divorced.'

34. Shortly after his pledge of marital loyalty, Lang made another vow: he took German citizenship. Years later, this move needed some explaining to the US immigration services.

35. In the eyes of some visitors, more like an intimidating cross between an anthropological museum and an art gallery than a comfortable marital nest.

36. Just a couple of months after their marriage, she had already completed the first draft of a script for his next production, *Die Nibelungen*.

28 AUGUST

LONDON

Eliot wrote to E. R. Curtius: 'Beyond your book and that of Hesse, and a few things of Spengler and Keyserling, I know almost nothing of German literature since 1914 . . .'

NEW YORK

George Gershwin's one-act jazz opera *Blue Monday Blues* opened at the Globe Theatre, as part of the revue *Scandals of 1922*. Gershwin, not long out of his teens, had already been working in the music business for seven years, and had scored a national hit in 1919 with his faux-Dixie anthem 'Swanee'. On the strength of this precocious success, he had been hired by the producer George White to compose *Follies of 1920* and *Follies of 1921* – huge hits, largely thanks to this exciting new composer.

But there was a lot of competition, so White knew that his 1922 show had to be special. Gershwin, naturally, was signed up again; W. C. Fields was booked as the star; and Paul Whiteman and his Orchestra – the hottest jazz band in New York – came to a special arrangement which allowed them to play in the show without having to give up their regular engagement at the Palais Royal, which was just a few blocks (or a quick sprint) away. Gershwin and Whiteman took an immediate liking to each other, and enjoyed collaborating on the show. But there were problems.

When it became obvious to the company, barely three weeks before the opening night, that the show was running short, Gershwin proposed the unusual idea of including a short musical drama, loosely inspired by Italian *verismo* operas, set in Harlem and featuring African-American characters.[37] A variant on the familiar story of 'Frankie and Johnny', it told the story of two star-crossed lovers: he cheats on her, she kills him. The lyrics to its arias – 'Blue Monday Blues', 'I'm Going to See My Mother', 'Has Anyone Seen My Joe?' – were written by Buddy DeSylva;[38] Paul Whiteman conducted from the pit.

37. Who, sad to tell, would be played in blackface; the producers claimed that there were not enough qualified black performers working on Broadway.
38. DeSylva went on to have a long and highly successful career as a songwriter, and later co-founded Capitol records.

Blue Monday was presented right after the first intermission, and its downbeat mood and tragic ending dismayed the opening-night audience, who were in the mood for the more usual froth and merriment. The critics tended to agree: Charles Darnton of the *New York World* called it 'the most dismal, stupid, and incredible black sketch that has probably ever been perpetuated' (perhaps he meant 'perpetrated'?); he suggested that the character who turned the gun on her lover would have been better employed shooting the whole cast, followed by herself.

Understandably, *Blue Monday* was cut from the show at once. But the consequences of this hasty collaboration – Gershwin and DeSylva had hurled it together in just five days and five nights of frantic work – were far-reaching. Though it remains one of the less well-known of his works, even under its later title of *135th Street*, many critics have suggested that it can be seen as the piece which established the template for much of Gershwin's finest work – most obviously his full-scale opera *Porgy and Bess*, but also his single most famous composition, *Rhapsody in Blue* (1924), which was commissioned by Paul Whiteman and almost overnight became his signature tune, demanded by audiences at every concert.[39]

LONDON

In late August, Kipling underwent a series of uncomfortable medical examinations to determine the cause of pain in his stomach. He was put on a 'no solids' regime for several weeks. He found the experience of a rectal probe so painful that he was moved to quip: 'If this is what Oscar Wilde went to prison for, he ought to have got the Victoria Cross.'

30 AUGUST

LONDON

T. E. Lawrence presented himself at the RAF recruiting office in Henrietta Street, Covent Garden, at 10.30 a.m. He stripped off his ragged clothes, and stood naked for medical and other examinations. He gave his

39. Gershwin later wrote that 'My association with Whiteman in this show I am sure had something to do with Paul's asking me to write a composition for his first jazz concert . . . There is no doubt that this was my start in the field of more serious music.'

age as 28 (he was 34), his trade as 'architect's clerk', and his name as John Hume Ross. After various confusions,[40] he was admitted, and posted to the RAF depot at Uxbridge for three months of basic training. His brutal experiences there are recorded in the opening section of his remarkable book *The Mint*, published posthumously.

The reasons for Lawrence's enlistment at the very lowest level of the forces have puzzled, fascinated and appalled countless people ever since. One thing is sure: it was not a sudden impulse. At times he said that he had been considering the move since 1919; at others since the very formation of the Royal Flying Corps. As early as January 1922, he had written to Sir Hugh Trenchard (1873–1956), the so-called 'father' of the Royal Air Force, asking for his help with his odd plan and presenting the move largely as a matter of literary ambition:

> You'll wonder what I'm at. The matter is that since I was 16 I've been writing: never satisfying myself technically, but steadily getting better. My last book on Arabia is nearly good. I see the sort of subject I need in the beginning of your Force . . . and the best place to see a thing is from the ground. It wouldn't 'write' from the officer level.

Trenchard must surely have had his doubts; surely no mere literary ambition could ever be strong enough to compel a former colonel – let alone an 'Uncrowned King' – to become a private?[41] Whether or not he fully believed him, he decided that Lawrence had more than earned the right to a favour, and when the two men met at the Air Ministry on 14 August, Trenchard told him that his enlistment could go ahead, under the supervision of Air Vice-Marshal Sir Oliver Swann.

40. The officer who interviewed him, Captain W. E. Johns, became suspicious about inconsistencies in his account, made some quick checks, and soon found out the secret of this nervous recruit. But Air Vice-Marshal Sir Oliver Swann intervened, and, after overruling the doctors who declared Lawrence unfit for service, the recruit was reborn as 352087 A/C Ross. Coincidentally, Johns was also a military man with literary ambitions. In 1922, he published his first novel, *Mossyface*. But he gained immortality in the late 1930s when he invented the character of Biggles, the intrepid RAF pilot, and hero to several generations of British schoolboys.

41. Lawrence mentioned the idea of writing an epic book about the development of the RAF to other correspondents, too, though he did not always add that his ambition to write it was the main reason for enlisting.

Few who have read Lawrence's works could believe for a moment that it was common-sense reasoning of this kind which led him to seek oblivion in the ranks, and Lawrence himself would explain his motives in radically different ways to different friends. On 11 November 1922, for instance, he wrote a private letter to the editor of the *Daily Express*, R. D. Blumenfeld,[42] suggesting that his main reasons for joining up were partly financial, partly political:

> When Winston at last let me go – it took four months work to make him: I refused salary, & begged for release each time I saw him, etc. – I found I was quite on the rocks: and so I enlisted, as a quick and easy way of keeping alive, and alive I am, in the ranks, and not always miserable . . .
>
> You know I was always odd, and my tastes my own. Also the only way I could escape politics entirely was to shut myself sharply off from my former way of living: and making a living with one's fingers is joyful work, & as clean as possible, after politics – to which not even the *Express* shall drag me back![43]

Lawrence's brother, Arnold Lawrence, surely saw matters more clearly when he said that in 1922, T. E. 'came as near as anyone could do to a complete breakdown, after nine years of overworking without a holiday, and several of them under a continuous nervous strain. He cured himself by enlisting.' Yet even this talk of exhaustion does not state the case strongly enough. True, Lawrence was exhausted, and in very poor health, but there were far more obvious ways in which he could have regained strength and health; true, he had had no real job since quitting both All Souls and his Colonial Office post, but there were any number of well-paid posts and sinecures he could have accepted – in fact, such tempting offers kept flowing in throughout his years of service.

Despite the best efforts of his biographers, Lawrence retains an irreducible element of pure enigma. Such efforts have not been in vain, though, since we can now conclude that his enlistment – he once, revealingly, called

42. An unlikely correspondent; Lawrence had written two articles for the *Express* in May 1922, and refused payment; with rare magnanimity, Blumenfeld had sent Lawrence a valuable edition of the *Arabian Nights* instead.
43. There is an unconscious irony in the last remark; see 27 December.

it 'mind-suicide' – was prompted not by any one simple reason but by several profound and concurrent emotions. To put the matter bluntly, it has been proposed that he felt guilt, both justified and neurotic, about the part he had played in the war and the subsequent years of diplomacy over the fate of the Middle East.[44]

It is also significant that Lawrence always had a strong ascetic streak, which sought out privation and hardship and even pain as assiduously as normal people seek comfort and ease; that he had a violently ambiguous attitude to his enormous fame, simultaneously relishing it and hating himself for that pleasure; that he had masochistic tendencies, both physically (it is now well known that he paid a fellow ranker to beat him) and spiritually; that he was tormented by his teeming brain and sought the comfort of mindless physical behaviour. And so on.

It seems possible, even likely, that Lawrence would not have been driven to such extremes, however, were it not for the efforts of Lowell Thomas, the showman who had in effect created the 'Lawrence of Arabia' myth with his post-war lecture shows.[45] When Thomas's biography of Lawrence went on sale in September 1925, Lawrence wrote to Mrs Bernard Shaw: 'From henceforth my way will be with these fellows here [i.e., in the ranks], degrading myself . . . in the hope that some day I will really feel degraded, be degraded, to their level. I long for people to look down on me and despise me . . .'

NEW YORK

Gilbert Seldes's long review of *Ulysses* was published in *The Nation* – with those of Edmund Wilson and Mary Colum, it was the last of the trio of contemporary notices which were reputed to have pleased Joyce the most: '. . . today [Joyce] has brought forth *Ulysses*, a monstrous and magnificent travesty, which makes him possibly the most interesting and the most formidable of our time'.

44. It should be added that if this political guilt was real in 1922, he had shaken it off by the end of the 1920s, when, as he wrote to Sir Gilbert Clayton, High Commissioner in Iraq: 'As I get further and further away from things, the more I feel that our efforts during the war have justified themselves, and are proving happier and better than I'd ever hoped . . .'

45. If it is true that the modern notion of 'celebrity' bears only a superficial resemblance to the classical notion of 'fame', then Lowell Thomas was one of the manipulators who helped corrupt the latter into the former. And T. E. Lawrence was one of the early beneficiaries and victims of 'celebrity culture'.

Much of what Seldes said repeated the terms of other favourable reviews; he differed from prevailing advanced opinion mainly in finding the parodic elements of the book admirable rather than a distraction:

> . . . the parodies themselves I find brilliant, but their function is more important than their merit. They create with rapidity and as rapidly destroy the whole series of noble aspirations, hopes and illusions of which the centuries have left their record in prose. And they lead naturally, therefore, to the scene in the brothel where hell opens.

Seldes declared that the 'galvanic fury' of the Nighttown episode was 'not equalled in literature'. He went on to speak of the novel's 'enormous absorption in things, by an enormous relish and savoring of palpable actuality. I think that Nietzsche would have cared for the tragic gaiety of *Ulysses.*' After further superlatives, and a prediction that Joyce's work would influence all subsequent novelists, he brought his piece to a resonant close:

> . . . this epic of defeat, in which there is not a scamped page nor a moment of weakness, in which whole chapters are monuments to the power and the glory of the written word, is itself a victory of the creative intelligence over the chaos of uncreated things and a triumph of devotion, to my mind one of the most significant and beautiful of our time.

SEPTEMBER

I SEPTEMBER

GERMANY

From Freiburg, Hemingway reported to the *Toronto Daily Star* on the collapse of the mark. He described the prevailing national mood as one of 'dogged sullenness or hysterical desperation'. Every day, he explained, the newspapers would print the new exchange rate for the mark on their front pages; and in the big towns like Berlin and Hamburg, those who still had money were going on a mad spending spree, buying jewels, furs, cars – anything that would retain value while the currency 'tobogganed'.

Bizarrely, there was little sign of such frenzied panic-buying in the smaller towns. In Freiburg, where Hemingway stayed in a hotel for about 20 cents a day, people seemed well fed and reasonably contented. The one overt sign of changed circumstances was hostility towards all foreigners, who were resented for the strength of their own currencies and suspected of being responsible for Germany's plight. Shopkeepers would be as rude as they dared to tourists, short of actually forcing them out of the shops.[1]

Hemingway's next few reports from Germany took a more whimsical, not to say knockabout turn: a comical account of a fishing trip in the Black Forest, a study of the rude ways of German innkeepers.[2] He returned to the subject of inflation on 19 September. In Kehl, he had exchanged 10 French francs for 670 marks; 10 francs being about 90 Canadian cents. He and his wife spent freely all day, and still had 120 marks left at

1. The local sense of relative well-being was clearly a case of a fool's paradise: for a short time, people were still able to afford groceries because merchants were selling goods at retail prices that were less than half of the wholesale prices at which they had been purchased. How long could this insane form of economics survive? Months? Weeks?

2. Even here, the subject of inflation was inevitable. He constructed an elaborate joke about a race between a Swiss hotelier's ability to hike prices 'with the easy grace of a Pullman car poker shark' and the accelerating plummet of the mark, and topped it off with a topical reference to Einstein: 'In spite of it being the monetary medium that is in daily use in the Einsteinian houschold, the mark still seems affected by the laws of gravity.'

the end of the day. Their five-course meal that night at Kehl's best hotel came to the equivalent of 15 cents. At one point they were watched longingly by a distinguished-looking old man who clearly craved the apples they were buying.

His final piece was on the many brutal riots that had broken out across the country, often quelled by the police with machine guns. The only people who were doing well, he concluded grimly, were the profiteers: particularly the arch-profiteer Herr Hugo Stinnes, who had arranged that all the material bought from Germany by France to carry out the French reconstruction should be supplied by . . . Herr Hugo Stinnes.

2 SEPTEMBER

BERLIN
President Ebert declared that 'Deutschland über alles' was now the official German national anthem.

PARIS
Proust suffered unusually violent fits of asthma on the 2nd and 3rd, and on the 4th, repeated attacks of vertigo: whenever he tried to climb out of bed, he fell to the floor. His powers of speech, memory and sight failed him several times. The precise cause of this decline remains unknown, though his doctors were probably right in thinking that his habit of dosing himself with alternating draughts of stimulants and narcotics must have been at the root of at least some of his ailments. Proust himself, having previously diagnosed his complaints as chronic uraemia, now became briefly persuaded that the culprit was carbon monoxide from his bedroom fire. He ordered his servants never to light the fire, and thus spent the weeks of his final illness in a cold room. He was a dreadful, rebellious patient, almost always doing the opposite of what his doctors advised.

Sensing that he would soon be dead, Proust threw himself into marathon bouts of writing and rewriting. Between the middle of August and the end of October, he revised the existing typescript of *La Prisonnière* three times (completing it on October 24). By the end of this stint, he had developed a severe cold, which deteriorated into bronchitis; his fever crept higher and higher. His doctor prescribed hearty meals. Proust, remember-

ing how his mother had nursed him in childhood, insisted on fasting, and would take nothing but milk and fruit. His doctor prescribed rest; Proust kept on writing. On the afternoon of 19 October, he once again disobeyed doctor's orders by going out for a walk, but he was forced to come back almost immediately, chilled to the bone and sneezing. He never stepped outside again, but stayed in bed, revising *Albertine Disparu* to the very end. At the start of November, it was confirmed that he had, as he suspected, contracted pneumonia – a disease which, at the time, had only two outcomes: spontaneous recovery, or death within a matter of a week or so. 'November has come,' he said to Céleste. 'November, that took my father.'

PARIS

After six months of trying, Harry Crosby (see 14 March) proposed to Polly Peabody by transatlantic cable. She wired back YES, so he immediately borrowed $100 and went to Cherbourg, only to be told that he would have to spend a week in quarantine. He was enraged, and somehow managed to bribe his way on to the *Aquitania* for the six-day crossing to New York.[3]

When the *Aquitania* docked in New York on 9 September, Polly was waiting beyond the barrier. Harry felt, he later said, like a marathon runner who had successfully completed a race but was on the verge of collapse. They were married that same afternoon in the chapel of the Municipal Building, and celebrated at the fashionable Belmont Hotel. They had just 48 hours before the *Aquitania*'s return trip, and Harry was determined to spend that time patching up matters with his family, who were staying in Washington, DC. The diplomatic mission was not a success.

Back in New York, they picked up Polly's children, Polleen and Billy, from the Belmont. As if only just aware of his new standing as a stepfather, Harry was hit by a sense of disillusion and panic, and disappeared for several hours. None the less, the new family boarded the ship on the 11th as planned, and sailed back to Paris, where they set up their first household at the Hôtel de l'Université on the Left Bank.[4]

Crosby kept his banking job for just over a year, eventually quitting in

3. The bribe left him penniless – a state he escaped, then embraced again, by winning $40 at cards and spending the entire windfall on champagne for fellow passengers. By midweek he grew bored with economy-style travel, so he dressed up in evening clothes and dined on caviar, mock turtle soup and hummingbirds on toast until a steerage inspector asked him to leave.
4. They later moved to an apartment on the Rue des Belles Feuilles.

November 1923, but his employment there was something of a polite fiction. He took days off at will, and even on the days when he did show up for work, he was easily tempted out of the front door of Morgan, Harjes et Cie, across the Place Vendôme, and into the warm welcome of the Ritz. It was possible that he did manage a little work now and then, though he appeared to spend most of the hours he condescended to put in at the office reading poetry, and dreaming of writing his own.

But poetry, and the publishing of poetry, was still in the future.

3 SEPTEMBER

USA

The release of a five-reel comedy feature, *Grandma's Boy*, starring Harold Lloyd.[5]

Lloyd (1893–1971) originally adopted fake glasses because it was felt that he was too handsome to play a comic lead without some supposedly unglamorous prop. The 'glasses character'[6] – sometimes called Harold – became one of the emblematic figures of the age: clean-cut and eternally adolescent, bumbling but doggedly optimistic, anxious but unexpectedly brave. Of Lloyd's own bravery there is no doubt: he performed most of his highly dangerous stunts himself, and was sometimes injured.[7]

Lloyd had made the transition from short, usually two-reel films to five-reel features in 1921. *Grandma's Boy*, like most of his films, was an immediate hit; it was also highly influential in the development of film comedy, since – like Chaplin's *The Kid*, released the previous year – it showed that a film richly laden with gags could also have room for character development without losing pace or audience appeal. *Grandma's Boy* is a simple yarn about human potential: Lloyd plays a namby-pamby fellow, too timid

5. Lloyd's work has not survived as well as that of Keaton and Chaplin, largely because of his refusal later in life to sell the films for television screenings at sufficiently low prices. This policy more or less guaranteed that several generations grew up without seeing them. In 1922, though, he was a healthy commercial rival for the other two stars, and has often been called the 'Third Genius' of American silent comedy. Though his films usually did not perform as well as Chaplin's at the box office, he made more of them – nearly 200 – and the persona he developed for the screen was every bit as well known to audiences of the 1920s as Chaplin's tramp and Keaton's stoic.

6. It has been suggested that the appearance of Clark Kent, the meek, bespectacled alter ego of Superman, was inspired by Lloyd's glasses character.

7. One of the most enduring images of the silent era is that of the glasses character dangling precariously from the hands of a giant clock, in *Safety Last*.

to win the heart of the girl he adores, until his grandmother gives him a magical charm from the Civil War. Emboldened by this supernatural aid, he defeats the bad guy, wins the girl, and finds that the 'magic charm' is actually the handle of his grandma's umbrella. He was a hero all along.

AUSTRIA

Having given up his job as a primary school teacher in Trattenbach, Wittgenstein took up a post in a secondary school in a village not far away: Hassbach. Even before he started there, he had taken against almost all of the locals – 'not human *at all* but loathsome worms'. Once he began work, he grew even more disgusted with the schoolteachers in particular, and with their claims to 'specialised knowledge', which infuriated him. He hated the place so much that he barely managed a month there before moving back into primary school teaching.

4 SEPTEMBER

BLACKPOOL

William Lyons and his colleague William Walmsey founded the Swallow Sidecar Company – the British manufacturing firm which later changed its name to Jaguar. In the early years, as the name suggests, the company devoted itself to the production of sidecars; its first proper car, a 2.5 litre saloon, was put on the market in 1935 as the 'SS Jaguar'. For obvious reasons, the now-alarming initials were dropped by the company in 1945, and all subsequent designs have been known simply as Jaguars.

6 SEPTEMBER

LONDON

Virginia Woolf wrote:

> I finished Ulysses, & think it a mis-fire. Genius it has I think; but of the inferior water. The book is diffuse. It is brackish. It is pretentious. It is underbred, not only in the obvious sense, but in the literary sense. A first rate writer, I mean, respects writing too much to be tricky; startling; doing stunts. I'm reminded all the time

of some callow school boy, say like Henry Lamb, full of wits &
powers, but so self-conscious & egotistical that he loses his head,
becomes extravagant, mannered, uproarious, ill at ease, makes
kindly people feel sorry for him, & stern ones merely annoyed; &
one hopes he'll grow out of it; but as Joyce is 40 this scarcely seems
likely. I have not read it carefully; & only once; & it is very obscure;
so no doubt I have scamped the virtue of it more than is fair. I feel
that myriads of tiny bullets pepper one & spatter one; but one does
not get one deadly wound straight in the face – as from Tolstoy,
for instance; but it is entirely absurd to compare him with Tolstoy.

The following day, Leonard gave her a copy of the review that Gilbert Sel-
des had written for the New York *Nation* (see 30 August), and she reluctantly
confessed to herself that Seldes 'makes it very much more impressive than
I judged'. Even so, she refused to deny the validity of her first impressions.

9 SEPTEMBER

TURKEY
As the Greco-Turkish war drew to its close, it had become obvious that
the Turks would soon have won a decisive victory. The latest success
for the Turkish army was the capture of Izmir. Greek forces retreated, with
the Turks in close pursuit.

DUBLIN
William T. Cosgrove took over as Irish premier.

10 SEPTEMBER

SUSSEX
The death of Wilfrid Scawen Blunt (1840–1922), one of the most colourful
figures of his age.[8] A few weeks earlier, Blunt had written to T. E. Lawrence,

8. Remembered today, if at all, as a poet and essayist, Blunt worked for the British Diplomatic Service
from 1858 to 1869 – the year in which he married one of Lord Byron's granddaughters. He was an

after reading about his resignation in the *Morning Post*: 'I congratulate you on having been true to your word and broken your official bondage. Liberty is the only thing a wise man's fighting for in public life.'

For students of modernism, Blunt is remembered chiefly by an affectionate reference in Pound's *Pisan Cantos*, where Pound recalls having paid a visit to Blunt's house in the English countryside.

11 SEPTEMBER

USA

D. H. Lawrence's thirty-seventh birthday. He and Frieda were driven into Taos to begin their new life in America, fifty-five miles to the north of Santa Fe, Taos was a sparsely populated town – really more of a scattered village – of some 1,800 souls. Mabel Sterne's property was at the edge of town, a mile from the central plaza. She had allocated the Lawrences a large, simple house 200 yards from her own, but she was so keen to introduce her pet writer to Indian life that she sent him off for five days to the Jicarilla Reservation, before he and Frieda had enough time to settle in and grow used to the thin air at 7,000 feet.[9]

The Lawrences soon found that life in Taos suited them well. They learned to ride, enjoying their equestrian outings despite frequent painful falls, and Lawrence found it utterly exhilarating to go galloping around in the desert. Their ample house, four rooms and a kitchen, was handsomely dressed in Indian rugs and paintings; they ate good, fresh food, made peach jam, and cooked wild plums. The only immediate inconvenience was the close presence of their '*padrona*', who was reluctant to leave them alone. She tended to smother them with (usually) well-meaning attention and to harry them into trips and small adventures that they might have

ardent anti-imperialist, and a major advocate of Irish independence, but he also enjoyed the perks of aristocratic life. He and his wife travelled extensively in Europe, the Middle East and India; both passionately fond of horses, especially Arabian horses, they co-founded a stud farm. He had many mistresses.

9. Lawrence – in search of the primitive, of the authentic, of dark gods – was not inclined to complain. 'I shall never forget,' he later wrote, 'when I first came into contact with Red Men, away in the Apache country . . . It was something of a shock. Again something in my soul broke down, letting in a bitterer dark, a pungent awakening to the lost past, old darkness, new terror . . .'

preferred not to have. She also began to compete with Frieda for Lawrence's love.[10]

The atmosphere grew progressively more chilly as Mabel's competitiveness with Frieda became more aggressive: she insisted that Lawrence needed 'a new mother!' It was now clear that they would soon have to leave, and Lawrence began scouting about for a less oppressive place to live. They eventually found somewhere both suitable and affordable: a five-room log cabin on the Del Monte ranch, owned by a local family, the Hawks. It would be much less physically comfortable than their Taos house, but at least they would no longer be suffocated by Mabel's good, and bad, intentions.

MADRID

The 18-year-old Catalonian artist Salvador Dalí applied to sit the entrance examinations of the Special School of Painting, Sculpture and Engraving – the teaching department of the San Fernando Royal Academy of Fine Arts. According to his autobiography, *The Secret Life of Salvador Dalí*, he made a terrible mess of the examination, which demanded that candidates should execute drawings from a cast of Jacopo Sansovino's *Bacchus*, paying strict attention to the exact measurements of their completed sketches. Halfway through, Dalí realised that his drawing was too small, so he rubbed it out and began again. The completed drawing was even smaller.

No need for concern: standards at the Special School were none too high at this period, and Dalí was duly admitted. On 30 September he began his formal studies, signing up for 'Perspective', 'Anatomy', 'Modelling', 'Statue Drawing' and 'History of Art (Antiquity and the Middle Ages)'. More significantly, his acceptance as a student meant that he was now

10. Mabel was undeniably generous, but even when not trying to seduce Lawrence away from Frieda, she demanded a high price in loyalty and gratitude, and at one point went so far as to command Lawrence to write a novel about her 'discovery' of Taos. 'I wanted Lawrence to understand things for me,' she later wrote. 'To take *my* experience, *my* material, *my* Taos and to formulate it all into a magnificent creation.' He began a half-hearted attempt, but soon abandoned it; the remains survive as a fragment known as 'The Wilful Woman'. He turned aside from this task, and picked up his abandoned manuscript of *Studies in Classic American Literature*, rewriting and completing the whole work in a pungent, aphoristic style by the end of the year. Mabel began to remind Lawrence ominously of his earlier benefactor, Ottoline Morrell, though Mabel was much more demanding; at times, indeed, a downright bully. Worse still, he came to think of her as a *strega*: a witch.

qualified to apply to one of Madrid's most extraordinary institutions – the Residencia de Estudiantes, popularly known as the 'Resi'.[11] It was here that he formed passionate friendships with two other young men who would go on to become among the most celebrated figures in modern Spanish culture: Federico García Lorca and Luis Buñuel.[12]

Buñuel was the first of the trio to arrive, entering the Resi in the autumn of 1917; at this time, it would have been almost impossible for anyone to guess that he would devote his mature life to making films, let alone become widely recognised as one of the greatest of directors. At 17, he was more a sportsman than an aesthete, and even by the vigorous, outdoorsy standards of the Resi – where the doctrine of *mens sana in corpore sano* was taken earnestly, and the official emblem was based on an ancient Athenian sculpture known as the 'Blond Athlete' – it was felt that he cultivated his already powerful physique to the point of fanaticism.[13]

11. Directly inspired by the collegiate systems of Oxford and Cambridge, the Residencia de Estudiantes was a unique institution in Spain. It began life as the offshoot of a progressive secondary school founded in 1876 by a group of visionary university teachers as a breeding ground for a new type of Spanish citizen – Europeanised rather than wilfully provincial, secular rather than dominated by the Catholic church, liberal rather than monarchical and reactionary. The school was to have an enormous impact on Spanish culture, quite disproportionate to its size, and was a major force in bringing the country into the modern world. Its equally influential offshoot, the Resi, had its humble origins in 1910 as a hostel for university students. The first intake was modest: just 17 men, housed in 15 bedrooms.

Since most of Madrid's students were forced to live either with their parents or in squalid boarding houses, there was an immediate demand for places at the Resi. Within five years it had to move to larger grounds, on a group of small hills at the northern end of the Paseo de la Castellana, about 20 minutes by tram from the town centre. The accommodation, in a series of light, airy brick pavilions built in the Moorish-inspired modern style of *neomudejar*, was austere to the point of monasticism, but always scrupulously clean and tidy, and also, crucially, cheap. Alcohol was forbidden – astonishingly for Spain, there was no wine with dinner – as was any rowdiness at night.

Its fine gardens, designed by the poet Juan Ramón Jiménez, were dominated by rows of poplars, and a small canal ran through the campus. Surrounded by the dry Castilian plain, it felt like a literal oasis as well as a spiritual one. In its great years, from 1922 to 1936, admission was restricted to 150 male students at any time, chosen from the whole range of Madrid's various places of tertiary education so as to create a stimulating, multi-disciplinary atmosphere.

12. Born in 1900 in the small town of Calanda in the province of Zaragoza, Buñuel was the eldest of five sons. His father was a rich entrepreneur who had come home from Cuba in middle age and married the prettiest girl in the village, 20 years his junior. Buñuel's mother doted on her oldest boy, and was relieved to think that life in the Resi would spare him the physical and moral unpleasantness of rented digs. She would have been dismayed to learn that one of Luis's main pastimes as a student was his search for lowlife in a series of nocturnal rambles around the capital's sleazier districts. He also enjoyed sampling the brothels of other cities, including those of Toledo, where on one memorable occasion he managed to hypnotise one of the working girls.

13. Every morning he would go running barefoot, throw javelins, hammer away at a punchball, and do endless press-ups. He also fancied his prowess as a boxer, though in practice he tended to throw

Disciplined in body, Buñuel remained feckless in mind. His lack of vocation at this time can be inferred from the casualness with which he wandered from faculty to faculty, and from the number of years it took him to graduate.[14] The only art form in which he expressed much interest was literature. Fond of drinking, talking and the company of like-minded men (women played no part in the intellectual life of the Resi), he soon belonged to some of Madrid's informal conversation groups – *tertulias*. Thanks to this habit, he found himself a member of one of Spain's earliest avant-garde organisations, which produced a magazine called *Ultra* and adopted the same name for their movement. Ultra's heroes were fairly up-to-date: Apollinaire, Cocteau, Diaghilev (the Ballets Russes had visited Spain in 1916 and 1917), Gris, Marinetti, Picasso and Pierre Reverdy. Their magazine published rising young talents, including – long before his rise to international fame – the Argentinian Jorge Luis Borges. Buñuel's first contribution was published in February 1922, by which time he was close friends with a young poet whose literary talents were already highly developed: Federico García Lorca.

Lorca, by common consent the greatest Spanish poet of the twentieth century, was six years older than Buñuel.[15] The pair first met in the autumn of 1919, when the young poet joined the Resi while (so the plan went) completing his studies at Madrid University. Already a published author – his father had funded a book of travel writings, published in 1918 – Lorca took the Resi by storm. 'Federico was brilliant and charming, with a visible taste for sartorial excellence,' Buñuel wrote many years later. 'His ties were always in impeccable taste. With his dark shining eyes, he had a magnetism that few could resist.' From 1920 to 1922, Buñuel was in effect an acolyte of Lorca.

In addition to his good looks, fine clothes and charisma, Lorca was also a brilliant conversationalist, a first-rate pianist, guitarist and singer, a gifted cartoonist and a spellbinding reciter of his own poems. He was

fights by his defensive moves, since he was scared of damaging his handsome face. His contemporaries nicknamed him Tarquinius Superbus: Tarquin the Proud.

14. He had enrolled in Madrid University's Department of Agricultural Engineering, but switched almost immediately to industrial engineering; and then to natural sciences, where he specialised for a year in entomology (a study which remained a lifelong obsession, and helped keep him mentally alert in old age). He eventually graduated with a degree in history.

15. He had been born into a wealthy farming family in 1898; his native village, Fuente Vaqueros, was not far from Granada.

unquestionably the star of his generation. There was one snag, however: he was gay, and had to keep his sexuality a nervously guarded secret, for even in the tolerant climate of the Residencia, homosexuality was taboo.[16]

Lorca was not one of those flashy young men who flourish on campus only to be lost in the larger world. His career was moving quickly: in 1920 he staged his first major play, *El Maleficio de la Mariposa* (*The Butterfly's Evil Spell*); in 1921, his first collection of verse, *Libro de poemas* (*Book of Poems*) was published, and greeted with a warm review on the front page of Spain's main liberal newspaper, *El Sol*; and in the summer of 1922, he had helped his friend Manuel de Falla stage a flamenco festival in the Alhambra. (See 13 June.) All of which meant that he spent very little time at the Resi in 1922, though his fellow students gossiped about him all the time, and everyone was in a state of excitement at the prospect of his imminent return. Dalí, already timid enough in his new surroundings, must have been daunted at the prospect of having to compete with this multi-talented Adonis. They finally met at the beginning of 1923.

Whatever wild ideas they may have entertained in café debates, the young fellows of the Residencia were sartorial conformists. They all favoured tailored suits in the fashionable British style, or golfing jackets for less formal occasions; they had their hair cut short, often by the barbers at the Ritz or the Palace Hotel. Dalí, by contrast, adopted a style closer to that of bohemian circles in the 1890s or 1960s: he had long, thickly tangled hair, flowing down over his shoulders, in imitation of a self-portrait by Raphael. He wore a huge wide-brimmed hat, a velvet jacket that came down to below his knees, floppy neckties, leather gaiters and a floor-length cloak, and he carried a gilded cane. Since he was agonisingly shy – an extraordinary contrast to the uninhibited exhibitionist of later years – he also appeared extremely solemn.[17]

An improbable friend for Buñuel, then, but Dalí had all sorts of depths for those willing to see past the silent, foppish exterior,[18] and the

16. Buñuel himself, sad to say, was homophobic, and sometimes indulged in the vile macho sport of queer-bashing, flirting with the men who cruised him and then luring them out to be thumped by other students. The future film-maker was entirely unaware that Lorca was gay, and when he eventually discovered the truth, it tore their friendship apart.

17. One contemporary reported that the young Dalí looked 'just like Buster Keaton'. Jokes were made about his oddity, and he was nicknamed variously 'the musician', 'the artist' or 'the Pole'.

18. He was soon discovered to be a brilliant painter in the Cubist style, and then to have a remarkable

Buñuel crowd took him up eagerly. By the end of his first term at the Resi, he had begun joining Luis for some of his nocturnal rambles through Madrid – experiences recorded in a watercolour of the time entitled *Sueños Noctambulos* (*Night-walking Dreams*). He responded to this unexpected popularity by changing his style completely, and within a matter of weeks he had trimmed his unruly hair into a Valentino style, taken up vodka and jazz music and was generally acting the part of a young swell.

When he finally met Lorca, at the beginning of 1923, the two young men hit it off almost at once, discovering how many things they had in common: a love of France, a hatred of Germany, a childhood rich in folk music and song, a taste for the poetry of Ruben Dario, an anger about social injustice . . . and a degree of uncertainty and worry about their sexual identity. Their friendship grew close and passionate, though Dalí would often break it off and sulk for long periods, usually because he was jealous of Lorca's social ease and conscious of his own inadequacies. Love ultimately turned to hate, especially between Buñuel and Dalí; but that was years ahead. For now, the three were all but inseparable.[19]

12 SEPTEMBER

LONDON

In a letter to the Scottish literary critic and politician J. M. Robertson (1856–1933), Eliot wrote: 'At one time I knew Mr Murry very well indeed, when I was working with him on the *Athenaeum*. Since then differences of opinion have divided us and he has treated me in his published writings, with either open patronage or disguised innuendo.'

and thoroughly modern range of interests. He knew all about Picasso at a time when Madrid had barely heard his name; he was steeped in Nietzsche and, more remarkably, in Freud's *Psychopathology of Everyday Life*, which had only recently been translated into Spanish; and he was a prodigiously hard worker.

19. There is not much documentation of how this extraordinary trio influenced one another: the memoirs by Dalí and Buñuel are notoriously unreliable, and Lorca was murdered before he had the chance to write his own; the Residencia's own records were mainly destroyed in the civil war. 'As a result,' Ian Gibson concludes in his biography of Dalí, 'it is almost impossible to reconstruct the development of the passionate relationship uniting three of Spain's most creative geniuses of the twentieth century.' That the experience told deeply on each of them, however, is beyond doubt.

GERMANY

Jung met Richard Wilhelm – who in the 1960s became world-famous as the translator of the *I Ching* – at the Darmstadt School of Wisdom. He was to call this encounter 'one of the most significant events of my life . . . Indeed, I feel myself so very much enriched by him that it seems to me as if I have received more from him than from any other man'. He went on to declare that 'I see Wilhelm as one of those great Gnostic intermediaries who brought the Hellenic spirit into contact with the cultural heritage of the East and thereby caused a new world to rise out of the ruins of the Roman Empire.'

ENGLAND

Sydney Schiff introduced Wyndham Lewis to the dying Katherine Mansfield. It was not a happy meeting. Paying no heed to her suffering, he began to argue with her ferociously, and made remarks that she found brutally cruel. He made blunt assessments of her limitations as a writer, and sneered at her infatuation with 'the Levantine psychic shark' – Gurdjieff. Even the thick-skinned Lewis soon realised that he had overstepped the mark, and though he could not quite bring himself to make a full apology, his next few letters to the Schiffs made comic references to the encounter with Mansfield, blaming her for picking a quarrel with him. A few days later, Lewis visited the Sitwell brothers at their home in Renishaw, near Sheffield.

13 SEPTEMBER

SYRIA

A record-breaking high temperature of 136.04° Fahrenheit (57.8° Celsius) was recorded in El Azizia.

SMYRNA

The most terrible military atrocity of the year came towards the end of the Greco-Turkish war. From 13 to 15 September, massive fires – almost certainly started by Turkish troops – swept through Smyrna, destroying most of the buildings and killing some 100,000 men, women and children. When the earliest readers of *The Waste Land* encountered Eliot's

reference to a Smyrna merchant, the place name would have jumped out at them as a topical horror.

Ernest Hemingway was sent to cover the war, but despite his sweeping summary of these events in later years – 'In the fall [of 1922] I went out to Constantinople, Anatolia, Smyrna, Thrace etc. as war correspondent for The Toronto Star and the International News Service' – the conflict was over before he got there. His first report from Constantinople was filed at the end of September.

14 SEPTEMBER

USA

Sometime during the late hours of 14 September or the early hours of the 15th, an Episcopalian pastor and his mistress were shot dead in woodland not far from their homes in New Brunswick, New Jersey. He was the 41-year-old Reverend W. Hall, of the church of St John the Evangelist; she was Eleanor Mills, 34, a married singer in the church choir. The bodies were not found until Sunday morning, by which time the maggots were at work; none the less, it was easy for the coroner to determine the extent of their wounds. The Rev. Hall had received a single bullet to the head; but Mrs Mills had not only been shot five times – once under the right eye, once over the right ear, and three times in the right temple – but had been viciously mutilated: both her tongue and her larynx had been cut out and thrown away, as if in mockery of her prowess as a singer.[20]

The affair between the Rev. Hall and Mrs Mills had been going on for some four years, and was public knowledge in the neighbourhood; there were also rumours that the couple had been on the brink of eloping. The Halls' maid reported that Eleanor had telephoned the Hall residence at about 7 p.m. on the 14th, and that the Reverend had left at once, saying that he was going to see Mrs Mills about a medical bill. Mr Mills, the cuckold, said that his wife had sneered at him before going out on her own; he had tried looking for her at 11 p.m. and again at 2 a.m., but could

20. The combination of respectability, adultery and horror fascinated the public, and the Hall-Mills murder became known by the press as the 'crime of the century', until eclipsed a decade later by the Lindbergh kidnapping.

not find her. The next morning, Mrs Hall's brother, Willie Stevens – 50 years old, and considered mentally deficient – was heard to say that 'something terrible' had happened in the night.

The leading suspects were Willie Stevens (a .32 cartridge had been found near the bodies, and Willie owned a .32 pistol); his brother Henry Stevens, a noted marksman; and a cousin of theirs, Henry Carpender. Another man was briefly arrested, then released. Rumours sprang up on all sides, one of them hinting darkly at Ku Klux Klan involvement. Eventually, Mrs Hall was charged with carrying out the brutal murder with the aid of Willie and Henry Carpender, but the trial was so poorly conducted that the case was dropped until 1926, when the husband of the Halls' maid claimed that his wife had been offered $5,000 in hush money. The case was reopened, and this time included the testimony of the so-called 'Pig Woman', who claimed to have been an eye-witness to the murder, and confirmed that she had seen the accused trio killing the couple. Unfortunately for the prosecution, her 1926 statement was radically inconsistent with the one she had offered in 1922, so the case was once again dropped. It remains unsolved.

USA/UK

Babbitt, the latest novel by Sinclair Lewis (1885–1951) was published simultaneously in the United States and Britain. The American publisher, Alfred Harcourt, confidently expected that it would be an immediate best-seller, and the first print run was a generous 80,500 copies.[21] He was not disappointed: the hard-cover edition went on to sell some 250,000 copies, and the reprint edition well over a million. Just a few years earlier, such a triumph would have seemed wildly improbable to Sinclair, who had spent most of his years since college drudging in poorly paid jobs in and around journalism, writing short stories and a handful of neglected novels. But the publication of his novel *Main Street* in 1920 had pushed him directly into the front ranks of American authors, and *Babbitt* was even more of a sensation, its prominence boosted as much by those outraged citizens who thought Lewis a vile and caustic anti-American as by those who were delighted by his powers of satire, observation and narrative construction.

21. Compare the more modest 15,000-copy run of Lewis's previous novel.

Babbitt – the name went almost immediately into the American language, where it still hangs on as the literate term for a smug, moderately prosperous, narrow-minded member of the management class – is a mordant portrait of a disagreeable small businessman, George F. Babbitt, who lives, works and is thoroughly pleased with himself in the Midwestern city of Zenith: a compound of several places well known to Sinclair from his travels, though Cincinnati, Ohio is one of the most obvious models.[22]

It seemed that you could hardly so much as walk into a bar, a church or a bus station without hearing people, many of whom had hardly read another novel, arguing bitterly over the sins and glories of *Babbitt*.[23] Those who were not angered or dismayed by the book were mainly impressed, both by the vitality of Sinclair's prose and by the precision of his insight into the minds of the 'booboisie', as Mencken had called Babbitt and his kind. Many of the reviews were raves; Lewis was particularly delighted by Rebecca West's notice for the *New Statesman*: 'It has that something extra, over and above, which makes the work of art, and it is signed in every line with the unique personality of the author.'

Letters of praise arrived from around the world, and many of them from big names. From England, H. G. Wells told Lewis that

> *Babbitt* is one of the greatest novels I have read for a long time. He is what we call a 'creation' but what we really mean is that he is a completely individualized realization of a hitherto elusive type. He is the common American prosperous business man *got* . . . I salute you with gestures of respect and affection. I wish I could have written *Babbitt* . . .

Somerset Maugham wrote from Bangkok: 'I think in many ways it is a much better book than *Main Street*. It seems to me a more complete and rounded work of art; of course, I read it with interest and amusement, but, as you will not be surprised to know, also with horror . . .' And Edith

22. Perhaps blind to the scathing intentions of the work, no fewer than five cities – Cincinnati, Duluth, Kansas City, Milwaukee and Minneapolis – competed to be identified as the true original of Zenith; Minneapolis even staged a 'Babbitt Week'.

23. Similar, if less impassioned discussions were happening across the Atlantic, too; even Trotsky, who read the novel in Russian translation, told an interviewer that 'I find *Babbitt* curiously interesting and instructive though it is too bourgeois in character.' Many Europeans, lapsing back into anti-Americanism, took the novel as a definitive condemnation of post-war America: hypocritical, mindless, stultifying.

Wharton – to whom Sinclair had dedicated the novel – admitted that she preferred *Main Street*, but

> there is much more life & glow & abundance in the new book; you must have felt a stronger hold on it, & a richer flow. I wonder how much of it the American public, to whom irony seems to have become as unintelligible as Chinese, will even remotely feel? . . .
>
> Thank you again for associating my name with a book I so warmly admire and applaud . . .

By the end of the year, Lewis was widely acknowledged to be America's leading novelist – though younger men, like Fitzgerald and Hemingway, were coming up fast. When he won the Nobel Prize in 1930, the citation – though it summarised five of his major books in detail – hinted strongly that the prize was being awarded not for *Main Street* or *Elmer Gantry* but for *Babbitt*.

17 SEPTEMBER

RUSSIA
Radio Moscow went on the air, using one of the most powerful transmitters in the world.

18 SEPTEMBER

SWEDEN
Benjamin Christensen's strange, almost unclassifiable film *Haxan* was released. The film was banned in the United States and many other countries for its scenes of nudity, torture and implied sexual perversion; the American premiere did not take place until 27 May 1929. It is one of the few films made in 1922 that is still frequently watched and discussed. It is also the only well-known film directed by Christensen (1879–1959), though he had a prolific cinema career in four different countries.[24]

24. Born in Denmark, he originally trained to be a doctor, but caught the show-business bug and became an actor – first on stage, then in films – and then a director.

Christensen brought *Haxan* to the Swedish film industry largely be-cause it would have been too expensive for Denmark.[25] He spent almost three years researching, developing and making the film, which was in-spired by his discovery of the fifteenth-century *Malleus Maleficarum* – 'Hammer for Witches' – in a Berlin bookshop. The completed film, which ran to 104 minutes, combined static and cheap lecture-hall-style sequences with dramatised vignettes, some of unusual power and undimmed eeriness.

Broadly speaking, the film falls into four movements. The first is an illustrated primer of early cosmology, heaven and hell, the origin of belief in demons and so on. The second illustrates a number of medieval super-stitions about witches and the Devil.[26] The third is essentially one long narrative about the cruelty, hypocrisy and malice of the medieval church's persecution of witches. The final section, set in the present day, combines documentary footage of elderly mentally ill women who in a less enlight-ened age would have been burned rather than taken into rest homes, and short dramas about modern psychological ailments such as somnambu-lism and kleptomania. The contention is that much of what earlier ages understood as demonic possession was actually mental illness.[27]

As this will make clear, the film's official mission, so to speak, was to debunk fanatical ignorance and praise science and compassion. But if there was hypocrisy among the Church's enforcers, there is something very close to the same in *Haxan*, which dwells lovingly on instruments of torture, on the curves of naked women seen from behind, on convents full of cavorting nuns (an anticipation of Ken Russell's *The Devils*), and on grotesque shock effects. In short, like yellow-press exposés of pornogra-phers and perverts, the film offers for thrills and titillation the very ele-ments it purports to hold in horrified contempt. Unsurprisingly, it was a huge hit.[28]

25. Eventually the costs reached some two million kronor, a record high for Swedish productions in its day.

26. Christensen himself plays Satan, heavily made up, tubby and constantly waggling his tongue lewdly.

27. Coincidentally, Freud's major written work of 1922 was *A Seventeenth-Century Demonological Neurosis*.

28. *Haxan* fell out of circulation for a while, but in 1968 was brought back to a highly appreciative young audience as *Witchcraft Through the Ages* – a shorter edit prepared by the film-maker Antony Balch, with a new musical score by the jazz violinist Jean-Luc Ponty and others, and a narration read in scratchy, cawing tones by the novelist William S. Burroughs.

Shortly after his film's triumphant release, Christensen was snapped up by the film company UFA, and brought to make films in Germany. In 1924 he was seduced into working for MGM in Hollywood, and then went on to work for Warner Brothers. Hollywood was not for him, though, and he eventually returned to work on stage and screen in Denmark. Today he is widely regarded as one of the country's greatest directors, second, perhaps, only to Carl Theodor Dreyer.

HUNGARY

After years of chaos and bloodshed, Hungary had finally been brought back to a degree of stability by its new prime minister, Count Istvan Bethen. The previous four years had been a nightmare for the country: after the collapse of the monarchy in 1918, it suffered large-scale invasions by Serbia, Czechoslovakia and Romania. The national Communist Party had established a short-lived Hungarian Soviet, ferociously opposed and finally defeated by 'White' elements, and causing both a Red and a White Terror. The Treaty of Trianon in 1920 had involved Hungary giving up two thirds of its pre-war territories, including those containing the larger part of its industry. To have brought the country back to order after these upheavals was remarkable; but any relief felt by the Hungarian people was soon turned sour by the beginnings of a hyper-inflation even worse than the one that tormented Weimar Germany.

PARIS

Joyce was now back in the city, and tried to make an appointment with Dr Bosch, only to find that he was still away on his summer vacation. Stuck in Paris, Joyce found the familiar chaos of 9 Rue de l'Université suddenly too depressing to bear, so he took out a contract (to begin on 1 November) on a furnished apartment at 26 Avenue Charles Floquet.

'I always have the impression that it is evening,' he told his young friend, the poet Philippe Soupault, who within a few years would be a famous member of the Surrealist movement. People remarked that his eyes looked permanently red now.

IRELAND

The September issue of the *Dublin Review* ran an article about *Ulysses* by 'Domini Canis' ('The Hound of the Lord') – that is, Shane Leslie.[29]

It was an angry, often quite funny piece. The Hound of the Lord began by growling about the impertinence of Valéry Larbaud's declaration that with *Ulysses* 'Ireland makes a sensational re-entrance into high European literature', and about the servile manner in which English critics such as Middleton Murry and Arnold Bennett seemed to have swallowed the French line. *Ulysses*, he continued, was no more than 'a fearful travesty on persons, happenings and intimate life of the most morbid and sickening description . . . *écrasez l'infâme!'*

Having drawn the battle lines, Leslie launched an all-out attack on the 'spiritually offensive' work – a 'Cuchulain of the sewer', an 'Ossian of obscenity'. He noted that the book had not yet been placed on the *Index Expurgatorius*, though he earnestly hoped that it soon would be, and he declared that no Catholic 'can even afford to be possessed of a copy of this book, for in its reading lies not only the description but the commission of a sin against the Holy Ghost'. And if possession was a spiritual hazard for Catholic readers, Joyce's book as a whole must be seen as 'the screed of one possessed'.

Leslie continued in this lively, scathing vein, pouring scorn on 'youthful dilettantes in Paris or London' who were claiming to understand a book of such profoundly Catholic blasphemy. After conceding that Joyce was capable of rising to the occasional verbal felicity, he ended in a vindictive flurry of negatives:

> Doubtless this book was written to make angels weep and to amuse fiends, but we are not sure that 'those embattled angels of the Church, Michael's host' will not laugh aloud to see the failure of this frustrated Titan as he revolves and splutters hopelessly under the flood of his own vomit.

DINARD

Olga Picasso fell suddenly ill, and had to be rushed back to Paris for an emergency operation, possibly for a miscarriage. The car trip from Dinard

29. Shane Leslie made a second attack on *Ulysses*, this time under his own name, in the October issue of the *Quarterly Review*. (See 29 October.)

was uncomfortable for the whole family: Picasso kept applying ice packs to Olga's head, while Paolo suffered badly from car sickness.

Shortly after Olga's operation, Picasso went back to Dinard on his own to collect the paintings he had executed since July. His return caused a great stir in the local press, since he had bought a fancy new car, a Panhard, and employed a chauffeur.[30] For his enemies, and his more rueful friends, this was a sign that his transition to haute-bourgeois ways under the influence of Olga was now complete. It was also the moment, as John Richardson notes, at which he finally passed from being merely rich and famous to being a full-blown modern celebrity – someone whose smallest activities were always newsworthy.

Back in his Paris studio, Picasso began to paint on a piece of wooden board, only seventeen inches or so wide. The subject was a couple of the immense women who had recently entered his paintings, racing across a beach, hands clasped high, hair flying, bosoms monumental.[31] This potent image is probably the best-known of all Picasso's works from 1922; he regarded it with special affection, and put it alongside the select number of other works that he would never sell or give away.

21 SEPTEMBER

LONDON

Eliot wrote a long and grateful letter to John Quinn, whose diplomatic efforts had finally resolved the complicated business of who would be publishing *The Waste Land* in America, and how, and when. He added:

> Whenever I get very tired or worried I recognise all the old symptoms ready to appear, with half a chance, and find myself under the continuous strain of trying to suppress a vague but intensely acute horror and apprehension. Perhaps the greatest curse of my life is noise and the associations which imagination immediately suggests with various noises . . .

30. An entirely reasonable indulgence: Picasso never learned to drive; he said that he was frightened it would ruin the suppleness of his hands and wrists.
31. A couple of years later, he would use greatly enlarged versions of these women for the theatre curtain for Diaghilev's 1924 production of Cocteau's *Le Train Bleu*.

Have critics ever noted this morbid sensitivity to the noises of city life as a key inspiration for the form of *The Waste Land* – a montage of different voices and sounds?

IRELAND
Yeats and his wife left Thoor Ballylee to settle in their grand new house: 82 Merrion Square, Dublin.

ITALY
Count Harry Kessler paid a visit to an old friend of his, now living in a kind of self-imposed exile in Rapallo: Edward Gordon Craig, the legendary director and man of the theatre. The two men had last met in 1914, but Craig struck Kessler as having hardly aged at all. Craig, his wife and their two children had been living modestly in the town for five years, ever since the failure of their theatre school in Florence.[32] They lived in constant hope of finding a rich patron. Meanwhile, their house – hung by Craig with grey sailcloth, and crammed with bookshelves devoted to the history of the theatre, ballet and puppetry – was like a small monastery dedicated to their art. Despite his deep admiration for Craig, Kessler found something childish about it: 'It was like paying a visit to a nursery, particularly when Mrs Craig and the son Teddy came out with some bloodthirsty Fascist opinions.' He concluded:

> It is close on tragic to see this undoubted genius, whose vision and ideas have for the past twenty years inspired the theatre the world over, from Russia via Germany and France to America, not exercising his gifts but living like an island exile while festival playhouses, international drama exhibitions, and revolutions in theatrical production still draw on his capital . . .

ATHENS
Following the defeat of the Greek army by the Turks, King Constantine I of Greece (1868–1923) abdicated his throne and went into exile. He was succeeded by his son, George II. Constantine's exile did not last long: he died in Palermo, Sicily, just four months later.

32. Their annual income was £250; a sum which would not have supported them for six weeks in London, Craig said.

22 SEPTEMBER

PALESTINE

With the approval of the League of Nations, this day marked the beginning of the British mandate in Palestine and Transjordan, until recently under the control of the Ottoman Empire. The League had also approved a memorandum of Lord Balfour, exempting Transjordan from the clauses of the mandate concerning the creation of a home for the Jewish people, and the facilitation of Jewish immigration and land settlement.[33]

NEW YORK

An article purporting to be based on a long interview with Rudyard Kipling appeared in a New York newspaper. According to this article, Kipling had expressed bitter hostility to the United States for, among other things, its late entry to the war. Kipling issued firm denials that he had ever said such things to the journalist, but the damage to his reputation in America was grave.

NEW YORK

Fitzgerald published *Tales of the Jazz Age*. In a letter to Max Perkins a couple of months earlier, he had written that 'I don't suppose such an assorted bill-of-fare as these eleven stories, novelettes, plays and 1 burlesque has ever been served up before in the history of publishing.' It included 'The Diamond as Big as the Ritz' and 'The Curious Case of Benjamin Button'.

23 SEPTEMBER

BERLIN

The Seventh International Psychoanalytic Conference was held from 23–27 September. Freud presented his paper 'Some Remarks on the Unconscious'. It was the last conference paper he ever gave.

33. Over the next decade or so, the Jewish population of the region increased by more than 10 per cent each year. The first revolt of the Palestinian people against this settlement began in 1936; and though the British mandate is long gone, its consequences are still with us.

25 SEPTEMBER

PARIS

The young poet René Crevel – he was 22 – came to Breton's apartment at 42 Rue Fontaine with plans that were strange even by the standards of this outré household. Just a few weeks earlier, Crevel had been on holiday with his family in Normandy. Various odd things had happened there, or so he claimed: for one thing, a young girl on the beach had begged him to press geraniums between her breasts. For another, he had attended a seance with that same girl and her mother, at which he had passed out and given voice to some mysterious statements, as though possessed. Crevel and Breton were notionally on cool terms, since Crevel had sided with Tzara at the doomed Congress of Paris, but when they bumped into each other, Crevel mentioned his Normandy seance and Breton agreed that the experiment must be repeated.

In the Bretons' living room, Crevel joined the trio of Robert Desnos (another young poet, who was also 22) and André and Simone Breton. The lights were extinguished, hands were joined and Crevel duly passed out. In Simone's words:

> It's dark. We are all around the table, silent, hands stretched out. Barely three minutes go by and already Crevel heaves hoarse sighs and vague exclamations. Then he begins telling a gruesome story in a forced, declamatory tone. A woman has drowned her husband, but he had asked her to. 'Ah! the frogs! Poor madwoman. Maaaaad . . .' Painful, cruel accents. Savagery in the slightest images. Some obscenity as well . . . Nothing can match the horror of it. Only the most terrifying passages of *Maldoror* could give you some idea.

If Crevel had exceptional gifts as a medium, they did not remain his exclusive property for long. Three days later, Desnos fell into a similar trance state, and answered, in writing, the questions put to him by the others.[34] In addition to some potent non-sequiturs, he managed to improvise a formally perfect sonnet. (Or had he prepared it in advance?)

34. Breton, hugely impressed, later published the results in a report, 'Entrée des mediums' in the November 1922 issue of *Littérature*.

The craze had begun. Almost every night for the next couple of weeks, the Bretons' flat was given over to these seances, or, as they became known 'sleeping fits'. It soon became clear – if it had not been so from the outset – that Crevel and Desnos were competing for Breton's attention and approval: Desnos accused Crevel of faking his trances; Crevel shoved Desnos so hard that his rival's head hit the mantelpiece.[35] All this racket did not escape the attention of the neighbours, and Simone had to bribe the concierge when she came bearing protests. But the Bretons had no intention of giving up their enthralling new game, even though the sessions usually left them exhausted and anxious.[36]

How seriously did Breton take these 'psychic' phenomena? He was certainly frustrated by his own inability to achieve trance states, and he must surely have been aware that some of the sleepers, especially Crevel and Desnos, were simply courting his attention.[37] Matters came to a head on an evening – not at Rue Fontaine – when ten participants had gone into a trance simultaneously, and made a mass attempt to hang themselves. Breton woke them all brusquely. These tamperings with other voices were becoming a serious morale crisis, possibly even a downright hazard. When the chance came to have a brief vacation in Spain, he was only too ready for a break.

27 SEPTEMBER

LONDON

E. M. Forster wrote to his closest Indian friend Syed Ross Masood – almost certainly the main model for the character of Aziz in A *Passage to India*,

35. Others joined in. The poet Benjamin Péret brought his girlfriend along to one of the sessions; she became hysterical, started screaming about her father, and had to be calmed by Breton's soothing attentions. Péret himself would howl with laughter and tell filthy stories; on one occasion, he became convinced that he was a flower.

36. André was so excited that he was even moved to bury the hatchet with Tzara, briefly, and invited his enemy round to join in. Tzara came, but mocked. Nor were all the proto-surrealists greatly smitten: Soupault was a sceptic, while Picabia and Aragon tried to stay away.

37. Desnos in particular piled effect on effect, claiming that he was now in telepathic communication with Marcel Duchamp in New York, and pouring out torrents of wild puns and other wordplay. Not to be outdone, Crevel began to make grim predictions: 'You will all become ill, one after another . . .' Reality played along with him: within a few days, Simone was struck on the head, Max Ernst began to spit blood and Eluard suffered a recurrence of his tuberculosis. Simone, for one, believed the curse had come true and was genuinely terrified.

and probably Forster's lover for a short period – explaining the difficulties he was having with the composition of his novel. The tone of the book had become darker than he had intended: he felt much more bitter towards the British after the Amritsar massacre, but he was also less enchanted with the Indians than he had once been:

> When I began the book I thought of it as a little bridge of sympathy between East and West, but this conception has had to go, my sense of truth forbids anything so comfortable. I think that most Indians, like most English people, are shits, and I am not interested whether they sympathise with one another or not. Not interested as an artist; of course the journalistic side of me still gets roused over these questions . . .

SWITZERLAND

Le Corbusier sent a letter to 'Mademoiselle Yvonne Gallis, chez M. Ed. Jeanneret, 20 rue Jacob', Paris – in other words, his own address. This is the first documentary evidence that his lover, Yvonne Gallis, had by now moved in with him. Le Corbusier – for many years an agonised celibate, too frightened of women to make overtures, too troubled by his Calvinist background to frequent prostitutes with an easy conscience – had finally discovered true love and regular sex. Though it was later rumoured that he had met Yvonne in a brothel, the reality was less excitingly sordid. He first encountered her towards the end of 1919 or the start of 1920, when she was working as a salesgirl and model at the couture house of Jove, where Le Corbusier – under his real name of Charles-Edouard Jeanneret – had shown some of his paintings.[38]

38. Yvonne, born Jeanne Victorine Gallis on 4 January 1892, was still a teenager when employed at Jove. She was pretty, sexy and highly flirtatious. For years to come she would often embarrass tradesmen and other male visitors by showing them what she invariably called her *cul* – her arse – and asking what they thought of it. She also loved practical jokes, and on one occasion decorously invited a Dominican father to sit down on a sofa, where she had hidden a whoopee cushion. From 1922 onwards, Le Corbusier contrived to live a double existence that suited him perfectly: the seemingly austere and high-minded public life of hard work, polemics, travels and increasing celebrity; and the private, humorous, domestic life of marital pleasures. Yvonne hardly ever appeared with him in public, and not many people even knew of her existence. Despite some major infidelities, and despite the fact that she was wilful, poorly educated, mildly indolent and in some ways coarse, the couple were to remain together happily enough for 37 years, until her death on 5 October 1957, the day before Le Corbusier's seventieth birthday.

If 1922 was the *annus mirabilis* of Le Corbusier's love life, it was also a significant time in his intellectual and artistic development. It was in this year's Salon d'Automne that he first made public his vision for a city of three million inhabitants, and his designs for what he called the Maison Citrohan.[39] He had been elaborating this scheme in a series of articles published between 1920 and 1922 in the magazine he co-edited, *L'Esprit Nouveau*. One of these articles used a phrase that was to become notorious: 'One needs to consider the house like a machine to live in . . .'

Some people found the idea of a machine house chilling, though Le Corbusier's intentions were wholly humane, and he intended something bright and, to his eyes, beautiful. A basic Citrohan dwelling took the form of a giant shoebox, the main element of which was a two-storey living room flooded with light from a wall made almost entirely of glass. The kitchen and a maid's room – note the expectation of domestic servants – would be set in a one-storey space at the back of the house; a spiral staircase would connect these to an upper storey with bedroom, bathroom and boudoir. The flat-topped roof of the building would serve as a sun terrace (note the expectation of a warm climate), and there would be space for two guest rooms, reached by exterior stairs. This simple design was, Le Corbusier believed, a foundation for a rich, varied and happy existence. Though the shapes of his designs were to change over the next 50 years, the values that imagined the Maison Citrohan remained consistent.

29 SEPTEMBER

MUNICH

Brecht's *Drums in the Night* (*Trommeln in der Nacht*) – his first play to be produced – opened in an expressionist style at the Munich Kammerspiele. It was directed by Otto Falkenberg, with a set designed by Otto Reigbert, and was an immediate success.

The critic Herbert Ihering came from Berlin to see what all the fuss was about, and was himself bowled over. In the *Berliner Börsen-Courier* of 5 October, he wrote that 'At 24 the writer Bert Brecht has

39. A name coined as a fond tip of the hat to the Citroën car, since one of Le Corbusier's ideas for this form of dwelling was that it might be mass-produced.

changed Germany's literary complexion overnight. Bert Brecht has given our time a new tone, a new melody, a new vision.' Ihering noted Brecht's 'physical sense of chaos and decay', and praised 'the unparalleled creative force of his language. It is a language you can feel on your tongue, in your gums, your ear, your spinal column . . .'

Ihering was to be the judge for that year's Kleist Prize – up until its abolition in 1932, the most important literary prize in Germany. Not surprisingly, on 13 November his newspaper announced that the winner of the 1922 prize was Brecht, not only for *Drums in the Night* but for his unproduced plays *Baal* and *In the Jungle of Cities* – works in which, the citation declared, Brecht's linguistic powers were even more amply displayed. 'His language is vivid without being deliberately poetic, symbolical without being over-literary. Brecht is a dramatist because his language is felt physically and in the round.'[40]

30 SEPTEMBER

TURKEY

On 30 September, Hemingway arrived in Constantinople, checked in at the Hotel de Londres, and almost immediately came down with malaria. In the course of the following two weeks, he sent home some harrowing dispatches, and saw horrors that would stay with him for years to come.

40. Following the award, *Drums in the Night* was picked up for production in theatres all over Germany, notably at the Deutsches Theater in Berlin, on 20 December, when Falkenberg again directed. Eventually, Brecht noted, it was performed upon 'some fifty bourgeois stages'. At this time, the author was conspicuously cool about the whole business; he liked to say that he had only written *Drums in the Night* for the money. In later years, after his conversion to Marxism, he frequently looked back on *Drums in the Night* with more obviously mixed feelings – he claimed to have been baffled and depressed by the way in which the play was cheered by the very people against whom it had been written. 'Here was a case where revolting against a contemptible literary convention almost amounted to contempt for a great social revolt.'

OCTOBER

1 OCTOBER

FONTAINEBLEAU

Remarkably few commentators on the cultural events of this year – Claire Tomalin, in her biography of Katherine Mansfield, is an honourable exception – have noticed that this was the month in which Lady Rothermere was to use some of her husband's huge profits from the *Daily Mail* and the *Daily Mirror* to back two idealistic ventures that would have surprised, if not alarmed, most of those papers' readers: Eliot's quarterly *The Criterion* and G. I. Gurdjieff's Institute for the Harmonious Development of Man, which opened on the first day of October. One might add that many potential readers of *The Criterion* would also have been surprised, if not alarmed, to hear that Eliot's titled patron was also the patron of a Greek-Armenian mystic and guru.

It is unlikely that Lady Rothermere would have found the conjunction as discordant as it seems to most people. She had already persuaded Eliot to join her in attending lectures in London by Gurdjieff's key disciple, P. D. Ouspensky.[1] And Eliot was no stranger to either Eastern or Western modes of mysticism. Gurdjieff's Institute was established in a wooded area south of Paris – at Avon, near Fontainebleau. The main building on the substantial estate was a former monastery, La Prieure, which had been converted into a private house in the nineteenth century, but had long since fallen into disrepair. Gurdjieff claimed to have raised much of the money for this impressive pile from the fees he received from patients – he treated rich junkies and alcoholics with hypnosis – from speculations in oil shares, and from the profits of two fashionable restaurants he had set up in Montmartre. The extent of Lady Rothermere's bounty was kept private.

1. Some critics, including Gary Lachman, have suggested that the meditations on times past, present and future in Eliot's later poems *Four Quartets* were partly influenced by Ouspensky.

Gurdjieff brought a hundred or so disciples with him when he arrived, and set them to work establishing a farm and restoring the various buildings. He reserved the most comfortable parts of the main house for himself and important guests; these areas became known as 'the Ritz'. Despite this rebellious sarcasm, it seems that almost all of the workers were willing serfs, since it was part of the Gurdjieff method to restore balance to lives out of kilter by demanding that everyone should take part in strenuous manual labour. (This part of the treatment, at least, did some of his followers a lot of good.) He also enforced asceticism on them, and made them live in small, comfortless cottages on the estate or in unheated, unfurnished rooms within the main house.

Finally, he set them to building a giant tent-like structure, using an aeroplane hangar frame. When completed, it was lined with carpets from Bokhara and Baluchistan. Disciples learned the Gurdjieffian dances here, and took part in games and rituals designed – in classic cult fashion – to 'break down' one's existing personality and construct a new, supposedly improved one.[2] Gurdjieff would preside over these rituals from a throne.

It was to this commune-in-construction that the dying Katherine Mansfield would travel a fortnight later.

TURKEY

Based throughout the month in Constantinople – 'a great sprawling city of a million and a half, crowded with a desperate element' – Hemingway filed almost 20 stories to the *Toronto Daily Star* in October. He had arrived in the city at about the same time as several thousand British troops – reinforcements whose presence assured the locals that Britain was ready to fight against Mustapha Kemal,[3] and encouraged the Greeks and Armenians to discard their recent Turkish fezzes and re-adopt Western hats.

On 9 October, the *Star* published Hemingway's report of his interview with Hamid Bey – the most powerful man in the 'Angora' government

2. The most famous of these games, which Gurdjieff displayed to spectacular effect when he took his dancers on tour to the United States a couple of years later, was one called 'Stop', which simply consisted of freezing, immediately, at the master's command.

3. The British commander-in-chief, General Harington, had just ordered Kemal to withdraw his troops from the Chanak area. The key disputed area was Thrace, which, if Kemal's forces took it, would give the Turks a strong foothold in Europe. If all the Greeks were to be expelled from Thrace, then Turkey and Bulgaria, both pro-Soviet, could easily unite into a powerful anti-Allied wedge in the Balkans.

apart from Kemal himself. Hemingway told him that Canadians were anxious about a possible massacre of Christians should Kemal's forces make a triumphal entry to the city.[4] Hamid Bey shrugged this off: what had the Christians to fear? They were armed and the Turks were not. There would be no massacre . . .

On 16 October, Hemingway reported, thousands of Christians began their exodus from Thrace. Since the Greek government had commandeered all the trains for the transport of soldiers, the refugees were forced to load all their worldly goods on to rickety old carts; others, poorer, carried ragged bundles on their backs. Most of the exiles were old men and women, or very young children. Meanwhile, three French and four British battalions moved in to take up the territory they were fleeing. By the 20th, the main column of refugees was 20 miles long: soaked, exhausted, starving . . . and yet strangely, frighteningly silent. There were half a million refugees in Macedonia alone – a massive strain on the country's resources, with no end in sight.

The atmosphere in Constantinople was one of 'tight-drawn, electric tension'. Everyone was braced for invasion, but not necessarily in a state of fear. Some were licking their lips: a 'collection of cutthroats, robbers, bandits, thugs and Levantine pirates' had descended on the town, waiting for Kemal's forces to arrive and the looting to begin. They were, as Hemingway put it, anticipating an 'Orgy'. But the Armenians, Greeks and Macedonians still living in the city were cold with fear. They were arming themselves and expecting the worst.[5] The substantial White Russian colony in the city was also petrified, aware that Kemal, as an ally of the Soviets, would hand them all over, many to face death sentences.

By the 24th, Hemingway could report an unexpected turn of Islamic opinion against Kemal. Regarded only a few months before as a new Saladin, who would lead all Muslims into a holy war against Western forces in the East, he was increasingly being seen as unreliable, perhaps even a traitor. He had made a treaty and an alliance with Soviet Russia; yet he also

4. Kemal's forces were now just a day's march from Constantinople. There had already been reports of Turkish irregulars in the Asiatic suburbs of the city. The British were carefully preparing for a possible attack, blowing up bridges and blocking crossroads. General Harington had ordered the suspension of ferry services across the Bosphorus.
5. One of this anxious crowd was Hemingway's Greek landlord, who had bought a hotel with his life's savings; Hemingway was now his only guest. 'Greece fought for the Allies in the war and now they desert us. We cannot understand it.'

had a treaty with France, and something very like an alliance. One of these pacts would have to be renounced.

The most damaging rumour of all, which would be fatal for Kemal if it became widely believed, was that he was secretly an atheist. Making a topical comparison, Hemingway suggested that Kemal was now 'in something of the position that Arthur Griffith and Michael Collins occupied in Ireland just before their death [*sic*].' In other words, he was being a pragmatist and a businessman: taking all the tangible gains that had come his way and making what seemed to the Pan-Islamists some humiliating concessions. As yet, Kemal did not have a de Valera figure to worry about; but Hemingway predicted that if he continued to play a waiting game, then a de Valera would surely appear on the scene.

The worst prospect of all, Hemingway predicted, would be a war between Britain and Turkey over Mesopotamia. Both countries were thirsty for Mesopotamia's oil; and if Kemal, atheist or no atheist, decided to assert his rights over the region, 'it may well be the blaze that will start the holy war that the Pan-Islamists are praying for . . .'

2 OCTOBER

RUSSIA

In great high spirits, Lenin came back to Moscow, and to direct rule of the country. He had been seriously ill for many months; in May, he had been found vomiting, and with severe stomach pains. His speech had become a little slurred, and there were traces of paralysis in his right side – clear signs that he had suffered his first stroke. Doctors ordered him to bed, with strict instructions not to do any work, but in less than three weeks he was shouting at them that he was entirely well and must be allowed to read and write again.[6]

By mid-July the doctors had relented to the point where he was allowed to see visitors and to read books – but not newspapers. Stalin came a couple of times, and, strange to say, they both enjoyed the visits. Stalin said that

6. They remained firm – a remarkable act of bravery – until Lenin began to guess what they were thinking. 'Is it paralysis?' he asked Dr Auerbach, with a rare note of weakness and pleading in his voice. 'If it is paralysis, what use would I be, and who would have need of me?' Luckily for Dr Auerbach, a nurse came in and the conversation broke off.

Lenin looked like a soldier who had been shipped back behind the battle lines; and he told Lenin the good news that for the first time since the Revolution, there had been a bumper harvest. The Famine Crisis was over. Lenin was reassured, and more optimistic than he had been for months.

By the start of September, his doctors had begun to allow him out for walks; a famous series of photographs was taken of him at this time. Finally they agreed that, after his four months of enforced rest, he might be allowed to go back to the Kremlin and work for about five hours a day, for five days a week. Ignoring them, he immediately started putting in 10-hour days, and on the weekends held conferences at home.

3 OCTOBER

WASHINGTON, DC
The first facsimile picture was sent across telephone wires.

LONDON
Virginia Woolf wrote to Roger Fry:

> My great adventure is really Proust. Well – what remains to be written after that? I'm only in the first volume, and there are, I suppose, faults to be found, but I am in a state of amazement; as if a miracle were being done before my eyes. How, at last, has someone solidified what has always escaped – and made it too into this beautiful and perfectly enduring substance? One has to put the book down and gasp. The pleasure becomes physical – like sun and wine and grapes and perfect serenity and intense vitality combined. Far otherwise is it with Ulysses, to which I bind myself like a martyr to a stake, and have thank God, now finished – my Martyrdom is over. I hope to sell it for £4.10.

The following day, she noted that Kitty Maxse – widely believed to be the original of Woolf's character Mrs Dalloway – had just died after falling down a flight of stairs. Woolf seems to have assumed that it was suicide: 'Still it seems a pity that Kitty did kill herself: but of course she was an awful snob.'

USA

Unwilling to face the arctic conditions of another winter in Minnesota, the Fitzgeralds moved back to New York. They began with a brief stay at their old haunt, the Plaza Hotel, where they met the writer John Dos Passos for the first time.[7] They became friends, and Fitzgerald introduced Dos Passos to Sherwood Anderson. Dos Passos agreed to help the Fitzgeralds look for a suitable house to rent in Great Neck, Long Island, and the trio set off together in a chauffeured red touring car. When the first few hours of house-hunting proved futile, they stopped off at the family house of the Fitzgeralds' friend Ring Lardner, who was, as usual, very drunk.

Eventually they found a comfortable house to rent at 6 Gateway Drive in Great Neck – just half an hour from Broadway by the Long Island Express.[8]

5 OCTOBER

LONDON

Eliot wrote to Valéry Larbaud about his *Criterion* essay on *Ulysses*. He apologised for having to cut those parts of the essay which were about other works by Joyce; and for having been obliged – after being let down by a usually reliable translator – to translate the essay himself.

Vivien, meanwhile, had severe bronchitis, was bedridden, and was very depressed.

7 OCTOBER

LONDON

Marie Lloyd,[9] the music-hall star, died. She had collapsed on stage at the Empire Music Hall, Edmonton, on 4 October, while performing her final

7. Fitzgerald had written a favourable review of Dos Passos's war novel, *Three Soldiers* (1921).
8. In a letter of 13 October, Zelda called it a 'nifty little Babbit-home' – an indication of just how far *Babbit* had already entered public awareness.
9. 'Marie Lloyd' was the stage name of Matilda Wood (b. 1870); she took the name from *Lloyd's Weekly Newspaper*, not the bank for which Eliot worked. She had been an entertainer from an early

number, 'I'm One of the Ruins That Cromwell Knocked About a Bit'. Members of the audience had noticed that she was staggering, but had assumed that this was just part of her act.

Eliot later wrote an extraordinary essay about the singer (see 19 December).

8 OCTOBER

GERMANY

Einstein and his wife set off on what would be a five-month trip, mainly to the Far East: they began with short visits to Colombo, Singapore, Hong Kong and Shanghai. 'After the Rathenau murder,' Einstein said, 'I very much welcomed the opportunity of a long absence from Germany, which took me away from temporarily increased danger.' The Einsteins were greeted enthusiastically in each of these places, though it was in Japan that they met with the most sensational response.

9 OCTOBER

LONDON

Sir William Horwood, commissioner of the London Metropolitan Police, was poisoned by chocolates – to be exact, Walnut Whips – that had been laced with arsenic. They had been sent to him by a mentally ill man with a grudge, Walter Tatam, but Horwood assumed that they were a present from his daughter. Though he only swallowed one before realising it was

age, and enjoyed her first taste of fame after her version of a standard music-hall song, 'The Boy I Love Is Up in the Gallery', became a hit with audiences. That song was fairly innocent – as, indeed, were most of the other songs in her repertoire until she got her hands on them. Winking and mugging, she could turn the most inoffensive of ditties into a deliciously filthy catalogue of double entendres. Guardians of public morality often tried to make her clean up her act, but had a hard time, since the lewdness existed neither in the lyrics nor even in the manner of performance, but in the knowing complicity between performer and audience.

She became associated with a number of music-hall numbers that are still remembered today, including 'My Old Man (Said Follow the Van)' and 'A Little of What You Fancy Does You Good'. Her private life was not happy: she married three times, and by about 1920 was drinking heavily. The devotion she inspired in her fans can be judged by the fact that about 100,000 mourners attended her funeral on 12 October.

contaminated, the dose was very powerful and only the swift intervention of police doctors saved him.[10]

DUBLIN

Yeats wrote to Olivia Shakespear from 82 Merrion Square:

> We have been in Dublin now for a couple of weeks and our house is getting into order. There is a great drawing room with a beautiful mantelpiece and George has made it look very fine . . .
>
> I spent the summer correcting proofs and writing a series of poems called 'Meditations in time of civil war' . . .

12 OCTOBER

PARIS

The second edition of *Ulysses* was published. According to Joyce, the entire imprint of 2,000 copies sold out within four days; the book cost £2.2s.0d per copy.

The Joyces set off on a holiday to the Côte d'Azur. By 13 October they were at Marseilles, and on the 17th they checked into the Hôtel Suisse in Nice. They had hoped that the mild climate would improve Joyce's health, but this year the weather was bad, and the storms and wind exacerbated his eye condition.[11] He consulted a Dr Louis Colin, who put five leeches on his eye to drain away the excess blood, and then bathed it with a powerful and painful solvent (salicylate of soda). The nebula duly shrank. Dr Colin also advised Joyce to drink red wine rather than white, but this was too great a compromise: no 'beefsteak' for the author of *Ulysses*.

10. After this incident, the many policemen who disliked Horwood, believing him to be cold, arrogant and comfortable only in the company of those officers who had also served in the armed forces, gave him the not entirely kind nickname 'The Chocolate Soldier'.

11. Dr Borsch, Joyce's ophthalmologist, had returned from his vacation at the beginning of the month. He thought that the British doctors had somewhat exaggerated the severity of Joyce's condition.

13 OCTOBER

BERLIN

Thomas Mann delivered a speech in support of the Weimar Republic at the Beethovensaal. The text of this speech was published the following month in *Die neue Rundschau*.

14 OCTOBER

GERMANY

Hitler's greatest propaganda coup of 1922 came with the 'German Day' in Coburg, northern Bavaria, on 14–15 October. He had been invited to take part in the event with a small delegation of NSDAP members. Instead, he decided to make a splash – calculating, correctly, that local socialists and trades unionists would be making some kind of show of resistance to their presence. Dipping deep into party funds, he hired a special train for the occasion, and packed it with 800 storm troopers. He also summoned boys from the Jugendbund – the 'Hitler Youth', the creation of which had been announced on 8 March.[12]

When Hitler's men arrived at Coburg station on the Saturday afternoon, they were met both by welcoming shouts of '*Heil!*' from local nationalists, and jeers and insults from about 300 workers. Ignoring the orders he had been issued by the local police, Hitler told his men to march through town with unfurled swastika flags. Outraged socialists spat at the SA men; at which point they broke ranks and attacked the hecklers with truncheons. After ten minutes of violence, in which the police sided with the Nazis, the local resistance subsided completely and the Nazis triumphantly held the streets as their own. Hitler was delighted. The event became known in Nazi mythology as 'the Battle of Coburg', as though it were a genuine military action rather than a riot.

12. Its inaugural meeting was held on 14 May; the 'German Day' was its first major public manifestation.

16 OCTOBER

LONDON

The inaugural issue of *The Criterion* finally appeared. It contained the first published version of *The Waste Land*. The contents page read as follows:

DULLNESS	George Saintsbury
PLAN OF A NOVEL	F. M. Dostoevski
(translated by S. S. Koteliansky and Virginia Woolf)	
THE LEGEND OF TRISTRAM AND ISOLT, I	T. Sturge Moore
THE WASTE LAND	T. S. Eliot
THE VICTIM	May Sinclair
GERMAN POETRY OF TO-DAY	Hermann Hesse
ULYSSES	Valéry Larbaud

Vivien wrote: 'It seems to me an achievement, by a man who has only his evenings, tired out by eight hours in the City, and who fills hot water bottles, and makes invalid food for his wretchedly unhealthy wife, in between writing!'

FONTAINEBLEAU

Katherine Mansfield arrived at Gurdjieff's Institute, in the company of Ida Baker. Unlike most disciples, she was given a pleasant room; Gurdjieff examined her the following day, and said that she could stay for two weeks 'under observation'. Though Gurdjieff was not famous for his kindliness, it seems likely that he could see that the young woman was dying, and did not force her to take part in the more back-breaking activities of the Institute.

She was put to work peeling vegetables: not a task for which she had much training, but she took to it with a will. She also looked after herself – made her own bed, set her own fires, and bathed herself in cold (of course) water. It was an emotionally satisfying regime, and she enjoyed feeling a useful, productive part of a large extended family, watching the others carry out the more brutal aspects of farming, such as slaughtering pigs. But it was dreadfully cold, and she kept her fur coat on at all hours of the

day and night. After a while, Gurdjieff – following an old peasant belief that sleeping above cows was a cure for tuberculosis – assigned her to sit for extended periods on a platform above the cowshed.

Though she tried her best to make friends with the others, many of whom spoke only Russian, her main company was provided by A. R. Orage,[13] Orage's English friend Dr Young, and Mansfield's appointed supervisor Olga Ivanova, aka Olgivanna Lazovitch Hinzenburg.[14]

Life at the Institute had much to offer; it was certainly better than sitting around in Paris and enduring expensive treatments by quacks. But it was no cure.

18 OCTOBER

THRACE
Hemingway set off on his arduous journey back to Paris. When he arrived, he was in a bad way: exhausted from his malaria, and covered with insect bites. He had to shave his head to rid himself of lice.

LONDON
The British Broadcasting Company was officially formed. It remained a company for five years, becoming a corporation in 1927.

HOLLYWOOD
The impresario Sid Grauman opened his lavish Egyptian Theater[15] by hosting the premiere of United Artists' *Robin Hood*, with Douglas Fairbanks in the title role. (See 1 January.) Grauman's cinema was the first specially built 'movie palace' outside downtown Los Angeles, so this was Hollywood's first true film premiere.

Robin Hood was a huge and immediate hit at the box office (it rapidly became the highest-grossing film of 1922), won rapturous reviews from the

13. Whose health improved considerably here; Gurdjieff made him give up smoking.
14. She was later to become Mrs Frank Lloyd Wright, and to run a harsh commune of her own in the United States.
15. Histories of the period often suggest that its design was inspired by the Tutankhamun craze of 1922, but that did not take off until November. Grauman was simply following a minor fashion for vaguely Egyptian design that was already quite well established.

critics ('the highwater mark of film production – the farthest step that the silent drama has ever taken along the high road to art') and, after a long period of neglect in the mid twentieth century, when all prints of the film were believed to have been lost, has become established as one of the summits of Hollywood's silent era.[16]

The earliest audiences for the film found it visually ravishing, as well as an exciting yarn, and the sumptuousness of its wood-and-plaster version of the Middle Ages can still impress eyes pampered by the infinite possibilities of CGI. The Academy Awards were not yet established, but *Robin Hood* won the contemporary equivalent – the *Photoplay* magazine 1922 Medal of Honor – awarded, in a break with convention, not to its director Alan Dwan, but to Fairbanks, in recognition that, despite the fact that 'a dozen or more men and women' had played major parts in creating the film, its 'conception and execution' should justly be acknowledged as his.

19 OCTOBER

LONDON
Further proof that not all the old gods of literature were dead. Just three days after the appearance of *The Waste Land*, A. E. Housman finally pub-

16. The amount of work that went into the making of the film had been prodigious. Douglas Fairbanks, who could be obsessive when a project caught his imagination, spent long hours reading chronicles and ballads, brooding over pictures, learning about tournaments and tapestries, castles and chargers. Fanciful though the film's narrative would eventually be, Fairbanks insisted that all the technical details be as accurate as possible.

The film had been budgeted at a million dollars (it would go well beyond budget to about $1.4 million); since the industry had the jitters, it was impossible to find anyone who would invest on such a scale, so Fairbanks put the money up himself. As pre-production began, he was forced to leave Hollywood for a few weeks to contest a law suit in New York; in his absence, more than 500 workmen began to build giant sets – and then to 'age' them by planting moss and ivy in the plaster's cracks. Work continued through the nights, illuminated by giant searchlights, plagued by mosquitoes. When Fairbanks stepped down from the train back from New York on 9 March, he asked, 'Well?' They put him in a car, and drove to the set on Santa Monica and La Brea. About 200 yards away, he had his first glimpse of what they had achieved in little over two months: 'My Gosh! It's astounding . . . it's fantastic!'

The film was an enormous boost to the local economy. Tourists flocked to the set to rubberneck, and many of them ended up being hired as extras and issued with costumes and – more thrilling by far for most of them – a full lunch box. Alan Dwan, the director, later noted that the recent war helped make his job easier – there was hardly a man who had not been through military training, so they all looked convincing as troops and responded efficiently to direction.

lished his long-awaited sequel to A *Shropshire Lad*: *Last Poems*. Housman had suggested an initial print run of 10,000 copies; his publisher, Grant Richards, more cautious, insisted that the impression should be limited to 4,000. It quickly emerged that they had both underestimated the post-war audience for Housman's work. Those 4,000 copies were all pre-sold, and a second imprint was well in hand by publication day.[17]

Popular interest in the book was duly fanned by the press. *The Times* not only ran a review of *Last Poems*, but devoted a leader to it. On 25 October, *Punch* published a flattering cartoon of Housman – shown dancing and playing a pipe, with a copy of his new book poking out of his knapsack – being greeted by a maternal Muse: 'O, Alfred, we have missed you! My Shropshire lad!'

What had caused this late flowering of Housman's poetic talents? Part of the answer lies in his awareness that his dearest friend, Moses Jackson, was suffering from a fatal illness, far away in British Columbia; *Last Poems* was, in part, conceived as a present to his dying friend.[18] And though many of the poems were composed in an extraordinary burst of productivity in the late months of 1921 and the early months of 1922,[19] some of the 'new' poems had been sitting on his desk since Victoria's reign.

Many writers who were young boys and girls in the 1920s have commented on the exceptional place that Housman played in their emotional development: Auden, for example, and Orwell, who once wrote that when he was in his late teens, 'the writer who had the deepest hold on the thinking young was almost certainly Housman'. The still more ardent cult of Eliot in the later 1920s and 30s was to put paid to the Housman cult; though Eliot himself seems to have admired Housman, and in one *Criterion* article pronounced that the poet-scholar was one of the best living writers of English prose.

17. By the end of the year, 21,000 copies of the book were in print – a truly remarkable sales figure for a small collection of verses by a man who had not published any poetry for decades. Meanwhile, A *Shropshire Lad* itself was selling a very respectable 3,000 copies a year. Its evocation of young lads going off to war had a fresh potency after four years of trench combat.

18. On publication day, as copies flew off the shelves (Cambridge bookshops had sold out of their allotment by lunchtime), Housman bundles up a small package – a signed copy of the book, clippings from *The Times*, and an affectionate valedictory letter – and put them in the post to 'dear Mo'. It was, he noted, almost exactly 45 years to the day since they had first met. Moses Butler died on 14 January 1923.

19. This fairly hasty process of composition is strikingly similar to that of A *Shrophire Lad*, much of which was written in the year of the Wilde trial, 1895, and some of it in the month of the trial.

LONDON

Lloyd George's coalition government fell.[20] A general election was called for 17 November.

21 OCTOBER

DUBLIN

Yeats wrote to the literary scholar H. J. C. Grierson:

> I think what I say of Ireland, at least, may interest you. I think things are coming right slowly but very slowly; we have had years now of murder and arson in which both nations have shared impartially. In my own neighbourhood [i.e., of the Tower] the Black and Tans dragged two young men tied alive to a lorry by their heels, till their bodies were rent in pieces. 'There was nothing for the mother but the head' said a countryman and the head he spoke of was found on the road side. The one enlivening Truth that starts out of it all is that we may learn charity after mutual contempt. There is no longer a virtuous nation and the best of us live by candle light.

He signed off with a cautiously optimistic note: 'I am working at present at the project of getting the Abbey Theatre adopted as the Irish State Theatre and I think I may succeed.'

22 OCTOBER

LONDON

Virginia Woolf wrote to Roger Fry, complaining about Eliot's ungrateful conduct over the Bel Esprit scheme to rescue him from toiling at the bank:

20. There were many causes for the end of the coalition; the simplest is that it was simply too large and internally divided to survive. Conservatives and Unionists were opposed both to Lloyd George's policies for social reform, and to what they saw as his unprincipled willingness to negotiate with the Irish leaders. It was widely felt that he had mishandled the Chanak crisis in September; and the Conservatives had shown, in June, that he had been involved in the sale of peerages and honours. The crunch came when Austen Chamberlain called a meeting of Conservative MPs at the Carlton Club. They voted by 187 to 87 to withdraw their support for the coalition.

There he has let us all go on writing and appealing for the past 6 months, and at last steps out and says he will take nothing less than £500 a year – very sensible, but why not say so at first; and why twist and anguish and almost suffocate with humiliation at the mere mention of money? It's on a par with not pump shipping [i.e., urinating] before your wife. Very American, I expect; and the more I see of that race the more I thank God for my British blood, which does at any rate preserve one from wearing 3 waist-coats; enamel buttons on one's overcoat, and keeping one's eyes perpetually shut – like Ezra Pound.

Her exasperated tone may have been partly due to a more general sense of anxiety and uncertainty. By October 1922, the future of the Hogarth Press was looking increasingly doubtful. 'Clearly we cannot go on publishing seriously with Ralph [Partridge] attached to us like a drone.'[21] Nor was her writing going as well as she might have wished. She had planned to read Sophocles, Euripides and the first five books of the *Odyssey* in the original, as preparation for the essay that would eventually be published as 'On Not Knowing Greek'. At the same time, she was rethinking *Mrs Dalloway*. But neither project seemed to her to be advancing very far, and as late as July 1923, the Greek essay was still up in the air.

On a more positive note, Forster had recently told her that he was finishing *A Passage to India*.

23 OCTOBER

GERMANY

German forces moved into Saxony, and crushed the Soviet republic that had been established there by local communists. The following day, the German Parliament gave Ebert a mandate to stay as president until July 1925.

NORTH CAROLINA

John Dos Passos wrote to his friend Arthur McComb expressing relief that he had, a few minutes earlier, finally said goodbye to 'that tiresome bitch

21. Leonard and Ralph Partridge had locked antlers, and Ralph refused to leave. He would not depart until March 1923.

Miss Nan Taylor' – a complaint about his literary life rather than his love life, since Nan Taylor was a leading character in his novel *Streets of Night*, which he had just completed. His woes had been partly aesthetic, partly physical. He was no longer interested in the style and substance of the book, which he had begun a few years earlier while he was still an undergraduate at Harvard, and then put away. Like Hemingway and his good friend Cummings, Dos Passos had been an ambulance driver during the war, serving in France and northern Italy, and the terrible sights he had seen there made everything about *Streets of Night* seem naive and irrelevant – 'a very garbage pail of wilted aspirations'. Still more troubling, his eyes had been giving him a great deal of pain, and for short periods he was panicked by passing episodes of blindness.

But he had pushed doggedly ahead on the manuscript so as to be able to cash in promptly on the unexpected success of his last novel, *Three Soldiers*, which had been published in September 1921 while he was travelling in Damascus.[22] The initial crop of favourable reviews in relatively small-circulation journals had been followed by much more overwhelming reaction in the mainstream press: THREE SOLDIERS BRANDED AS TEXTBOOK FOR SLACKERS AND COWARDS, ran the headline of the *Chicago Tribune* for 13 March 1922. Recognising the value of all publicity, and concluding that *Three Soldiers* had annoyed exactly those he had wanted to annoy, Dos Passos was just as pleased with the denunciations as the praise.

With *Streets of Night* finally tucked away, Dos Passos could turn his attention to writing a book that genuinely interested him. This eventually proved to be his breakthrough work: *Manhattan Transfer*.

22. One of the letters that reached him when he checked into his hotel there congratulated him on suddenly being 'as famous as Wrigley's'. The year had been a busy and restless one. After Damascus, he went on to Beirut and then Paris before returning to the United States in late February. His travel book *Rosinante on the Road Again* was published in the US in March, a reprint of his first novel, *One Man's Initiation: 1917*, in June, and his collection of poems *A Pushcart at the Curb* in October. He spent weeks in New York, and in Cambridge, went hiking in Pennsylvania and the Catskills, attended John Peale Bishop's wedding on 17 June, retreated to Syracuse and Maine, then in late September came back to New York, where he went on a rather frightening drunken spree with Zelda and Scott Fitzgerald. It began with a lavish lunch at the Plaza, then turned into a road trip to Great Neck and, at Zelda's insistence (Scott sulked in the car with his bottle of whisky) some hair-raising rides on a Ferris wheel. North Carolina was a relief after that.

LONDON

Eliot wrote to Pound, saying that he was too exhausted to make a trip to Paris, and was instead going for ten days of quiet rest at a seaside resort. He also discussed his intention to approach Yeats for some verses. On the 26th, a review of both *The Waste Land* and *The Criterion* appeared in the *TLS*; the author (uncredited) was Harold Child, and his verdict on Eliot was favourable. 'We know of no other modern poet who can more adequately and movingly reveal to us the inextricable tangle of the sordid and the beautiful that make up life.' He also approved of *The Criterion* in general, describing it as '. . . not only that rare thing amongst English quarterlies, a purely literary review, but . . . of a quality not inferior to that of any review published either here or abroad'.

24 OCTOBER

CHANGSHA, HUNAN, CHINA

Mao Zedong's wife, Yang Kaihui, gave birth to his first child, a son, at their house, Clear Water Pond. (She was Mao's second wife; he had been bullied into an arranged marriage by his father when he was only 14, but his first wife died little more than a year later.) Mao, 29 years old that year, was not present for this birth, because he was away on Communist Party business, negotiating on behalf of the builders' union.

If this detail suggests that Mao was the typical ardent young Party activist, putting the welfare of the proletariat before his private concerns, then it is highly misleading. Until about two years earlier, Mao had been about the least likely revolutionary leader imaginable. Intellectually gifted but idle, snobbish and selfish to a remarkable degree, Mao had rejected his own peasant background, from which he had been freed at the age of 17 by training to be a teacher. By his mid-twenties, he had come to despise both peasants and workers, and – partly inspired by some German philosophers – had hatched a private philosophy which boiled down to pragmatic self-interest.

It was exactly this sense of looking out for himself, not any profound study of Marx and Engels, which had led him to join the newly formed Chinese Communist Party in 1920. A chance encounter with the country's leading philosopher of Communism, Professor Chen Duxiu, had

been his big lucky break. Despite many claims to the contrary, the CCP was being funded directly from Moscow. Professor Chen, seeing that Mao was bright (though not that he detested hard work), set him the task of opening a Marxist bookshop, with a small but handy salary. A year or so later, Mao was invited to the first CCP Congress in Shanghai; and then to help set up the Party's Hunan branch.

Mao was not particularly good at the task, but the Moscow money kept flowing in regardless, and allowed him to give up his day jobs as a schoolteacher and a freelance journalist, marry, and set up home in an idyllic traditional house, with plenty of land for crops and a large pond of good drinking water. Life on the home front was spoiled a bit by Mao's habit of picking up new girlfriends all the time, and on the political front by the Party's growing recognition that he was pretty ineffective. Realising that he was in danger of losing his Russian sinecure, Mao resolved to cut a more revolutionary figure. He joined strikers, visited coal and zinc mines, took part in demonstrations. No one could have foreseen quite how far this policy would eventually take him.

FRANCE

Cocteau wrote to his mother from Pramousquier, telling her about his 'novelette' ('I call it a novelette even though it is longer than my novel [*Le Grand Écart*] . . .'), *Thomas L'Imposteur*. He expressed uncertainty about his achievements with the book so far, saying that he was daunted at times by the fact that it was the most ambitious project he had ever undertaken: if he succeeded, it would be a great step forward; if he failed, the result would be 'chocolate mousse'. He noted, however, that Radiguet, a severe critic, had so far approved of what he had read.

Taking a major French classic – Stendhal's novel *La Chartreuse de Parme* – as one of his models, Cocteau was attempting an ambitious fiction of love and war, concentrating on the two sectors of the recent conflict that he had known best from his Red Cross work, Flanders and Champagne. The novel's hero, a young marine, is a poetic soul from a humble background who lives out the fantasy that he is in fact a general's nephew. 'Imposture', in this novel, is less a species of deceit or charlatanism than a triumph of the imagination: in other words, it is a kind of poetry.[23]

23. Gide, who disapproved of the way in which *Le Grand Écart* had fought shy of admitting its hero's

USA

D. H. Lawrence's collection *England, My England and Other Stories* was published.

25 OCTOBER

DUBLIN

The third Dáil enacted the constitution of the Irish Free State.

R.A.F. UXBRIDGE

T. E. Lawrence – or, as he now was, 352087 Aircraftman John Hume Ross – said that he would like Wyndham Lewis to draw a portrait of D. G. Hogarth[24] for *Seven Pillars of Wisdom*.

Lewis visited Venice in October, in the company of Nancy Cunard.

USA

The October issue of H. L. Mencken's magazine *The Smart Set* included a very short story – only a paragraph long – entitled 'The Parthian Shot'. This was the first published work of Dashiell Hammett (b. 1894), the father and undisputed master of hard-boiled detective fiction, author of *The Thin Man, Red Harvest, The Maltese Falcon* and other classics of the genre. Hammett had quit his job at the Pinkerton Detective Agency in February 1922, and had determined to launch himself as a professional writer. In November 1922, he published his second (also very) short story, 'Immortality', in 10 *Story Book,* under the partial pseudonym of Daghull Hammett; in December, as Peter Collinson, he published 'The Barber and his Wife' in *Brief Stories* and 'The Road Home' in a pulp magazine

true sexual nature, was far more approving of this work, since he read Thomas's wooing of a lovely girl as yet another of the character's impostures. Cocteau heartily denied that this had been his intention. Yet the poems he wrote during their stay in the south, which have become accepted as classics of twentieth-century love poetry, were all inspired by his tender passion for Radiguet. They were the verse counterparts of the set of fine drawings of Radiguet asleep that Cocteau also made during this same miraculous summer of 1922.

24. (1862–1927; sometime Keeper of the Ashmolean Museum, Lawrence's mentor in his early career as an archaeologist, and an intelligence officer for the Arab Bureau during the war; the screenwriter Robert Bolt explained that Hogarth was one of the real-life figures behind the composite character of Mr Dryden in David Lean's *Lawrence of Arabia*.)

called *The Black Mask*, which would become a regular outlet for his short fiction. Just a few months later, Hammett came up with the character known as 'the Continental Op'; his career was launched.

LIMA

Two hundred copies of a modestly priced pamphlet by the 30-year-old poet César Vallejo (1892–1938) went on sale to anyone who would buy. This was the inauspicious, indeed almost invisible launch of the poem-sequence *Trilce*, now recognised as the greatest achievement of Peru's greatest poet.[25] It remains, according to some authorities, the most formally radical poem in the Spanish language, comparable to *Finnegans Wake*.

Vallejo[26] only published three collections of poetry in his lifetime. He worked on the 77 poems which make up *Trilce* over the course of four years. Some of them were produced by techniques of automatic writing very similar to those of the surrealists, though he did not know about the surrealists at the time. The text is crammed with neologisms, puns and weird syntax; not surprisingly, it did not win a very wide readership for many years.

26 OCTOBER

ROME

Under pressure from Mussolini, the Italian Parliament was dissolved.

25. As I type these lines, the radio announces the award of the Nobel Prize for Literature to Mario Vargas Llosa – an eloquent admirer of Vallejo. Vargas Llosa wrote the preface to an English-language translation of Vallejo's collected poetry.

26. He was born in the small town of Santiago de Chuco, in the Peruvian Andes, the youngest of 11 children; the family was poor, and Vallejo had to interrupt his studies from time to time to earn money. At one point he worked on a sugar plantation – one of the experiences that inclined him towards communism. He took a BA in Spanish literature in 1915, and moved to Lima, where he worked as a schoolmaster. His first book was *Los Heraldos Negros* (*The Black Heralds*), published in 1919 (though the title page says 1918). Vallejo's life was hard at this time; his mother died in 1920, and he served a prison term of 105 days for his alleged part in fomenting a riot in his home town. He fled to Europe in 1923, and lived frugally there, mainly in Paris, until his death. His remains are buried in the Montparnasse cemetery.

27 OCTOBER

LONDON

The Hogarth Press published its first full-length book: Virginia Woolf's novel *Jacob's Room*, in an edition of about 1,200 copies. The jacket illustration was by Vanessa Bell.[27]

A short work, less than 60,000 words, *Jacob's Room* recounts the life of its central character, Jacob Flanders, from boyhood to his death, presumably some time in his late twenties or thereabouts, in the First World War. En route, we see him attending Cambridge, pottering around in London and Paris, and travelling in Italy and Greece. The narrative can be quite demanding, as Woolf jumps from one character's point of view to another's, and then another's, seldom signposting the change of perspective. Her style is highly wrought – perhaps excessively so – and occasionally lyrical. There are many digressions, sometimes representing a chain of thought in some character's mind, often impossible to pin down to any one consciousness. Sample:

> As for the beauty of women, it is like the light on the sea, never constant to a single wave. They all have it; they all lose it. Now she is dull and thick as bacon; now transparent as a hanging glass. The fixed faces are the dull ones. Here comes Lady Venice displayed like a monument for admiration, but carved in alabaster, to be set on the mantelpiece and never dusted. A dapper brunette complete from head to foot serves only as an illustration to lie upon the drawing-room table . . .

And so on.

Eliot wrote to her:

> You have freed yourself from any compromise between the traditional novel and your original gift. It seems to me that you have bridged a certain gap which existed between your other novels and the experimental prose of *Monday or Tuesday* and that you have made a remarkable success.

27. It sold well enough to permit a second impression of 2,000 copies just a few weeks later, and was published in America the following February.

As her biographer Quentin Bell remarks, *Jacob's Room* marked the beginning of Woolf's fame; and is the book which is generally taken to be the starting point of her mature career as a writer.

BIRKENHEAD

Eric Blair boarded the SS *Herefordshire*, for the three-week journey that would take him to Rangoon, and thence to Mandalay. There was not much for first-class passengers like him to do in those weeks, except idle, gorge, play deck tennis and learn to tolerate the heat.[28]

The *Herefordshire* docked at Rangoon in November. Blair and Alfred Jones, the other trainee who had accompanied him out, spent a few days making the mandatory courtesy calls on local officials, and then boarded the train for the 19-hour journey northwards to Mandalay, right in the heart of Burma. They were met at the station by Roger Beadon,[29] the third of that year's successful candidates, who took them directly to the police mess, just adjacent to the Burma Provincial Police Training School. The mess would be their home for the next 14 months, and they often had it all to themselves.

28. Two mildly shocking incidents during the voyage gave him food for uncomfortable thought, both at the time and for years to come. He was hugely impressed by the air of manly authority and competence he witnessed in the four European quartermasters who took turns at the ship's wheel; still an impressionable and unworldly 19-year-old, he regarded them as godlike figures. But then, one afternoon, he caught a glimpse of one of these deities 'scurrying like a rat', and trying to disguise the handful of custard pudding he had furtively lifted from the passengers' massively laden dining tables. His astonishment at seeing a highly trained craftsman, who held their lives in his hands, reduced to stealing scraps and leftovers 'taught me more than I could have learned from half a dozen socialist pamphlets'.

The second incident was a lesson in, as we would now say, racism. When the *Herefordshire* put in at Colombo, the usual swarm of coolies came on board. One of these men was carrying a passenger's tin uniform case, and was swinging it around so clumsily as to threaten people's heads. Seeing this, a white sergeant gave him a tremendous kick up the backside, and sent him sprawling. Not one passenger protested. 'The most selfish millionaire in England, if he saw a fellow-Englishman kicked in that manner, would feel at least a momentary resentment. And yet here were ordinary, decent, middling people . . . watching the scene with no emotion whatever except a mild approval.' Blair, the disaffected Etonian sceptic, was taking his first nursery steps on the road to socialism.

29. Beadon was to remember Blair as a very quiet, withdrawn, lugubrious man, tall (6' 3") and painfully thin, with his uniform or mufti always seeming to hang on him untidily. Though not actively unpleasant, he took no part in the world of snooker and pink gins and dances, preferring to stay alone in his room and read. This was not necessarily seen as a bad thing by his superiors: bookish officers were often better equipped to deal with long nights of tropical solitude than their more gregarious peers, who all too often succumbed to the bottle or the opium pipe.

A standard nine months' training at the school, followed by five probationary months in the field, was the usual prelude to a first proper posting. Blair and the rest of that year's intake learned – mainly by rote – police procedure, law and languages: Burmese and Hindustani. Blair may not have cut much of a martial figure, but his linguistic abilities surprised his fellow students almost to the point of amazement. By the time he left Burma, five years later – 'five boring years within the sound of bugles', he once said – he was able to go into temples and converse with the *hpongyis*, or priests, in their own elaborate sociolect: the sign of a very high level of competence indeed.

Blair's time in Burma was uncomfortable, lonely, melancholic, frustrating and from time to time enraging. He was no saint, and his autobiographical writings freely admit to times when he would shout at and strike servants just as the coarsest English troops did; times when he fantasised about how sweet it would be to plunge a bayonet into the guts of a smirking Buddhist monk. In the long run, though, a time spent in service of Empire proved to be an ideal training for a writer committed to the end of imperialism.

28 OCTOBER

ROME

Mussolini's fascists took control of the Eternal City in an event usually known as the March on Rome. This grand name – which implies a high degree of discipline and drama – adds unwarranted dignity to a much more chaotic event. What happened was that some 20,000 fascist soldiers – Blackshirts – had converged on the capital from four directions. For the most part they were underfed, ill-armed and poorly trained. Their advance was halted about 20 miles outside the city, and because of torrential rain, some of them decided to give up and go home. The Italian army could easily have crushed this motley rebellion, but there was no political will to deploy it. The following day, 29 October, King Victor Emmanuel III invited Mussolini to form a new government. Mussolini arrived the day after that wearing a black shirt, black trousers and a bowler hat. He duly became premier – the youngest in the history of Italy.

29 OCTOBER

LONDON

Virginia Woolf wrote to David Garnett to compliment him on his recent novel *Lady into Fox*.

Garnett's novella, or long short story, was one of the strangest productions of the year; it tells, quite simply, what happens when a young wife is suddenly and miraculously transformed into a vixen. Parts of it read like a story for children – though it is brutal at times, and includes reflections on sexual jealousy and other adult themes. Part of it is grimly comic, especially in the earlier pages, where the baffled husband makes a spirited attempt to live a normal, middle-class married life, with games of cards and evenings at the piano. It is closer to Kafka's *Metamorphosis* than to other English tales of supernatural transformation, and one reading of the book might be that the husband – as his neighbours think – has simply sunk into a horrible delusion. Garnett constantly denied that it was an allegory of any kind, though in later years it dawned on him that it might be read as an account of marital devotion carried to an extreme.

From a literary point of view, the most impressive part of the book is its portrayal of the way in which its heroine, Mrs Silvia Tebrick, is gradually taken over by her new foxy nature. At first she is wholly a young woman trapped inside a fox's body, and insists on wearing clothes: '. . . while he tied the ribands his poor lady thanked him with gentle looks and not without some modesty and confusion'. The couple take tea together, and enjoy Handel and Gilbert and Sullivan. But then she starts to eye their caged bird in a strange way, and to chase the ducks. Finally she savagely kills and greedily eats a rabbit. From this point on, the tale is one of how Mr Tebrick's love for her survives even after she runs wild, mates with a dog fox, and has cubs.

Lady into Fox was illustrated with woodcuts by R. A. Garnett; it won both the Hawthornden and the Tait Black prizes in 1923.

BERLIN

Count Harry Kessler mused on events in his diary:

In Italy the Fascists have attained power through a *coup d'état*.
If they retain it, then this is an historic event which can have

unforeseeable consequences, not only for Italy but the whole of Europe. It may be the first step in the successful advance of the counter-revolution. Until now, as in France for example, counter-revolutionary governments have still at least behaved as though they were democratic and peace-loving. Here a frankly anti-democratic and imperialist form of rule gains the upper hand again. In a certain sense Mussolini's *coup d'état* is comparable (in the opposite direction, of course) to Lenin's in October 1917. Perhaps he will usher in a period of fresh European disorders and wars . . .

This fascist victory was stirring and inspirational to the Nazis, who followed the triumph avidly.

On 30 October, Kessler wrote: 'Mussolini has been appointed Prime Minister by the King of Italy. This may turn out to be a black day for Italy and Europe.'

On the 31st, the art dealer René Gimpel recorded a conversation with the famous and highly influential art critic Bernard Berenson:

I am in Florence. Mussolini has been appointed president of the Council. Much talk of Fascism. Berenson commented: 'These Fascists are the same people who requisitioned my most precious wines three years ago in the name of the Florentine Soviet Committee; then they were Communists. They don't know what they are. The only lucky Italians are the ones who live abroad. I've lived here for thirty-two years and I've never seen a government, and that's their way of governing, like their police, who lie low during strikes. When the government comes up against some difficulty, they disappear; when everything is settled by the nature of things, they reappear, triumphant. But nevertheless everything works in this country. That's because Italy isn't a nation, it's a civilization!'

After dinner Berenson, that model of integrity, tried to sell me pictures, and very bad they were!

RUSSIA

The Red Army occupied Vladivostok, and repelled the Japanese forces on the city's outskirts. More good news for Lenin.

LONDON

The *Sunday Chronicle* reported on a speech by 'Mr Alfred Noyes, the well-known' poet, at the Royal Society of Literature, in which he launched a scathing attack on the 'literary Bolshevism of to-day'. The main target was 'Mr James Joyce's *Ulysses*', and Mr Noyes had been uncompromising: 'It is simply the foulest book that has ever found its way into print.'

He expressed astonishment and dismay that so many metropolitan intellectuals had praised the book, and had spoken of Joyce as a writer of genius: the 'only sound analysis' that had so far appeared in Britain, he said, was that in the *Sporting Times*, which had called *Ulysses* 'the work of a madman'. Were the book to be brought before a criminal court, Noyes continued, 'it would be pronounced to be a corrupt mass of indescribable degradation'.

Far more disturbing than the book alone, Noyes said, was the 'appalling fact' that 'our pseudo-intellectuals' had been boosting Joyce's name at the very time when the reputations of great Victorian writers, such as Tennyson, were being attacked from many sides. The whole affair 'is the extreme case of complete reduction to absurdity of what I have called "the literary Bolshevism of the Hour"'.

It is clear that by this time Noyes had read Shane Leslie's hostile review of *Ulysses*, this time published under his real name, in the October issue of *Quarterly Review*. This second onslaught was significantly longer than the *Dublin Review* article, but no less ferocious: 'As a whole, the book must remain impossible to read, and undesirable to quote . . .' And again Leslie sounded the increasingly familiar 'bolshie' note: '. . . We shall not be far wrong if we describe Mr Joyce's work as literary Bolshevism. It is experimental, anti-Christian, chaotic, totally unmoral.'

Probably recognising that the readership of the *Quarterly Review* would be less upset than that of the *Dublin Review* about Joyce's blasphemies against the Catholic church – that it might, indeed, include quite a few Protestants – Leslie has done with his religious objections to the book quite swiftly ('From any Christian point of view this book must be proclaimed anathema, simply because it tries to pour ridicule on the most sacred themes and characters in what had been the religion of Europe for nearly two thousand years'). He concentrates instead on making the case that the book is obscene, revolting, obscure, poorly written . . . and possibly a gigantic hoax, which has hoodwinked the 'Praetorian guard of critics' in both France and England.

31 OCTOBER

NEW YORK

The World We Live In, a play by Karel and Josef Čapek, had its American premiere.

LONDON

John Maynard Keynes set off for Berlin, where he had been invited by the German Chancellor to attend a conference on the stabilisation of the mark. This was scheduled to begin on 2 November; he left a little early so as to have time with his friend Carl Melchior.[30]

MOSCOW

Seemingly quite well again, Lenin made his first public appearance at the All-Russian Central Executive Committee, in the Throne Room of the Kremlin Palace. Dressed in a rather worn and slovenly military uniform, he went unnoticed as he passed by the 300-odd delegates, until he was almost at the stage. Then a gigantic cheer went up, silenced when Lenin raised his hand. His doctors, he said, would only allow him to speak for 15 minutes; and so he spoke for exactly that, checking the time with sly glances at his wristwatch.

He reviewed the state of the Revolution; he announced that Vladivostok had been recaptured from the Japanese; he spoke of the need for radical cuts in the bureaucracy. Afterwards, he went back into the green room, where he was mobbed by correspondents from around the world. One artist from a New York paper told him, 'The world says that you are a great man.' 'I'm not a great man,' Lenin replied. 'Just look at me.'

30. Carl Melchior (1871–1933): one of the most influential figures in the German financial world. He had been an advisor at the Paris Peace Conference in 1919, and, in 1922, went on to be a Chairman of the powerful pharmaceutical concern, Belersdorf AG. Throughout the 1920s, he advanced the unpopular (to many Germans) argument that Germany should at least attempt to make the huge financial reparations demanded of them by the Allies, even though this could only be a short-term policy. His work brought him into frequent contact with J. M. Keynes, and they became good friends.

NOVEMBER

1 NOVEMBER

CONSTANTINOPLE

The Ottoman Empire was abolished, and the Grand National Assembly took control of Turkey; the legitimacy of the GNA's rule was internationally recognised some months later at a treaty conference held in Laussane. The last of the Ottoman Sultans, Mehmed VI Valentin, duly abdicated. On 17 November, he went into exile in Italy.

LONDON

In preparation for the imminent launch of the BBC, Parliament introduced a ten-shilling radio licence.

2 NOVEMBER

AUSTRALIA

The Australian airline Qantas began its first passenger services.

LONDON

Eliot arrived back from his brief holiday in Worthing. Vivien wrote an extraordinary letter to Pound, complaining about Lady Rothermere, or, as Vivien called her, 'the Rothermere woman': 'She is unhinged – one of those beastly raving women who are the most dangerous.' She continued in this vein, referring to the Gurdjieff Institute as if it were a mental hospital:

> She is now in that asylum for the insane called La Prieure where she does religious dances naked with Katherine Mansfield. 'K. M.', she says in every letter – 'is *the most intelligent* woman I have *ever* met.' K. M. is pouring poison in her ear (of course) for K. M. hates T[om Eliot] more than anyone.

It sounds nonsensical, even paranoid. Yet on the following day Eliot also wrote to Pound, expressing much the same fears and resentments, if in rather more temperate language.

> Lady Rothermere has been getting increasingly offensive ever since the *Criterion* came out, and especially since she entered her retreat for maniacs. I wish you could see her before she leaves Paris and tell her bluntly that the *Criterion* is a SUCCESS. I have had nothing but good notices. Nearly all the copies are sold (600 printed). But this woman will shipwreck it.

Pound replied swiftly, counselling Eliot not to carry out his emergency plan of trying to buy the title from Lady Rothermere.

LONDON

Macmillan published two handsome volumes of their collected edition of W. B. Yeats: *Later Poems* and *Plays in Prose and Verse*. The artist Charles Ricketts designed the green cloth binding, and produced drawings of a unicorn and a fountain for the endpapers. A few days later, Yeats wrote a grateful letter to Ricketts:

> Yesterday my wife brought the books up to my study, and not being able to restrain her excitement I heard her cry out before she reached the door 'You have perfect books at last.' Perfect they are – serviceable and perfect. The little design of the unicorn is a masterpiece in that difficult kind . . .

He went on to report recent acts of violence: a minor bomb that had been thrown in the street outside a recent meeting of the Dublin Arts Club,[1] and a much larger one on the far side of Merrion Square a few days earlier which was powerful enough to crack Yeats's windows.

1. The audience was by now so inured to explosions that the man who was speaking at the time did not even bother to pause.

THRACE

Hemingway travelled to Muradli in eastern Thrace to observe the withdrawal of Greek troops. The territory had now been ceded to the Turks by the Allies, and the Greek forces were given just three days to evacuate. In one sense they were a pitiful sight: dirty, exhausted, lice-ridden and plagued by mosquitoes, clad in the remains of badly fitting US army uniforms. They left behind them a trail of abandoned machine-gun nests, gun positions and fortified ridges from which they had been keyed up to fight the incoming Turks. And yet, Hemingway insisted, they were far from pathetic: they still looked like good troops – tough and sturdy. There was no doubt in his mind that they would have made a formidable opponent for the invaders. So what had gone wrong? After talking with various military observers, he concluded that these doughty soldiers had been betrayed at the highest level.

Until recently, they had been well officered by men who had served with the British at Salonika; under such leadership, they might easily have captured Angora and ended the war by force. Instead, all the seasoned field officers had been abruptly dismissed by King Constantine, and replaced by members of the Constantinist party, most of whom had spent the war in Switzerland and had never so much as heard a shot fired. Their conduct of subsequent battles was not merely incompetent but tragically, criminally negligent.[2] Hemingway's verdict was blunt: Constantine had failed these men. 'They are the last of the glory that was Greece. This is the end of their second siege of Troy.'

Hemingway returned to Constantinople, where the panicky sense of impending massacre had died away pretty much overnight. The Royal Navy had steamed into the Sea of Marmora, and sent a message to Hamid Bey that if there was any massacre of Christians, the city would be shelled into oblivion. This may have been a bluff, but if so it was a bluff that worked. A sense of calm returned.[3]

2. In one disgraceful episode in Anatolia, where the Greek infantry were mounting a ferocious attack on the Turks, they came under massive fire by their own artillery. British observers who watched this appalling sight wept with frustration and rage, but could do nothing.

3. Indeed, a slight element of farce entered the skirmishes that followed: Kemal's one submarine, a gift from the Soviets, had been driven away by the guns and depth charges of RN destroyers and was now operating profitably as a pirate, under the Jolly Roger. An RN patrol vessel investigated a boatload of Turkish women who were crossing over from the Asian side of the city, and discovered them to be men – Kemalist troops who would operate inside the city in the event of an invasion.

His last report filed, Hemingway – now suffering quite badly from the malaria he had contracted from the mosquitoes of Constantinople – set off for Sofia, where he wrote a long article reflecting on the horror of the Thracian evacuation, and describing his further experiences of watching the retreating Greek soldiers while en route to Bulgaria. He reminded his readers that, no matter how long it took his dispatches to reach the paper, a long column of a quarter of a million civilian refugees was still shambling slowly towards Macedonia.[4]

3 NOVEMBER

MUNICH

Less than a week after the Italian *coup d'état*, the Nazi Party functionary Hermann Esser proclaimed, to a crowded Festsaal in the Hofbräuhaus: 'Germany's Mussolini is called Adolf Hitler.' In retrospect, this announcement may be seen as the beginning of the Führer cult.

4 NOVEMBER

VALLEY OF THE KINGS, EGYPT

The English archaeologist Howard Carter and his men uncovered what was obviously a stone step. By the next day, they had cleared it. Carter at once saw that this was a discovery of the first importance: they had at last uncovered the entrance to Tutankhamun's tomb.

Though the participants had no idea that they were on the brink of worldwide fame, one of the most ravenously consumed stories of the year – indeed, of the decade – was about to break. It was a major event in the history of archaeology, but it has also been described as the world's first true media event: a kind of collective fantasy, created by the press, which touched the lives of literally millions of people both at the time and over the next few years.

4. He bade farewell to the subject with a vignette of drinking wine with 'Madame Marie', a local innkeeper who was stoically indifferent about the incoming Turks. The Greeks, the Turks, the Bulgars – in the end, she shrugged, they were all the same. Then she cheekily overcharged him for his stay, apologised for the fact that her rooms had given him lice, and told him to console himself that it was better to be lice-ridden than to sleep out in the street.

5 NOVEMBER

MOSCOW

The opening of the Fourth Congress of the Communist International. Lenin, still gravely ill, was unable to attend, but wrote a letter, which was read out at the opening of proceedings. Amongst the participants was the literary star of the rising Harlem Renaissance, Claude McKay; during his attendance at the Congress, he met both Trotsky and Bukharin.[5]

6 NOVEMBER

DUBLIN

Yeats wrote to his friend, the literary scholar Herbert Grierson:

> We are preparing here, behind our screen of bombs and smoke, a return to conservative politics as elsewhere in Europe, or at least to a substitution of the historical sense for logic. The return will be painful and perhaps violent, but many educated men talk of it and must soon work for it and perhaps riot for it.

He added that many of these men were looking with interest at 'individualist Italy'.

EGYPT

Carter sent a coded telegram to his patron, George Edward Stanhope Molyneux Herbert, 5th Earl of Carnarvon, at his family seat, Highclere Castle, near Newbury. Decoded, the telegram read:

> AT LAST HAVE MADE WONDERFUL DISCOVERY IN VALLEY STOP A MAGNIFICENT TOMB WITH SEALS INTACT STOP RE-COVERED SAME FOR YOUR ARRIVAL STOP CONGRATULATIONS ENDS

5. On 30 November, the Congress addressed 'The Black Question', and affirmed the solidarity of the communists with the struggles of African-Americans and other oppressed peoples of colour.

Carnarvon's initial response was rather cool:

POSSIBLY COME SOON

But then he reflected, and grew more excited.[6] If Carter truly thought
that his new discovery was MAGNIFICENT, it was clearly time to
go and see just what he had uncovered. Carnarvon sent off a second
telegram:

PROPOSE ARRIVE ALEXANDRIA 20th

Carter duly waited for his patron to arrive.

7 NOVEMBER

LONDON

Eliot wrote again to Pound, on the question of publishing a story by Kath-
erine Mansfield.

> I myself should much prefer to have something from Murry; he is
> at least in every way preferable to his wife. The latter is not by any
> means the most intelligent woman Lady R. has ever met. She is
> simply one of the most persistent and thickskinned toadies and
> one of the vulgarest women Lady R. has ever met and is also a
> sentimental crank.

On future editorial policy, he suggested that as 'there are only half a
dozen men of letters (and no women)' worth publishing, he wanted to so-

6. Carnarvon had been involved with Carter's work, on and off, for some 13 years, and in the
early period there had been several major disappointments, due in part to Carter's youth and in-
experience – he was entirely self-trained as an archaeologist. In the last five years, however, Carter's
working methods had become far more systematic. Modelling his new approach on plans for artil-
lery barrages that had been developed during the Great War, he had, in 1917, taken a two-and-
a-half-acre triangle of land in the centre of the Valley, using as reference points the tombs of
Rameses II, Merneptah and Rameses VI. He divided this triangle into a grid system, and, with a
team of up to 100 labourers, set about the painstaking clearance of the site right down to the level of
its bedrock. The process had cost his patron dearly, to the tune of some £35,000, and had thus far
yielded nothing much more interesting than a few broken pots.

licit articles from eminent people in other fields: Sir James Frazer, the anthropologist and student of myths; the neurosurgeon and psychologist William Trotter; Sir Arthur Eddington, the astronomer; and the physiologist Sir Charles Sherrington. In the event, none of these sages ever contributed to *The Criterion*.

MOSCOW

Writing in collaboration with Sergei Yutkevich, Sergei Eisenstein – soon to establish himself as the most celebrated, and perhaps the most gifted of Soviet film directors – published his first theoretical article on the cinema: 'The Eighth Art. On Expressionism, America, and, of course, Charlie Chaplin'. It appeared in the magazine *Ekho*. At this time, Eisenstein was still working in the Moscow theatre, and had not directed so much as a single foot of film.[7]

BERLIN

Kessler wrote about the inflation crisis: 'Nine thousand marks to the dollar. The daily rate of exchange shows the progress of our decline like the temperature chart of a very sick patient.'

8 NOVEMBER

BERLIN

Vladimir Nabokov was beginning to make literary friends, co-founding a circle of young emigré writers, who called themselves by the mock-heroic name of the Brotherhood of the Round Table (Bratstvo Kruglogo Stola). The man who had suggested the group, Leonid Chatsky, described his colleague as a 'twentieth-century Pegasus' – one part giraffe, one part seahorse: 'Sirin', tall and thin, seemed only to move his neck when he read out his compositions. It was an exciting period: during 1922 and 1923, many of the leading Russian writers spent at least some time in Berlin: Gorky, Mayakovsky, Pasternak, Tsvetaeva, Bely and others. 'Sirin' was a minnow among these whales; but in the English-speaking world, 'Nabokov' would eventually outgrow them all.

7. He was to make his cinematic debut in 1923 with a short film designed to be screened as part of a play, and then in 1924 made his first real feature, *Strike*.

LONDON

Eliot wrote to Richard Aldington, and explained that he was having considerable difficulty in writing the review of *Ulysses* that he had promised to *The Dial*; he complained that he found it hard to express his opinions 'intelligently, inasmuch as I have little sympathy with the majority of either its admirers or its detractors'.

10 NOVEMBER

STETTIN

Having finally, after some four months of uncertainty and delay, been granted an exit visa from Russia, Stravinsky's mother arrived in Stettin, where once again she was trapped in red tape, this time for a travel visa for Belgium. Three days later, she was able to leave, and met up with Igor in Germany. The two of them travelled to Paris together, arriving on 14 November.

BERLIN

A telegram arrived at Einstein's residence. Translated from the German, it read: 'Nobel Prize for Physics awarded to you; more by letter.'[8] There was no one home chez Einstein to receive the news, and the rumour that he was among the last to hear of the honour became firmly established as part of his popular myth. Recent biographers have exploded this amusing tale: in reality, Einstein had been quietly tipped off well in advance.

The physicist and his second wife,[9] Elsa (also his cousin), were en

8. This is confusing for compilers of reference books, for on the very same day, a telegram bearing the identical message was delivered to Niels Bohr in Copenhagen. The follow-up letter to Einstein, from Professor Christopher Aurivillius, secretary of the Royal Swedish Academy of Sciences, explained that Einstein's award was for 'your work in theoretical physics, and in particular your discovery of the law of photoelectric effect, but without taking into account the value which will be accorded your theories of relativity and gravitation, once they are confirmed'. Bohr's prize was for 'services in the investigation of the structure of atoms and of the radiation emanating from them'. This apparent conundrum is easily resolved. Einstein's was the delayed 1921 prize; Bohr's the 1922 prize. The other Nobel Laureates for 1922 were: Peace: Fridtjof Nansen; Chemistry: Francis W. Aston; Physiology or Medicine: shared by Archibald V. Hill and Otto Myerhoff; Literature: Jacinto Benavente.

9. Under the terms of the 1919 decree of divorce between Einstein and Mileva, his first wife, Mileva was entitled to the entire sum of the prize in the (likely) event that he won it. In 1923, that sum – $32,000 – was duly transferred to her.

route to Japan, where they were to stay until 29 December. That nation was gripped by Einstein mania, and the reception was even more enthusiastic than the one he had enjoyed in Paris. A reporter noted that 'When he arrived at the station there were such large crowds that the police was unable to cope with the perilous crush . . . Einstein remained modest, friendly and simple . . . At the Chrysanthemum festival the centre of attention was neither the Empress nor the Prince Regent, everything turned on Einstein.'

At the end of the year, the Einsteins left Japan for their next stop: Palestine.

11 NOVEMBER

DUNDEE

Still badly weakened by his recent operation for appendicitis, Winston Churchill delivered his election speech for the Dundee constituency, for which he was standing as Liberal candidate. His notes for the speech, set out in carefully indented lines as if they were poetry, were reminiscent of an Old Testament prophet – or, indeed, of *The Waste Land*. He began with a broad vision of the twentieth century as a 'terrible and melancholy' era, full of disasters and horrors – a time in which all the advances civilisation had made over the previous thousand years had been reduced to 'bankruptcy, barbarism or anarchy'.

He asked his audience to contemplate the contemporary global disaster: China and Mexico 'sunk into confusion'; Russia, where a small set of 'Communist criminals' were tyrants; Ireland, where civilisation and Christianity had regressed; Egypt and India driven backwards towards 'primordial chaos'. His climax was a masterpiece of foreboding and challenge:

> *Can you doubt, my faithful friends*
> *as you survey this sombre panorama,*
> *that mankind is passing through a period marked*
> *not only by an enormous destruction*
> *& abridgement of human species,*
> *not only by a vast impoverishment*

& reduction in means of existence
but also that destructive tendencies
have not yet run their course?
And only intense, concerted, & prolonged efforts
among all nations
can avert further & perhaps even greater calamities.

Churchill would lose the Dundee seat.

12 NOVEMBER

PARIS

The Joyces packed up their belongings, left their hotel and returned to Paris, where they moved into their new rented flat on the Avenue Charles Floquet. Joyce had two major arguments this month – one with Sylvia Beach, the other with Frank Budgen. On the 17th, he admitted to Harriet Shaw Weaver that Sylvia Beach had a good deal to complain about in handling his affairs:

> Possibly the fault is partly mine. I, my eye, my needs and my troublesome book are always there. There is no feast or celebration or meeting of shareholders but at the fatal hour I appear at the door in dubious habiliments, with impediments of baggage, a mute expectant family, a patch over one eye howling dismally for aid . . .

LONDON

Eliot wrote to Gilbert Seldes.[10] Among other matters, he thanked Seldes for his review of *The Waste Land* in the latest *Dial*.

USA

The release of *Tess of the Storm Country*, starring Mary Pickford – 'America's Sweetheart'. This was Mary Pickford's only major film appearance in 1922.

10. For Seldes and *Krazy Kat*, see 20 January.

LONDON

Virginia Woolf wrote to Lady Robert Cecil: 'Leonard has been meeting Lord Robert. He has seen his constituents, and they seem cordial; but if he does get in (I'm talking of Leonard) I shall divorce him. Unfaithfulness is not with women only. In fact politics seems worse to me than mistresses.'

A week or so earlier, she had written to Dora Sanger: 'Why do you accuse Leonard of indifference to public affairs? Here he is slaving all day to make the world safe for democracy or some trash like that. It's on the cards he will be Woolf MP before long, and I may dedicate my life to tea parties on the terrace.'[11]

It was also in November that Virginia attended a lecture in London by Paul Valéry,[12] who had recently published *Charmes*.

The other main French connection for Bloomsbury this month: Roger Fry went for treatment in the clinic of Dr Émile Coué (1857–1926) at Nancy.

14 NOVEMBER

LONDON

The British Broadcasting Company began radio transmissions in the United Kingdom from station 2LO in Marconi House.

11. By mild coincidence, Leonard was standing as a Labour candidate against Virginia's cousin, H. A. L. Fisher. During the run-up to the general election, Virginia often wondered, with some anxiety, whether there might not be a 'ghostly chance' that Leonard might win his seat. She need not have worried: in the event, he was to come fourth out of six candidates.

12. Paul Valéry (1871–1945), who has a strong claim for the title of France's major twentieth-century poet, had published relatively little until the First World War. He had made a promising beginning to his literary career with poems, articles, an idiosyncratic critical study of Leonardo da Vinci and an unclassifiable, partly autobiographical prose work, *Monsieur Teste* (*Mr Head*, 1896). But he suffered from a kind of mental breakdown or existential crisis on 4 October 1892, and from about 1898 onwards maintained a long silence.

He re-emerged as a writer of note in 1917, with the publication of *La Jeune Parque* ('The Young Fate'), which, though only 512 lines long, cost him four years of effort. In 1920 he brought together a collection of his early verses, mainly in revised form, as *Album des vers anciens*. The publication of *Charmes* in 1922 confirmed his exceptional talents; it contained one poem, 'Le Cimitière Marin' ('The Graveyard by the Sea'), that has become one of the best-known and best-loved of all modern French verses.

LONDON

Eliot wrote to Pound on the evening of the UK elections, mostly about Bel Esprit and his money anxieties in general, but also in loyal defence of Vivien, and the part she had played in making him a poet: '. . . also it must be remembered that she kept me from returning to America where I should have become a professor and probably never written another line of poetry . . .' His final note was grim: 'I have not yet seen Lady R. I am looking forward with horror to seeing her tomorrow . . .'

15 NOVEMBER

UNITED KINGDOM

The general election. One of the candidates for the Labour Party was Bertrand Russell. He had originally been proposed – by the radical historian (and chairman of the University Labour Party) R. H. Tawney – as candidate for the potentially winnable seat of London University. But members of the party insisted that H. G. Wells be put forward instead.[13] Instead, Russell was asked to stand in a Tory stronghold – his own neighbourhood, Chelsea, where his opponent would be the unbeatable Sir Samuel Hoare. Russell accepted the doomed mission, partly because he did not greatly relish the prospect of becoming an MP, partly because it gave him a good opportunity to make his support for Labour well known.

The election results proved to be momentous, and shaped British political life for the rest of the century. The Conservatives, under Andrew Bonar Law (1858–1923) gained a clear majority, with 344 seats. But the Labour Party managed to double its presence in the Commons, taking 142 seats; while the Liberals, under Herbert Henry Asquith, won only 62, and the so-called National Liberals, led by David Lloyd George, 50. Bonar Law was duly made prime minister.

This was, in effect, the end of the Liberal era in British politics; Labour was now firmly established as the nation's second party. On 22 November, to the disgust of Leonard Woolf, and the delight of Russell, the anti-war leader Ramsay MacDonald was made leader of the Labour Party.

13. To the disgust of Tawney, who felt, in the words of Beatrice Webb, that 'Bertrand Russell is a gentleman and H. G. a cad'.

AUSTRIA

Wittgenstein wrote to Ogden about the finished copies of the *Tractatus Logico-Philosophicus*, which had just reached him at the village of Puchberg, in the Schneeberg mountains: 'They really look nice. I wish their contents were half as good as their external appearance.' Wittgenstein was now teaching in a primary school again.

16 NOVEMBER

USA

The New York Times reported that the Russian Communist Party had issued a condemnation of Einstein's theories, saying that they were 'reactionary in nature, furnishing support of counter-revolutionary ideas' and 'the product of a bourgeois class in decomposition'.

PARIS

Hemingway wrote to Harriet Monroe, asking her when she intended to publish the poems he had sent her; bragging that the Three Mountains Press was about to bring out a collection of his writings, edited by Pound; and gossiping about various acquaintances. His most topical news was that Ford Madox Ford, the distinguished English novelist and editor, was due to arrive in Paris the following day for a stay of about a month. This was a matter of keen interest to Hemingway, who liked to keep tabs on visiting celebrities.[14]

PARIS

Vladimir Mayakovsky, one of the most prodigiously gifted young Russian poets, who was still not disillusioned with the Bolsheviks, visited Igor Stravinsky at the composer's studio. This was a small room in the upper part of a pianola factory on the Rue Rochechouart, next door to the house where Chopin had lived during his stay in Paris.

> The soul-searching wail of pianolas being tested floated up even through closed doors . . . The composer's tiny upstairs room was

14. When he met Ford in Pound's studio a few days later, however, he took an instant dislike to this tall, stout, rather stiff character with a walrus moustache and watering eyes.

crowded with grand pianos and pianolas. Here Stravinsky creates his symphonies; he can hand his work directly in to the factory, trying the musical proof on the pianola. He speaks rapturously of composing for eight, for sixteen, even for twenty-two hands!

17 NOVEMBER

BARCELONA

André Breton delivered his lecture 'Caractères de l'évolution moderne et ce qui en participe' at the Ateneo – in part to promote the Dalmau Gallery's opening of an exhibition of work by Picabia.[15] Delivered, as its title suggests, in French, and with few concessions to the fact that the local audience might not quite be up to complex arguments in a foreign language, the lecture none the less made a considerable stir. Picabia attended with his mistress, Germaine Everling, who later became his wife.

Complex and uncompromising as it was in parts, its general drift seemed plain enough: Breton declared that Dada was now altogether *passé* – a contention that enraged the local Dada group – and condemned Tzara's conduct during the Congress of Paris: 'It would not be a bad thing to reinstitute the laws of the Terror for things of the mind.' But he boosted what he called the new generation – the artists Picasso, Picabia, Man Ray;

15. Breton had set off from Paris in the company of Simone, Picabia and Germaine Everling on 30 October, travelling in Picabia's sports car, an open-air Mercer. Breton wore a leather pilot's helmet, thick pilot's goggles and a heavy fur coat. The strange party broke their journey in Marseilles, where they visited a colonial exposition and Breton bought what he took to be a stuffed armadillo, for 20 francs. He carried the thing around like a lapdog, and held it inside his coat, until an apparent miracle took place: the armadillo, evidently not stuffed at all but merely comatose, came back to life and jumped to the ground. But Breton and Picabia hated the rest of the exhibition, with its phoney African huts and equally fake black jazz bands. Picabia tried to cheer Breton by taking him and his armadillo to the red-light district, but the strangely prudish Breton, never comfortable in brothels, found the experience of being teased by prostitutes embarrassing and depressing.

They arrived in Barcelona on 7 November, and the Bretons rented a room in the Pension Nowe on Ronda San Pedro. Breton did not greatly care for most of the things he saw in the town, though the sight of Gaudí's cathedral, the Sagrada Familia, bowled him over. He sent Picasso a postcard, asking 'Do you know this marvel?' Simone came down with serious food poisoning – salmonella – and the couple would gladly have returned to Paris had it not been for Breton's promise to give his lecture. She lay bedridden; Breton wrote an eight-page automatic poem about their plight, 'Le Volubilis et je sais l'hypotenuse', which he dedicated to her.

the writers Aragon, Eluard, Peret, Desnos ('the knight who has gone furthest') – and he confirmed the enduring importance of Lautréamont, Rimbaud, Cravan and others. He also suggested that like Futurism and cubism, Dada might best be understood as a forerunner of a more general and diffuse modern movement, as yet unnamed, which was about to find vigorous and revolutionary expression. Two years later, Breton gave that movement the name 'surrealism'.

Salvador Dalí did not attend this lecture, but it seems likely that he would have read, and perhaps even owned a copy of the Picabia exhibition catalogue, which included a preface by Breton with much the same content as his Barcelona speech. If so, he would have noted Breton's conspiratorial use of the word *nous*, the 'we' in question being the writers and artists associated with his journal *Littérature*; and Breton's insistence that it was in Paris, and Paris alone, that the modern spirit was being forged.

By 20 November, Breton was himself back in Paris. He made an abortive bid to set up a new salon, 'Salon X', to protest against more traditional art exhibitions, but the artists he approached (Brancusi, Duchamp, Ernst, Picabia, Picasso) were none too keen, and the project fizzled out by the end of the year.[16]

18 NOVEMBER

RAF FARNBOROUGH

T. E. Lawrence, who hero-worshipped Churchill, sent him a letter of condolence:

> Of course I know that your fighting sense is urging you to get back into the scrimmage at the first moment: but it would be better for your forces to rest & rearrange them: & not bad tactics to disengage a little. The public won't forget you soon, & you will be in a position to choose your new position [*sic*] and line of action

16. It was also in November that Max Ernst put together his own 'salon' – a strictly pictorial one, in the canvas he entitled *The Meeting of Friends*. Running in from the right is Breton, with a cape over his shoulder; the other figures are Paul and Gala Eluard (in whose Saint-Brice home Ernst worked on the painting), plus Aragon, Crevel, de Chirico, Desnos, Peret, Soupault . . . in short, most of the key members of what would soon be the first true surrealist group.

more freely, for an interval. I needn't say that I'm at your disposal
when you need me – or rather if ever you do. I've had lots of chiefs
in my time, but never one before who really was my chief . . .

Churchill had come only fourth in the Dundee election polls; the win-
ning candidate was a Temperance man, so this was not entirely a reflec-
tion of the national swing towards the Tories. None the less, it felt like a
crushing rejection – though, unlike some of his supporters, Churchill
never spoke bitterly about the Dundee electorate. He had seen the appall-
ing conditions in which the poorest constituents lived, and understood
clearly, even sympathetically, how they might have grounds to hate and
distrust the rich.

PARIS

At about 5.30 in the afternoon, Proust died. Among those in attendance
were his brother, Dr Robert Proust; Dr Bize and his orderlies, laden with
oxygen bladders and syringes; his chauffeur Odilon, who had brought
him his final glass of iced beer from the Ritz; and, of course, his unflag-
gingly faithful housekeeper Céleste. He submitted to injections, but took
Céleste angrily by the wrist, pinching her with all the strength left in him,
and reprimanded her for letting the medics come.[17] The last word he ut-
tered, semi-conscious, was 'Mother'.

The news of Proust's death had a remarkable impact on Paris. The
British journalist A. K. Walkley reported to *The Times*:

> To judge from the newspapers, there have been tremendous 'cri-
> ses' in public affairs lately: the triumph of Fascismo in Italy, the
> Lausanne Conference, the English elections. But to many of us
> the great events are merely spectacular; they pass rapidly across
> the screen, while the band plays irrelevant scraps of syncopated
> music, and seem no more real than any other of the adventures,
> avowedly fictitious, that are 'filmed' for our idle hours. They don't
> come home to our business and bosoms. But one announcement

17. A few days earlier, he had told Céleste that if she did not prevent the doctors from tampering
with him in his final hours, instead of letting death take its uninterrupted course, he would come
back and haunt her.

in *The Times* of last Monday week shocked many of us with a sudden, absurdly indignant bewilderment like a foul blow: I mean the death of Marcel Proust . . .

LONDON

Eliot wrote to Richard Aldington enclosing a clipping – the 'Books and Bookmen' column by Brother Savage from the *Liverpool Post* of 16 November. The article gave a highly prejudiced and potentially damaging account of the Bel Esprit scheme:

> Until recently Mr Eliot was earning his livelihood in a London bank. Attempts had previously been made by his admirers to persuade him to give himself up to literature, and they pointed to his poetry and *The Sacred Wood*, a book of criticism, as work which substantiated their claim for him as an author with a future. Actually, as the amusing tale went at the time, the sum of £800 was collected and presented to Mr Eliot there and then. The joke was that he accepted the gift calmly, and replied: 'Thank you all very much: I shall make good use of the money, but I like the bank!' . . .

It went on to report Eliot's subsequent nervous breakdown. Still, the piece was accurate in some of its details – so accurate that there must surely have been a leak from within Eliot's circle of friends and acquaintances. Eliot suspected Aldington, and his note came very close to being a direct accusation: '. . . you ought TO know as well as I FROM what source it is likely TO have emanated . . .'

Eliot threatened legal action, but settled for a full apology printed on 30 November in the *Liverpool Daily Post and Mercury* beneath his formal letter of protest, and signed by the paper's editor.

19 NOVEMBER

PARIS

A dozen or so of Proust's nearest friends and family members were invited to see his body lying in state. One of the mourners was Cocteau, who noticed on the mantelpiece the 20 manuscript volumes for *À la Recherche du*

Temps Perdu: 'That pile of paper on his left was still alive, like watches ticking on the wrists of dead soldiers.' Two painters, one sculptor and a photographer – Man Ray – were asked to produce images of the author. Man Ray's image became the best known of these deathbed portraits.

LONDON

A well-known canting journalist of the *Sunday Express*, James Douglas, reviewed Aleister Crowley's *The Diary of a Drug Fiend*, under the headline 'A Book for Burning'.[18] The piece set off a moral panic.

Douglas – who had recently railed against Aldous Huxley's *Antic Hay* for its 'ordure and blasphemy', summed the book up as 'describing the orgies of vice practised by a group of moral degenerates who stimulate their degraded lusts by doses of cocaine and heroin'. No less damning, he compared it to that notoriously depraved book *Ulysses*.[19]

18. *Drug Fiend* had already been reviewed, in oddly mixed terms, by an anonymous critic in the *TLS* who said that it showed neither the literary flair of a de Quincey nor the sharp realism of a Zola, but that none the less 'the book teems both with an immense fertility of incidents and idea, and with an amazingly rich crop of rhetoric', and was a 'phantasmagoria of ecstasies, despairs, and above all verbiage'. *The Observer* conceded that there was 'a certain compelling power about the descriptions of degradation'.

19. Crowley is seldom, if ever, mentioned in conventional histories of literature, and yet – leaving aside any consideration of his own copious writings – he came into contact with quite a few of the key figures of literary modernism. In 1930, for example, he travelled to Lisbon at the invitation of Fernando Pessoa – then an obscure, shabby-genteel clerk, today almost universally acclaimed as the greatest Portuguese-language poet of the twentieth century. Pessoa, who dabbled in the occult, was a great admirer of Crowley's 'Hymn to Pan'. The two poets seem to have hit it off fairly well during their short friendship, but as so often, the Englishman's noisy, bourgeois-baiting antics with a much younger mistress landed him in trouble with the Lisbon police, so he faked his own suicide, with Pessoa's help. By the time the hoax was uncovered, Crowley was safely in Berlin. The episode is still not well known.

Neither is the fact that Crowley was also one of the early reviewers of *Ulysses*, which he discussed both sympathetically and shrewdly in an article, 'The Genius of Mr James Joyce', published in *New Pearson's Magazine*, July 1923. Like most critics of the day, he began by associating Joyce and Freud: 'Every new discovery produces a genius. Its enemies might say that psycho-analysis – the latest and deepest theory to account for the vagaries of human behaviour – has found the genius it deserves . . .' But Crowley was no enemy: he had nothing but praise for 'a writer who will in time compel recognition from the whole civilised world':

> I have no space to enter upon the real profundity of this book or its amazing achievements in sheer virtuosity. Mr Joyce has taken Homer's *Odyssey* and made an analogy, episode by episode, translating the great supernatural epic into terms of slang and betting slips, into the filth, meanness and wit and passion of Dublin today. Then the subtle little alien is shown exploiting, as once the 'Zeus-born, son of Laertes, Odysseus of many wiles' exploited, the ladies and goddesses of 'the finest story in the world' . . .

The following weekend, the *Sunday Express* carried a banner head-line on its front page:

COMPLETE EXPOSURE OF DRUG FIEND AUTHOR
Black Record of Aleister Crowley.
Preying on the Debased.
His Abbey.
Profligacy and Vice in Sicily

The paper had somehow tracked down Crowley's former associate, the novelist Mary Butts, and extracted a damning interview from her. One result of all this lurid publicity was entirely to the benefit of the Beast: *Drug Fiend* rapidly sold out its first print run of 3,000 copies. But the pub-lisher, William Collins, took fright, refused to authorise a second print run, and cancelled the contract for Crowley's autobiography.

Crowley had by this time returned to Cefalù, arriving there via Rome (where he performed an act of sex magick with a prostitute) in late Octo-ber; he read the *Sunday Express* tirade in his abbey,[20] and was rattled. After consulting the *I Ching*, he wrote a letter to the paper's proprietor, Lord Beaverbrook, asking for better treatment and an independent enquiry. No reply was forthcoming.

20 NOVEMBER

LAUSANNE
The opening of the conference to ratify the Turkish victory: there were rep-resentatives from England, France and Italy as well as Greece and Turkey.

Hemingway arrived on the 22nd, and remained there until 16 De-cember. In breach of his contract, he was filing reports to three different

Had this come from a writer of more reputable standing, Joyce would have had every reason to be delighted with it. But the fact that the 'wickedest man in the world' was so impressed with the novel would have confirmed all the darkest suspicions of his Catholic detractors.
20. The days of the Abbey of Thelema were already numbered. Rumours of depravity, fornication and human sacrifice had spread from the villagers to the authorities; and Mussolini's new adminis-tration did not look tolerantly on decadent foreigners. On 23 April 1923, Crowley was summoned to the local police headquarters and issued with a deportation order. He was eventually expelled from Sicily on 30 April 1923, and set sail for Africa.

employers: not only to his paper, but to the International News Service (using the pseudonym John Hadley) and to Hearst's Universal News Service. When, in December, the INS queried his expenses claims and demanded fuller accounting, he sent them an angry cable: SUGGEST YOU UPSTICK BOOKS ASSWARDS.

It was in Lausanne that he conducted his second interview with Mussolini.

21 NOVEMBER

WASHINGTON, DC
Appointment of the first female senator of the United States, Rebecca L. Felton of Georgia.

CZECHOSLOVAKIA
Karel Čapek's play about immortality, *The Makropulos Case*, opened at the Vinohrady Theatre in Prague.[21] It was a good year for Čapek (1890–1938), who also published a science-fiction novel, *The Absolute at Large*, and, in collaboration with his painter brother, another play, *The Fateful Game of Love*. Two years earlier, in their play *R.U.R.*, the brothers had coined the word 'robot'.

PARIS
The funeral service for Marcel Proust was held at the church of Saint-Pierre-de-Chaillot. As a Chevalier of the Légion d'Honneur, Proust was entitled to full military honours. The musicians played Ravel's *Pavane for a Dead Infanta*, and the Abbé Delpouve pronounced absolution. Among the crowds who had come to pay their respects were Ford Madox Ford[22] and James Joyce, the latter no doubt already regretting their abortive encounter at the Majestic in May. Diaghilev was there too, as were the writers Maurice Barrès and François Mauriac, and the conservative politician

21. It inspired the Czech composer Janáček to spend 1923–5 composing an opera, with his own libretto, based on the drama.
22. Ford later said that it was the experience of Proust's funeral that inspired him to begin work on his sequence of novels *Parade's End*, a work little read nowadays but still occasionally valued (for example, by Anthony Burgess) as the greatest fiction written by an English novelist in the twentieth century.

Leon Daudet. The most improbable writer in attendance was Vladimir Mayakovsky.

22 NOVEMBER

OXFORD
Bertrand Russell delivered a paper entitled 'Vagueness' to the Jowett Society.

NEW YORK
Carl Van Vechten wrote a high-spirited note to his friend Arthur Davidson Ficke, who was about to get a divorce that same day:

> Dear Arthur, Life is too amusing! Wallace Stevens drank a pint of my best Bourbon yesterday and then told me how much he disliked me . . .

Wallace Stevens's first collection of poems, *Harmonium*, was published by Knopf in 1923 – quite a late debut, since Stevens was 44. His reputation, especially in the United States, grew and grew over the following decades, and he now rivals the likes of Eliot, Pound and William Carlos Williams for the laurels as the major American poet of the twentieth century.

24 NOVEMBER

DUBLIN
The popular novelist and IRA member Robert Erskine Childers was executed by a firing squad of the Irish Free State army, for being in illegal possession of a pistol.

25 NOVEMBER

PARIS
For the first time in the City of Light, Stravinsky conducted a performance of the 1919 *Firebird Suite,* as well as *Fireworks* and passages from

The Nightingale. He then left Paris with his mother, taking her to Biarritz for a much-needed holiday.

LUXOR

Accompanied by his daughter Lady Evelyn Herbert, Lord Carnarvon finally reached Luxor. In the weeks since he had received Carter's momentous cable, workers had managed to clear a sloping 30-foot passageway leading down to the tomb, where a second sealed doorway stood between them and the dead prince.

On the 26th, Howard Carter and Lord Carnarvon became the first people to enter the tomb of Tutankhamun for some 3,000 years. What happened next has been handed down to posterity in the pages of Carter's book *The Discovery of the Tomb of Tutankhamun* (1923):

> The decisive moment had arrived. With trembling hands I made a tiny breach in the upper left-hand corner . . . candle tests were applied as a precaution against possible foul gases, and then, widening the hole a little, I inserted the candle and peered in, Lord Carnarvon, Lady Evelyn and Callendar[23] standing anxiously beside me to hear the verdict. At first I could see nothing, the hot air escaping from the chamber causing the candle flames to flicker, but presently, as my eyes grew accustomed to the light, details of the room within emerged slowly from the mist, strange animals, statues and gold – everywhere the glint of gold. For the moment – an eternity it must have seemed to the others standing by – I was struck dumb with amazement, and when Lord Carnarvon, unable to stand the suspense any longer, inquired anxiously, 'Can you see anything?', it was all I could do to get out the words, 'Yes, wonderful things.'[24]

23. Arthur Callendar, known to old friends including Carter as 'Pecky'.

24. This is not a strictly accurate account; nor are the words strictly Carter's. His book was ghost-written, drawing heavily on his notebooks, by Arthur Mace (an associate curator of Egyptian art at the Metropolitan Museum in New York), with the assistance of the popular novelist Percy White (Professor of English Literature at the Egyptian University). White, a prolific craftsman with some 30 titles to his credit, had recently published a semi-autobiographical novel, *Cairo*. When one compares Carter's notebooks, or Carnarvon's own account, with the version published in *Discovery*, it immediately becomes apparent that White had made the whole procedure at once more dramatic and more memorable. Carnarvon's article in *The Times*, for example, records that Carter's words

News of the discovery first broke in *The Times* on 30 November, and, in the words of Christopher Frayling in *The Face of Tutankhamun*, 'public interest in the discovery . . . had reached epic proportions in Europe and America by Christmas 1922'. The 'craze' – itself a twenties word – for all things Tut took off at once,[25] and lasted longer than even the most optimistic of cashers-in might have expected: at its height, well into 1925, and then – because of its major influence on the style known as art deco – for many years after.[26]

Cartier and Van Cleef & Arpels both launched jewellery lines featuring Anubis dogs, baboons and vultures; bright young things danced the 'Tutankhamun Rag'; French ocean liners were decorated in lacquered panels based on Egyptian bas-reliefs; Ramses of Cairo introduced a perfume called Secret de Sphinx; Leon Bakst brought out an 'Isis' collection; and the Folies Bergères introduced the Egyptian-style giant feather fan for a 'Tutankhamen's Follies'. By February 1923, *The New York Times* was reporting on an insatiable demand for 'Tut-Ankh-Amen designs for gloves, sandals and fabrics' – for London and New York had rapidly caught up with the Tut-mania of Paris.

Liberty brought out a 'Tutankhamen hat' in March, and Lady Elizabeth Bowes-Lyon – about to marry into the monarchy, and later to become Queen and Queen Mother – demanded a Tut-inspired theme for her April wedding. Nor was it only the rich and grand who succumbed: the high streets became clotted with Ancient Egyptian odds and ends, mass-produced in bakelite or plastic – scarabs, obelisks, hieroglyphics. Huntley and Palmer issued a biscuit tin in the shape of a funeral urn, music halls embraced the sand dance; cinemas in the 'Egyptian' style were built all over London . . . Every shop was crammed with 'Egyptian' toffees, 'Egyptian' soaps, and the new 'Pharonic' Singer sewing machine.

were 'There are some marvellous objects here.' But history remembers the far more potent 'Yes, wonderful things.' Stirring stuff: an intoxicating compound of detective work, mystery, exoticism and fairy tale.

25. Curiously, however, a vogue for Ancient Egypt had begun among Parisian couturiers a full season earlier, as though the dressmakers were clairvoyant.

26. One of those touched by the craze was James Joyce. According to a memoir written by his fellow Irishman-in-exile Arthur Power, Joyce was fascinated by the religious beliefs implied by the decorations in the tomb. The discovery made him reminisce about how impressed he had been by the Egyptian and Assyrian monuments in the British Museum, and how they suggested to him that 'the Egyptians understood better than we do the mystery of animal life, a mystery which Christianity has almost ignored . . .'

It was even suggested that the new London Underground extension, which joined Tooting and Camden Town, should be named the Tutancamden Line.

TOKYO
Crown Prince Hirohito was appointed Prince Regent of Japan.

26 NOVEMBER

UNITED STATES
The opening of *The Toll of the Sea* – Hollywood's first generally released film to use the two-tone Technicolor process. There had been seven earlier colour features using various technologies, but this was the first not to require distributors to use a special projector. The film was directed by the now obscure Chester M. Franklin, and is also notable for featuring Anna May Wong, Hollywood's first Asian star, in her first leading role. Its story was a Chinese variation on the theme of *Madame Butterfly*: the beautiful young Lotus Blossom sees an American floating in the sea off the coast of China, and has him rescued. They fall in love, but the American's friends all warn him against taking Lotus Blossom back to America. Several years later they meet again; Lotus Blossom has borne a half-American son, and decides that he will have a better life in the United States. So she sends her boy off with his father, then returns to the ocean where their love began, and drowns herself.

NEW YORK
The New York Times Book Review reported that the *Dial* award had been given to 'Thomas Seymour [*sic*] Eliot'.

UNITED STATES
Just two months after the successful release of *Grandma's Boy*, Harold Lloyd's new five-reeler *Dr Jack* opened in cinemas across America. This time, Lloyd played a benevolent, plain-dealing doctor who eventually rescues the girl, a rich hypochondriac, from the clutches of a swindling quack.

Meanwhile, Lloyd's greatest rival in the field of comedy was set on a new path.

27 NOVEMBER

HOLLYWOOD

The cameras began to roll on *A Woman of Paris*, Chaplin's debut for United Artists. It was his first serious dramatic feature, and his first film in which he did not actually appear (save for an uncredited three-second cameo as a bumbling porter). He had nursed the ambition to branch away from comedy for some years.[27] Sombre notes had begun to creep into his recent film work, and *The Kid* had been an obvious step in the direction of straight drama.

In the end, the project he settled on was put together from the racy stories he had been told by the notorious Mrs Peggy Hopkins Joyce, née Margaret Upton, with whom he had a brief affair shortly after coming back from his long European vacation.[28] He began to compile detailed notes from Mrs Joyce's reminiscences about an affair with Henri Letellier, a rich publisher whom Chaplin had met in 1921; and about a young man who had killed himself for love of her. Chaplin liked both the story and the Parisian location, and he started to struggle with an outline for a film called *Destiny*. It went through several more changes of title before he settled on *A Woman of Paris*.

He devoted a vast amount of work to the project, which meant a great deal to his sense of artistic dignity: the Clown was finally playing Hamlet. He engaged a troupe of research assistants and consultant experts on Parisian atmosphere, architecture, decor, cuisine and manners, and they fell over one another trying to prove who was the most profoundly steeped in *la vie Parisienne*. He even paid a regular salary to an artist who was supposed

27. As early as 1917, he had tried to buy the rights to Hall Caine's *The Prodigal Son*, which he saw as a potential vehicle for himself, and he had also considered the likes of *The Trojan Women*, and a movie about Napoléon and Josephine, to star himself and Edna Purviance.

28. Mrs Joyce, originally a country girl from Virginia, was the woman for whom the term 'gold-digger' had been coined, sometime around 1920. She had married her first millionaire, Stanley Joyce, at the start of the war, divorced him, pocketed a million dollars, became a Ziegfeld Girl for a while, then married and divorced four more millionaires in very rapid succession. She came to Hollywood in 1922, determined on a career in movies and soon met Chaplin, who took to her immediately he heard her turning the air blue when the director she had wanted for her debut film, Marshall Neilan, dared to slap her bottom. For several weeks, she and Chaplin went everywhere together, and the papers began to finger him as her sixth millionaire victim. This was not to be, and she moved on to seduce Irving Thalberg, while Chaplin began a much-publicised affair with the beautiful actress Pola Negri, who liked to tell the press that they were engaged to be married. They never did.

to be painting a portrait of the heroine, but never came up with an adequate result. Chaplin cast Edna Purviance in the role of the elegant mistress, and Adolphe Menjou as her lover.

The shooting went on for seven months. To the astonishment of most of his team, Chaplin worked without a screenplay; the reality was that he did not need one, since he had planned almost every shot and had the whole film in his head. This was the main reason why he decided to shoot the film in a linear, scene-after-scene order – a practice as unusual in 1922 as it is today.[29]

By the end of the shoot, A *Woman of Paris* had cost a fairly hefty $351,853. Chaplin was understandably nervous about how his first drama would be received – so much so that he wrote an explanation of his motives, which was printed as a special programme note for the New York premiere. To his delight, the gala openings on both coasts were euphoric events, and the reviews were the stuff of dreams: 'There is more real genius in Charles Chaplin's A *Woman of Paris* than in any picture I have ever seen,' said the *New York Herald* – a sentiment which echoed in review across the nation and across the Atlantic. In Britain, the *Manchester Guardian* called it 'the greatest modern story that the screen has yet seen'.

Sadly, it was the gushing enthusiasm of these reviews that helped murder it at the box office. The critics were all acclaiming Chaplin as a major dramatic artist, but the audience did not want art, they wanted Charlie, they wanted the Tramp. In New York, the first run actually lost money. Elsewhere, it barely broke even. Chaplin was bitterly disappointed, and as soon as he could, he withdrew the prints from circulation for 50 years. It was a failure for which he was ill-prepared, and he knew he had to re-establish his credentials as a comic, and soon. While casting around for a new subject, he visited Mary Pickford and Douglas Fairbanks. After breakfast, he began to amuse himself by looking at stereograms on historical subjects. One in particular struck him. It was from 1898, and showed prospectors in the Klondike: the Gold Rush.

29. Not that he was extravagant in other respects. One famous scene, shot on the night of 29/30 November, is meant to show a train arriving at a French railway station. Instead of using an actual train, Chaplin's cameraman, Rollie Totheroe, simply cut suitable apertures in a 10-foot board, then passed it in front of a spotlight. The lights that shone on the heroine's upturned face looked exactly like those cast by a moving train carriage.

LONDON

Virginia Woolf recorded the warm response to *Jacob's Room*: 'People – my friends I mean – seem agreed that it is *my* masterpiece, & the starting point for fresh adventures.'

28 NOVEMBER

PARIS

Man Ray sent two photographic prints to his friend and patron Ferdinand Howald in America – 'rayographs' that would be used in his newly published book *Les Champs Délicieux*, with an introduction by Tristan Tzara. He complained to Howald and his parents that he was suffering from a 'nasty cold'; a self-diagnosis that may have been true, but which did not admit that the more pressing condition that had sent him to bed was a bout of extreme depression, so extreme that he was on the point of suicide.

The cause of this depression is a mystery. On the face of it, Man Ray had every reason to be cheerful. In the 18 months or so since he had arrived in Paris, with little more than a hundred francs in his wallet and some paintings in his luggage, he had done very well for himself. In a short period he had made plenty of influential friends, courted some important patrons, staged a one-man show, become fashionable in advanced circles as a portrait photographer,[30] was earning a decent amount of money (though by no means as much as would soon come his way; he still could not afford to employ regular assistants), and was on the brink of real fame.[31]

Nor was he lonely any more. A few months earlier, he had met and immediately fallen for a beautiful young artist's model, Alice Prin, better known in her neighbourhood and to posterity as the legendary Kiki de Montparnasse. They were to live together for six years; she was his mistress, his muse and his frequent photographic subject.[32] They never married, though she habitually called herself Kiki Man Ray.

30. It was Man Ray who was summoned by Cocteau to carry out the deathbed study of Proust.
31. Just this month, *Vanity Fair* had run four of his 'rayograms' as part of a flattering article: 'A New Method of Realizing the Artistic Possibilities of Photography: Experiments in Abstract Form, Made Without a Camera Lens, by Man Ray, the American Painter'.
32. It is Kiki, for example, who posed for the classic erotic-surrealist joke photograph 'Le Violon d'Ingres', in which she is seen from behind in the pose and minimal costume of one of Ingres's

By the time he met her, not long after his move to a decently sized studio at 31 bis Rue Campagne-Première, not very far from the Métro station in Boulevard Raspail ('a swell place', he enthused on a postcard to his parents in July 1922), he had just completed another of his most celebrated images – the haunting portrait of the Marquise Casati. Man Ray had accidentally double-exposed the image, thus giving her two sets of eerily staring eyes. Far from being put off, she found the result 'thrilling', ordered dozens of copies and sent them out to the members of her crowd. This was the point at which Man Ray's commissions started to come from the rich set as well as the Montparnassians.

Man Ray's earliest months in Paris had been made bearable, indeed possible, by the generous care of Marcel Duchamp.[33] Encouraged by Duchamp, he booked a transatlantic passage and arrived in the city on 22 July 1921. Duchamp was waiting for him at the Gare Saint-Lazare; he installed Man Ray at a cheap hotel ($3 a week), then whisked him off to a reception at the Café Certa at 11 Passage de l'Opéra. There to greet him were Aragon, Breton, Eluard, Jaques Rigaut and Soupault. All of these writers were soon to be his friends.[34] When Duchamp left for New York at the start of 1922, Tristan Tzara took over the role of invaluable local guide and go-between; and though this was the time when Breton and company were busy administering the death blows to Parisian Dada, Breton never objected to this amiable contact.

Man Ray was delighted by the café atmosphere of Paris and its new night life: jazz bars, cocktails . . . But he was very low on funds, and often

odalisques; May Ray has inscribed two sounding holes in her back, so the image is a visual pun (woman = violin) inspired by an idiomatic phrase (a 'violon d'Ingres' is a hobby).

33. He had first met Duchamp during the artist's visit to the United States in June 1915; they became friends almost at once, and remained so for the next half-century. Man Ray was already set on a career as an artist. He had been born on 27 August 1890, into a Jewish-Russian immigrant family, the Radnitskys, and was given the name Emmanuel. He adopted the pseudonym Man Ray as early as 1911. His family were quite poor, but they indulged their son's talents, even after he renounced the architectural studies which, in their eyes, would have led to a safe profession, and declared himself a painter.

Like many other American artists, Man Ray was powerfully affected by the Armory Show of February 1913, which introduced cubism and other innovations to the United States. He met Stieglitz, who became something of a mentor, and – toying with the idea of also being a poet – corresponded with Pound. But it was Duchamp who really changed his life, and set him on the right path.

34. Indeed, one of the great diplomatic feats of Man Ray's life was his ability to stay friendly with all sides during the various artistic and ideological bust-ups of 1922–4. He became known as the man who never feuded with anyone.

reduced to sponging off his new friends. Once again, the resourceful Duchamp stepped in, finding him a maid's room at 22 Rue la Condamine, in which he could live for a while for free. Gradually, commissions for photographic portraits started to come in.[35]

Another important patron at this time was the flamboyant and multi-talented fashion designer Paul Poiret, soon to be acclaimed by the American writer and journalist Janet Flanner (now mainly remembered for her half-century as Paris Correspondent for *The New Yorker*, from 1925 until her retirement in 1975) as 'the sartorial genius of fashion'. Man Ray showed an immediate flair for shooting models and clothes, so Poiret was happy to keep employing him, and over the next few years he would often call Man Ray in to be court photographer at his lavish dinner parties.

Soon Man Ray had sufficient money to be able to move into a small room at 15 Rue Delambre, in the heart of Montparnasse.[36] On 3 December 1921, he held his first Parisian one-man show at the Librarie Six – 35 works, mostly paintings he had brought over from New York, but also some collages and 'objects'.[37] The show was a great hit with the public, and much discussed, but no one bought any paintings. Man Ray was more sanguine than might be expected; painting, he was increasingly coming to feel, was something from his American past. From now on, photography would be more than just a convenient way of earning a passable living: it would be at the centre of his art.[38]

35. One early coup: Sylvia Beach asked him to take a shot of Joyce by way of promoting *Ulysses* – Man Ray had been among those present at the Valéry Larbaud lecture on Joyce – and she began to decorate the walls of Shakespeare and Company with Man Ray's portraits.

36. This was the compact place that was described admiringly by Gertrude Stein in *The Autobiography of Alice B. Toklas* as being more ingeniously arranged than any space she had seen, including cabins on small boats. He had somehow managed to accommodate three large cameras, a developing area and a bed into a room that was not much more than an oversized cupboard. He photographed Stein, and a roll call of all the major names in painting and sculpture – Picasso, Matisse, Picabia, Léger, Braque – as well as Poulenc, Eluard, Max Jacob . . .

37. The most famous of these, made on and for the day as a present to be given to Philippe Soupault, was *Le Cadeau (The Gift)*. He had simply glued 14 tin tacks to the base of a flat iron: one of the simplest yet most troubling of Dada objects. Someone had stolen it by the end of the day, but it had already made its way into art history, and Man Ray would re-create it from time to time. At the age of 83, he endorsed an edition of 5,000 replicas, each one selling for $300.

38. His sense of photographic vocation grew after the winter of 1921–2, when he discovered (possibly by accident) the poetic properties of images produced without a lens, using simply small objects, variable light sources and photographic paper. This technique was not in itself anything new – it had been around since the dawn of photography, and Henry Fox Talbot had made similar experiments – and other artists were working on similar techniques throughout the 1920s. It was Man Ray, though,

Whatever the cause of his depression in the final months of 1922 – one possibility is that he was painfully jealous of Kiki – it does not seem to have been long-lived. In the months that followed, both his income and his international reputation grew and grew. He experimented with film; he took on assistants, including Berenice Abbott, later to become an important photographer in her own right; he befriended the veteran documentarist of Parisian streets, Eugene Atget.[39] Within a couple of years, Breton would be lauding this American newcomer as a leading proponent of surrealism in the arts, the peer of Ernst, de Chirico and Duchamp.

30 NOVEMBER

MUNICH
Hitler addressed a crowd of 50,000 National Socialists.

who pioneered an idiosyncratic style with these works, and who influenced many of those who came later – including Moholy-Nagy, who claimed for many years that he too had come up with the method in 1922, but later confessed how deeply the example of Man Ray had told in his own work.
39. All of Man Ray's assistants of the 1920s went on to have major careers: Jacques-André Boiffard, Bill Brandt and Lee Miller.

DECEMBER

1 DECEMBER

DUBLIN

Yeats wrote to the artist Edmund Dulac (whose designs for Yeats's most recent collection of poems had so delighted him) to report that he had been made a senator.

> I am on the Irish Senate and a probable income as senator, of which I knew nothing when I accepted, will compensate me somewhat for the chance of being burned or bombed. We are a fairly distinguished body, much more so than the lower house, and should get much government into our hands . . .

He also told Dulac that his mornings were given over to working on his 'philosophy' – that is, on the early drafts of *A Vision*.[1] His finale is glum: 'How long our war is to last nobody knows. Some expect it to end this Xmas and some equally well informed expect another three years . . .'

NEW MEXICO

The Lawrences left Taos and were driven in a beat-up old Ford to the Del Monte cabin by a new friend, a young Danish painter, Kai Gotzsche. As they expected, conditions in the Del Monte house were fairly comfortless, especially to start with, but they soon came to enjoy their life in this still more remote part of New Mexico. They would not be wholly isolated throughout the winter months: Gotzsche had agreed to rent a three-room cabin next door to the Lawrences with his friend Knud Merrild, also a Dane, also a painter; Merrild would remain a good friend of Frieda for the rest of her life.[2]

1. It would eventually be published by Werner Laurie in 1925 in an edition of 600 signed copies.
2. In 1938, he wrote an affectionate memoir of this time.

The three men set to making the place more habitable – chasing away rats, chopping wood, hauling water. They filled the cellars with apples, and bought delicious creamy milk, fresh from local cows. The quartet often ate their evening meals together, and enjoyed late-night singing. Lawrence's health was unusually good, and he was happy to have escaped from Mabel's overwhelming presence, especially as they had managed to make the break without an obvious angry quarrel.

Almost by accident, the couple had finally achieved a way of life that meshed with Lawrence's ideal of harmonious, semi-communal retreat.[3] When not busy with carpentry, plastering and other household chores, Lawrence completed his manuscript of *Studies in Classic American Literature*, signing off with the address: LOBO, NEW MEXICO.[4]

LONDON

Eliot's letter to the publisher of *The Criterion*, Cobden-Sanderson included a reference to a short story by Pirandello, a translation of which

3. It was how they had once hoped to live with Katherine Mansfield and John Middleton Murry, in 1916.

4. They were soon to have guests, too. Lawrence invited his American agent Robert Mountsier to come and stay, and told him that he could pay his train fare to New Mexico from his accumulated royalties. He also invited his loyal and enthusiastic American publishers, Thomas and Adele Seltzer. Mountsier and the Seltzers both came at the end of the month, though fortunately (Mountsier was vehemently anti-Semitic, and the Seltzers were Jewish) they only overlapped by a day.

The Seltzers' stay was idyllic, in a nostalgic, European style. Lawrence and Frieda built vast pine-log fires, cooked Christmas puddings and mince pies, baked bread, roasted chickens, sang Christmas carols and played with their new puppy, Bibbles, a gift from Mabel. They took the Seltzers on tours to the local hot springs at Manby, and to the Taos Pueblo, and to visit the writer Witter Bynner in Santa Fe. Thomas and Lawrence entered into an orgy of shop talk, including a discussion of *Ulysses*, a copy of which Seltzer had sent to Lawrence a few weeks earlier. Lawrence found it 'tiresome'.

The Seltzers loved every minute of the stay, but they were not so beguiled by this old-school hospitality as to soften their words when it came to Mountsier. Lawrence should drop him, Thomas insisted: he knew quite well that the Seltzers would publish him handsomely and fairly; Lawrence had no need for an agent, let alone one who, unlike the Seltzers, was not utterly convinced of his genius. This last point stung. Mountsier had disapproved of both *Aaron's Rod* and *Kangaroo*.

Their arguments were potent. When Mountsier arrived at the end of the month, to stay for no less than four uncomfortable weeks, Lawrence found it impossible to feel kindly disposed towards him. Eventually, in February 1923, he sacked him. From now on, his American business would also be handled by his English representatives, the Curtis Brown agency. He experienced no deep sense of liberation, though; the whole business had left him feeling churlish, and impatient with all modern Americans. 'I tell you what, there is no life of the blood here. The blood can't flow properly.' He began to yearn for a society and a landscape even closer to the Dark Gods, and started to lay plans for a journey to Mexico.

had been submitted to their quarterly; Eliot said that he thought it 'quite good', and 'The Shrine' duly appeared in the January 1923 issue.[5]

A few days later, Eliot had lunch with Yeats in the Savile Club. 'I enjoyed seeing him immensely; I had not seen him for six or seven years and this was really the first time that I have ever talked to him for any length of time alone. He is really one of a very small number of people with whom one can talk profitably about poetry,' he wrote to Ottoline Morrell.

PARIS

Issue number 7 of *Littérature* published Picabia's illustration of Duchamp's play on words, '*Lits et Ratures*' – 'Beds and Erasers'. It is a risqué image, showing a pair of large men's shoes pointing downwards, and a pair of women's shoes pointing upwards, flanking them. On the soles of the men's shoes are drawings of a woman and a man. It would take a very innocent mind to miss the erotic meaning.

POLAND

Josef Pilsudski resigned as Polish state chief marshal.

3 DECEMBER

LAUSANNE

Hemingway went to the railway station to meet his wife Hadley, who had come to join him from their flat in Paris. He was startled and dismayed to find her sobbing so violently that she could not tell him what awful thing had just happened. According to his version of events in *A Moveable Feast*, Hemingway tried to reassure her that whatever it was, it could not possibly warrant such agonies, and that everything was going to be all right.

Hadley calmed down enough to tell him her story. When she had been packing for her trip, it struck her that Hemingway might like to show his work to his journalist colleague Lincoln Steffens, who was also in

5. It had been a good year for Pirandello – one of his most famous works, *Enrico IV*, had been staged with great success in Milan, and had consolidated the fame, or notoriety, he had won the previous year with the scandalous first run of *Six Characters in Search of an Author*. Over the next two years, Pirandello became a well-known public figure throughout Europe.

Lausanne. So she hastily gathered his papers and crammed them into a small valise before setting off for the Gare de Lyon. At the station she handed the valise over to a porter; but when she got into her compartment, the valise was missing. With the help of the conductor, she searched the rest of the train and found nothing. The case had obviously been stolen.

Worse still, the papers she had pulled together included not only the sole draft of Hemingway's first novel, but most of his other manuscripts from the past year, including the carbon copies. According to Hemingway,[6] he immediately took a train to Paris and hunted through the apartment to confirm that almost all his writings had gone. He also hints that he went off on some kind of furious binge to cope with his rage at Hadley. On the advice of Steffens, Bill Bird and other friends, he considered taking out advertisements offering a reward for the return of the valise, but nothing came of this.[7]

USA

Near the start of December, the novelist Willa Cather, whose latest book *One of Ours* had been published in September,[8] travelled from Vermont to her home town of Red Cloud, Nebraska, where she had been born in 1873 (though she liked to lop three years off her age, and to say that her birth year was 1876). Already famous, she had been teaching at Bread Loaf School at Middlebury College. One of her reasons for returning home this month was that she and her parents were about to be received into the Episcopalian church by the local bishop, Dr George Beecher. She had been raised as a Baptist.

6. His biographers have disputed the account, and shown that he did not return from Lausanne until well after Christmas.

7. Some readers of *A Moveable Feast* have felt that the story of the lost manuscripts is too bad to be true; but for all that Hemingway dressed up the story later in life, there is no reason to doubt the reality of the central event, which he complained about at great length to his friends. When he wrote to Pound about the loss of this 'Juvenilia' on 23 January 1923, he acknowledged that the poet would no doubt think that it was a salutary purgation, but begged him not to rub it in. In three years' time he might be able to look back calmly on this catastrophe. At the moment, he was badly stung, especially by the loss of a work he referred to as 'Paris 1922'. Hemingway was a good judge of Pound's character. Pound wrote back to tell him that he should regard the incident as 'an act of Gawd'; no one, he insisted, had ever lost much of value by the suppression of immature work.

8. Though grudgingly reviewed by Edmund Wilson, the novel was awarded the Pulitzer Prize in 1923.

LONDON

Throughout December, Virginia Woolf was preoccupied with a series of negotiations with Hutchinson about the future of the Hogarth Press; it distracted her seriously – 'This autumn has been perhaps the busiest of my dilatory life,' she wrote in her diary for 3 December – but she kept up other contacts despite the effort.[9] On the 4th, Eliot wrote to her describing the *Liverpool Post* affair (see 18 November) in some detail, and also explaining about the 'Wellwisher' insult;[10] he thought that he had managed to trace the slander to a tea party in the Bosschere household.[11] He also discussed *Jacob's Room*, only part of which he had so far managed to read. He declared himself impressed.[12]

LONDON

Since Forster's publishers had been intolerably slow in bringing out *Alexandria*, and had ignored the sequence of 'stingers' he had fired at them, he took it into his head that the Hogarth Press might be a suitable home for his second book of Alexandrian essays, based on his wartime journalism for the *Egyptian Mail* and other papers. Both Virginia and Leonard were keen on the idea, and *Pharos and Pharillon* eventually appeared in 1923.[13]

9. It was at this time that Woolf first met Aldous Huxley: 'Aldous very long, rather puffy, fat faced, white, with very thick hair, & canary coloured socks, is the raconteur; the young man of letters who has seen life.' On 15 December she wrote that she had just encountered her future lover Vita – 'the lovely gifted aristocratic Sackville West' – and Harold Nicolson at a dinner hosted by Clive Bell. Four days after this entry, she dined with Vita, but there were no immediate romantic overtures, and the affair was slow to develop. She was also concerned with the *amours* of others in their set. On 22 December she wrote to Vanessa Bell, expressing alarm at the rumours that Maynard Keynes had fallen for Lydia Lopokova. 'Seriously, I think you ought to prevent Maynard before it is too late.'

A few days later, she wrote that 'The human soul, it seems to me, orients itself afresh every now and then. It is doing so now . . .' She continued: 'No one can see it whole, therefore. The best of us catch a glimpse of a nose, a shoulder, something turning away, always in movement. Still, it seems better to catch this glimpse, than to sit down with Hugh Walpole, Wells, etc. etc. and make large oil paintings of fabulous fleshy monsters complete from top to toe . . .'

10. Eliot had been sent a letter signed 'Your Wellwisher', which had included four three-halfpenny stamps; this satirical gesture pained him deeply. The anonymous 'Wellwisher' had obviously heard about Pound's 'Bel Esprit' project, designed to ease Eliot's financial problems and help him escape from his exhausting job at Lloyd's Bank.

11. Jean de Bosschere (1893–1954) was a Belgian engraver, poet and novelist.

12. The Hogarth Press was to be the first publisher of *The Waste Land* in book form, in 1923. Eliot was very pleased with the results, and blamed the typos on his own terrible proof-reading. Two decades later, in May 1941, he would write Woolf's obituary.

13. Though less often read than most of Forster's other books, it has the distinction of making the

The book carried a dedication in Greek, which, translated, read: 'To Hermes, Psychopomp' – a salute, it is usually assumed, to Forster's lover Mohammed, who had recently died.

Alexandria: a History and a Guide, Forster's only book of 1922, was finally published in December.[14]

6 DECEMBER

NEW YORK

Gilbert Seldes published a long, admiring and influential essay, 'T. S. Eliot', in *The Nation*. Much of the first part of the essay was concerned with introducing and explaining Eliot's strengths as a critic, and informing the reader that, among an elite audience, Eliot's reputation was already vastly greater than his fairly slender output might have suggested. Seldes then turned to 'The Waste Land', dwelling chiefly on the poem's roots in myths of fertility and infertility, and proposing that, while it at no point sentimentalised the lost past of Europe, it everywhere insinuated that 'even in the cruelty and madness which have left their record in history and in art, there was an intensity of life, a germination and fruitfulness, which are now gone'.

He concluded by drawing attention to the affinities of *Ulysses* and 'The Waste Land':

English-speaking world aware for the first time of the great poet Cavafy, whom Forster had come to know quite well in his Alexandrian days. Eliot soon published Cavafy in *The Criterion*.

14. Not long afterwards, it suffered a fate part tragic, part farcical. Forster was sent a letter explaining that a freak fire in the warehouse had destroyed all the copies of the book that had not been sent out to shops; a generous cheque was enclosed, funded by the publisher's insurance policy. A few weeks later he received a second letter: to their surprise, the publisher discovered that these books had not after all been destroyed, since they had been stored in a fireproof cellar. This was an awkward situation, which they resolved according to a curious logic. Rather than refund the insurance claim, they had gone ahead and burned the copies themselves. There was not to be another edition until 1938.

Meanwhile, Forster continued to labour at his last and most highly regarded novel. *A Passage to India* was published in 1924. Its final pages were profoundly affected by his enthusiasm for T. E. Lawrence's *Seven Pillars of Wisdom*, which astonished him with his combination of introspection and broadness of vision. He had been loaned a copy of the book by Siegfried Sassoon; he told Sassoon that it had moved him almost to tears, and he begged for an introduction to Lawrence. (They had in fact briefly encountered each other on 22 February 1921 at a lunch for Prince Feisal in Berkeley Square.) They met in March 1924, and, despite some awkward moments, became good friends.

It will be interesting for those who have knowledge of another great work of our time, Mr Joyce's 'Ulysses', to think of the two together. That 'The Waste Land' is, in a sense, the inversion and the complement of 'Ulysses' is at least tenable. We have in 'Ulysses' the poet defeated, turning outward, savoring the ugliness which is no longer transmutable into beauty, and, in the end, homeless. We have in 'The Waste Land' some indication of the inner life of such a poet. The contrast between the forms of these two works is not expressed in the recognition that one is among the longest and one among the shortest of works in its genre; the important thing is that in each the theme, once it is comprehended, is seen to have dictated the form. More important still, I fancy, is that each has established something of supreme relevance to our present life in the everlasting terms of art.

Eliot wrote an appreciative reply to Seldes on the 27th: see below.

IRELAND
The Irish Free State came into being. Tim Healy was appointed the country's first governor general; W. T. Cosgrove became President of the Executive Council. In London, the UK Parliament had just passed the Irish Free State Constitution Act, legally sanctioning the creation of an independent Irish nation. The civil war, however, continued.

BIRMINGHAM
The City of Birmingham Choir gave the premiere performance of Ralph Vaughan Williams's Mass in G Minor, which the composer had completed the previous year. It was the first Mass written in the English manner since the sixteenth century.

USA
The American magazine *Outlook* published an article by Ellen Welles Page, entitled 'A Flapper's Appeal to Parents'. It began:

If one judges by appearances, I suppose I am a flapper. I am within the age limit. I wear bobbed hair, the badge of flapperhood. (And, oh, what a comfort it is!) I powder my nose. I wear fringed skirts, and bright-coloured sweaters, and scarfs, and waists with Peter

Pan collars, and low-heeled 'finale hopper' shoes. I adore to dance.
I spend a large amount of time in automobiles . . .

The over-starched grammar gives the game away: what might have been
an amusing commentary on fashions soon turns into a sickly plea for par-
ents and children to be each other's best friends.

9 DECEMBER

POLAND

Marshal Pilsudski officially transferred his powers to Gabriel Narutowicz,
who became the new Polish president. He was to serve for barely a week.

Narutowicz was assassinated on 16 December – a date that still re-
mains notorious in Polish history. The Polish parliament chose Stanislaw
Wojciechowski as his successor.

11 DECEMBER

DUBLIN

The first meeting of the Irish Senate.

LONDON

The last day of the murder trial of Frederick Bywaters and Edith Thomp-
son at the Old Bailey – a trial that had captured the morbid imagination
of the whole country, if not the world, and was reported in a highly sensa-
tional manner. Both defendants were found guilty and sentenced to death.

One of the aspects of the case that fascinated contemporaries was
that it seemed quite possible that Thompson was guilty of nothing worse
than cheating on her husband and having an overactive imagination.
Edith (b. 1893) was several years into a boring marriage to Percy Thompson
when she began an affair with Bywaters, a merchant seaman almost a de-
cade younger than her. She wrote her lover many lurid and melodramatic
letters, in some of which she talked of yearning for her husband's death,
and boasted that she had sometimes tried to poison his food (though no
evidence of this was ever found).

On 3 October, Mr and Mrs Thompson were returning from a night at the theatre when a man jumped out from a bush and attacked them. Edith was heard by neighbours to scream, 'No, no, don't!' and was hit savagely, falling to the ground. Percy was both punched and stabbed, and died soon after of his wounds. The assailant – now known to be Bywaters – ran away but was caught by the police. He offered no resistance, and willingly showed the police where he had hidden the bloody knife. He denied that he had set out with intent to kill, saying that the confrontation with Percy had become more violent than he had expected. He also insisted that Edith had had no idea about his intentions; but when the police read the love letters in his possession, she was arrested too.

The trial began on 6 December, and was the subject of a media feast. It did not hurt newspaper sales that Edith was young, middle class, spirited and pretty. For a while, it seemed as if things were going her way, especially as Bywaters confirmed repeatedly that she had played no part in his attack. Her lawyers told her to keep as silent as possible so as to make things difficult for the prosecution, but she obviously enjoyed the limelight so much that she could not resist putting on a show, flirting with the jury, contradicting herself, striking poses. Later, her lawyers said that she had condemned herself through 'vanity and arrogance'.

When the death sentence was passed, Edith went into screaming hysterics, and Frederick shouted her innocence one last time. Now that the trial was over, there was a massive swing in public opinion in favour of the couple. Bywaters's loyalty was seen as gallant; and the idea of hanging a (young, pretty, middle-class) woman abhorrent. The last time a British woman had been sent to the gallows was in 1907. More than a million people signed a petition asking the Home Secretary for clemency.

Edith's execution, on 9 January 1923, was unusually nasty. Though heavily sedated, she continued to struggle and scream; and when she dropped, she had a massive vaginal haemorrhage – almost certainly a miscarried foetus. Her hangman, John Ellis, was haunted by this day and eventually committed suicide. The case passed into popular culture, and has been treated either directly or obliquely in many films (including Hitchcock's *Stage Fright*), books and plays.[15]

15. Both Joyce and Eliot shared the general sense of fascination with the case. For Joyce, the death sentence was appalling, and he talked about it at great length with his friend Arthur Power: 'What a

12 DECEMBER

HARLEM

Jean Toomer – still little known at this time, but within a matter of months to become one of the stars of that sudden, rapturous explosion of African-American poetry, fiction, painting, music and other arts, the Harlem Renaissance – wrote to his white friend Waldo Frank, announcing the completion of his debut novel: 'My brother! CANE is on its way to you! For two weeks I have worked steadily at it. The book is done.'

Widely acclaimed as a masterpiece on its publication the following year, *Cane* is still regarded as one of the finest products of the Renaissance. But Toomer would go on to disappoint his more militant and political colleagues; like many other writers and intellectuals, he was seduced by the charisma of G. I. Gurdjieff, and came back from a trip to Europe interested only in preaching Gurdjieff's philosophy of the Fourth Way.[16]

14 DECEMBER

LONDON

John Reith, a tall, ascetic 33- year-old former engineer, son of a minister in the Free Church of Scotland and himself a devout Christian, accepted the BBC's offer to become their general manager, despite being unsure

terrible thing the law can be sometimes . . . there should be some tempering of the law to suit the difference between a brutal murder, and the act, for instance, of a woman killing her child in desperation, and then trying to kill herself – a double crime in the eyes of the law . . .' In France, Joyce believed, a woman in Mrs Thompson's circumstances would never have been executed. Joyce scholars have identified no fewer than 45 allusions to the case in *Finnegans Wake*.

Eliot took quite a different view on the matter. On 8 January 1923, he wrote to the editor of the *Daily Mail*, congratulating him on the paper's stern line on the 'crusade of the sentimentalists' – the million people who had written to the Home Office asking for the death penalty on the 'Ilford Murderers' to be quashed. Eliot applauded the *Mail*'s refusal to fall in with the 'flaccid sentimentality'. In the same letter, he commended the paper's coverage of *fascismo*, and its portrait of Mussolini as Italy's saviour from Bolshevism. It has been suggested that Eliot's poem 'Triumphal March' was in part inspired by the *Mail*'s coverage of the March on Rome.

16. Briefly put, the Fourth Way was Gurdjieff's synthesis of the three esoteric traditions of self-transcendence: control of body (the way of the fakir), control of the mind (the way of the monk), control of the emotions (the way of the yogi). Gurdjieff claimed that his system took the best of all three other ways and then perfected them into a Fourth. The term 'Fourth Way' is still widely used by followers of Gurdjieff and Ouspensky.

quite what the job involved, or indeed – as he noted in his first book, two years later – what 'broadcasting' meant. He took up his post on 29 December, writing in his diary, 'I am trying to keep in close touch with Christ in all I do and I pray he may keep close to me. I have a great work to do.'

Reith was the single most important figure in the development of the BBC. He was managing director, then director general until his retirement in June 1938,[17] and it was his vision of the BBC's role that made it a dominant force in British culture. His own formulation in *Broadcast Over Britain* is probably the best summary:

> As we conceived it, our responsibility was to carry into the greatest possible number of homes everything that is best in every department of human knowledge, endeavour and achievement, and to avoid the things which are, or may be, hurtful. It is occasionally indicated to us that we are apparently setting out to give the public what we think they need – and not what they want, but few know what they want, and very few what they need.

This unashamedly paternal approach to the masses may sound rather chilly, and Reith himself could be an unattractive, authoritarian man (he remained fond of Mussolini for many years, and admired Hitler well into the 1930s), yet the practical outcome of this combined high-handedness and high-mindedness was largely for the good, and far more democratic than it sounds.[18]

17. He went on to be chairman of Imperial Airways.

18. Almost everyone could afford a radio, or at least find access to one, as the figures for licensing suggest. In 1923, during the BBC's first full year of operation, 80,000 licences were issued; in 1924, a million; and by 1939, nine million. But these figures do not represent the genuine size of the listenership. Informed estimates suggest that for every licensed wireless receiver, there were five sets in use. After 1928, the audience for BBC programmes seldom fell short of a million, and could be as high as 15 million. By 1935, some 98 per cent of the population had regular access to transmissions. The nation became united over the air in a way it had never been before.

All but the very poorest and most disenfranchised could tune in, and for many listeners it provided a rich and varied source not only of entertainment and news, but of many of the pleasures that had been denied to them by poor or minimal education. Nor was the benefit all one-way: many of the writers and artists in this book found rewarding new outlets and audiences through Reith's BBC. Eliot began to broadcast frequently from 1929 onwards, beginning with literary digressions on such subjects as Elizabethan prose and seventeenth-century poetry from Donne to Milton, and later addressing questions of Christian doctrine and ethical values. (*The Waste Land* was not broadcast in full on the BBC until 1937. It proved gratifyingly successful, and provoked many listeners to send in fan mail.)

KYOTO
Einstein delivered a public speech, widely reported around the world, explaining the route by which he had arrived at the Theory of Relativity.

15 DECEMBER

NEW YORK
The first publication of *The Waste Land* in book form.

MOSCOW
Lenin suffered his second massive stroke. From now until his death, he was an invalid; worse, he was in effect Stalin's prisoner. Pretending great anxiety over his comrade's welfare, Stalin declared that Lenin needed rest and seclusion, and he gained an order from the Central Committee allowing him severely to restrict the number of people who might visit Lenin, and the number of letters he might be allowed to read. Stuck in a wheelchair, Lenin was only allowed to dictate for 5 to 10 minutes a day. His two main secretaries – Nadezhda Allilulyeva (aka Mrs Stalin) and Lydia Fotieva – reported everything he said directly back to Stalin, though Lenin seems not to have realised what was going on. Meanwhile, Stalin began to take pleasure in reading medical books, and predicting Lenin's imminent death; he became more and more openly contemptuous of Lenin, and at one point told his colleagues, with premature relish, 'Lenin kaput.'

17 DECEMBER

LONDON
Count Harry Kessler, having docked at Harwich, made his way to the capital. Because of the war, he had not been able to visit London since

By 1926, Reith felt confident enough in his achievements to write: 'We believe that a new national asset has been created . . . the asset referred to is of a moral and not the material order – that which, down the centuries, brings the compound interest of happier homes, broad culture and true citizenship.' Pompous, to be sure; but closer to the truth than Reith's critics were willing to allow.

1914. His previous visit had been in the company of Rodin, just a week before the start of hostilities; he remembered how, crossing the Channel, he had asked Rodin whether he would like something to eat, and the sculptor had replied, '*Non, je n'ai pas faim. Je regarde la nature. La nature me nourrit.*' 'I recalled all of it as the train carried me through the sooty, mean London suburbs,' wrote Kessler. 'In the late afternoon, I walked along the Embankment towards Westminster. The sun shone on wet streets and heavy clouds scudded low across the sky. The whole city was bathed in a violet and golden light that turned the Thames to glowing copper.'

The following day, he went shopping.

> Not much change in the shops. They are as good class and as elegant as they used to be. But there is no longer the astounding amount of bustle and luxury as in 1914 and which is still to be met in Paris. It can be sensed that the country has become poorer and the shoppers rarer . . .

And in the evening, to the theatre, to see a musical comedy, *The Lady of the Rose*: 'To my astonishment, at least half of the men in the stalls were in lounge suits, the rest in dinner jackets, and only five or six in tails. A real revolution or, more accurately, the symptom of such.'

IRISH FREE STATE
The last British regiments quit Ireland.

18 DECEMBER

KIERLING, LOWER AUSTRIA
Kafka made the penultimate entry in his diary.[19] It was his first jotting for more than a month. He had evidently been reading Kierkegaard: 'All this time in bed. Yesterday *Either/Or.*'

19. The final entry was to be made some six months later, on 12 June 1923. Kafka died a year after writing those words, on 3 June 1924. His remains were buried in the Jewish cemetery in Prague-Straschnitz.

DUBLIN

Yeats wrote to Olivia Shakespear: 'On Wednesday next I get a D.Litt from Trinity College, and feel that I have become a personage.' In two postscripts, added on the 19th and 20th, he reported on executions and the burning of Senator Campbell's house. Mrs Campbell had begged the irregulars not to turn her children out into the streets at night; it seems that the irregulars were reduced to tears by this appeal, but said that they could not disobey their orders. But one of them helped Mrs Campbell to rescue the children's Christmas toys from the flames.

> Strange tragedy of thought that creates for men such crimes but I don't suppose that these men were mere conscripted rebels. Democracy is dead and force claims its ancient right, and these men, having force, believe that they have [the] right to rule. With democracy has died too the old political generalizations. Men do not know what is, or is not, legitimate war.

ITALY

Fascist forces began a three-day killing spree in Turin, a city with strong radical conditions, now identified by Mussolini's regime as a potential base for resistance to the new order. Communists, socialists and trades union men were beaten and shot dead.

19 DECEMBER

USA

The Dial published Eliot's remarkable essay on the death of Marie Lloyd. (See 7 October.) It was a curious mixture of personal confession – contemplating her death had, he suggested, depressed him to the point where all literary matters seemed quite insignificant – aesthetic argument and apocalyptic foreboding. Asking himself why Marie Lloyd was the last great exponent of her art, he concluded, first, that her cockney audiences recognised that she was reflecting their lives with a precision that could only be born of intimacy, and, second, that the basis of her act was collaborative. Marie's audience was not a passive recipient of her talent, but an active participant in creating her act's meaning – to take a simple example, by seeing the bawdy sense of her superficially innocent banter.

Eliot went on to reflect how a bond of this kind was essential to all the arts, and especially the dramatic arts. He contrasted the vitality of Marie Lloyd's work with the drugged and supine quality of audiences for the cinema and other modern entertainments; he also flayed the middle classes as spiritually dead, quite incapable of producing a representative artist of such shamanic potency as Marie had exercised over the lower classes. At this point he cited W. H. R. Rivers:[20]

> In a most interesting essay in the recent volume of Essays on the Depopulation of Melanesia the great psychologist W. H. R. Rivers adduces evidence which has led him to believe that the natives of that unfortunate archipelago are dying out principally for the reason that the 'Civilization' forced upon them has deprived them of all interest in life. They are dying from pure boredom.

He concluded by waxing prophetic, imagining a future society of nightmarish imaginative parasitism, in which advanced technology supplies all possible comforts and diversions, all experience comes at one remove, and children even listen to their bedtime stories by means of earphones. (How many readers of *The Dial* could have seen this as anything more than morbid scare-mongering?) He ended on a note of defeat, as if the grimness of his speculations had reduced him to silence.

USA

In the same issue of *The Dial*, Edmund Wilson published his first major piece on Eliot, 'The Poetry of Drouth'. He began by recapitulating the key elements of Eliot's career in letters, and stressed how remarkable it was that a very small body of work had created such a disproportionately vast effect, and made Eliot such a commanding figure among those in the know. Though he saw Eliot's 'limitations', Wilson said, he also recognised *The Waste Land* as a great advance on his earlier verse: 'it sounds for the

20. Eliot maintained a keen interest in Rivers over the next few years, and the 'great psychologist' was one of the main influences on *Sweeney Agonistes*. As Rivers's late writings began to appear posthumously, Eliot kept careful watch. He asked Wyndham Lewis to review *Medicine, Magic and Religion* for *The Criterion* of January 1925, and alluded to Rivers again in his essay 'Charleston, Hey! Hey!' (*Nation and Athenaeum*, 29 January 1927), where he says of John Rodker that he is 'up-to-the-minute, if anyone is; we feel sure that he knows all about hormones, W. H. R. Rivers and the Mongol in our midst'. In the same year, he invited Robert Graves to review *Psychology and Ethnology* for *The Criterion*. Rivers was now a permanent part of English literature as well as British science.

first time in all their intensity, untempered by irony or disguise, the hunger for beauty and the anguish at living which lie at the bottom of all his work'.

Wilson spends a good part of his essay elucidating the importance of the 'Fisher King' myth to the substance and intent of the poem: Eliot, he says, uses the ancient myths investigated by Jessie L. Weston in *From Ritual to Romance* as 'the concrete images of a spiritual drouth'. And he goes on to anticipate all the objections that have been made, and will no doubt continue to be made, against Eliot's poem, starting with the accusation that it is nothing more than a collection of scraps, of no more interest than a ship in a bottle.[21]

Wilson acknowledges that most of these complaints, and others, have at least some foundation in reality – for instance, that Eliot's verses can seem the product of a constricted emotional experience, and that there is a quality in some of his work that can be seen as 'peevish superiority'. But, he responds: 'Mr Eliot is a poet – that is, he feels intensely and with distinction and speaks naturally in beautiful verse – so that, no matter within what walls he lives, he belongs to the divine company . . .' He concludes:

> . . . the race of the poets – though grown rarer – is not yet quite dead; there is at least one who, as Mr Pound says, has brought a new personal rhythm into the language, and who has lent even to the words of his great predecessors a new music and a new meaning.

IRISH FREE STATE

The National Army carried out the executions at the Curragh Camp of seven Republican guerillas, part of a team that had been sabotaging the local railways. The executions created a great deal of resentment and anger in the district.

21. There is an unexpected reference to Eugene O'Neill: Wilson reports that at least one critic has said of Eliot that if only he looked more closely at his Sweeney figure, he would find 'O'Neill's Hairy Ape'.

20 DECEMBER

GERMANY

Thomas Mann attended a spiritualist seance. It was not his first experience of a medium – according to his family, he had at one time been in the habit of sneaking off to seances about twice a week – but it was an occasion that made a very powerful impression on him.

This is a little surprising, since to judge by the accounts he later wrote of this night (and two others in January 1923), the whole occasion reeked of stagecraft. The seance was convened by a Dr Albert Freiherr von Schrenk-Notzing, an expert in sexual pathology and nervous conditions;[22] present at the event were a zoologist, a well-known actor, a Polish painter and several others. The medium was a teenage boy, 'Willi', who had been dressed up in long dark robes with luminous tapes on it so that people could follow his movements when the lights went down. A woman held Willi's wrists, while Mann was asked to clamp the boy's knees between his own. The idea was that Willi would reply 'yes' or 'no' to questions by moving – he would squeeze Mann's hand for a positive, or bend his body sideways for a negative. The zoologist played throughout on a sort of mouth organ; and there were a series of props – a handbell, a typewriter, a slate with chalk, an electric bell.

The first half of the session was not very impressive. During the second half, for which Mann had given over his job as knee-squeezer to another seeker, things took off. He experienced an unpleasant sensation throughout his body, akin to seasickness. A handkerchief, dropped on the floor, jumped up three times and then hurled itself down on the table. The electric bell rang. The handbell was picked up and rung. Invisible fingers ran across the typewriter, spelling out two lines of gibberish. For some reason – possibly the seasickness – Mann was convinced that no trickery was involved in these phenomena.[23]

22. His occult text *Materialisations-Phänomene* had been widely ridiculed on its first appearance before the war, but was taken much more seriously on its post-war republication.
23. In fact, he was so stirred by the experience that he wrote an article, 'Okkulte Erlebnisse' ('Occult Experiences'), for the *Neue Rundschau*. He also used many of the details from the seance in his long novel-in-progress, *The Magic Mountain* (in the antepenultimate section of the seventh and last chapter). He gives the protagonist, Hans, the seasickness he himself had felt, and uses such details as the non-stop music, the leaping handkerchief and so on. He also makes Hans flee the event in terror – a move corresponding to his own departure from the third seance, and his decision never to

PARIS

Cocteau's *Antigone* opened in Montmartre, at Charles Dullin's Théâtre de l'Atelier, along with Pirandello's *La Volupté de l'Honneur* (*Il Piacere dell'Onestà*). A stripped-down version of Sophocles' tragedy, *Antigone* called on some of the leading talents of the age: incidental music by Arthur Honegger, decor by Picasso, and costumes by Chanel.

> To costume my princesses, I wanted Mlle Chanel, because she is our leading dressmaker and I cannot imagine Oedipus's daughters patronizing a 'little' dressmaker. I chose some heavy Scotch woolens, and Mlle Chanel's designs were so masterly, so instinctively right, that an article in the *Correspondent* praised them for being historically accurate . . .

Dullin played the part of Creon, while Antigone was played by a young Greek dancer, Genica Atanasiou, who spoke little French and had to be taught her part syllable by syllable. In the early part of the run, Cocteau himself provided the voice of the Chorus.

The run-up to the first night was tense and at times chaotic, so much so that when Picasso was finally summoned to execute the sets, he found a mainly bare stage on which almost nothing was ready save for some masks that Cocteau had made, hung high on either side of a hole in a blue backdrop with a white wooden panel beneath them. Cocteau issued him a simple instruction: use this set to bring to mind a hot, sunny day.

Many another artist would have made an indignant retreat at this point; instead, Picasso pulled off one of his trademark 'miracles', as people had begun to call his moments of lightning improvisation. He walked back and forth on the stage for a while, pondering his options, then picked up a stick of sanguine, with which he began to rub the rough white boards, giving them the look of marble. Next he picked up a brush and a bottle of ink, and drew some swift dramatic lines. Finally he blackened a few spaces here and there. As if by supernatural intervention, three Greek columns were suddenly visible. It was such an astonishing coup that everyone present stood up and applauded him.

dabble in spiritualism again. After his mother died, on 11 March 1923, he made no attempt to reach her soul via a medium.

Applause continued to fill the theatre once the show opened: *Antigone* was an immediate hit.[24] It ended up running for about 100 nights, and, as Dullin recalled, 'Many society people came to the performances because of Chanel, Picasso and Cocteau. Sophocles was only a pretext, and Pirandello a mere curtain-raiser.' This run also saw the beginnings of Cocteau's long reign as a cult figure, adored by the rising generation: 'Young men were so smitten by Cocteau's work and were so under his spell, that they found it quite natural to attend *Antigone* as a claque, in the same spirit in which they would have gone to Mass . . . One heard tales of some of them scaling the lamp-posts in the rue de l'Anjou to see Cocteau leave his house.'[25]

21 DECEMBER

PARIS

Joyce wrote to his aunt, Mrs William Murry, in Dublin, asking her if she might be willing, if he sent her an exercise book, to jot down notes on anything she could remember about some of the 'curious types' he had known as a child. This was one of the earliest stages in his preparation for writing *Finnegans Wake*.[26] For Christmas he had sent Harriet Shaw Weaver a copy of Sir Edward O'Sullivan's facsimile edition of *The Book of Kells* – not only one of the books often cited in the *Wake*, but (in his eyes at least) one of its precursors.

24. Ezra Pound praised the show in his 'Paris Letter' for *The Dial*.

25. As one might have expected, the Surrealists did not miss the opportunity to create trouble for Cocteau. On the third night, shortly after the curtain rose, one of the actors delivered the line 'He [Creon] attaches the greatest importance to the execution of his orders.' A voice – instantly recognisable to those in the know as that of André Breton – shouted from the audience: 'He's wrong!' As Cocteau put it, in later years: 'It was the voice of one of our fellow fighters, and I shouted back at him through the opening that we wouldn't proceed with the performance until the interruption ended and the troublemakers were removed. They were escorted out and the play continued. This is the sort of thing that happened in those days: everything was done *en famille*.'

26. Joyce finally picked up his pen and started the *Wake* on 11 March 1923. It would occupy him for the next 16 years.

23 DECEMBER

LONDON
The BBC began regular daily broadcasts of a news programme. The following day, Christmas Eve, it broadcast Britain's first-ever radio drama, *The Truth about Father Christmas*.

MOSCOW
Vladimir Lenin, gravely ill and, in effect, under house arrest by Stalin (see 15 December), began to dictate the series of notes that eventually became famous as 'the 1922 document': his political last will and testament. Originally planned as notes for his appearance at the next party congress, where he intended to challenge Stalin's dangerously growing power and demand his removal from office, they were meant to be kept top secret until then. Some were dictated to a stenographer who sat in the next room, listening to Lenin's voice on a telephone link.[27]

Despite the occasional incoherence of these notes, three main themes emerged clearly enough, and all three came back to the threat posed by Stalin: the fate of Georgia (Lenin was agonised at the likelihood that Stalin would treat his native region in the spirit of an old-style Russian bully and tyrant); the ominously waxing power of bodies such as the Politburo and the Central Control Commission, which were now under Stalin's control; and the burning question of who should succeed Lenin after his death.

Lenin reviewed the qualities of the main figures in the leadership contest, and found them all wanting in some key way. He had come to favour the idea of a collective leadership, which might contain the vices of any one leader. Bukharin? He was 'the favourite of the whole Party', but his theoretical views 'can only be described as Marxist with reserve'; though he was the most intellectually powerful of the younger men, his mind was still essentially 'scholastic', and he had never properly embraced dialectical materialism. Trotsky? He 'was personally perhaps the most capable man in the present Central Committee, but he has displayed excessive self-assurance and shown excessive preoccupation with the purely

27. It has often been observed that these notes betray extreme distress – even a mind at the end of its tether: repetitive, rambling and at times frenzied. Lenin was in a state of near-suicidal despair: he even asked, as he had at the time of his first stroke, to be given poison so that he could kill himself, but Stalin refused to supply it.

administrative side of work'. But there was no doubt in Lenin's mind as to the worst possible successor; and the major point of his testament was that Stalin should be stopped before he became unstoppable.

> Stalin is too coarse [in Russian: *glub*, a word difficult to translate, but which has connotations from 'buffoonery' to something like 'sadism'] and this defect, although quite tolerable in our midst and in dealings between Communists, becomes intolerable in a General Secretary. For this reason I suggest that the comrades think about a way to remove Stalin from that post and replace him with someone who has only one advantage over Comrade Stalin, namely greater tolerance, greater loyalty, greater courtesy and consideration to comrades, less capriciousness, etc.[28]

24 DECEMBER

SWITZERLAND

Le Corbusier sent a passionate, yearning note to Yvonne Gallis from his parents' house. He had not yet told them about his love, and to communicate with her he had to scribble letters on the sly, and then walk through the snow to post them unseen. Though he was now 36, he was still playing the part of the good boy, helping to cut wood for the winter pile and slaughter pigs for the holiday celebrations, but he seemed cheerful enough, even though he had to sleep on a wooden board in a freezing cold loft. What troubled him most was the sexlessness of this existence: having just recently discovered the ecstasies of consummated love, he was aching for his woman: 'In my chilly room under the eaves, I'll be thinking

28. Unfortunately for Lenin, Stalin's spies passed all these notes on to him. Stalin grew increasingly contemptuous of Lenin, and matters came to a head when Lenin heard of how he had recently showered Krupskaya (Mrs Lenin) with violent abuse and threatened her with an investigation by the Central Control Commission. He wrote his former comrade an angry letter, demanding an apology: Stalin's reply was so condescending, malicious and snide that Lenin fell seriously ill again from distress; by 9 March 1923, he had suffered his third major stroke, which robbed him of his power to speak. For the next 10 months, until his death on 21 January 1924, all he could manage were repeated pairs of syllables.

Against Lenin's expressed wishes, he was not buried next to his mother's grave in Petrograd but was embalmed to lie in state – Stalin's idea, forced through the Politburo despite the opposition of Trotsky and Bukharin, and, some said, partly inspired by the Tutankhamun fad that had filtered through from the West.

of my brave little girl far away in her soft beddy-bye while I'm sleeping on a plank . . .'

25 DECEMBER

NEW YORK

No fewer than eight plays opened in Manhattan on Christmas Day, and as a professional drama critic, Dorothy Parker had to 'wrap her shabby garments about her and rush out into the bitter night, to see as many as possible of the new plays'. She was tired, despondent, lonely and often tearful. She had only her dog Woodrow Wilson and her caged bird Onan (so called because he spilled his seed on the floor) for company, since her passionate affair with Charles MacArthur, begun in the late summer, had come to a sordid end some weeks before.[29]

PARIS

Pound wrote a short but information-crammed letter to his mother, mentioning, among other things, that Joyce had dropped by with some food and drink. He also reported that 'Yeats has been made a sennatorrrr of the

29. Though MacArthur had originally found her fascinating, the spell soon wore off, and since he was an accomplished and tireless seducer, his eye started to drift towards other women. Dorothy, on the other hand, was hopelessly smitten; she spent her time writing love poems for and about him, and wept when she saw him with his latest conquests. Then she discovered that she was pregnant with his child. This was agonising: she knew that she was not gifted with even mild maternal feelings, but she did not want to lose MacArthur's child. While she procrastinated, the Round Table staged another show, a sequel to *No Sirree!* entitled *The Forty-Niners*.

Once again, all the wits pitched in. She and Benchley wrote a weird one-act play called *Nero*, which had nothing to do with ancient Rome, but included Queen Victoria, Cardinal Richelieu and the New York Giants. George Kaufman and Marc Connelly directed. Once the show had closed, after 15 performances, Dorothy determined to have an abortion. For a few days she said nothing about the experience. Drink soon loosened her tongue, however, and she spent late nights in Tony's and other bars lamenting and cursing. One rumour had it that MacArthur had given her $30 towards the abortion. It was, she said, like Judas making a refund.

She drank more and more heavily, and would stay in bed all day until it was time to go to the theatre. Slowly she grew more and more fascinated by suicide, and determined to kill herself. She finally put the plan into action a week or so into January. Using her husband's cut-throat razor, she made a deep gash in her left wrist and a lighter one in her right. The seriousness of her death wish is doubtful; before slashing, she had ordered dinner from the Swiss Alps restaurant on the ground floor of her building, and it was the deliveryman who found her. She was rushed to hospital. When well enough to receive visitors, she played the clown as usual, wisecracking, swearing and shaking around her wrists, to which she had tied gay pale-blue ribbons.

new Irish hell-for-leather'; that he had posted his review of Cocteau's *Antigone* to *The Dial*; that he had a piece due for publication in the next *Criterion*;[30] and that he had managed to put three of his Malatesta cantos into approximate order, so as not to be burdened with too many notes for his imminent trip to Italy.

27 DECEMBER

LONDON
The weather in England over the Christmas period was, in Eliot's adjective, 'miserable'. He wrote to Gilbert Seldes expressing both gratitude and distress: gratitude for praise of *The Waste Land* by both Seldes and Edmund Wilson; distress at the fact that Wilson had taken the opportunity of this review to boost Eliot at the expense of Pound – he wrote of 'the extremely ill-focussed Eight Cantos of [Eliot's] imitator Mr Ezra Pound'. Eliot insisted that he considered Pound the most important living poet in the English language.

UK
The *Daily Express* ran a front-page story claiming that a 'famous war hero' was lurking in the ranks of the RAF under an assumed name: 'UN-CROWNED KING' AS PRIVATE SOLDIER ran the headline, and there was more, and worse, to come, both in the centre pages and over the next few days, with further headlines such as PRINCE OF MECCA ON RIFLE PARADE. Journalists flooded to Farnborough, where – as David Garnett put it – Lawrence was 'valiantly protected' by his new ranker friends. But the damage was irreversible. As a result of this exposure, Lawrence was forced to leave the RAF on 23 January 1923, though thanks to his tenacity and his influence in high places, he was back in the ranks again by March 1923 – this time as an army private, serving under the new identity of 'T. E. Shaw'.[31]

30. Though he seemed doubtful that it would escape the editor's pencil, the piece, 'On Criticism in General', did appear in the January 1923 issue.
31. On the same day the storm broke, Lawrence had been writing a long letter to George Bernard Shaw, to whom he had sent a copy of the 'Oxford' *Seven Pillars* for professional advice (see 17 August).

PARIS

Towards the end of the year, the Pounds set off from their apartment to spend about three months in Italy – Florence, Rome, but mainly Rapallo, the town where they would eventually settle in 1924. The Hemingways came to join them in mid-February until about 10 March 1923, and the two couples went on a mainly enjoyable walking tour of the Romagna – the country of one of Pound's historical heroes, Sigismondo Malatesta, the Renaissance *condottiere* and important patron of the arts.[32]

The two writers agreed to differ for the time being on the subject of Mussolini, whom Pound increasingly (and implausibly) admired as a present-day Malatesta. Hemingway boasted to Pound that Mussolini had threatened him at the Lausanne conference and told him he could never visit Italy again. This claim is highly improbable, not least since Heming-

Dear Mr Shaw
　　　Your letter reached me on Christmas day, and has interested me immensely – especially one phrase . . . it's immodest of me to refer to it – but you say that it's a great book. Physically, yes, in subject, yes: an outsider seeing the inside of a national movement is given an enormous subject: but is it great in treatment? I care very much for this, as it's been my ambition all my life to write something intrinsically good. I can't believe that I've done it, for it's the hardest thing in the world, and I've had so much success in other lines that it's greedy to expect goodness in so technical a matter. However your phrase makes me hope a bit: will you let me have your honest opinion as to whether it is well done or not? When I was actually writing it I got worked up and wrote hardly, but in the between-spells the whole performance seemed miserable, and when I finished it I nearly burned the whole thing for the third time. The contrast between what I meant and felt I could do, and the truth of what my weakness had led me to do was so pitiful. You see, there's that feeling at the back of my mind that if I really tried, sat down and wrung my mind out, the result would be on an altogether higher plane. I funk this extreme effort, for I half-killed myself as it was, doing the present draft: and I'd willingly dodge out of it. Isn't it treated wrongly? I mean, shouldn't it be objective, without the first-person-singular? And is there any style in my writing at all? Anything recognisably individual? . . .

Though Lawrence never met James Joyce, he was fascinated by the work of his fellow Irish writer. (As he grew older, he embraced the idea of himself as an Irish patriot; in his own eyes, he was Lawrence of Hibernia, not Arabia.) And though he never accumulated many possessions, he was very much attached to his small collection of books, in particular his signed first edition copy of *Ulysses* (number 36). An inventory of the books Lawrence owned at the end of his life also includes *Dubliners, A Portrait of the Artist as a Young Man, Pomes Penyeach* and three of the extracts from *Work in Progress* (later: *Finnegans Wake*) issued by Faber and other publishers: *Anna Livia Plurabelle* (NY, Crosby Gaige, 1928), *Haveth Childers Everywhere* (London, Faber, 1931) and *Tales Told of Shem and Shaun* (Paris, Black Sun Press, 1929). Lawrence, incidentally, went on to translate the *Odyssey*.
32. Pound was beginning work on Malatesta for his new set of cantos. Hemingway later claimed that he had called on his knowledge of military strategy to clarify Malatesta's conduct of his battles in Piombino and Orbetello.

way, seldom reluctant to talk about his encounters with celebrities, does not seem to have mentioned it to anyone else.

30 DECEMBER

MOSCOW

Lenin discovered, to his horror and rage, that Russian Soviet troops, under the command of Ordzhonikidze, had invaded the previously autonomous Georgian Soviet. Hundreds of Georgians were killed; thousands thrown into prison. A Bolshevik Lenin had, until recently, admired, Felix Dzerzhinsky – himself one of the bloodiest of all the Russian revolutionary leaders, and a firm believer in the usefulness of terror campaigns – had been sent to the region to report back to Moscow on the action. Dzerzhinsky had blandly noted that, though there had been 'a few excesses', the region was now tranquil. In other words, there had been a bloodbath. Who had ordered this act of 'Great Russian Chauvinism'? Lenin understood at once that it must have been Stalin. He wrote a furious denunciation not only of Stalin, Ordzhonikidze and Dzerzhinsky by name, but, by implication, the entire Soviet government – 'typical Russian bureaucrats, rascals and lovers of violence'.[33]

But even as Lenin was pouring out his terror, anger and remorse on to the page, the 'bureaucrats' were drawing up the treaty that would unite Russia, Ukraine, Belarus and the Transcaucasia into the USSR – the Union of Soviet Socialist Republics. He kept on writing furiously into the last day of 1922. But the treaty had already been signed the previous day, and the USSR born. Stalin had won.

33. Nor did he spare himself: 'I am, I believe, strongly guilty before the workers of Russia for not having intervened energetically or drastically enough in the notorious question of "autonomization", which, it appears, is officially called the question of the Union of Soviet Socialist Republics . . .' After explaining that he had been ill over the summer when the question of union arose, and that he had taken no part in the decision to dispatch an army and use force, he called the present state of affairs a 'swamp'. 'They say that unity was needed in the apparatus. But where do these assertions come from? Is it not from the same Russian apparatus which, as I observed in one of the previous sections of my diary, we have taken over from Tzarism, only tarring it a little with the Soviet brush?' He went on to predict that unless measures were taken, the Communist project would drown in 'the Great Russian sea of chauvinist riffraff like a fly in milk'. And – a standard point of reference for such denunciations – he recalled the immortal figure of stupidity and oppression, Derzhimorda, the police chief from Gogol's Government Inspector. For Derzhimorda, read Stalin.

31 DECEMBER

NEW YORK

The last major film premiere of the year: *Salome*, adapted from the play by Oscar Wilde, with 'Nazimova' – i.e., the Russian-born actress Alla Nasimova (1879 – 1945) in the title role. An unusual instance of a film which managed to create a scandal without doing well at the box-office, *Salome* is now the best-known of her films. She is also remembered as an expert seducer of beautiful women.

LONDON

Eliot's last two letters of the year were to Cobden-Sanderson and Henry Eliot. To his brother, he mainly confided the difficulties of running *The Criterion*, and lamented how little time he had for reading.

> . . . what I particularly long for is time to fill in the innumerable gaps in my education in past literature and history. There is very little contemporary writing that affords me any satisfaction whatever; there is certainly no contemporary novelist except D. H. Lawrence and of course Joyce in his way, whom I care to read . . .

He went on to describe Vivien's latest illnesses and miseries. 'Vivien has been very tired since Christmas. She sat up to dinner in the evening on that day for the first time in months . . .'

His last written words of 1922 took the form of a brief PS about one of the notable American books of 1922: 'V. has read me some bits of *Babbitt*. It has some good things in it.'

AFTERMATH

The Leading Players

T. S. ELIOT continues, despite extreme fluctuations in academic fashion, and a number of powerful attempts to diminish or even destroy his reputation, to be considered the leading English-language poet of the twentieth century; *The Waste Land* is still widely regarded as the century's most important single poem. His many literary essays also established him as one of the period's major critics, whose far-reaching influence on generation after generation of scholars and teachers has proved more durable even than the work of the slightly younger critics who learned from him: I. A. Richards, William Empson and F. R. Leavis in the UK, Allen Tate, John Crowe Ransom, Edmund Wilson and others in the United States.

The spiritual crisis given voice (or voices) in *The Waste Land* found a resolution when Eliot joined the Anglican communion on 29 June 1927. He remained a discreetly pious and humble churchgoer for the rest of his life, and for many years served as warden of his parish church, St Stephen's, Gloucester Road. Eliot also became naturalised as a British subject in 1927, and shortly after his change of nationality declared himself a royalist, much to the dismay of his admirers on the political left. Vivien Eliot's mental and physical condition grew worse; the couple separated in 1932, when Eliot used the occasion of being invited back to Harvard to take up the Charles Eliot Norton chair to sever his connection with her. In 1938, Vivien was confined to a mental asylum in Stoke Newington, where she remained for nine years until her death in 1947.

Eliot edited *The Criterion* until its final issue, in January 1939. By this time, he had left his job at Lloyd's Bank (1925) and joined the new publishing firm of Faber and Gwyer, later Faber and Faber, where he worked with considerable distinction until his retirement. He took pleasure both in promoting the new work of Joyce, Pound and other old friends, and in cultivating the writers of rising generations, including W. H. Auden.

Eliot was not a prolific writer of poetry, and his *Collected Poems* is a relatively modest volume; his most notable verses after *The Waste Land* include the strange and terrifying 'Sweeney Agonistes' (1932, though made up of two 'fragments' from 1926 and 1927), 'The Hollow Men' (1925), 'Ash Wednesday' (1930) and the long sequence *Four Quartets*, a complex work on religious and philosophical themes that also, with the passage of time, encompassed Eliot's response to World War II and, as in *The Waste Land*, tacit and not-so-tacit autobiography. Its components are *Burnt Norton* (1936), *East Coker* (1940), *The Dry Salvages* (1941) and *Little Gidding* (1942); the four parts were first published together in 1945.

He also wrote a number of full-scale verse dramas, beginning with *Murder in the Cathedral* (1935) – a deliberately Agatha Christie-ish title for the tale of Thomas Becket's martyrdom – and continuing with a group of plays that reworked themes from classical tragedy in the sort of upper-middle-class contemporary settings familiar to West End audiences used to Noël Coward or Terence Rattigan: *The Family Reunion, The Cocktail Party* and so on. Surprisingly commercial in their day, they are seldom revived with much success.

In the time not given to his duties at the office or as a churchman, Eliot also wrote widely on social, political and religious matters. His essays *Notes Towards the Definition of Culture* and *The Idea of a Christian Society* give the most adequate account of his views; an earlier work, *After Strange Gods,* was tactfully allowed to fall out of print when Eliot became uncomfortable about the tenor of some of its passages (including a much-quoted, and often misquoted, remark about the effect on traditional communities of 'a large number of free-thinking Jews'). All of these works are quite short, too short to amount to a definitive outline of his political philosophy, and they have often been derided by those who find Eliot's severe form of conservatism inhumane or repugnant. Yet his stature as a thinker of the right has, if anything, grown with the years.

Late in life, Eliot finally achieved personal happiness in his marriage to Esme Valerie Fletcher, known to friends as Valerie. She had been his secretary at Faber since 1949, so they already knew each other well when they eventually married on 10 January 1957. The groom was 69, the bride 32. By the time of Eliot's death on 4 January 1965, he was internationally famous to a degree no one could reasonably have predicted 40 years earlier. His mortal remains were cremated in Golder's Green, and the ashes

taken to the parish church of East Coker, the village in which his ances-
tors had lived before moving to America.

Both in his lifetime and more and more in recent years, Eliot has
been attacked for certain anti-Semitic passages in both his prose and his
verses – not, usually, on the grounds that he should ever have published
such things (which are no worse, if no milder, than comparable passages
by other writers of his day who also made nasty cracks about the Jews or,
in wilfully insulting lower-case, jews) but because he permitted them to
be published unrevised after the free world learned about the Final So-
lution. The issue remains contentious, and uncomfortable for those
who, admiring Eliot from the centre and the left, find it hard to accept
that such powerful verses should have been nourished by such sordid
disdain.

Since the advent of feminism from the 1960s onwards, it has also been
commonplace to paint Eliot as the villain in the story of 'Tom and Viv': at
best a timid, emotionally incompetent and ultimately cowardly betrayer
of his poor wife, at worst a sadist and bully who was the true cause of her
dismaying condition. This debate, too, continues, though the harrowing
account of Eliot's suffering which has emerged with the publication of his
letters (to date, as far as 1925) has hardly given much fuel to the opposition.

Perhaps the strangest and silliest aspect of Eliot's posthumous career
has been the immense success of the musical *Cats*, a crowd-pleasing spec-
tacle based on his book of light verse for children and others, *Old Possum's
Book of Practical Cats* (1930). The revenues from this production have
greatly increased the fortune of Eliot's widow and his publisher.

A British poll among the general reading public in 2009 showed an
unusual agreement of popular and academic taste. Eliot was voted the
Nation's Favourite Poet.

JAMES JOYCE continued to live in Paris with his family for the next
18 years. After the frequent upheavals and perpetual financial crisis of his
youth, he now began a relatively uneventful middle age. For most of this
period he worked steadily at his next project, the incomparable dream-
novel *Finnegans Wake*; ever gifted at finding patrons, he formed an invalu-
able friendship with Maria and Eugene Jolas, who edited the avant-garde
journal *transition*. Chapters of the *Wake*, then known to Joyce's followers
as *Work in Progress*, were frequently published in the pages of *transition*.

Meanwhile, Harriet Shaw Weaver continued to fund Joyce's life with un-flagging generosity.

There was, then, good reason for Joyce to feel contented with his lot, but he had grounds for misery, too. He continued to be tormented by his eyes, and underwent nine operations with Dr Louis Borsch before the lat-ter's death in 1929. In the 1930s, he made several trips to Switzerland, sometimes to have treatments for his vision, sometimes because of his daughter's troubles. Lucia had begun to show serious signs of mental ill-ness in about 1930, around the time that her short-lived flirtation with Joyce's new young friend and occasional amanuensis Samuel Beckett came to an end. In 1934, Jung took her on as an analysand, but the treat-ment does not seem to have done her much good. In 1935, she was placed in a mental institution in Ivry-sur-Seine.

When the German tanks rolled into France in 1940, Joyce fled with Nora, now legally his wife (they had been married in London in 1931), to his old retreat, Zurich. He would have been safe there, but his own body betrayed him. On 11 January 1941, he suffered a perforated ulcer; two days later, on 13 January, he died. He was buried in the Fluntern Cemetery, near the Zoo; his funeral was secular, and the Swiss tenor Max Mieli sang an extract from Monteverdi's *L'Orfeo* in his honour.

Nora lived on till 1951; in the same year, Lucia was moved from France to St Andrew's mental hospital in Northampton, where she re-mained an inmate until her death at the age of 75. (Grim symmetry: Eliot's first wife and Joyce's daughter both spent their last years as mental patients.) Giorgio Joyce died in 1976.

EZRA POUND's career after 1922 is so extraordinary as to read like a work of improbable fiction. From that year, when he picked up the threads of a major project he had been planning several years earlier, until almost half a century later, he devoted the bulk of his poetic talent to composing *The Cantos*. Eliot published the first of the true Cantos (earlier versions are now referred to as the Ur-Cantos) in *The Criterion* in 1923. It is a hard poem to describe: at times strikingly plain, and lyrical in a rather old-fashioned way, at times clotted with what seems like great chunks of undi-gested research, at times polyglot (in Mandarin, ancient Egyptian hieroglyphs and classic Greek as well as Italian, French, German . . .), fragmentary and densely allusive to the point of being incomprehensible.

It is a poem of history – both the histories of Europe, America and China, and the catastrophic history that was unfolding as Pound wrote. It is fair to see him as one of the villains of that history; but also, perhaps, as one of its victims.

Pound's personal life during the years of composition was unorthodox. In the autumn of 1922 he met Olga Rudge, the concert violinist, and began an affair with her which lasted until his death almost exactly 50 years later. When he and Dorothy finally settled in Rapallo in 1924, Olga was pregnant with his child; Mary was born on 9 July 1925, and almost immediately farmed out to a local peasant woman, who was paid a modest monthly sum for her upkeep. As if in retaliation, Dorothy then became pregnant, and gave birth to their son Omar Pound on 10 September 1926. Once again the child was handed over to others – in this case to Dorothy's mother Olivia, who lived in Kensington, and who raised Omar to be a little English gentleman. Pound hardly saw anything of the boy until he made a short visit to London in 1938, by which time Omar was 12.

Pound's public life was a disgrace. Like many roads to hell, it began with good intentions. He was appalled by the slaughter of the Great War, and set himself to enquire into its deepest causes. It did not take him long to conclude that it was a war about profits, which had been stage-managed by arms manufacturers and other forces of finance capitalism. This was a line of argument that might easily have taken him towards the political left, and he did for a while express his admiration for Lenin. However, he hooked on to the economic theories not of Marx but of one C. H. Douglas, who had come up with a heretic model for economies known as Social Credit.

So far, so harmless. But Pound was not content with promoting a scheme that most conventional economists, such as Keynes, regarded as crackpot. He asked himself who the villains were, and came up with the answer: capitalists. And who were the biggest capitalists? Why, the Jews, of course. Up to this point, Pound seems to have been no more anti-Semitic than most men or women of his age. But he stoked his hatred with research that 'proved' to his satisfaction that civilisations rose and fell to the extent that they permitted the practice of lending at interest: usury, or as Pound called it, Usura. This most sophisticated of literary minds somehow persuaded himself that history was a simple matter of good guys and bad guys. The next move was to cast around for a suitable good guy

for modern times. Pound decided that the ideal candidate was Benito Mussolini.

Pound only met his hero once, on 30 January 1933. Reading between the lines of his fawning account, it was something of a farce. When Pound tried to explain all about *The Cantos*, Mussolini delivered a one-word verdict: it sounded '*divertente*': 'amusing'. A perfunctory, even insulting compliment, but Pound fell on it eagerly as proof that 'the Boss' had cut immediately to the heart of the matter by understanding that the deepest function of poetry was to provide pleasure. Hugely encouraged by this, and dreaming of a role as philosopher-poet to a king, he began to write anti-Semitic articles for the Italian press, and for Oswald Mosley's British Fascist journal *Action*.

He also began to broadcast, from 1935 onwards, on Rome Radio. The authorities had been wary for many months of letting him near a microphone, suspecting that he might be some kind of unconventional double-agent. Once satisfied by his credentials, they let him rant as he pleased. His major preoccupation at this time was to warn the United States to stay out of any coming European war. Increasingly convinced that his was an important voice that politicians would listen to with respect, he took his crusade to America, where he held a press conference in New York and lobbied members of the government in Washington, DC.

Pound continued his broadcasts when the war began, becoming even more frenzied and splenetic after the US was foolish enough to ignore his advice and enter the war. He railed against Roosevelt – 'Jewsevelt' – and said that the war had been caused by 'sixty kikes'. Among those who listened to his broadcasts were members of the Allied armed forces. Some of these worked for military intelligence, and they took Pound's words as offering comfort to the enemy and incitements to disaffection among the troops. He was indicted, in absentia, for treason on 20 July 1943.

After the successful invasion of Italy by the allies, Pound went on the run for a while, before finally returning to Rapallo. On 2 May 1945, he was taken captive by a group of partisans, who released him after a couple of days. But Pound realised that his re-arrest was imminent, so he and Olga turned themselves in to the American authorities. On 24 May, Pound was transferred to the United States Army Disciplinary Center, to the north of Pisa. Despite his age – he was now 60 – and the non-violent nature of his offence, he was imprisoned with murderers, rapists and other serious

criminals in a metal cage, exposed to heat by day and frost by night. It was inhumane treatment, though it is easy to understand why the officers thought that a known traitor deserved harsh handling. Within three weeks, Pound broke down, and was transferred to more comfortable quarters in the prison hospital. He was allowed to use a typewriter to work on the new Cantos he had begun to write while in the cage.

The law determined that Pound should return to the United States for a proper trial. He arrived in America on 15 November 1945, and 10 days later was formally charged with treason. After debating the case, the court in Washington, DC, ordered that he be sent to a local mental institution, St Elizabeth's, so that his degree of sanity – or insanity – might be assessed. His early days in the hospital were grim: he was kept under close supervision on a ward known as the 'hell-hole', among inmates who shrieked, gibbered and drooled. Since he was clearly not in such an advanced degree of lunacy as these patients, he was transferred to the much more agreeable surroundings of Chestnut Ward, which was to be his home for the next 12 years.

Pound's supporters have been inclined to paint this period of his life in lurid colours, suggesting that it was a torment for him. Others have pointed out that in many ways it suited him perfectly well. For the first time in his adult life he did not have to scrabble around for money, and was free to read and write as he pleased, working – among other projects – on a translation of Sophocles's *Women of Trachis* and the later Cantos. He was allowed to entertain visitors, including Dorothy, and often held informal court in an alcove that he more or less took over as his own territory.

Meanwhile, his increasingly distinguished friends – including Eliot and Hemingway – made repeated efforts to have him released. The most highly publicised of these attempts came in 1949, when Eliot and the other judges of the newly established Bollingen Prize for Poetry agreed to give the award to Pound for the Pisan Cantos (1948) – not merely to affirm their steady faith in his literary talent but to embarrass the authorities into re-examining his case. They may have been successful in the first matter – the Pisan Cantos are considered one of the high points of Pound's epic – but the award outraged so many people that it served mainly to remind the general public of Pound's infamy. He remained in St Elizabeth's for almost a decade more.

In 1958, the authorities finally agreed that it was safe to release him. In July, he sailed back to Italy; almost the first thing he did on arrival was to greet the press with a fascist salute. For a while he lived with his daughter and son-in-law at Castle Brunnenberg, near Morano; then he went back to the familiar haunts of Rapallo. By the end of 1959, he was beginning to show signs of depression, and of a slow withdrawal into almost complete silence. Sometimes he would lament his whole life's work, calling it a 'botch', and berate himself for his idiocy. On one famous occasion, he met the younger (Jewish) poet Allen Ginsberg, who admired Pound very much in spite of the old man's vile racial theories; Pound, in a rare moment of recantation, admitted that he had been afflicted by the 'stupid suburban prejudice' of anti-Semitism. A recantation, yes, but not exactly an apology.

Pound returned to Venice – his first European home – for the final stage of his life. He shared a modest apartment near the Piazza San Marco with Olga Rudge; one of his few enduring pleasures was the local ice cream. He died on 1 November 1972 – Year 50 of the modernist calendar – with Olga at his side; his remains were buried in a Venetian cemetery, not far from the grave of Igor Stravinsky. Dorothy Pound died the following year; Olga, though frail, lived on until 1996.

Pound's work has been the cause of bitter arguments, and not only because of his fascism. His name is not as well known to the general public as those of Eliot and Joyce, and he has never been widely read outside universities. A number of pioneering critical studies, including books by Hugh Kenner in North America and Donald Davie in the UK, made a formidable case for Pound's accomplishments as original poet, translator, critic and teacher; these were followed by countless further monographs, essays, editions, biographies and conferences. By the early 1970s, when Kenner published his highly influential book *The Pound Era*, many readers were ready to accept his contention that Pound was the central figure in modernism; and, implicitly, the greatest poet of the twentieth century.

Many, but not all. The English poet Philip Larkin – born, incidentally, in 1922 – was probably the most famous of the men and women of letters who thought Pound at best a thin and patchy talent, at worst a pernicious charlatan. Larkin lumped Pound together with two other dreadful 'P' men, Picasso and Charlie Parker, as the villains who had destroyed poetry, painting and jazz, replacing beauty with wilful ugliness, lucidity with gibberish and bogus erudition, melody with cacophony, shape with

chaos. It seems likely that the common reader, had she or he read much Pound, would be inclined to agree. And in the early twenty-first century, fewer and fewer universities ask their undergraduates to read more than a small handful of inoffensive anthology pieces.

This is not the place to argue for the merits of Pound's poetry. (Though it is worth mentioning that he is very much a poet's poet, and has inspired a surprising number of other writers, from the most traditional to the most experimental.) But anyone who cares for the work of Eliot, or of Joyce, owes a debt to Pound's discrimination, vigour, selflessness and determination. As noted earlier, without his intervention, Eliot might have spent his life at Harvard teaching philosophy and be largely forgotten by the literary world; Joyce might have carried on drinking, sponging and alienating potential publishers, and gone to his grave as the obscure author of *Chamber Music*. Or perhaps their respective talents might have drawn others to nurture and fight for them. What is certain is that the literary miracle of 1922 was largely wrought by Ezra Pound.

The Laureates

No fewer than 12 of the writers who played a significant role in the year went on to win the Nobel Prize for Literature:

1923: William Butler Yeats
1925: George Bernard Shaw
1929: Thomas Mann
1930: Sinclair Lewis
1934: Luigi Pirandello
1936: Eugene O'Neill
1946: Hermann Hesse
1947: André Gide
1948: T. S. Eliot
1950: Bertrand Russell
1953: Winston Churchill
1954: Ernest Hemingway

There can be little doubt that Joyce would have won the prize had he lived just a few more years. There can be even less doubt that Pound

would never have been a Nobel Laureate; for many readers, his wartime conduct remains unforgivable.

The Tyrants and the Leaders

SIR WINSTON CHURCHILL served as prime minister twice, from 1940 to 1945 and from 1951 to 1955. Even his keenest admirers would admit that his long and chequered political career was stained with grave mistakes and worse: in his own view, the most lamentable decision he ever made was to return Britain to the Gold Standard in 1924, so provoking the massive depression which led to the General Strike of 1926. Even his most passionate detractors cannot deny his decisive and righteous role in seeing and warning against the threat posed by Hitler, in preparing the nation for a long, cruel but essential armed struggle, in sustaining morale during the terrifying early war years, and in forging the necessary bonds with Roosevelt and Stalin. Churchill was shaken by his defeat in the election of 1945, which brought Labour to power, and his second term of office was marred by ill health and depression – 'Black Dog'. He died on 24 January 1965; in 2002, a poll conducted by the BBC suggested that the bulk of the nation still regards him as the greatest of all Britons.

MOHANDAS 'MAHATMA' GANDHI was assassinated by a Hindu nationalist on 30 January 1948, just months after the Indian Independence Act (18 July 1947). His policies of non-violent civil disobedience – Satyagraha – and of a mass boycott of British goods and institutions had been the principal instruments in bringing about the end of British rule in India; his international reputation as a man of unimpeachable virtue was also important in making the end of the Raj inevitable. Einstein once called him 'a role model for generations to come', and the *Time* magazine poll of 'People of the Century' put Gandhi at number two, just behind Einstein. The immediate consequences of Independence were tragic: some 12 million people were displaced, and an unknown number, in the hundreds of thousands, died. Gandhi is still greatly revered by most Indians, and is known as 'Father of the Nation'. Einstein's prediction came true: Gandhi has been an inspiration to many champions of equality and justice, from Martin Luther King to Barack Obama.

•

ADOLF HITLER was appointed German chancellor on 30 January 1933, and set about transforming the Weimar Republic into the Third Reich. The success of the Nazi movement in reconstructing Germany's factories, roads and armed forces was so swift and striking as to appear miraculous to the nation's people. When the time came to launch his plans to make Germany ruler of all continental Europe, Hitler showed them that he was as unstoppable in war as in peace. By the start of 1941, he controlled almost all of western Europe save the nations held by his allies in Italy and Spain, and large parts of North Africa. Switzerland and Ireland stayed officially neutral. Only the United Kingdom remained free and fighting. His fortunes turned after he decided to violate the Nazi–Soviet peace treaty and sent an army of three million men into Russia, and after Japan's attack on Pearl Harbor brought the United States into the war against the Axis powers. He committed suicide in Berlin on 30 April 1945, as Soviet forces overran the city. It is estimated that – in addition to all those who died in the war he created – some 17 million people were killed on his orders: Jews, Poles, Soviet POWs and civilians, homosexuals, the disabled and mentally ill, and political opponents. The scale of the massacre is outdone by both Stalin and Mao, but Hitler's sinister reputation as the most evil tyrant of all time is as potent as ever, partly because of the macabre theatricality in which he dressed up his atrocities, partly because of the sheer lunacy of the vision that inspired his mass slaughter.

HO CHI MINH founded the Democratic Republic of Vietnam, a one-party (communist) state, and was its president from 1945 until his death in 1969, though in the last few years of his life he had less and less political power and was kept on as an inspiring figurehead. As leader of the Viet Minh, he conducted the war of independence which culminated in the humiliating defeat of French forces in 1954, and the withdrawal of French troops. As leader of the Viet Cong, he subsequently directed the war against the United States forces based in South Vietnam. He died on 3 September 1969, six years before the Viet Cong forces were finally victorious. The captured city of Saigon was renamed Ho Chi Minh City; the cult of personality that made 'Uncle Ho' an object of national reverence has lasted to the present day.

VLADIMIR LENIN died on 21 January 1924.

MAO ZEDONG was, from 1 October 1949 to his death on 9 September 1976, the leader of the People's Republic of China. He is often credited with laying the foundations for China's status as a twenty-first-century superpower. The cost of this was horrifying beyond imagination. To take just two examples: the 'Great Leap Forward', a five-year plan for the modernisation of Chinese agriculture and the development of its heavy industries, begun in January 1958, created the worst famine in human history. Some 30 million peasants died of starvation. The so-called 'Cultural Revolution' of 1966 unleashed a nightmare of violence, as the young Red Guards tortured and massacred everyone deemed to be an enemy. It also destroyed much of the traditional Chinese culture. The number of deaths directly attributable to Mao is impossible to calculate, but may well exceed 70 million.

BENITO MUSSOLINI rapidly took on more and more power, so that by 1925 he was in effect absolute ruler of Italy. To consolidate his influence, he built up a formidable police state (1925–7) and, dreaming of a 'New Roman Empire', began to pursue an aggressive foreign policy, notably in Ethiopia, where the superior firepower of the Italian forces, and their merciless use of poison gases and other modern instruments of war, ensured an easy victory over the local resistance. Mussolini went on to forge alliances with other right-wing movements in Europe. He provided armed support for Franco from 1936 to 1939, and in May of that year signed a pact with Hitler. This made Italian entry into World War II all but inevitable, and Mussolini declared war on Britain on 10 July 1940. His early bullishness began to fade when he saw the military folly of Hitler's attack on the USSR, and the triumph of the Allied armies in North Africa as they fought their way eastwards towards an invasion of Italy. His political position weakened dramatically, to the point where he was driven from office in 1943. The Germans installed him as nominal ruler of their occupied region in the north of Italy, but this fragile arrangement was short-lived. On 28 April, Mussolini and his latest mistress, Clara Petacci, were captured and shot by partisans. The following day, their corpses were driven to Milan and dumped in an open square. The crowd that gathered hoisted the remains up on meat-hooks, and stoned and spat on

them. Ezra Pound mentions this scene in a terse elegy for Mussolini in the Pisan Cantos.

JOSEPH STALIN, who was appointed General Secretary of the Communist Party of the Soviet Union's Central Committee in 1922, held that title until his death some 30 years later. Under his rule, the USSR became a waking nightmare of murder both planned and indiscriminate, mass deportations, imprisonment in the 'Gulag' camps, show trials, torture, famine and fear. At the same time, the deliberately fostered 'Cult of Personality' led many citizens to the belief that he was a benevolent patriarch, bordering on a god. Stalin's death toll is impossible to calculate with any accuracy, for lack of adequate records, but it numbers in the many millions. Some of these deaths were due more to fatally incompetent or misconceived attempts at reform than to blood lust, as in the 'Great Famine' of 1932–3, in which some six to eight million people starved. Millions more, most of them from the Soviet Union's ethnic and national minorities, died in forced resettlement campaigns. Probably more than 14 million perished in the Gulags. It is quite possible that 20 million died from famine and related causes, and anything from 20 to 30 million in the Great Terror of the late 1930s and in the Gulags, giving a total of up to 50 million. Or possibly a higher figure still. Stalin died on 5 March 1953. Polls taken in the former Soviet Union in recent years suggest that almost half the population continue to regard him as a wise and courageous leader.

LEON TROTSKY, after leading a failed attempt at opposition to Stalin's increasingly ruthless and arrogant conduct of government, was expelled from the Communist Party and, in February 1929, deported. He spent his early years of exile in Turkey, France and other countries, writing articles and books which denounced Stalin's betrayal of Leninism and formulating his own theories of permanent revolution – the brand of Marxist thought that became known as Trotskyism, and served as an inspiration for the anti-Stalinist extreme left for many decades. He finally settled in Mexico, where he lived for some time in the house of the famous painter Diego Rivera and his artist wife Frida Kahlo; Trotsky and Kahlo had an affair. It was at this time that Trotsky met André Breton. On 20 August 1940, an NKVD agent attacked Trotsky with an ice pick; he died the following day.

The Writers

ANNA AKHMATOVA has long been recognised in the West as one of the major Russian poets of the century, and perhaps the greatest. She also exhibited a degree of courage and intransigence rare in the history of literature. One of her masterpieces is *Requiem* (1935–40), an impassioned and harrowing account of the Stalinist terror. Though her work was not officially banned in the USSR, save for a period when Stalin's notorious cultural minister Andrei Zhdanov was in power, an unofficial boycott meant that she was reduced almost to starvation from about 1925 to 1936 – 'the Vegetarian years', as she called them, when she scraped by on the income from (usually anonymous) translation chores: Victor Hugo and Leopardi were among the authors she translated. Her son, Lev, was in and out of prison throughout these same years, and in 1949 was sentenced to 10 years in a Siberian labour camp. It is notable that the only poems Akhmatova ever published in favour of the Stalinist regime date from this time, no doubt in an effort to keep him alive. Meanwhile, her own work enjoyed a thriving reputation among the surviving intelligentsia, though often its only means of transmission was verbal. Akhmatova would write down a poem, give it to a friend to memorise, then burn the paper at once. By this means her work reached into the depths of the Gulags. She also became a mentor to a rising group of younger poets, of whom the most famous is Joseph Brodsky (Nobel Prize for Literature, 1987). After the death of Stalin, she enjoyed the benefits of a thaw, which allowed her not only to be published officially but to travel in the West. In 1965, she visited Oxford, and was given an honorary doctorate. She died on 5 March 1966; thousands attended her funeral.

BERTOLT BRECHT gave up his early, vaguely anarchistic rebel-without-a-cause posture and by the end of the 1920s was a committed Marxist; oddly, he never joined the Communist Party. Predictably, he was driven into exile – Scandinavia, America – when the Nazis came to power, but returned to East Germany shortly after the war and was given his own company, the Berliner Ensemble, which he ran with his wife, Helene Weigel. Despite his being, as his detractors pointed out, the apparently willing servant of a Stalinist regime, his reputation in the West seldom suffered; and many who were hostile to his political views were willing to concede that the work of the Berliner Ensemble, which toured extensively

in the West, was brilliant. By intellectuals of the left, at least, Brecht was and is regarded as the outstanding playwright of the century, for works such as *Life of Galileo, Mother Courage and Her Children, Saint Joan of the Stockyards* and others; his influence on radical theatre and film-making (for example, the later work of Jean-Luc Godard) has been un-equalled. He died of heart failure on 14 August 1956, at the age of 58; in his last few years, he had shown some signs of beginning to chafe against the tyrannical nature of the GDR. Helene Weigel continued to run the Berliner Ensemble until her death in 1971.

ANDRÉ BRETON officially founded surrealism in 1924, with the publi-cation of the First Surrealist Manifesto, and remained the movement's leader until his death – a tyrannical leader at times, who was in the habit of excommunicating anyone who, in his eyes, had strayed from the true faith. (Hence his occasionally being called 'the Pope' of surrealism.) Al-ways a man of the far left, he joined the French Communist Party in 1927; always a rebel, he resigned in 1933. In 1938, a grant from the government allowed him to travel to Mexico – which impressed him greatly, as a natu-rally surrealist land – where he met Trotsky. At the outbreak of war, he joined the French army medical corps. When France fell, his writings were declared unpatriotic and duly banned. He managed to escape to the Caribbean and the United States in 1941, and spent much of the war un-happily in New York. In 1946, he returned to France, and picked up the threads of his writing and his extensive collection of modern art and ethnographic objects. His many publications include the hallucinatory memoir-novel *Nadja* (1928), his highly influential anthology of black hu-mour (1940), *Arcane 17* (1945) and the *Ode to Charles Fourier* (1947). Bre-ton's poetry is now an accepted part of the modern French canon. He died on 28 September 1966, a little too soon to be gratified by the sight of sur-realist slogans being painted on the streets of Paris in May 1968.

CYRIL CONNOLLY wrote two masterpieces of introspective gloom, *Enemies of Promise* and *The Unquiet Grave* (1944), as well as hundreds of reviews and essays. He was one of the most powerful non-academic critics in the UK, comparable to Edmund Wilson, and his admiration for Eliot and Joyce (and, indeed, Pound) was one of the factors in their rise to ca-nonical status. From 1940 to 1949 he edited – brilliantly – the celebrated

literary journal *Horizon* – which helped sustain an unexpectedly lively cultural life in Britain during the hardest years of the war. He died on 26 November 1974.

ALEISTER CROWLEY died in 1947, impoverished, addicted to heroin and largely forgotten, in a humble boarding house on the south coast of England. His posthumous fame rocketed when he was taken up as a hero of the counter-culture in the 1960s (his face can be seen on the cover of the Beatles' Sgt Pepper album). Today he is probably better known and better understood than ever before, particularly in his role as prankster or trickster. He has inspired many writers, musicians and film-makers, from Somerset Maugham to Donald Cammell, and Kenneth Anger to Genesis P-Orridge.

E. E. CUMMINGS captured the popular poetry audience of America with his immediately recognisable brand of verse – playful in form, often facile in sentiment. As a result, his books sold unusually well, and still do. Though he is often thought of as rebellious and bohemian by those who know little of his biography, he grew more and more conservative with the years, and became both a right-wing Republican and a supporter of Joseph McCarthy. He died on 3 September 1962.

JOHN DOS PASSOS's major work is his USA trilogy: *The 42nd Parallel* (1930), *Nineteen Nineteen* (1932) and *The Big Money* (1936). He went on to publish some 20 more books before his death on 28 September 1970, but few if any of these are much read.

SERGEI ESENIN's marriage to Isadora Duncan collapsed after less than a year. He returned to Moscow, and spent the last two years of his life in a chaos of drink and womanising, though he somehow managed to write some of his best-known poems at this time. He hanged himself on 27 December 1925. His work was banned under both Stalin and Khrushchev, but he is now one of the most popular of Soviet poets.

F. SCOTT FITZGERALD's most famous novel, *The Great Gatsby* (1925), which has sold in the millions and has often been called 'the great American novel', is set in the summer of 1922; it includes a number of passages inspired by *The Waste Land*. Eliot himself was one of its first admirers,

and wrote to Fitzgerald that it 'seems to me to be the first step American fiction has taken since Henry James'. Following its publication, Scott and ZELDA FITZGERALD spent a good deal of time living an ostensibly gay and carefree life as glamorous expatriates in France and elsewhere; Scott became good friends with Hemingway, though Hemingway disliked and distrusted Zelda, whom he suspected of trying to destroy Fitzgerald's talent by encouraging his heavy drinking. It is true that wild drinking and chronic money worries, caused by always living beyond their means, were the dark side of this time, and it took Fitzgerald nine years to complete his fourth novel, *Tender Is the Night* (1934). Meanwhile, in 1930, Zelda had been diagnosed as suffering from schizophrenia, and from 1932 until her death was shunted from mental hospital to mental hospital. She published a novel of her own, *Save Me the Waltz* (1932), which Scott disliked for its humiliating revelations about their life together. Still short of money, Fitzgerald moved to Hollywood and worked as a 'hack' for the movie studios; he used his experiences there as the basis for a series of 17 stories about 'Pat Hobby', a lightly fictionalised version of himself. He also worked on a novel inspired by the career of Irving Thalberg, which was left unfinished but was eventually published after his death as *The Last Tycoon* (1941). He began a final love affair, continued to drink recklessly, and died of heart failure on 21 December 1940. Zelda outlived him by eight years, and died in a fire at her last hospital in Asheville, North Carolina.

E. M. FORSTER published *A Passage to India* in 1924, and never completed another novel, though he did write in other forms: journalism, essays, a libretto and a documentary film script. *Maurice*, an unpublished fiction on gay themes begun in about 1913, was finally published in 1971, just a few months after Forster's death on 7 June 1970. In 1946, he was made an honorary fellow of King's College, Cambridge, and spent much of his mature life there. The popularity of his novels has been boosted by their adaptation into audience-pleasing films.

FEDERICO GARCÍA LORCA fell out badly with his former friends Dalí and Buñuel over their film *Un Chien Andalou*, which he chose to interpret as a personal attack. He was murdered by an anti-communist death squad on 19 August 1936. Lorca's works were banned under Franco's

rule until 1953, when a partial rehabilitation began. Since then, his reputation has soared, and he is often cited as Spain's major modern poet – and, on the strength of such internationally acclaimed dramas as *Blood Wedding* (1932) and *The House of Bernardo Alba* (written in 1936, but not performed until 1945), also its major playwright.

DASHIELL HAMMETT wrote a handful of the best detective yarns ever published, including *The Maltese Falcon* (1930) and *The Thin Man* (1934). He suffered from poor health for much of his life, but insisted on volunteering for the US armed forces when America entered the war. He served with the army in the Aleutian Islands. Hammett, a lifelong man of the left (he joined the American Communist Party in 1937), spent a good deal of time in political agitation, and suffered for it: he was imprisoned for contempt of court after repeatedly pleading the Fifth Amendment while under cross-examination, and was blacklisted in the McCarthy period. He died on 10 January 1961.

THOMAS HARDY, who regarded himself primarily as a poet, would no doubt have been pleased by the dramatic revaluation of his poetry in the 1950s and afterwards, brought about largely by members of the loosely connected set of writers known as The Movement, and particularly by Philip Larkin and Donald Davie, who wrote an influential monograph, *Thomas Hardy and British Poetry*, asserting Hardy's centrality to the national tradition. He died on 11 January 1928, at the age of 87.

ERNEST HEMINGWAY became the most celebrated and instantly recognisable American author of his generation, as much for his swaggering, ultra-virile persona as for his writing. His literary output is surprisingly slim – just seven novels, of which the most widely read were *A Farewell to Arms* (1929), inspired by his experiences in the Great War; *For Whom the Bell Tolls* (1940), similarly inspired by his time in Spain during the civil war (1940); and *The Old Man and the Sea* (1951), which drew on his passion for deep-sea fishing. He served as a correspondent in World War II, sometimes exceeding his brief by taking part in military actions, and played a lively role in the liberation of his beloved Paris. He remained loyal to his friendship with Pound, even though he found the poet's political vision abhorrent, and used his growing distinction to lobby for Pound's

release. Heavy drinking took a toll on his physical and mental health; he killed himself with a shotgun on 2 July 1961. His deliberately pared-down style and his old-fashioned, macho values continue to divide readers, though the former has been an immense influence on one school of American writing.

HERMANN HESSE also became a hero of the counter-culture in the 1960s and 1970s, when it was almost essential for an idealistic youth to have read *Siddhartha*, *Steppenwolf*, *The Glass Bead Game* and other novels, some of which sold in their millions. Hesse anticipated various themes central to hippies: spiritual quests, the wisdom of the East and – so it seemed – the visions induced by LSD and other hallucinogenic drugs. This cult has long since faded, though Hesse's major works remain in print. Since he died on 9 August 1962, he was unaware of the extraordinary dimensions to which his new following would grow.

A. E. HOUSMAN died in 1936, at the age of 77.

ALDOUS HUXLEY developed from a smart young satirist into a visionary novelist and finally a mystic. His major novels of the 1930s include the enduringly popular *Brave New World* (1932) – whose vision of a future world now seems more accurate than Orwell's dystopia – and *Eyeless in Gaza* (1936). Huxley moved to the United States in 1937, settled in Los Angeles and made some money by writing for Hollywood; his most significant credit was for the 1940 *Pride and Prejudice*, though he was also co-writer of the 1944 *Jane Eyre*. During his first years in America, he grew increasingly fascinated by mysticism, and for a while embraced Vedanta. In the 1950s, he also became interested in psychic research and consciousness-altering drugs. (He may have been introduced to peyote as early as 1930, at a dinner in Berlin with Aleister Crowley.) Experiences with mescalin inspired the long essays *The Doors of Perception* (1954) and *Heaven and Hell* (1956), works that later became part of the core reading list for hippies. He went on to take quantities of LSD, still legal at the time, and – at his own written request – was administered a dose on his deathbed. News of his death on 22 November 1963 (another English man of letters, C. S. Lewis, died on the same day) was kept from the front pages by the reports from Dallas of the assassination of President John F. Kennedy.

FRANZ KAFKA died on 3 June 1924. His best friend, Max Brod, famously refused to follow Kafka's instructions that all his unpublished manuscripts should be destroyed, and over the next few years he arranged for their publication in German: *Der Prozess* in 1925, *Das Schloss* in 1926 and *Amerika* in 1927. English-language versions by the married team of Willa and Edwin Muir became available in the 1930s: *The Castle* (1930), *The Trial* (1935) and *America* (1938). In the anxious climate of the years leading up to the war, with the nightmare states of Nazi Germany and Stalinist Russia growing at once more savage and more powerful, Kafka's work seemed almost supernaturally prophetic, and found a keen response in the intelligentsia. After the war, the undeniably potent, yet enigmatic nature of Kafka's fictions lent itself to all manner of alternative readings – as religious allegories, as portents of the 'alienation' of life in Eastern Europe (or the 'existential' West, terrified of atomic war), as poems of the Freudian myth . . . The slim corpus of Kafka's novels was rapidly augmented by the re-publication of his short stories and the discovery of his letters, diaries and other personal writings. He has been written about in countless books, and has been portrayed both in serious works of art and in jokey, pop-culture versions.

D. H. LAWRENCE remained in America on and off for the next three years, but in 1925 he returned to northern Italy, where he was able to pick up his friendship with Aldous Huxley and others. He continued to write, though he also returned to painting in oils; a London exhibition of his work in 1929 was raided by the police on the predictable charge of obscenity. He died, from complications of tuberculosis, on 2 March 1930. The major novel of his last years, *Lady Chatterley's Lover*, remained unpublished in its full form until 1960, when Penguin Books decided to challenge British obscenity laws by bringing out a paperback edition. The famous 'Chatterley Trial', now seen as a major event in British cultural history, ended with a 'not guilty' verdict on 20 November 1960. Lawrence's standing in English literature was not very high at the time of his death, and most of the obituaries were hostile, save for that of E. M. Forster, who generously declared him 'the greatest imaginative novelist of our generation'. The most important champion of Lawrence's posthumous reputation was, again, the Cambridge critic F. R. Leavis, who in *D. H. Lawrence, Novelist* (1955) and other

writings proclaimed his centrality to the 'Great Tradition' of the English novel.

T. E. LAWRENCE was forced to resign from the RAF in February 1923, just a few weeks after his exposure by the press. Adopting another pseudonym, T. E. Shaw, he enlisted in the Tank Corps later that year, but did not find the army as much to his taste as the RAF. After steady lobbying and string-pulling, he returned to the RAF ranks in August 1925, and remained with the service until obliged to retire in March 1935; he generally claimed to be very happy with his humble role. Lawrence's RAF service lacked the high drama of his Arabian career, but was not without event. He was posted to India from 1926 to 1928 – where he spent some of his free time working on a commissioned translation of Homer's *Odyssey* – but had to be recalled when rumours both there and at home had it that he was working on a secret mission. He died on 19 May 1936, as a result of injuries sustained in a motorcycle crash; he had been notorious in the RAF for his love of fast and reckless cycling. Weeks later, the first trade edition of *Seven Pillars of Wisdom* was published and became an instant best-seller. Lawrence's other major book, *The Mint*, was published in a highly censored version in 1955: it is a tersely written and at times brutal account of his experiences in the RAF. Lawrence's fame, already great in his own lifetime, has grown all the greater over the decades: there have been hundreds of books about him, and many portrayals in documentaries and dramas. The outstanding example of the latter is the 1962 film *Lawrence of Arabia*, directed by David Lean from a script by Robert Bolt; though it played fast and loose with the factual record, it provided a delicate and largely persuasive portrait of Lawrence's complex, paradoxical character.

SINCLAIR LEWIS enjoyed further literary success with his novels *Arrowsmith* (1925), *Elmer Gantry* (1927) and *Dodsworth* (1929), each of which was made into a notable film, and published several more books – few of them now read – until his death from illnesses caused by his alcoholism, in 1951.

OSIP MANDELSTAM died – or was murdered? – in a Siberian transit camp on 27 December 1938, officially of an unspecified 'illness'. The seeds

of this terrible ending had been sown five years earlier, when Mandelstam had been brave or foolhardy enough to publish the so-called 'Stalin Epigram', a horrified response to the Great Famine of the early 1930s; it has been described as a suicide note in 16 lines. He was sent into exile with his wife Nadezhda – who later wrote two intensely moving memoirs of her life with the poet – eventually freed, then re-arrested. In the West, he and his some-time lover Anna Akhmatova are highly regarded as two of the poets who are more than simply magicians of the Russian language: they are heroes of their country's darkest times.

THOMAS MANN died on 12 August 1955; he had lived in the USA from 1939–52, and spent the last three years of his life in Switzerland. His major works include *The Magic Mountain* (1924), the tetralogy *Joseph and His Brothers* (1933–43) and *Doctor Faustus* (1947).

VLADIMIR MAYAKOVSKY remained a loyal Bolshevik for several years after 1922; thanks to his talent and his ideological trustworthiness, he was allowed almost unequalled freedom to travel in the West. But he began to have his doubts about the direction the USSR was taking, and he gave these doubts expression in satirical plays about the Russian bureaucracy and related topics, notably in *The Bedbug* (1929). Reference books state that he killed himself on 14 April 1930; this is probably so, though documents have come to light that make it seem possible that the suicide was stage-managed by the NKVD. In the immediate wake of his death, the Soviet press felt at liberty to attack him for formalism – a chorus of disapproval which rapidly changed its tune when Stalin declared that Mayakovsky had been the most talented of all the early poets of the regime, and that not to appreciate him was tantamount to a crime. With this imprimatur, Mayakovsky's fame in the Soviet Union was guaranteed; despite it, many capitalists and members of the bourgeoisie have also acknowledged his poetic talent.

VLADIMIR NABOKOV became world-famous thanks to the scandal created by his novel *Lolita* (1955), whose narrator is a middle-aged man obsessed with pre-pubescent girls. The scandal also made him wealthy enough to be financially independent for the first time in his life. After settling in Berlin in 1922, he remained in the city – for which he did not

greatly care – until 1937, teaching and writing and building a local reputation. In 1925, he married Vera; they had one son. In 1940, he joined the flood of émigrés to the United States, where Wellesley College took him in and provided him with agreeable employment as a professor of comparative literature. The post allowed him plenty of time to write novels in the English language, as well as to pursue his other great intellectual passion, lepidoptery. He later took up a similar post at Cornell. Nabokov often told his students that the greatest twentieth-century works of fiction were *Ulysses*, Proust's *À la Recherche* . . . , Kafka's *Metamorphosis* and Bely's *Petersburg*. After the *Lolita* affair, Nabokov had enough money to retire to Switzerland, and moved to Montreux in 1960. He died on 2 July 1977. Critical opinion on his achievement is divided between a majority faction who think he is one of the finest prose stylists in the language, and a much smaller group who are sceptical. *Lolita* remains his most famous novel, though the cognoscenti tend to favour *Pale Fire* (1962).

EUGENE O'NEILL wrote about a dozen plays between 1922 and his death on 27 November 1952. In the last decade of his life, his ability to write was severely hampered by his various illnesses, including a Parkinson's-like tremor in his hand which forced him to dictate his work. None the less, his autobiographical masterpiece *A Long Day's Journey Into Night* (written in 1941, first performed 1956) was one of the fruits of these invalid years. He remains, by informed consent, the most important of American dramatists.

GEORGE ORWELL/ERIC BLAIR served in Burma until 1927, when he came home on leave, reassessed his life and determined to reinvent himself as a writer. Among the general reading public, he is best remembered for *Animal Farm* and *Nineteen Eighty-Four*, published shortly before his premature death on 21 January 1950; more bookish readers tend to admire him as a reviewer and essayist, and as the master of a clear, trenchant and memorable prose style that can attain unexpected beauty. He has been called the finest English essayist since Hazlitt. In recent years, his name has often been dropped approvingly by neo-conservatives; Orwell, though a ferocious critic of communism and its various heresies, remained a democratic socialist to the end, and would have been disgusted at their nerve. Orwell once wrote that the three modern writers who most interested him

were Eliot, Joyce and Lawrence – though he was lukewarm in his response to Eliot's later poetry.

DOROTHY PARKER survived her suicide attempt by 45 years, and lived on until 1967. In 1925, she was appointed as one of the board of editors put together for the launch of *The New Yorker,* and she contributed poems, articles and reviews to its pages throughout the twenties and beyond. Highly successful as a journalist and writer of quirky verses, she developed an equally lucrative secondary career as a writer for stage and screen. She also became increasingly radical in her views, and paid the price for them in the McCarthy period. One of her major political passions was the rising civil rights movement, and she left her entire fortune to Martin Luther King's foundation. She proposed as her epitaph: 'Excuse my dust.'

LUIGI PIRANDELLO wrote many novels, plays and other literary works, but outside Italy his high reputation rests mainly on two plays, 1921's *Six Characters in Search of an Author* – which provoked a riot on its opening night – and *Henry IV (Enrico IV)* from 1922. Non-Italians also tend to be unaware of the unsavoury aspect of Pirandello's conduct in the Mussolini years: Il Duce made him the controller of the Teatro d'Arte di Roma, and he enjoyed all manner of privileges under Mussolini's reign. It is true that he tore up his fascist party card during an argument in 1927, and that he was long kept under scrutiny by the secret police. One must place against this, though, his apparently whole-hearted declaration of fascist loyalty, and the curious fact that he offered his 1934 Nobel Prize medal to be melted down as part of the war effort in Abyssinia. He died on 10 December 1936.

RAYMOND RADIGUET published his first novel, *Le Diable au Corps,* in 1923. He died that December, on the 12th, from typhoid fever. He was 20 years old. His second novel, *La Bal du Comte d'Orgel,* was published in 1924.

GEORGE BERNARD SHAW wrote only one more play of any note between 1922 and his death on 2 November 1950: *Saint Joan,* an international success inspired by the French heroine's canonisation in 1920.

Though he still cuts a witty, charming figure in the public imagination, Shaw frequently embraced views that were at best dubious, at worst evil. In the 1930s, he became a fervent supporter of Stalin's regime (he was, of course, far from being the only Western intellectual to be so duped); at the other extreme, he supported de Valera's letter of condolence to the German nation on the death of Hitler. He is still the only person to have won both the Nobel Prize for Literature (1925) and an Oscar (for the film version of *Pygmalion*, 1938).

EDITH SITWELL's many books include the best-seller *English Eccentrics* (1933); she herself became widely recognised as a splendid example of the species, and her extravagant appearance was familiar to thousands who had never read her verses. She died on 9 September 1964. *Façade* is still frequently performed, and enjoyed.

GERTRUDE STEIN had her first and only best-seller in 1933, with the trade paperback edition of *The Autobiography of Alice B. Toklas*. Purporting to be a memoir of Stein as seen by her lover, it was in fact an autobiography, written in a fairly plain and palatable style. It surprises some of her admirers that she was politically quite conservative; she sometimes declared herself a Republican, she wrote admiringly of Franco, and during the war she even managed to praise Maréchal Pétain (perhaps for strategic reasons; as a Jew in occupied France, she needed to curry favour). She died at the age of 72, in 1946; Carl Van Vechten was her literary executor.

EVELYN WAUGH's best-known (and, his more fastidious admirers would say, his worst-written) novel, *Brideshead Revisited*, begins with the early Oxford idyll inspired by his experiences as a freshman in 1922. The novel brought him fame twice over, the first time on its publication in 1945 – it was a best-seller – and then in 1982, when it was adapted into a lavish serial by Granada Television. Waugh had converted to Catholicism in 1930, but *Brideshead* is his first novel with a conspicuously Catholic theme. His later years were wretched, and at times tormented – he despised the increasingly egalitarian culture of Welfare State Britain – and he died at the age of 62, on 2 April 1966. The title of his novel *A Handful of Dust* is taken from *The Waste Land*.

•

H. G. WELLS lived until 13 August 1946, writing steadily at a rate of one or two books a year. With the possible exception of his 1933 novel *The Shape of Things to Come* – the basis for the remarkable British film *Things to Come* (1936), directed by William Cameron Menzies from a script by Wells – none of his later books are now widely read. His scientific romances, however, have remained uninterruptedly in print, still enthral readers and are still being made into films. Wells once suggested that his epitaph should be 'I told you so. You damned fools.'

EDITH WHARTON's autobiography, *A Backward Glance*, appeared in 1934, and though she published a dozen or so further works of fiction and non-fiction, it was her only publication of any note after *Glimpses of the Moon*, with the possible exception of *The Buccaneers*. Thanks in part to the blossoming of feminist literary criticism in the 1970s – but partly, too, because they are works of such outstanding merit – the reputation of her earlier novels grows greater with the years. Her work has often been adapted for the screen, the most famous film version being *The Age of Innocence* (1993), directed by Martin Scorsese.

EDMUND WILSON easily lived up to his early promise as a brilliant young critic, and went on to be America's leading Man of Letters. He wrote in many genres, including the novel, but was respected mainly as a critic and historian of ideas. His book *Axel's Castle* (1931), which discusses modernist literature in terms of its development from late-nineteenth-century symbolism, was one of the critical works which cemented Joyce and Eliot as modern classics. His 1940 book *To the Finland Station*, a study in the theories and practice of revolution from Vico (Joyce's hero) to Lenin, has sometimes been regarded as his own masterpiece. A dogged womaniser and heavy drinker, Wilson somehow found the time to write hundreds of critical essays, learn new languages, and take up all manner of political causes, from protest against the US tax system during the Cold War to the campaign for Native American rights. In addition to boosting Eliot and Joyce, he also promoted the works of Hemingway, Dos Passos, Faulkner, Nabokov and his old Princeton friend F. Scott Fitzgerald. Ten years after his death (on 12 June 1972), the Library of America series was launched; this project, for which Wilson had argued tirelessly, aims to

publish the central works of American literature in definitive, handsome but reasonably affordable editions.

VIRGINIA WOOLF, another beneficiary of the rise of feminist criticism, is now widely regarded as a major figure in literary modernism, particularly for such novels as *Mrs Dalloway* (1925) and *To the Lighthouse* (1928). She is also seen as an important polemicist for and theoretician of feminism in her own right: the essay *A Room of One's Own* (1929) and the less well-known but more powerful *Three Guineas* (1938) are the key works. In the early years of the war, Woolf succumbed to a familiar state of depression, and feared the onset of madness. She drowned herself in a river on 28 March 1941. Her friend Eliot was one of those who wrote an obituary.

W. B. YEATS used the money from his 1923 Nobel Prize to pay off all of his debts, and those of his late father. He remained a member of the Irish Senate until 1928, when he resigned on grounds of poor health. The most enduring fruit of his time as a senator was the beautiful Irish coinage: he was appointed to the coinage committee in 1924, and though he was not entirely contented with the outcome, his suggestions shaped the coins of his country until Ireland adopted the euro. Unlike many lyric poets, Yeats enjoyed a flowering of his talent in his later years. (He sometimes attributed this flood of creativity, and a vigorous new erotic life, to the vasectomy he had performed in 1934.) Many of his late poems are expressions of the supernatural model of the cosmos he outlined in *A Vision* (first published in 1925, then revised for later editions). Some of them also express a profoundly anti-democratic political view that verges on fascism, if not fully endorses it; under the influence of Pound, Yeats was one of several leading modernists who admired Mussolini. Some of Yeats's admirers consider that the poems collected in *The Tower* (1926), *The Winding Stairs* (1929) and *New Poems* (1938) are the high-water mark of his achievement. He died on 28 July 1939.

The Artists, Architects, Musicians and Performers

LOUIS ARMSTRONG gave deep pleasure to countless millions as a prolific and hard-working trumpeter, singer and all-round entertainer. His pre-eminence as the greatest of all jazz artists is rivalled – if at all – only by

Duke Ellington; though Ellington, patrician where Armstrong was unabashedly vulgar, never quite rivalled 'Satchmo's' popular touch. Armstrong died, wealthy, fulfilled and widely loved, on 6 July 1971. He had recently (1968) had a number one hit in the United Kingdom with 'What a Wonderful World' – a schmaltzy effort redeemed, as so often, by the gravelly wonder of his incomparable voice.

BÉLA BARTÓK is now regarded (with the possible exception of Liszt) as the greatest of Hungary's composers. Among the high points of his career are the 1936 *Music for Strings, Percussion and Celesta* and six superb string quartets. An early anti-fascist, Bartók refused invitations to play in Germany after the Nazis took power, and when war broke out fled to America. His years there were not easy – though not quite as terrible as some accounts have claimed – since he was not well known as a composer, only as a pianist and ethnomusicologist. A research grant from Columbia University, to work on Serbian and Croatian folk songs, kept him from extreme poverty. He finally won over America with his *Concerto for Orchestra*, which had its premiere in December 1944 and was an immediate hit; but he died from leukaemia the following year, on 26 September.

'COCO' CHANEL died on 10 January 1971. Her personal reputation was wounded by her affairs with high-ranking German officers during the Nazi occupation of France, and she moved to Switzerland for almost a decade after the end of the war, before making a triumphant return to Paris and her profession in 1954. She has been the inspiration for several films and dramas, including one about her brief affair with Stravinsky; experts in the field tend to regard her as the most influential costumier of her age.

JEAN COCTEAU pleased and surprised new generations up until his death at the age of 74 on 11 October 1963. Cocteau maintained that no matter in which medium he was working, he was first and foremost a poet; if so, then he is perhaps the outstanding poet of cinema, since at least two of the films he directed in late middle age, *La Belle et la Bête* (1946) and *Orphée* (1949), rank as classics. The ardent young critics and film-makers of the *nouvelle vague* admired him deeply as one of the handful of visionaries (Renoir, Vigo, Gance) who redeemed French cinema. It is said that his fatal heart attack was brought on by the shock of hearing that his good friend Edith Piaf had died the same morning.

•

SALVADOR DALÍ managed the remarkable coup of making his paintings and other artworks so palatable to rich investors, especially in the United States, that he himself grew immensely wealthy. In 1939, Breton gave him the derisive, anagrammatic nickname 'Avida Dollars', and expelled him from the surrealist movement – a fact largely disregarded by the world at large, for whom Dalí's work is the quintessence of surrealism. One of the great events of his life was his marriage to Gala (formerly the wife of Paul Eluard) in 1934; Gala was his muse, and her image appears in many of his paintings. He sat out the war comfortably in the United States – a fact scornfully noted by Orwell in a scathing review of Dalí's autobiography in 1944; Orwell called him 'a despicable human being' – and in 1949 returned to Catalonia, where he enjoyed good relations with Franco's regime, and was eventually elevated to the Spanish nobility. He died, after some rather pathetic late years, on 23 January 1989. The vulgarity and opportunism of his later work should not be allowed to discredit the many virtues he displayed in youth. He is greatly honoured in his native region, where Dalí-related sites, including a major museum, are popular with tourists.

SERGE DIAGHILEV died in Venice on 19 August 1929. His remains are buried in the cemetery of San Michele, as are those of his collaborator Igor Stravinsky and Ezra Pound.

MARCEL DUCHAMP completed his monumental work *The Large Glass* (also known as *The Bride Stripped Bare by Her Bachelors, Even*) in 1923. He was on close terms with the surrealists, though he never formally joined them. (He did, however, join the Collège de Pataphysique, and was one of the co-founders of its sub-commission, the Oulipo.) As far as most people knew, he abandoned making art entirely after 1923, and devoted his life to playing chess. In fact, he was secretly at work between 1946 and 1966 on a last major piece, *Étant Donnés*. He died on 2 October 1968: both his admirers and his detractors would agree that he changed modern art radically with his contention that anything could be transformed into an artistic creation by mere fiat. Whether this was a great liberation or a catastrophe is a matter of conviction.

ISADORA DUNCAN declined into alcoholism, and died in a freak car accident in Nice on 14 September 1927, when her long scarf became

caught up in a wheel. Her reputation as one of the indispensable creators of modern dance remains intact.

MANUEL DE FALLA, now acknowledged as Spain's most important composer of the twentieth century, fled his country when Franco came to power and settled in Argentina. He doggedly refused all attempts to coax him back to Spain, and died in his new country on 14 November 1946.

GEORGE GERSHWIN is estimated to have been the highest-paid composer in the history of Western classical music. His most ambitious and complex piece was the 'folk opera' *Porgy and Bess* (1935), which has often been called the greatest American opera. His most frequently performed composition is the jazz-influenced *Rhapsody in Blue* (1924), first performed by Paul Whiteman's orchestra. He died on 11 July 1937.

GEORGE HERRIMAN died on 26 April 1944. His Krazy Kat strips have frequently been reprinted, and have enchanted several generations.

PAUL HINDEMITH was for some years suspected of being a Nazi sympathiser, and a recipient of Nazi patronage. The reality is far less clear-cut: it now seems as if his acts of support for the regime were mostly aimed at saving his own skin, and he was as often condemned as endorsed by the Nazis: Goebbels, for example, sneered at him as an 'atonal noisemaker'. Hindemith spent a good deal of the 1930s on missions to Turkey, at the invitation of Atatürk; he helped both to reform and to establish methods of musical education in that country, and to set up musical companies. In 1938, he and his Jewish wife fled to Switzerland, and then, in 1940, to the USA, where he taught at Yale. Hindemith returned to Zurich in 1953, and remained there until his death in 1963.

WASSILY KANDINSKY continued to teach at the Bauhaus until it was finally closed down by the Nazis in 1933. He escaped to Paris, and became a French citizen in 1939. His years in Paris were not easy, since abstract painting was not yet in fashion, and he was obliged to live and work frugally, in a small flat that also served as his studio. Critics tend to be kind to this late period of his work, which can be seen as a synthesis of his various approaches over the years. He died on 13 November 1944.

•

PAUL KLEE also continued to teach at the Bauhaus, in his case until April 1931, and then took up a new teaching post in Düsseldorf. His international reputation grew significantly in these years, and he was, among other things, a great favourite of the surrealists, who first saw his work in 1925. With the rise of Hitler, he came under attack by the Nazi press, and his home was raided by the Gestapo. In 1933, he escaped to Switzerland; in the same year, he suffered from the first symptoms of a wasting disease, scleroderma, which eventually killed him on 29 January 1940. His work – which ran to some 9,000 paintings and drawings – is still frequently exhibited and widely admired.

LE CORBUSIER has been the object of more angry denigration and more adulation than any other architect. To his enemies – of whom one of the most articulate is the American urban historian Jane Jacobs – he is the villain who inspired a thousand ugly, life-cheapening and socially catastrophic housing projects. To his admirers, he is the visionary who best grasped the nature of what modern architecture might and must be. It may be argued that he was more significant as a theorist than a practitioner, though he did have a number of opportunities to make his visions real. Among his leading projects are the Villa Savoye (1924–31); the large-scale housing project 'Unité d'Habitation' in Marseilles (1946–52); and much of the heart of Chandigarh in India, which exemplified his theories of the 'radiant city'. It surprises many – especially those who think of his work as architectural Bolshevism – that he held rather right-wing views, and drifted further to the right with age. His death while swimming on 27 August 1965 prompted a chorus of praise across the world, from President Lyndon B. Johnson to the Kremlin.

WYNDHAM LEWIS was exceptionally prolific, both as an artist and as a writer (of novels, polemics, criticism, philosophy and poetry). He maintained, not without justice, that he was pushed to the margins of British cultural life because of his right-wing views (which for a while bordered on the fascist; he wrote an approving study of Hitler in the early 1930s, though he soon changed his mind), unacceptable at a time when most literary intellectuals were moving rapidly leftwards. Lewis spent the war years in the United States and Canada, and returned to England to pick up what he could of his literary and artistic careers – both of them curtailed by the

steady onset of blindness. He died on 7 March 1957. His reputation as a writer was for a long time wholly overshadowed by Eliot, Pound and Joyce – all of whom he criticised harshly in *Time and Western Man* – and most of his many books either fell out of print or were republished in tiny print runs by independent presses. In the last couple of decades, however, his work as an artist has become widely discussed, frequently exhibited and generally praised; the informed consensus now has it that he is one of the great English painters, particularly in the field of portraiture. His portraits of Eliot (1938, 1949) and Pound (1939) are among his best-known works.

MAN RAY remained in Montparnasse for the next 20 years, forming friendships with the surrealists and exhibiting with them, experimenting with avant-garde films, and above all excelling in photography. One of his famous subjects was Joyce. In 1939, he began a turbulent affair with his model and assistant Lee Miller, who went on to become an important photographer in her own right. Man Ray went back to America for the duration of the war, living mainly in Los Angeles; in 1946, he took part in a double wedding: he and his bride Juliet, Max Ernst and Dorothea Tanning. But he was homesick for Paris, and moved back there for good in 1951. He died on 18 November 1976.

HENRI MATISSE, who died on 3 November 1954 at the age of 84, is usually paired with Pablo Picasso as one of the two giants of twentieth-century painting and related arts. Thanks to the brilliance of his colours and the life-affirming spirit of his work, whether sensual or serene, Matisse remains the more popular of the pair; reproductions of, say, *Jazz* (1947) and other works are hung on walls that would never display, say, *Les Demoiselles d'Avignon*. In 1941, Matisse endured a colostomy operation; though he was often obliged to use a wheelchair, he continued to create with undiminished vigour and invention, and excelled in a medium he more or less invented – the arrangement of cut-out figures. One of his most celebrated works in this form, *The Snail*, was completed just before his death.

PABLO PICASSO is, in the popular imagination, the definitive modern artist; for ill as well as good. More than a century after *Les Demoiselles d'Avignon*, a large number of people have still not come to terms with any of Picasso's work save, perhaps, his pre-cubist productions. Conservatives and liberals alike are dismayed by his later politics: after years of seeming

apolitical, he joined the French Communist Party in 1944, and remained a member until his death, long after many other communists had resigned in disgust after the savage crushing of the Hungarian rising of 1956, the invasion of Czechoslovakia in 1968 and so on. In 1950, he accepted the Lenin Peace Prize. Traditionalists and feminists alike have been appalled by his erotic adventures: he married only twice, but had several long-term affairs (with Marie-Thérèse from 1927; Dora Maar in the 1930s and 1940s; Françoise Gilot from 1944 to 1953) and many dalliances, usually with women who were several decades younger than the artist. Yet none of these attacks has seriously compromised his historical standing. He effected what can now be seen as the most significant and far-reaching revolution in pictorial language since the development of perspective. He reinvented himself again and again, with an energy and creativity that borders on the amazing. His treatment of both male and female sexuality is at once savage and searching, and retains its power to disconcert; *Guernica* rivals Goya in its pity and terror; yet he can also be light, witty, playful, charming. His talent and his place in modern culture are, simply, unique.

ERIK SATIE, whose celebrity in his own lifetime never reached far beyond the artistic circles of Paris, has become internationally famous to a degree that would surely have astonished him; one of his pieces, the *Trois Gymnopédies* has been performed and recorded so often as to amount to a musical cliché. His celebrity is partly due to having been championed by the more thoughtful breed of rock musicians, such as Frank Zappa, and partly because the rise of such forms as 'ambient music' have made Satie's work much more pleasing to the informed ear. After his death, from cirrhosis of the liver, on 1 July 1925, his friends made a search of his small flat in the Parisian suburb of Arcueil; scattered among his meagre possessions they found a treasure trove of unpublished and unperformed scores.

ARNOLD SCHOENBERG, the greatest composer of the century? (See below, IGOR STRAVINSKY.) With the exception of a couple of his earliest, pre-serial pieces, Schoenberg's music has never managed to please crowds in the way that Stravinsky's has, and for many listeners it remains harsh, cerebral and intimidating. Yet his place as a giant of modern music is beyond reasonable dispute, whether for his own work or for his overwhelming influence on various disciples, above all Anton Webern and

Alban Berg. From 1926 to 1933, Schoenberg taught a master class at the Prussian Academy of Arts in Berlin. Like so many others, he was driven into emigration – and seems to have re-embraced his Jewish heritage as a result – moving first to Paris and then to Los Angeles, where he lived for the rest of his life. He did not much like Stravinsky, and saw little of him, but he did befriend another musical neighbour, George Gershwin, with whom he enjoyed playing tennis. Schoenberg taught classes at both UCLA and USC; the most celebrated of his pupils was John Cage. He died on 13 July 1951, leaving incomplete his most ambitious work – the three-act opera *Moses and Aaron*.

IGOR STRAVINSKY, the greatest composer of the century? (See above, ARNOLD SCHOENBERG.) After 1922, Stravinsky continued to work for some three decades in the neoclassical style, which he had begun to develop in 1920 or thereabouts. Some of the high points of this period are his three symphonies – *Symphony of Psalms* (1930), *Symphony in C* (1940) and *Symphony in Three Movements* (1945) – as well as his opera *The Rake's Progress*, with a libretto by W. H. Auden (1951). He adopted French citizenship in 1934, and then, after moving to the US at the age of 58, took American citizenship in 1945. His first wife, Katerina, died in 1939, leaving him free to marry his mistress, Vera de Bosset (1888–1962) in 1940. After some initial awkwardness in his new American home in Los Angeles, Stravinsky began to make close friendships with some of the leading figures in all the arts. (Schoenberg lived not far away, but they did not often meet.) He particularly enjoyed the company of resident or visiting English writers, above all Huxley, but also Auden, Dylan Thomas and Christopher Isherwood. He saw less of Eliot, but the poet and the composer admired and liked each other. Like many of the modernists, Stravinsky was politically conservative; apart from a short-lived enthusiasm for Mussolini, though, he was not led into extremist positions. He died in New York City on 6 April 1971, and his body was sent to the cemetery of San Michele, Venice.

FRANK LLOYD WRIGHT is usually considered the greatest American architect. His best-known work, and probably the masterpiece of his late years, is the Guggenheim Museum of Art in New York City – an elegant spiral ramp which alludes to the form of a seashell. Work on this building

occupied him from 1943 to 1959. Other outstanding works of his later life include the world-famous Fallingwater (1934–7) in Bear Run, Pennsylvania; his home, Taliesin West, in Scottsdale, Arizona; and his one sky-scraper, the Price Tower in Bartkesville, Oklahoma. He died, a prophet honoured in his own country, on 9 April 1969.

The Cineastes

LUIS BUÑUEL. After the dazzling Parisian coup of his early collaborations with Dalí – *Un Chien Andalou* and *L'Âge d'Or* – Buñuel made some excellent films in both France and Spain, before fleeing to the United States when Franco's forces won the civil war. He worked for a while in Hollywood, and then at the Museum of Modern Art in New York. After the war, in 1946, he moved to Mexico, which would be his home for the rest of his life, though he returned to France and even Spain to direct some of his films. Unlike many directors, he enjoyed a late flowering: *The Discreet Charm of the Bourgeoisie* (1972) and *That Obscure Object of Desire* (1977) are among his best films. In collaboration with his favourite screenwriter, Jean-Claude Carrière, he published a highly enjoyable autobiography, *Mon Dernier Soupir* (*My Last Breath*). He died in 1983.

CHARLIE CHAPLIN, or SIR CHARLES CHAPLIN, built on his experience as a feature film director, and went on to make *The Gold Rush* (1925) – a commercial hit, and probably his best-known film – *City Lights* (1931), *Modern Times* (1936), *The Great Dictator* (1940), *Monsieur Verdoux* (1947) and *Limelight* (1952). While he was in Europe, his political enemies – he was a victim of the McCarthy era – arranged for him to be denied a re-entry visa. He spent almost all of the rest of his life in Switzerland, mainly in good health until shortly before his death on Christmas Day 1977.

SERGEI EISENSTEIN made some of the enduring classics of early Soviet cinema: *Strike* (1924), *Battleship Potemkin* (1928) and *October* (1927). These films brought him acclaim both at home and in the West, and for a while he was in such favour that he was not only allowed to travel extensively overseas but, in 1930, to accept a Hollywood contract. Nothing substantial came of this, nor of an abortive production set in Mexico.

Eisenstein was summoned home, and redeemed himself by making the patriotic historical drama *Alexander Nevsky*, with music by Prokofiev. Unfortunately, the Hitler–Stalin pact made the anti-German burden of the film ideologically unacceptable. The director had another chance at redemption with a projected trilogy about Ivan the Terrible. Part One of the film (1944) was a great success with Stalin, but Eisenstein was increasingly being accused of 'formalism', and he was in disgrace again when he died of a heart attack on 11 February 1948, at the age of 50.

ROBERT FLAHERTY worked in documentary films for the rest of his life (d. 23 July 1951), but never rivalled the success of *Nanook*. His other notable films are *Man of Aran* (1934) – which, like *Nanook*, came under fire for its faking of 'traditional' ways of life – and *Louisiana Story* (1948).

SIR ALFRED HITCHCOCK, after his abortive start in 1922, rapidly became acknowledged as one of Britain's leading film-makers – first with silents, and then with sound films such as *The Man Who Knew Too Much* (1934) and *The Thirty-Nine Steps*. He went to the United States in 1939, and worked there for the rest of his prolific career. In all, he made 50 features, few of them poor, many of them classics: *Notorious* (1946), *Rear Window* (1954), *North by Northwest* (1959), *Psycho* (1960) and *The Birds* (1963). Polls of film critics over the last few decades have regularly included *Vertigo* as one of the top ten best films, and one authoritative poll put it second only to *Citizen Kane*. The tendency to regard Hitchcock as a serious artist as well as a consummate popular entertainer was boosted by some idolatrous articles from the French critics and would-be directors of the *nouvelle vague*, especially François Truffaut. Hitchcock has no real peer as a director; he has been called the Dickens of cinema.

BUSTER KEATON turned his energies towards making feature films, some of which – *Our Hospitality* (1923), *Sherlock Jr.* (1924) and above all *The General* (1926) – are often voted the greatest comedies ever produced. His career suffered from vertiginous ups and downs, and towards the end of his life he was happy to accept cameo roles, most famously in *Sunset Boulevard*, where, in effect, he played himself. One of his very last performances was in the philosophical short *Film* (1965), written by Joyce's young friend Samuel Beckett. He died on 1 February 1966.

•

FRITZ LANG was a notorious spreader of myths about his own career, and the much-repeated story of how he was offered control of the entire German film industry by Goebbels shortly after the Nazis came to power is almost certainly untrue. What is beyond dispute is the quality and historical significance of his Weimar films: *Die Nibelungen* (1924), *Metropolis* (1927) and, perhaps his masterpiece, *M* (1931). Lang divorced his wife, who had become a fully paid-up Nazi, in 1933, and left Germany in 1934. Like many other talented refugees, he ended up in Hollywood, where he made many films between 1936 and 1957, sometimes as many as two a year. A number of them were tough thrillers, and did not have much in the way of a critical reputation until, like Hitchcock, Lang was taken up as an auteur by the young French directors. The most famous moment of his later career was his role in Jean-Luc Godard's *Le Mépris* (1963). He died on 2 August 1976.

F. W. MURNAU's career was cut short when he died in a car crash on 11 March 1931. *Nosferatu* remains his most famous film, but he made at least two more classics of the German cinema, *The Last Man* (*Der letzte Mann*) in 1924 and *Faust* in 1926. In 1927, he made the Hollywood film *Sunrise*, which fared poorly at the box office but is now regarded as one of the greatest of all films. He did not live to see the premiere of his last movie, *Tabu*, a troubled collaboration with Robert Flaherty. Fritz Lang gave the speech at Murnau's funeral.

ERICH VON STROHEIM (d. 1957) fought bitterly against his studios and producers until he gave up directing for good in 1933. Film historians consider that the butchering of his film *Greed* from an original running time of ten hours to one fifth of that length, and the subsequent loss of all rushes in a fire, is one of the worst artistic calamities Hollywood has known. Von Stroheim concentrated on his career as an actor, and is often best remembered for his roles in *La Grande Illusion* and *Sunset Boulevard*.

The Thinkers and Gurus

GREGORY BATESON went on to work in several distinct fields: anthropology, psychiatry, semiotics, and the developing disciplines of systems

theory and cybernetics, both of which he helped create. From 1936 to 1947, he was married to the best-known of all American anthropologists, Margaret Mead. He carried out most of his mature work in the United States; in 1956, the year he took American citizenship, he and three of his colleagues formulated the 'double-bind' theory of schizophrenia, a theory made popular in the 1960s by the radical therapist widely assumed to have invented it, R. D. Laing. Bateson's most widely read work is *Steps to an Ecology of Mind* (1972). He died on 4 July 1980.

ALBERT EINSTEIN fled Germany in 1933, shortly before the Nazis began to burn his books and put an assassination bounty of $5,000 on his head. He settled at the Institute for Advanced Study in Princeton, where he spent the rest of his life, mainly working – with no success – at the development of a unified field theory (sometimes called the 'Theory of Everything') and contesting the standard view of quantum physics. Though he had long been a pacifist, the threat that Germany might develop atomic weapons alarmed him so much that he lobbied President Roosevelt to initiate the Manhattan Project. For the rest of his life, he was tormented by the possibility that this may have been his greatest mistake. Long before his death on 18 April 1955, Einstein had become as much a myth as a living man and working scientist: he occupied a role in the popular imagination as the wisest and kindest of Wise Old Men, as well as a lovable absent-minded professor. He was offered the presidency of Israel in 1952, but politely declined; in America, he supported many left-wing and progressive movements, and was a doughty champion of racial equality. In 1999, *Time* magazine nominated him as Person of the Century.

SIGMUND FREUD's major publications after 1922 are the so-called 'meta-psycho-analytic' essays *The Future of an Illusion* (1927, on religious faith), *Civilization and its Discontents* (1930) and *Moses and Monotheism* (1939). In February 1923, he discovered a small, apparently benign growth in his mouth. This was the first sign of the jaw cancer, caused by his heavy smoking, which was to torture him for his last years. In 1931 – like a last flowering of the humane German spirit – he was awarded the Goethe Prize for contributions to literature. A year later, the Nazis came to power, and began burning his books. He remained stubbornly at work in Vienna despite harassment by the Gestapo – bullying that he met with consider-

able personal courage. But the *Anschluss* of 1938 had made it impossible for him to stay much longer, so he took refuge in England, settling at 20 Maresfield Gardens in Hampstead; today the home of a Freud museum. By the autumn of 1939, the pain of his cancer had become insupportable, and with the assistance of his friend Dr Max Schur, he took some fatal doses of morphine, and died on 29 September. He was, in a way, fortunate: his four sisters were all murdered by the Nazis in extermination camps. The story of the triumph and retreat of Freudian theory in the years following his death is a long and extraordinary one. For many years after the war, especially in America, the psychoanalytic profession flourished, and Freudian terms and ways of thinking – not always well understood – permeated many areas of life, from movies to literary criticism. Even the most parochial souls had some idea of what was meant by the Oedipus complex. In the late twentieth century, thanks in part to advances in neurology and related sciences, and in part to embarrassing scandals within the psychoanalytic world, Freud's theories were so severely undermined as to be regarded by most scientists as a hoax or a delusion. Curiously, this debunking has done little to diminish the status of Freud in literary circles, where his fundamental concepts – and those of latter-day Freudians, above all Jacques Lacan – are still taken by many intelligent people as self-evidently true. A less extreme version of this latter view is the perfectly tenable one that Freud's shortcomings as a scientist in no way diminish his standing as a moralist in the classic European sense, or as a literary stylist of a very high order; and that whatever follies have been committed in his name, the general effect of his work has helped foster a more tolerant and compassionate culture than the one in which he was educated.

G. I. GURDJIEFF became known, unjustly, as 'the man who killed Katherine Mansfield'. As is wholly clear from the record, Mansfield was already at the point of death when she arrived at his institute; if he hastened her demise at all, it can only have been by a matter of days, and it is quite possible that she derived some comfort from his regime. Others who visited the Institute – including Crowley – were very impressed by what they saw. In 1924, Gurdjieff suffered a near-fatal car accident, and, in his long convalescence, closed down most of the activities of the institute to devote himself to writing his immense trilogy *All and Everything*. These three

books were not published in English until after his death: *Beelzebub's Tales to His Grandson* in 1950, *Meetings with Remarkable Men* in 1963, and the unfinished *Life Is Real Only Then, When 'I Am'* in 1974 (private) and 1978 (trade). He lived and taught in Paris throughout the Occupation, and died on 29 October 1949. Gurdjieff's doctrines are still being taught at institutes in many countries, and the list of disciples is impressive, ranging from Frank Lloyd Wright to P. L. Travers, author of *Mary Poppins*.

CARL JUNG coined many terms that have made their way into the common speech of various languages: notably the words complex, introvert and extrovert; but also archetype, synchronicity, shadow, anima, and collective unconscious. As his work proceeded, he moved away from notions of analytic cure and towards investigations of art, mythology and the occult. In his 1944 book on alchemy, for example, he contended that the quest for the Philosopher's Stone – generally regarded by historians as confused and incoherent fumbling towards the origins of modern chemistry – was in fact an account of the progress of the soul through stages of initiation and enlightenment. Many of his later books are frankly mystical, including his best-selling and highly readable autobiography *Memories, Dreams, Reflections* (published in 1962 – a few months after his death on 6 June 1961). Jungian analytic psychology is still practised as a therapeutic method, but Jung's influence has been most profound and pervasive in the realm of culture – thanks in part to the popular works on mythology written by his follower (and sometime commentator on Joyce) Joseph Campbell, whose *Hero with a Thousand Faces* is now a set book for screenplay writers.

JOHN MAYNARD KEYNES, though he has had no shortage of detractors over the last 30 years or so, is none the less widely held to be the most brilliant of twentieth-century economists, and certainly the most influential. His revolutionary model of economies, which broke altogether with the classical school of Adam Smith and his disciples, was articulated in a number of complex and densely argued works, including the *Treatise on Money* (1930), and his masterwork, *The General Theory of Employment, Interest and Money* (1936). The economic system now known as 'Keynesian' was adopted by the Allies during World War II, and dominated the development of all the advanced Western nations in the period from 1945

to the late 1970s. Keynes died on 21 April 1946, so he did not live to see the full flowering of his theories; but he was already known to the general public as the man 'who saved capitalism'. Keynesian policies were jettisoned in some countries thanks to the rise of the so-called monetarist school, inspired by Friedman, Hayek and others (Keynes, incidentally, admired Hayek's *Road to Serfdom* and agreed with much of it); in the eyes of many pundits and commentators, he was obviously discredited. But the global economic crisis that began in 2007 has brought him directly back to the centre of economic debate, and many of the emergency policies adopted in the USA, the UK and elsewhere in the last few years have been inspired by him. Keynes, whose non-technical writings are delightfully lucid and eloquent, is often made into a bogeyman by the right. In fact he was in politics a man of the centre – in many respects an old-school liberal – and regarded communism with antipathy and scorn.

BRONISLAW MALINOWSKI's *Argonauts of the Western Pacific* was rapidly acknowledged as one of the towering achievements of anthropology, and it made him world-famous. For much of the next two decades, he taught at the London School of Economics, and helped it to become a world centre for anthropology. The outbreak of war saw him in the United States; he stayed there, and taught at Yale until his death on 16 May 1942.

P. D. OUSPENSKY split from Gurdjieff in 1924, and went on to teach his own forms of wisdom – forms that can be distinguished from Gurdjieff's only by the initiated. His major publication in the years before his death in 1947 was *A New Model of the Universe* (1931). *In Search of the Miraculous*, an autobiography that gives a detailed portrait of his time with Gurdjieff, was published shortly after his death. Recent studies, notably by Gary Lachman, have suggested that Ouspensky's clandestine influence on the literary world of the 1920s and 1930s was considerably greater than has generally been assumed.

WILHELM REICH died in a Maine prison, of a heart attack, on 3 November 1957, while serving a two-year term for contempt of court. His early works, including *The Mass Psychology of Fascism* (1933), were part of an ambitious project to reconcile the apparently incompatible doctrines of

Freud and Marx; this part of his oeuvre proved highly influential on the New Left of the 1960s and 1970s. But his work began to take far more eccentric turns, into areas reminiscent more of science fiction than of science. He escaped from the Nazis in 1934 and eventually settled in Oslo until 1939. In that year, he moved to America, and soon established a thriving and profitable psychoanalytic practice. He also began to conduct 'experiments' – actual scientists would deny them that name – designed to confirm his increasingly bizarre views of the universe. His most famous creation was the so-called 'orgone accumulator': simply, a metal-lined wooden box that was meant to capture 'orgones', a primal cosmic energy. Reich claimed that by sitting in the box, patients would not only experience immense sexual stimulation, but could be cured of many ailments, including cancer. He managed to persuade Einstein to join him in an 'experiment' on 13 January 1941. Einstein initially conceded that the slight rise of temperature they measured in the accumulator might offer some support to the Reichian world-view, but soon changed his mind. In 1942, with money from his practice and from a growing band of disciples, Reich bought a former farm in rural Maine, and renamed it Orgonon. The FBI were already keeping a discreet eye on his strange activities, but he was largely undisturbed until a hostile article was published in *The New Republic*, branding him a sinister charlatan. Further sceptical articles followed, and the Food and Drug Administration took an interest, eventually banning him and his followers from shipping orgone accumulators across state lines. When one of Reich's henchmen defied the ban, Reich was summoned to court in Portland, Maine. He conducted his own defence, and was found guilty of contempt and sentenced to two years. In August 1957, the FDA also burned about six tons of his books and papers in New York, apparently blind to the unfortunate connotations of this act. Reich's posthumous influence on science has been close to nil, though his theories have told deeply in radical forms of psychotherapy and in novels, films and rock music. A cult film, Dušan Makavejev's *W.R.: Mysteries of the Organism* (1971), helped make him another of the hippy movement's grandfather figures.

W. H. R. RIVERS was restored to public attention in the 1990s by Pat Barker's award-winning trilogy *Regeneration*, which included a moving portrait of Sassoon's treatment by the compassionate doctor, as well as

reminiscences of his time on the Torres Straits expedition. Few of Rivers's publications are still in print; the scope and nature of his achievement has yet to be adequately explored, but it was obviously immense.

BERTRAND RUSSELL became better known to the public as a polemicist and spokesman of protest movements – above all, the Campaign for Nuclear Disarmament – than for his work as a philosopher, though his *History of Western Philosophy* (1945) was a best-seller that provided him with a comfortable income for the last decades of his life. His own work in philosophy has been overshadowed by that of his former protégé Ludwig Wittgenstein. Some were surprised by his being awarded the Nobel Prize for Literature in 1950, since his prose was never as distinguished as that of, say, Keynes. In his own view, Russell's greatest achievement was to have saved the world from a nuclear war: he phoned Khrushchev during the Cuban Missile Crisis of 1962 and secured the Soviet leader's assurance that he would not launch an attack on the West.

NICOLAI TESLA, who in the 1890s and 1900s had been the best-known and most widely admired electrical engineer and inventor in America, died, alone and impoverished, on 7 January 1943, in the small New York hotel room that had been his home for the last decade. He was 86. The brilliance of his earlier accomplishments became shadowed by his reputation for increasing eccentricity; many portrayals of the 'mad scientist' at around this time – for example, in the early *Superman* comics – were inspired by Tesla. Among other oddities, he became obsessed with pigeons, which he would rescue from Central Park and keep in his rooms. Tesla was a celibate, and eventually an urban hermit. In the years since his death, he has regained a strange new form of celebrity, as one of the real-life figures who haunt the public imagination at the point where science-fiction overlaps with conspiracy theories. He has been portrayed in countless films, novels, plays, video games and so on, most famously as a supporting character in Christopher Nolan's *The Prestige* (2006), in which he is played by David Bowie.

RICHARD WILHELM's translation of the *I Ching* became an unlikely best-seller when it was taken up by the hippies as a tool for divination. He died on 2 March 1930.

•

LUDWIG WITTGENSTEIN effected two major revolutions in English-language philosophy: first with the *Tractatus Logico-Philosophicus*; and then, having decided that this was fundamentally misconceived, with the work that was eventually published, posthumously, as *Philosophical Investigations* (1953). For four years after the publication of the *Tractatus*, he carried on working in obscurity as a village schoolteacher, but resigned for good in 1926 after a couple of incidents in which he lost his temper with slow students and hit them hard. He spent much of the next two years back in Vienna, working on the design and building of the Haus Wittgenstein for his sister Margaret (who gave him the task because she saw how desperately he needed something to occupy him). He applied himself to this project with a perfectionism that bordered on the fanatical, and though the building has been much admired by architectural historians, Margaret found it a chilly, inhuman place, more suited to gods than to fleshly mortals. Invited back to Cambridge by Russell, Keynes and others, Wittgenstein resumed his philosophical work there in 1929, and was soon awarded a PhD on the strength of the *Tractatus*; he also became a British national. Though he took over a professorship from G. E. Moore in 1939, he was never entirely comfortable in Cambridge, and would depart for long periods of silent retreat. During the war, he worked at Guy's Hospital, London as a dispensary porter; few of the many people he saw realised that he was a famous philosopher, and he was horrified on the rare occasions when patients did recognise him. After three more years of idiosyncratic work at Cambridge, where he thought intently about the questions that are pursued in the *Investigations*, he appears to have suffered some kind of breakdown, and went to Ireland from 1947–8 to recuperate. He developed prostate cancer, which spread to other parts of his body, and died in Cambridge on 29 April 1951. The publication of the *Philosophical Investigations* two years later cast a spell over much of the English-speaking world of philosophy, and set off a tidal wave of publications, which continues to this day. Adherents of Heidegger or other so-called 'Continental' thinkers may dispute the fact, but for the non-Continentals Wittgenstein is unquestionably the most important philosopher of the century. His influence has reached far beyond professional philosophy and into the arts, not least because the doggedly plain language in which the *Investigations* were written makes it a seductively easy read – though

fully to grasp its implications may be the work of years, or a lifetime. Wittgenstein's strange character, with its paradoxical meeting of deep humility and arrogance, racking guilt and capacity for simple pleasure, loneliness and coldness – and, to be sure, his incomparable genius – makes him a fascinating figure even for those who cannot grasp his work. In an earlier century, he would probably have been a saint.

SELECT BIBLIOGRAPHY

Letters, Memoirs and Primary Texts

Acton, Harold, *Memoirs of an Aesthete* (1948, Methuen, London)

Brecht, Bertolt (ed. and trans. John Willett and Ralph Manheim), *Bertolt Brecht: Collected Plays, Volume I, 1918–1923* (1970, Methuen, London)

Brecht, Bertolt (ed. Herta Ramthun, trans. John Willett), *Diaries 1920–1922* (1987, Methuen, London)

Budgen, Frank, *James Joyce and the Making of Ulysses* (1934, Grayson & Grayson, London)

Buñuel, Luis (trans. Abigail Israel), *My Last Breath* (1984, Jonathan Cape, London)

Burns, Edward (ed.), *The Letters of Gertrude Stein and Carl Van Vechten, 1913–1946*, Volume I (1986, Columbia University Press, New York)

Cather, Willa, *Not Under Forty* (1936, Knopf, New York)

Chaplin, Charles, *My Autobiography* (1964, Simon & Schuster, New York)

Connolly, Cyril, *Enemies of Promise* (1938, Routledge & Kegan Paul, London)

Conrad, Joseph (ed. Laurence Davies and J. H. Stape), *The Collected Letters of Joseph Conrad, Volume 7, 1920–1922* (2005, CUP, Cambridge)

Eisenstein, Sergei (ed. and trans. Richard Taylor), *Writings 1922–1934* (1988, BFI, London)

Eliot, T. S. (ed. Valerie Eliot), *The Waste Land: A Facsimile and Transcript of the Original Drafts including the Annotations of Ezra Pound* (1971)

Eliot, T. S. (ed. Christopher Ricks), *Inventions of the March Hare: Poems 1909–1917* (1996, Faber & Faber, London)

Eliot, T. S. (ed. Valerie Eliot and Hugh Haughton), *The Letters of T. S. Eliot, Volume I, 1898–1922, Revised Edition* (2009, Faber & Faber, London)

Fitzgerald, F. Scott, *The Great Gatsby* (1925, Scribner's, New York)

Fitzgerald, F. Scott, 'Echoes of the Jazz Age', in *The Crack-Up*, ed. Edmund Wilson (1945, New Directions, New York)

Fitzgerald, F. Scott (ed. John Kuehl and Jackson Bryer), *Dear Scott/Dear Max: The Fitzgerald/Perkins Correspondence* (1971, Scribner's, New York)

Gimpel, René (trans. John Rosenberg), *Diary of an Art Dealer* (1963, 1966, Farrar, Straus and Giroux, New York)

Hemingway, Ernest, *A Moveable Feast* (1994 revision of 1964 edition, Arrow, London)

Hemingway, Ernest (ed. William White), *Dateline Toronto: The Complete 'Toronto Star' Despatches, 1920–1924* (1985, Scribner's, New York)

Hesse, Hermann (trans. Mark Harman), *Soul of the Age: Selected Letters of Hermann Hesse 1891–1962* (1991, Farrar, Straus and Giroux, New York)

Joyce, James (ed. Stuart Gilbert), *Letters of James Joyce* (1957, Viking, New York)

Joyce, James (ed. Richard Ellmann), *Letters of James Joyce, Volume Three* (1966, Faber & Faber, London)

Joyce, Stanislaus (ed. Richard Ellmann, preface by T. S. Eliot), *My Brother's Keeper* (1958, Faber & Faber, London)

Kafka, Franz (ed. Max Brod, trans. Joseph Kresh and Martin Greenberg), *The Diaries of Franz Kafka 1910–1923* (1949, Secker & Warburg, London)

Kafka, Franz (trans. Richard and Clara Winston), *Letters to Friends, Family and Editors* (1977, Schoken Books, New York)

Kessler, Count Harry (ed. and trans. Charles Kessler), *The Diaries of a Cosmopolitan, 1918–1937* (1971, Weidenfeld & Nicolson, London)

Keynes, John Maynard, and Lopokova, Lydia (ed. Polly Hill and Richard Keynes), *Lydia & Maynard: The Letters of Lydia Lopokova and John Maynard Keynes* (1989, Andre Deutsch, London)

Lawrence, T. E. (aka 352087 A/C Ross), *The Mint: The Complete Unexpurgated Text* (1978, Penguin, Harmondsworth)

Lawrence, T. E. (ed. Malcolm Brown), *The Letters of T. E. Lawrence* (1991, OUP, Oxford)

Lewis, Wyndham, *Blasting and Bombardiering: An Autobiography 1914–1926* (1937, Eyre & Spottiswoode, London)

Mansfield, Katherine (ed. Vincent O'Sullivan and Margaret Scott), *The Collected Letters of Katherine Mansfield, Volume 5, 1922* (2008, OUP, Oxford)

McAlmon, Robert, and Boyle, Kay, *Being Geniuses Together, 1920–1930* (1970, Michael Joseph, London)

Nabokov, Vladimir, *Speak, Memory: An Autobiography Revisited* (1967, Weidenfeld & Nicolson, London)

Nabokov, Vladimir (ed. Fredson Bowers), *Lectures on Literature* (1980, Weidenfeld & Nicolson, London)

Nayman, Anatoly (trans. Wendy Rosslyn), *Remembering Anna Akhmatova* (1991, Peter Halban, London)

Pound, Ezra, *Selected Letters 1907–1941* (1950, Faber & Faber, London)

Pound, Ezra, *The Cantos of Ezra Pound* (1970, New Directions, New York)

Pound, Ezra (ed. Forrest Read), *Pound/Joyce: The Letters of Ezra Pound to James Joyce* (1970, New Directions, New York)

Pound, Ezra (ed. William Cookson), *Selected Prose 1909–1965* (1973, Faber & Faber, London)

Pound, Ezra (ed. Brita Lindberg-Seyersted), *Pound/Ford: The Story of a Literary Friendship* (1982, Faber & Faber, London)

Pound, Ezra (ed. Timothy Materer), *Pound/Lewis: The Letters of Ezra Pound and Wyndham Lewis* (1985, Faber & Faber, London)

Pound, Ezra, and Zukofsky, Louis, *Pound/Zukofsky, Selected Letters* (1987, Faber & Faber, London)

Pound, Ezra (ed. Thomas Scott, Melvin Friedman and Jackson Bryer), *Pound/The Little Review: The Letters of Ezra Pound to Margaret Anderson* (1988, Faber & Faber, London)

Pound, Ezra, *Early Writings, Poems and Prose* (2005, Penguin, New York)

Pound, Ezra (ed. Mary de Rachewiltz, A. David Moody and Joanna Moody), *Ezra Pound to his Parents: Letters 1895–1929* (2010, OUP, Oxford)

Pound, Omar, and Litz, A. Walton, *Ezra Pound and Dorothy Shakespear: Their Letters 1909–1914* (1985, Faber & Faber, London)

Power, Arthur, *Conversations with James Joyce* (1974, Millington, London)

Prokofiev, Sergey (trans. and ed. Anthony Phillips), *Sergey Prokofiev, Diaries 1915–1923: Behind The Mask* (2008, Faber, London)

Sassoon, Siegfried, *The Complete Memoirs of George Sherston* (*Memoirs of a Fox-Hunting Man, Memoirs of an Infantry Officer, Sherston's Progress*) (1937, Faber & Faber, London)

Schoenberg, Arnold (ed. Erwin Stern, trans. E. Wilkins and E. Kaiser), *Letters* (1964, Faber & Faber, London)

Schoenberg, Arnold, and Kandinsky, Wassily (ed. Jelena Hahl-Koch, trans. J. C. Crawford), *Schoenberg–Kandinsky: Letters, Pictures and Documents* (1984, Faber & Faber, London)

Stein, Gertrude, *The Autobiography of Alice B. Toklas* (1933, Harcourt, Brace & Company, New York)

Stein, Gertrude, and Van Vechten, Carl (ed. Edward Burns), *The Letters of Gertrude Stein and Carl Van Vechten 1913–1946* (1986, Columbia University Press, New York)

Svevo, Italo (trans. Stanislaus Joyce), *James Joyce* (1950, New Directions, New York)

Waugh, Evelyn, *A Little Learning: The First Volume of an Autobiography* (1990 revised edition from 1964 original, Penguin, London)

Wilson, Edmund, *Axel's Castle: A Study in the Imaginative Literature of 1870–1930* (1931, Scribner's, New York)

Wilson, Edmund (ed. Leon Edel), *Edmund Wilson: The Twenties, From Notebooks and Diaries of the Period* (1975, Farrar, Straus and Giroux, New York)

Wilson, Edmund, *Literary Essays and Reviews of the 1920s and 1930s* (2007, Library of America, New York)

Woolf, Virginia, *Mrs Dalloway* (1925, Hogarth Press, London)

Woolf, Virginia (ed. Anne Olivier Bell), *The Diaries of Virginia Woolf, 1920–1924* (1981, Penguin, Harmondsworth)

Wright, Frank Lloyd, *An Autobiography* (1977, Horizon Press, New York)

Secondary Texts

Ackroyd, Peter, *T. S. Eliot* (1984, Hamish Hamilton, London)

Agee, James, *Agee on Film Volume I: Reviews and Comments* (1958, McDowell Obolensky, New York)

Allen, Frederick Lewis, *Only Yesterday: An Informal History of the 1920s* (1957, Harper Perennial, New York)

Appel, Alfred Jr, *Jazz Modernism: From Ellington and Armstrong to Matisse and Joyce* (2002, Knopf, New York)

Avery, Todd, *Radio Modernism: Literature, Ethics and the BBC, 1922–1938* (2006, Ashgate, Hampshire)

Banham, Rayner, *Theory and Design in the First Machine Age* (1960, The Architectural Press, London)

Barnouw, Eric, *Documentary: A History of the Non-Fiction Film* (1993 2nd revised edition, OUP, New York)

Baxter, John, *Buñuel* (1994, Fourth Estate, London)

Bedford, Sybille, *Aldous Huxley: A Biography* (originally two volumes, 1972, Chatto & Windus, London; one-volume edition 1993, Pan Macmillan, London)

Bell, Quentin, *Bloomsbury* (1968, Weidenfeld & Nicolson, London)

Bell, Quentin, *Virginia Woolf: A Biography* (1972, Harcourt Brace Jovanovich, New York)

Benstock, Shari, *No Gifts from Chance: Edith Wharton, a Biography* (1994, Scribner's, New York)

Bergreen, Lawrence, *Louis Armstrong, An Extravagant Life* (1997, Broadway Books, NY)

Booth, Martin, *A Magick Life: A Biography of Aleister Crowley* (2000, Hodder & Stoughton, London)

Bowker, Gordon, *James Joyce: A Biography* (2011, Weidenfeld & Nicolson, London)

Boyd, Brian, *Vladimir Nabokov, The Russian Years* (1990, Chatto & Windus, London)

Bradbury, Malcolm, and McFarlane, James (eds), *Modernism: A Guide to European Literature 1890–1930* (1976, Penguin, Harmondsworth)

Brocheux, Pierre, *Ho Chi Minh, A Biography* (2007, CUP, Cambridge)

Brownlow, Kevin, *The Parade's Gone By . . .* (1968, Secker & Warburg, London)

Carpenter, Humphrey, *A Serious Character: The Life of Ezra Pound* (1988, Faber & Faber, London)

Chang, Jung, and Halliday, Jon, *Mao, The Unknown Story* (2005, Jonathan Cape, London)

Cheney, Margaret, *Tesla: Man out of Time* (1981, Dell, New York)

Conrad, Peter, *Modern Times, Modern Places: Life & Art in the 20th Century* (1998, Thames & Hudson, London)

Crawford, Robert, *The Savage and the City in the Work of T. S. Eliot* (1990, Clarendon Press, Oxford)

Crick, Bernard, *George Orwell: A Life* (1980, Secker & Warburg, London)

Davenport-Hines, Richard, *A Night at the Majestic: Proust and the Great Modernist Dinner Party of 1922* (2006, Faber & Faber, London)

Delong, Thomas A., *Pops: Paul Whiteman, King of Jazz* (1983, New Century, New York)

Douglas, Ann, *Terrible Honesty: Mongrel Manhattan in the 1920s* (1995, Farrar, Straus and Giroux, New York)

Eisner, Lotte H. (trans. Roger Greaves), *The Haunted Screen* (1969, Thames & Hudson, London)

Ellmann, Richard, *James Joyce* (1959, OUP, Oxford)

Ellmann, Richard, *The Consciousness of Joyce* (1977, OUP, New York)

Ellmann, Richard, *Four Dubliners: Wilde, Yeats, Joyce and Beckett* (1987, Hamish Hamilton, London)

Farr, Finis, *Frank Lloyd Wright* (1961, Scribner's, New York)

Fass, Paula S., *The Damned and the Beautiful: American Youth in the 1920s* (1979 revised edition, OUP, New York)

Fischer, Louis, *The Life of Mahatma Gandhi* (1950, Harper & Brothers, New York)

Foster, R. F., *W. B. Yeats: A Life; Volume I, The Apprentice Mage 1865–1914* (1998, OUP, Oxford)

Foster, R. F., *W. B. Yeats: A Life; Volume II, The Arch Poet 1915–1939* (2003, OUP, Oxford)

Frayling, Christopher, *The Face of Tutankhamun* (1992, Faber & Faber, London)

Freedman, Ralph, *Life of a Poet: Rainer Maria Rilke* (1996, Farrar, Straus and Giroux, New York)

Furbank, P. N., *E. M. Forster: A Life, Volume Two: Polycrates' Ring, 1914–1970* (1978, Secker & Warburg, London)

Gay, Peter, *Weimar Culture* (2002 revised edition of 1968 text, Norton, New York)

Gay, Peter, *Modernism: The Lure of Heresy – From Baudelaire to Beckett and Beyond* (2009, Vintage, New York)

Gelb, Arthur and Barbara, *O'Neill* (1960, Harper & Brothers, New York)

Gibson, Ian, *Federico García Lorca: A Life* (1989, Pantheon Books, New York)

Gibson, Ian, *The Shameful Life of Salvador Dalí* (1997, Faber & Faber, London)

Gilbert, Martin, *Winston S. Churchill, Volume IV (1917–1922)* (1975, Heinemann, London)

Gordon, Lyndall, *Eliot's Early Life* (1977, OUP, Oxford)

Gordon, Lyndall, *T. S. Eliot: An Imperfect Life* (Norton, New York, 1999)

Grant, Michael (ed.), *T. S. Eliot: The Critical Heritage, Volume I* (1982, Routledge & Kegan Paul, London)

Graves, Robert, and Hodge, Alan, *The Long Weekend: A Social History of Great Britain, 1918–1939* (1941, Faber & Faber, London)

Hastings, Selina, *Evelyn Waugh: A Biography* (1994, Sinclair-Stevenson, London)

Hayman, Ronald, *K: A Biography of Kafka* (1981, Weidenfeld & Nicolson, London)

Hayman, Ronald, *Thomas Mann: A Biography* (1995, Scribner's, New York)

Hayman, Ronald, *A Life of Jung* (1999, Bloomsbury, London)

Hobsbawm, Eric, *Age of Extremes: The Short Twentieth Century, 1914–1991* (1994, Michael Joseph, London)

Hochman, Elaine S., *Bauhaus: Crucible of Modernism* (1997, Fromm International, New York)

Hone, Joseph, *W. B. Yeats* (1943, Macmillan, London)

Hussey, Andrew, *Paris: The Secret History* (2006, Penguin, London)

Isaacson, Walter, *Einstein: His Life and Universe* (2008 revised edition, Pocket Books, New York)

Jackson, John Wyse, and Costello, Peter, *John Stanislaus Joyce: The Voluminous Life and Genius of James Joyce's Father* (1997, Fourth Estate, London)

James, Lawrence, *The Golden Warrior: The Life and Legend of Lawrence of Arabia* (1990, Weidenfeld & Nicolson, London)

Jenkins, Roy, *Churchill* (2001, Macmillan, London)

Jones, Ernest (ed. Lionel Trilling and Steven Marcus), *The Life and Work of Sigmund Freud* (1962, Hogarth Press, London)

Jones, Max, and Chilton, John, *Louis: The Louis Armstrong Story* (1971, Little, Brown & Co., Boston)

Keats, John, *You Might as Well Live: The Life and Times of Dorothy Parker* (1970, Simon & Schuster, New York)

Kenner, Hugh, *The Pound Era: The Age of Ezra Pound, T. S. Eliot, James Joyce and Wyndham Lewis* (1972, Faber & Faber, London)

Kershaw, *Hitler: Volume I, 1889–1936: Hubris* (1998, Penguin, London)

Kiberd, Declan, *Ulysses and Us: The Art of Everyday Living* (2009, Faber & Faber, London)

Kincaid-Weekes, Mark, *The Cambridge Biography of D. H. Lawrence, Volume II: Triumph to Exile 1912–1922* (2011, CUP, Cambridge)

King, Francis, *The Magical World of Aleister Crowley* (1977, Weidenfeld & Nicolson, London)

Kracauer, Siegfried, *From Caligari to Hitler: A Psychological History of the German Cinema* (1947, Princeton University Press, Princeton)

Kurrzke, Hermann (trans. Leslie Wilson), *Thomas Mann: Life as a Work of Art* (2002, Princeton University Press, Princeton)

Lachman, Gary, *In Search of P. D. Ouspensky* (2004, Quest Books, Wheaton, Illinois)

Lancaster, Marie-Jaqueline, *Brian Howard: Portrait of a Failure* (2005, Timewell Press, London)

Lee, Hermione, *Virginia Woolf* (1997 revised edition, Vintage, London)

Levin, Harry, 'What was Modernism?', in *Refractions: Essays in Comparative Literature* (1966, OUP, New York)

Lewis, David Levering, *When Harlem was in Vogue* (1981, Knopf, New York)

Lewis, Jeremy, *Cyril Connolly: A Life* (1997, Jonathan Cape, London)

Mack, John E., *A Prince of Our Disorder: The Life of T. E. Lawrence* (1976, Harvard University Press, Boston)

Mackenzie, Norman and Jeanne, *H. G. Wells, A Biography* (1973, Simon & Schuster, New York)

Maddox, Brenda, *Nora: The Real Life of Molly Bloom* (1988, 2000, Mariner Books, New York)

McCormack, W. J., *Blood Kindred: The Politics of W. B. Yeats and His Death* (2005 edition, Pimlico, London)

McGilligan, Patrick, *Fritz Lang: The Nature of the Beast* (1997, Faber & Faber, London)

Meade, Marion, *Dorothy Parker: What Fresh Hell is This?* (1988, Villard Books, New York)

Meade, Marion, *Bobbed Hair and Bathtub Gin: Writers Running Wild in the Twenties* (2004, Doubleday, New York)

Mellow, James R., *Hemingway: A Life Without Consequences* (1992, Houghton Mifflin, Boston)

Meyers, Jeffrey, *The Enemy: A Biography of Wyndham Lewis* (1980, Routledge & Kegan Paul, London)

Meyers, Jeffrey, *D. H. Lawrence, A Biography* (1990, Macmillan, London)

Meyers, Jeffrey, *Edmund Wilson, A Biography* (1995, Houghton Mifflin, Boston)

Meyers, Jeffrey, *Orwell: Wintry Conscience of a Generation* (2000, Norton, New York)

Milton, Giles, *Paradise Lost: Smyrna 1922* (2008, Basic Books, New York)

Mitchell, Leslie, *Maurice Bowra, A Life* (2009, OUP, Oxford)

Mizener, Arthur, *The Far Side of Paradise: A Biography of F. Scott Fitzgerald* (1969 revised edition, Heinemann, London)

Mizener, Arthur, *Scott Fitzgerald and his World* (1972, Thames & Hudson, London)

Monk, Ray, *Ludwig Wittgenstein: The Duty of Genius* (1990, Jonathan Cape, London)

Monk, Ray, *Bertrand Russell: The Spirit of Solitude, 1872–1921* (1996, Jonathan Cape, London)

Monk, Ray, *Bertrand Russell: The Ghost of Madness, 1921–1970* (2000, Jonathan Cape, London)

Montefiore, Simon Sebag, *Stalin: The Court of the Red Tsar* (2003, Vintage, New York)

Moody, A. David, *Ezra Pound: Poet: A Portrait of the Man and his Work; Volume 1, The Young Genius 1885–1920* (2007, OUP, Oxford)

Moore, James, *Gurdjieff: Anatomy of a Myth: A Biography* (1991, Element Books, London)

Mundy, Jennifer (ed.), *Duchamp Man Ray Picabia* (2008, Tate Publishing, London)

Murray, Nicholas, *Kafka* (2004, Little, Brown, London)

Nicholson, Virginia, *Among The Bohemians: Experiments in Living 1900–1939* (2006, Penguin Books, London)

North, Michael, *Reading 1922: A Return to the Scene of the Modern* (2002, OUP, New York)

O'Brian, Patrick, *Pablo Ruiz Picasso: A Biography* (1976, Collins, London)

Page, Norman, *A. E. Housman, A Critical Biography* (1983, Macmillan, London)

Painter, George D., *Marcel Proust* (1965, Chatto & Windus, London)

Pais, Abraham, *Einstein Lived Here* (1994, Clarendon Press, Oxford)

Payne, Robert, *The Life and Death of Lenin* (1964, Simon & Schuster, New York)

Penrose, Roland, *Picasso: His Life and Work* (1958, Gollancz, London)

Polizzotti, Mark, *Revolution of the Mind: The Life of André Breton* (1995, Bloomsbury, London)

Prater, Donald, *Thomas Mann: A Life* (1995, OUP, New York)

Raine, Craig, 'The Waste Land', in *Haydn and the Valve Trumpet: Literary Essays* (1990, Faber & Faber, London)

Reeder, Roberta, *Anna Akhmatova, Poet & Prophet* (1995, Allison & Busby, London)

Rhode, Eric, *A History of the Cinema from its Origins to 1970* (1976, Allen Lane/Penguin, London)

Richardson, John, *A Life of Picasso: Volume III: The Triumphant Years 1917–1932* (2007, Jonathan Cape, London)

Ricks, Christopher, *T. S. Eliot and Prejudice* (1988, Faber & Faber, London)

Robinson, David, *Buster Keaton* (1970, BFI/Thames & Hudson, London)

Robinson, David, *Chaplin: His Life and Art* (1985, Collins, London)

Sawyer-Laucanno, Christopher, *E. E. Cummings, A Biography* (2005, Methuen, London)

Schnitzer, Luda and Jean (eds) (trans. David Robinson), *Cinema in Revolution: The Heroic Era of the Soviet Film* (1973, Secker &Warburg, London)

Schorer, Mark, *Sinclair Lewis: An American Life* (1961, McGraw-Hill, New York)

Seigel, Jerrold, *Bohemian Paris: Culture, Politics, and the Boundaries of Bourgeois Life, 1830–1930* (1986, Viking, New York)

Seymour-Smith, Martin, *Robert Graves – His Life and Work* (1982, revised edition 1987, Paladin, London)

Shelden, Michael, *Orwell: The Authorised Biography* (1991, Heinemann, London)

Shloss, Carol Loeb, *Lucia Joyce: To Dance in the Wake* (2004, Bloomsbury, London)

Skelton, Geoffrey, *Paul Hindemith, the Man behind the Music* (1975, Gollancz, London)

Skidelsky, Robert, *John Maynard Keynes 1883–1946: Economist, Philosopher, Statesman* (2003, Macmillan, London)

Slobodin, Richard, *Rivers: Part I: Life* (1978, Columbia University Press, New York)

Spoto, Donald, *The Dark Side of Genius: The Life of Alfred Hitchcock* (1983, 1988, Frederick Muller, London)

Spurling, Hilary, *Matisse the Master: A Life of Henri Matisse: The Conquest of Colour, 1909–1954* (2005, Hamish Hamilton, London)

Squires, Michael, and Talbot, Lynn K., *Living at the Edge: A Biography of D. H. Lawrence and Frieda von Richthofen* (2002, Robert Hale, London)

Steegmuller, Francis, *Cocteau: A Biography* (1986, Constable, London)

Stock, Noel, *The Life of Ezra Pound* (Routledge & Kegan Paul, London, 1970)

Stravinsky, Vera, and Craft, Robert, *Stravinsky in Pictures and Documents* (1978, Simon & Schuster, New York)

Sultan, Stanley, *Eliot, Joyce and Company* (1987, OUP, New York)

Surya, Michel (trans. Krzysztof Fijalkowski and Michael Richardson), *Georges Bataille: An Intellectual Biography* (2002, Verso, London)

Sykes, Christopher, *Evelyn Waugh: A Biography* (revised edition 1977, Penguin, Harmondsworth)

Symonds, John, *The Great Beast* (1971, revised 1973, Granada, Herts.)

Tomalin, Claire, *Katherine Mansfield: A Secret Life* (1987, Viking, London)

Truffaut, François, *Hitchcock* (1978 updated edition, Granada/Paladin, St Albans)

Turnbull, Andrew, *Scott Fitzgerald* (1962, The Bodley Head, London)

Twombly, Robert C., *Frank Lloyd Wright: An Interpretive Biography* (1973, Harper & Row, New York)

Von Salis, J. R. (trans. N. K. Cruikshank), *Rainer Maria Rilke: The Years in Switzerland* (1964, University of California Press, Berkeley)

Walker, Alexander, *Rudolf Valentino* (1976, Hamish Hamilton, London)

Walsh, Steven, *Stravinsky: A Creative Spring: Russia and France 1892–1934* (1999, Knopf, New York)

Ward, Geoffrey C., and Burns, Ken, *Jazz: A History of America's Music* (2000, Knopf, New York)

Webb, James, *The Occult Establishment, Volume II: The Age of the Irrational* (1981, Richard Drew Publishing, Glasgow)

Weber, Nicholas Fox, *Le Corbusier: A Life* (2008, Knopf, New York)

Weber, Nicholas Fox, *The Bauhaus Group: Six Masters of Modernism* (2009, Knopf, New York)

White, Eric Walter, *Stravinsky: The Composer and his Works* (1966, Faber & Faber, London)

Willett, John, *Art & Politics in the Weimar Era: The New Sobriety 1917–1933* (1978, Pantheon, New York)

William, Martin, *The Jazz Tradition* (1971, New American Library, New York)

Williams, James S., *Jean Cocteau* (2008, Reaktion Books, London)

Wilson, Jean Moorcroft, *Siegfried Sassoon: The Journey from the Trenches: A Biography 1918–1967* (2003, Duckworth, London)

Wilson, John Howard, *Evelyn Waugh, A Literary Biography 1903–1924* (1996, Associated University Presses, London)

INDEX